BUDDHISM AND AMERICAN CINEMA

SUNY series in Buddhism and American Culture
John Whalen-Bridge and Gary Storhoff, editors

BUDDHISM
and
AMERICAN
CINEMA

EDITED BY
John Whalen-Bridge
and
Gary Storhoff

FOREWORD BY
Danny Rubin

Cover art © Losw / Bigstockphoto (for film reel and file photo) and © Beboy / Bigstockphoto (for Buddha statue)

Published by State University of New York Press, Albany

For information, contact State University of New York Press, Albany, NY
www.sunypress.edu

Production by Diane Ganeles
Marketing by Fran Keneston

Library of Congress Cataloging-in-Publication Data

Buddhism and American cinema / edited by John Whalen-Bridge and Gary Storhoff ; foreword by Danny Rubin.
 pages cm. — (SUNY series in Buddhism and American culture)
 Includes bibliographical references and index.
 ISBN 978-1-4384-5349-1 (hc : alk. paper)
 ISBN 978-1-4384-5350-7 (pbk.: alk. paper)
 1. Buddhism in motion pictures. 2. Motion pictures—Religious aspects—Buddhism. 3. Motion pictures—United States—History and criticism.
I. Whalen-Bridge, John, editor of compilation. II. Storhoff, Gary, editor of compilation.
 PN1995.9.B795B79 2014
 791.43'682943--dc23

 2013047789

10 9 8 7 6 5 4 3 2 1

This book is dedicated to the memory of Gary Storhoff.

CONTENTS

Buddhism" in Popular Culture
 Richard C. Anderson and David A. Harper 133

7. Buddhism, Our Desperation, and American Cinema
 Karsten J. Struhl 157

8. Christian Allegory, Buddhism, and Bardo in Richard Kelly's
Donnie Darko
 Devin Harner 179

9. "Beautiful Necessities": *American Beauty* and the Idea
of Freedom
 David L. Smith 199

 Afterword: On Being Luminous
 Gary Gach 215

 Bibliography 227

 Filmography 243

 About the Contributors 247

 Index 253

FOREWORD

DANNY RUBIN

I once wrote a movie about a man who rubs a lamp and discovers a genie. The event takes place on a very depressing day in this man's life, and he inadvertently wishes that the whole day had all been a dream. Before you know it—poof! The genie grants his wish, and the man's entire day does turn out to be a dream —but not *his* dream (he should have been more specific!). Instead the dream belongs to someone else, an equally lonely woman, and the story soon becomes hers. When she finally does meet the man with the genie it's a big moment because she has truly met the man of her dreams. The story is romantic and sweet and magical, and the dreams within dreams inspired one of my friends to observe, "You probably don't know this, but you're Hindu."

Then there's that other movie I wrote about the man who repeats the same day over and over again. February second. *Groundhog Day.* The same friend observed, "You probably don't know this, but you're Buddhist."

My friend's observations may or may not have merit. I once wrote a western about a hanging. Does that make me a cowboy? But what I love about writing movies is the way I get to explore interesting stories and simultaneously explore myself. Who is the guy, I ask, who made this choice or that choice? What does he believe that underlies his decisions? What values are revealed? Which are really me? From the mixed dust of dreams and memories, from creations and from discoveries, I refine my own story with every new screenplay, each time getting closer and closer to someone I believe to be

me. That is what I get from writing movies. And occasionally some money, too.

When I wrote *Groundhog Day* I wasn't trying to write a Buddhist movie. But, keep in mind that Phil Connors, the cynical weatherman stuck in time, wasn't trying to become a better person, even though he eventually did exactly that. He was just trying to get through the day. Every morning was a new opportunity for him to ask, "Now what? What am I doing here? What could I be doing here? What should I be doing here?" The accumulation of days and of experiences pushed Phil toward greater understanding and greater refinement. All it took for him was a sense of mindful awareness—and zero chance of escape.

Writing screenplays is a lot like that. "Now what? What am I doing here? What could I be doing here? What should I be doing here?" This is a daily meditation on the blank page. Maybe all screenwriters are natural Buddhists.

Of course I'm not always looking inward, and I do occasionally seek out perspective and knowledge from others. I mean, I may not be seeking enlightenment but I'm not seeking ignorance either.

So, for instance, although I am not personally an expert on either Buddhism or American film, here I find myself on the leading edge of a wonderful collection of essays on the subject, and I'm thinking I should probably read them. I invite you to join me. For our convenience they have been placed immediately following this foreword. Will reading these essays bring us any closer to enlightenment? Or better: Will it help us get our screenplays produced? Of course I don't yet know the answer to these questions, but in reading, as in writing, I remain open to the delight of unintended results, and what that can teach me about myself.

ACKNOWLEDGMENTS

This project was a slow train comin' and was pushed along by the hands of Baey Shi Chen, Jacqueline Chia, and Nirmala Iswari. Funding for this wonderfully helpful support was provided by Dean Brenda Yeoh's Dean's Office of the Faculty of Arts and Social Sciences at the National University of Singapore, paperwork along the way having been signed by heads-of-department Robbie Goh and Lionel Wee of ELL. Thank you all for helping this project along.

Thanks also to Linda Storhoff and Helena Whalen-Bridge for your help with this project.

An earlier version of Eve Mullen's "Buddhism, Children, and the Childlike in American Buddhist Films" appeared in the *Journal of Religion and Film* as "Orientalist Commercializations: Tibetan Buddhism in American Popular Film," 2, no. 2 (October 1998). Likewise, David L. Smith's "'Beautiful Necessities': *American Beauty* and the Idea of Freedom" appeared in the *Journal of Religion and Film* 6, no. 2 (October 2002). An earlier version of Jiayan Mi and Jason Toncic's "Consuming Tibet: Imperial Romance and the Wretched of Holy Plateau" appeared in *Tamkang Review* 42.1 (December 2011).

A TRIBUTE TO GARY STORHOFF

CHARLES JOHNSON

I've had a good run.

—Gary Storhoff (1947–2011)

I'm going to remember Dr. Gary Storhoff as an outstanding scholar to whom I am forever indebted, a gentleman, a dedicated teacher, devoted father and family man, and my brother in the Buddha-dharma. I only learned about his passing away yesterday from his wife. He died at age sixty-three, exactly a week ago on November 7, peacefully at home with his family after a year-long bout with cancer. Never did he complain about his illness or the fact that, as he put it, he was leaving this "beautiful world."

We were introduced in the best of possible ways—by his work. I read one of his scholarly articles on my work, and I was so impressed by his insight, the depth of his knowledge of literature and philoso-phy (Western and Eastern), that I called his English department at the University of Connecticut (Stamford) and left a message, thank-ing him for this gift of the mind and spirit. It was Dr. Storhoff who first made clear the presence of Buddhist epistemology in my story "Moving Pictures."

Later, at one of the sessions for the Charles Johnson Society at the American Literature Association, I heard him present a brilliant analysis of another of my stories, "Executive Decision," and after-ward I told him that he'd inspired me to take another pass at Bud-dhist epistemology in a work of fiction, one that perhaps would be less elusive than in "Moving Pictures." That story, "Kamadhatu: A Modern Sutra," appears in *Shambhala Sun* (March 2012): 37–41. (I owe the existence of that story to him.) I should also mention that

after Storhoff read his paper that day, I saw another participant who read a paper before him lean toward Gary and enthusiastically whisper, "You win! You win!" I believe that is the feeling everyone will have when they encounter Dr. Storhoff's scholarship. It is original, top-tier, rigorous, and deeply learned.

He was one of the founding members of the CJ Society, one highly respected by the other officers for his personal and professional integrity. He authored one of the best books on my work, *Understanding Charles Johnson*, for which I am deeply grateful. And for the last few years, he coedited with John Whalen-Bridge the groundbreaking three-volume series on Buddhism and American Culture. In addition to his books, he authored sixty-five articles and chapters in American, African American, and ethnic literature journals. He received two teaching awards and served for two years as assistant to the director at the Stamford campus. He is survived by his mother, his wife of thirty-nine years, a son (a film animator), a daughter, and two brothers. His ashes will be scattered at his home in Danbury and his childhood home in North Dakota.

Like a stone tossed into a pond, his absence among us will ripple outward and be felt by many for a very long time: by family, friends, his students, colleagues, those who care about American Buddhism and literary/academic culture. I remember him as a quiet man—quiet in that solid, steady, reliable American heartland way that someone would be who was born in Duluth, Minnesota, and grew up in North Dakota. He never promoted himself but instead let his works and deeds speak for him. I am convinced that a man like Gary Storhoff is an achievement of culture and civilization. That he was the very embodiment of culture and civilization. And that, of course, explains his humility. Do not underestimate all the decades of disciplined living, devotion to learning and the highest ideals of teaching, love and sacrifice for others required to produce a true man of character, credentialed and accomplished, like Gary Storhoff. We academics (and artists) sometimes tilt toward cynicism; we often silently watch the everyday, selfless work of our colleagues but fail to properly honor them until their sudden absence leaves a hole in our lives. What I'm saying is that men and women such as him are a crucial bridge between generations, transmitting day in, day out "the best that has been known and said in the world" (to borrow a phrase from Matthew Arnold), in the West and the East, from those who

came before us to those who will follow us and embrace 24/7—as Storhoff did—the daily, demanding work of keeping the goodness, truth, and beauty to be found in culture and civilization alive and vividly present from one era to the next. What I wrote about M. L. King Jr. in *Dreamer* (words adapted from the *Tao Te Ching*), I would say about Storhoff: "Not putting on a show, he commanded respect; not justifying himself, he was distinguished; not boasting, he was instantly acknowledged."

I will sorely miss Dr. Storhoff. But, even as I grieve, I find great joy in the brilliant gifts that he so generously gave to us. Those gifts of the mind and spirit (and his personal example) will never—ever—be tarnished by time. Thank you, Gary.

Introduction

Some (Hollywood) Versions of Enlightenment

JOHN WHALEN-BRIDGE

Buddhism has been a subject of cinematic attention since film's origins, often signifying exoticism, both in flattering and unflattering ways. Film as a form of documentary practice begins in the late nineteenth century, and film as a form of public entertainment has frequently found Buddhism to be an interesting subject. Franz Osten and Himansu Rai created what might be considered the first "Buddhist film" in 1925 when they recast Sir Edwin Arnold's 1861 poetic epic of the same name into the film *Light of Asia*.[1] This is the oldest film that has been screened at International Buddhist Film Festival events. In English-language cinema, Buddhist ideals are sometimes presented in disguised forms, such as when we find a Shangri-La entrusted to ancient Caucasian caretakers in *Lost Horizons* (1937). The Asian wise man with no attachment makes occasional appearances, sometimes breaking through into television, as in the television show *Kung Fu* (1972–1975).

Buddhism in popular culture can be overt in this manner, or it can be inferred. For example, critics have argued that Buddhist bodhisattva ideals find their way into science fiction fantasies such as the Jedi Code of the *Star Wars* films. The countercultural celebration of Asian difference has been an important motivation; Orientalist fantasy can also account for the widespread dissemination of signs and symbols originating from Asian philosophical and religious writings and systems of practice.

Asian philosophy and religion has inspired American writers, mainly poets and essayists associated with Transcendentalism, and countercultural writers of the mid twentieth century, especially the Beats, engaged with Asian thought much more thoroughly. In the 1990s, film seems to have superseded literature as the vehicle for transcultural exchange, and we might want to ask why. In part the issue would seem to be the declining prestige of literature as a leading form of cultural expression. In the twenty-first century, it has become surprising to see an American poet or novelist discussed in the media in relation to a large national concern such as the 9/11 attacks on the World Trade Center. We are much more likely to see a movie director or an actor commenting on a major event, an effect of celebrity worship that Brad Pitt ridiculed when he was asked his opinion about Tibet as a geopolitical issue: "Who cares what I think China should do [about Tibet]?" he told *Time* magazine. "I'm a fucking actor . . . I'm a grown man who puts on makeup" (Garner). That said, actors such as Richard Gere have used their fame to publicize Tibet as a human rights issue, even going so far as to get himself banned as an Academy Award presenter after he used the event to denounce the Chinese government.[2]

In addition to being the spiritual and temporal leader of the Tibetan people in exile, the Dalai Lama arose over a ten-year period to become a kind of superstar. He was first given a visa to give religious teachings in the United States during the Carter administration in 1979.[3] While images of Buddha and representations of Buddhist practices appeared sporadically in European and American cinema before World War II, increasing somewhat in the postwar period as a result of American military involvement in Asia and the countercultural enthusiasms of Beat writers such as Allen Ginsberg, Jack Kerouac, Gary Snyder, and others, cinematic representation of Buddhism increased dramatically after the Dalai Lama was awarded the Nobel Prize for Peace in 1989.[4] The decade that followed could be described as a cinematic Buddha Boom. The most well-known cinematic representations of Buddha or Buddhism have been *Little Buddha* (1994), *Kundun* (1997), and *Seven Years in Tibet* (1997), and these films have extended popular knowledge of Buddhism considerably.[5]

Whether Buddhist beliefs (about karma or reincarnation) or practices (meditation, especially) have been in the foreground or

in the background, it is uncontestable that films, even as they have traded upon the exoticism of Buddhism in the American *imaginaire*, have made Buddhism far less exotic than it was previously.[6] Buddhist film is important because it is a marker of the impact of Asian philosophy and religion on American culture. It is also important as a culture resource, a way to signify within American culture in ways that are quite distinct from what had previously been expressed. This volume brings together mostly thematic approaches to Buddhist film, and the focus is overwhelmingly on feature-length "fictional" films. Why focus only on feature-length films? This volume is the first of its sort, and the essays in it are responses to a call for original essays on the topic. There is much to be studied in the area of documentary expression. The phrase "Buddhist film" will make us think of celebrities such as Brad Pitt and Keanu Reeves. This is highly significant (and weird), but it is a first association and, hopefully, not the conclusion. These films have established the notion of "Buddhist film" in various strands of academic and nonacademic discourse, a notion that has been granted a degree of reification by the world phenomenon of the "Buddhist film festival."[7]

Since 2003, there have been more than two dozen well-publicized, international Buddhist film festivals, which would suggest that there is such a thing as a "Buddhist film." The films shown in those festivals are from many countries. Some are nonscripted documentaries, some are full-length feature films meant for a wider distribution, and the festivals have also presented television show episodes and other manner of evidence that Buddhist ideas and images have been making their way into American and European societies through visual media. This volume—the first book-length collection on Buddhism and film—focuses mainly on American feature-length movies intended for wide distribution.

There are two distinct kinds of Buddhist films: those that are about Buddhism and those that aren't. Some Buddhist films represent Buddhism, meaning the actual Buddha, important Buddhist figures, ordinary people who are Buddhists, and so forth. But about half of the essays discuss movies structured around themes that resonate with Buddhist concerns, even though the films do not directly treat ideas, characters, or settings that are typically associated with those concerns. Some of the films that deal directly with Buddhism as a worldview that are treated in detail include *Heaven and Earth*

(1993), *Seven Years in Tibet* (1997), *Kundun* (1997), and *The Cup* (1999).[8] These films, we note, are all about persons or populations who are understood as victims of historical processes. Ly Le Hayslip's autobiographical works about the turmoil she experienced as a result of war in Vietnam are the textual basis for the third film of Oliver Stone's Vietnam trilogy. The two Tibet films released in 1997 mark the ascent of the Dalai Lama within the American imagination. First given permission to visit America in 1979, he won a Nobel Prize for peace ten years later and a Congressional Medal in 2007. Khyentse Norbu's *The Cup* is noteworthy in *not* constructing Buddhists as victims, even though the film recognizes colonial domination by the People's Republic of China in several key scenes. The American-made films center on Buddhism as a locus of innocence and, therefore, powerlessness. Cultural interpreters become suspicious when the most direct representations of an identity directly feed into a flattering form of self-understanding, for example, the moral critic, if not the savior.

There has been much discussion of Eurocentrism and of Western (as it were) ideas and images achieving a kind of semiotic colonization within Asian societies. If one wanted to enquire as to how specifically Asian cultural practices and expressive traditions have fared at making the trip the other way, one could look at phenomena such as Asian martial arts, forms of self-cultivation such as meditation and yoga, and religious systems such as Buddhism. The list is not complete, but if one wanted to consider the cultural expressions through which Buddhism enters the American *imaginaire*, the three main avenues would appear to be the literary imagination, popular film, and of course books (and, more recently, DVDs and downloads) concerned with directly teaching methods and approaches to Buddhist meditation. Which films have been the most significant direct representations of Buddhism, for American audiences? The films treated at length in this volume are of central importance.

Groundhog Day is perhaps the best example of a "non-Buddhist Buddhist movie." All schools of Buddhism maintain that in order to be free from the cycle of suffering (samsara), beings must first give up all forms of craving or attachment. Phil Connors either learns this lesson in one day or ten thousand days, depending on how you look at it. *Groundhog Day* offers the scenario in which one character is trapped within a single day, one that repeats itself endlessly,

albeit with the possibility of change and learning. This magic-realist framework can be understood quite well in terms of a Buddhist understanding of samsara (the notion that beings are trapped in a cycle of repetition because of ignorance) and karma (the notion that our problems are caused by past actions and that we must eliminate causes if we do not want to repeat results). The notions of samsara and karma, when put together, are problems that require some form of purification, either by meditation or good works of the sort that bring beings to modify their reactive behaviors. Phil is initially arrogant and has contempt for others, but he is able to gradually modify himself until the conditions for happiness—and escape from the punishing cycle—arise.

Just as Freud ranges through an analytically comprehensive set of reactions to human suffering in the opening pages of *Civilization and Its Discontents*, the film *Groundhog Day* explores Phil's range of responses to his own cycle-bound condition. Initially, he feels horrified by the discovery that he is trapped within the American holiday known as Groundhog Day, doomed to wake up to the Sonny and Cher song "I Got You, Babe" for the rest of his (endless?) existence. This horror gives way to suicidal despair, until Phil turns a corner and experiences his godlike phase, a period of the film in which he uses his general foreknowledge to advantage. Buddhism has a concept known as the Six Realms of Existence that can be considered either a literal division of existence or a set of psychological dispositions. The lower realms are the Hell, Animal, and Hungry Ghost realms. The upper realms are those of the Gods, Demigods, and Humans. It is a mistake, however, to think the God realm is the ideal position, since gods indulge to the point at which they fall into lower realms—as is the case with Phil. His indulgence leads to suicidal despair.

In the last third of the film, Phil has become bored with indulgence and sets out on a path of self-cultivation. Before the movie is over, he has saved lives, helped old ladies, repeatedly caught a child who falls from a tree (but who *never* thanks him!), and he has mastered playing the piano and speaking French. It is interesting that he attempts repeatedly to save the old man and that he catches the child who falls from the tree. We can see that learning the piano could be a stay against boredom, but his altruistic acts are less easily explained. The film never mentions that he may be purifying himself, but it is only when he is completely free of his most acquisitive urge—to

capture Rita's body and then her heart—that he escapes the cycle. He suffers because of various kinds of greed. When he overcomes the desires that cause suffering, suffering ceases.

Then there are the "Buddhist films" that do *not* represent Buddhism, either directly or figuratively. If we look, we will find them mentioned in Buddhist blogs, and they sometimes have appeared in Buddhist film festivals. Often, this is because a central thematic concern of the film resonates quite strongly with a central thematic concern of Buddhism itself, whether or not one would want to argue for a direct influence. One important theme in many strands of Buddhist belief is signified by the word that comes from the Tibetan tradition, "bardo." A bardo is any limbo-like intermediary period, but it is used most often to refer to the state that, some Buddhists believe, occurs between an individual's death and some form of future incarnation.[9] Another key thematic idea predominant within Buddhism and that has inspired American filmmakers is the notion that our self-understanding—and perhaps even our experience of all phenomena—is inflected at all levels by delusion. Essays in this volume focusing on delusory experience and between-life and midlife bardos include *Lost in Translation* (2003), *American Beauty* (1999), *Donnie Darko* (2001), and *Fight Club* (1999). None of these films is directly concerned with Buddhism in the manner of the previously mentioned films. On the one hand, the films can be seen as ways in which something alien is translated into more familiar terms. Also, the films can be seen as essential statements about "how we are" that are then subject to Buddhist-inspired modes of interpretation, such as when one author develops the concept of samsara by using the more familiar term "desperation" and locating it within the film *It's a Wonderful Life* (1946).

Part 1, Representation and Intention, collects essays on the most well-known American movies that have directly represented Buddhism. This section begins with "Buddhism and Authenticity in Oliver Stone's *Heaven and Earth*," by Hanh Ngoc Nguyen and R. C. Lutz, an essay that takes issue with the initial negative reception met by Stone's 1993 film. In particular, Hanh and Lutz develop a response to Julia Foulkes's complaint that Stone and Le Ly Hayslip (author of the book on which the movie is based) have grossly misrepresented Buddhism and refashioned the religion to make it more palatable for a

Western audience. Hanh and Lutz argue that this is not the case, but, rather, that Stone has successfully represented a rich mixture of folk and Buddhist elements that has been expressed in Hayslip's nonfictional narratives and in other representations of Vietnamese religion.

In chapter 2 Eve Mullen's "Buddhism, Children, and the Childlike in American Buddhist Films" looks at how filmmakers in the West have appropriated Buddhism, considering films such as *Little Buddha* (1993), *Seven Years in Tibet* (1997), and *Kundun* (1997) in relation to what Donald Lopez calls "New Age Orientalism," a mode of imagination in which American rescuers save helpless Asians from Asian villains. The first section contains several essays that represent Buddhism directly but always within the key of Otherness, as we see again in chapter 3. In "Consuming Tibet: Imperial Romance and the Wretched of the Holy Plateau," Jiayan Mi and Jason C. Toncic discuss idealistic visions of Tibet before the Chinese invasions of the 1950s, exploring the Orientalist predecessors to the "Buddha Boom" films of the 1990s by drawing on cultural expressions from a half-century before. James Hilton's *Lost Horizon*, travel writer Sven Hedin's novels, and Frank Capra's cinematic recasting of the Hilton novel are the examples considered. Through a study of the imperialist attitudes present in these representations, and drawing on Edward Said's critique on Orientalism and W. J. T. Mitchell's ideology of the imperial landscape, Mi and Toncic show that these texts misrepresent and distort Tibet through its modes of conquest. During the Cold War and through the 1990s, American audiences have rallied around Tibet— perhaps it was the only issue about which the extremely conservative senator Jesse Helms and the entirely countercultural poet Allen Ginsberg agreed.

Chapter 4, Felicia Chan's "Politics into Aesthetics: Cultural Translation in *Kundun, Seven Years in Tibet*, and *The Cup*" offers a comparative analysis of films by Martin Scorsese, Jean-Jacques Annaud, and in relation to the problem of Orientalism, considering various successes and failures of these films to adequately address the problem of a dialectally reductive way of presenting the (Western) self in relation to a Buddhist (and therefore "Eastern") other. Chan hopefully considers the possibilities of Buddhist cinema in the larger sense, perhaps looking forward to a nondualist aesthetic that does not so regularly fall into exoticization.

Part 2, Allegories of Shadow and Light, concerns films that may or may not be informed by a Buddhist intention, but the author makes the case with regard to each of these films that a Buddhist-informed reading is a highly rewarding approach. In Tibetan Buddhism as popularized by books such as *The Tibetan Book of the Dead* the concept of the bardo, the space between one life and the next, is a central concept. We could say that many of these films occupy a semiotic "bardo" space between the films that are intentionally Buddhist (both in terms of representation and thematic/philosophical emphasis) and films that are not about Buddhism but that can be usefully understood from a "Buddhistic" point of view.

Chapter 5 is "Momentarily Lost: Finding the Moment in *Lost in Translation*," by Jennifer L. McMahon and B. Steve Csaki, and it provides a close reading of Sofia Coppola's *Lost in Translation* (2003) in relation to Buddhist concepts of momentariness and selflessness. Rather than consider persons as bodies that contain impermanent selves or souls, Buddhist psychology understands "self" to be a side effect of numerous conditions that shift from moment to moment. The film concerns two characters who are momentarily lost and caught in an instance of psychological bardo. "Momentarily Lost" traces the film's consideration of suffering and lostness in a generously nonjudgmental manner, which McMahon and Csaki compare to the suspense of judgment that is a key feature of mindfulness meditation techniques.

If Nguyen and Lutz have argued for the (artistically if not financially) successful crossing of Buddhism from Vietnamese into American culture, in chapter 6 Harper and Anderson consider the ways in which American cultural co-optation and assimilation have produced a rather unusual kind of Buddhist discourse. In "Dying to Be Free: The Emergence of 'American Militant Buddhism' in Popular Culture," David A. Harper and Richard C. Anderson discuss the notion of redemptive violence as shown in American movies and popular culture that characterizes "American Militant Buddhism." The authors explore the ways in which American popular culture has adopted and appropriated Buddhism and reworked them to fit into the American mythos—the Manifest Destiny and the American Dream in such movies as the *The Matrix* (1999), *Fight Club* (1999), and *The Last Samurai* (2003), as well as the popular rock band Rage

Against the Machine. Using the term "American Militant Buddhism," Harper and Anderson explore the effects and consequences of reinforcing or legitimizing the right to spread liberation by employing violence.

The next "bardo film" concerns not the individual per se but the culture at a moment of transformative impasse. In "Buddhism, Our Desperation, and American Cinema," Karsten J. Struhl uses films that are not thematically connected with Buddhism in chapter 7 to explore the relation between desires, cravings, and meaningful existence faced by the individual within a materialist and consumerist society. Through *Wall Street* (1987), *Annie Hall* (1977), *Leaving Las Vegas* (1995), and *It's a Wonderful Life* (1946), Struhl looks at a number of cravings from money, status, love, alcohol, and suicide through a Buddhist perspective in order to reveal how these cravings imply a deeper existential problem of the illusion of the self and contribute to growing Buddhist film criticism. Chapter 8 is "Christian Allegory, Buddhism, and Bardo in Richard Kelly's *Donnie Darko*," Devin Harner's exploration of a syncretic imagination of the bardo state in Richard Kelly's *Donnie Darko* (2001). Harner posits that the cyclical open-endedness of *Donnie Darko* is a deliberate philosophical and theological ambiguity fostered by Kelly, a form of cultural translation that brings concepts such as the bardo across cultural borders.

In the ninth chapter, "'Beautiful Necessities': *American Beauty* and the Idea of Freedom," David L. Smith analyzes *American Beauty* (1999), a film portraying the bardo between lives. Contrary to our expectation that death and the various social and psychological conditions of our lives are radically limiting factors, the film explores the ways in which the postmortem standpoint from which the film is narrated opens up a space of appreciation and a path to freedom rather than the more typical notion that the moment of death begins a process of judgment and constraint.

As Gary Gach notes in his afterword, "On Being Luminous," film appears to be a natural allegory for Buddhism—it projects, quite unsubstantially, a series of images that connect us to a real world we believe in more if we look at it less carefully. As soon as the projector slows down, the individual frames appear, and the narrative continuity is revealed to be a working fiction. This breakdown of reality into causes and conditions—or, in the language of film, into sounds,

shadows, and wishes—can appear at times to be a tragedy, while other times it is presented as the way to freedom. In films as different as *The Cup*, *Groundhog Day*, and *The Matrix*, it can be both.

This book and the rest of the series Buddhism and American Culture would not have been possible without the work of my coeditor, Gary Storhoff, who passed away on November 7, 2011. About a year earlier, Gary wrote to a few friends to say that his recent medical check-up revealed that the pain he had been calling "an old sports injury" was in fact stage-four cancer of a sort that the doctors did not expect to beat. As always, Gary was a living lesson in graciousness. Faced with people who said things like "I'm glad I got cancer because it made me appreciate life," Gary came back quickly with "I'm *not* happy this has happened, but I did the right things and I've had a good run." I worked with Gary on this project for over ten years, and it was always a pleasure to find the balance. He is greatly missed, and this volume is dedicated to his memory. May all sentient beings have the good fortune to meet truly fine individuals like Gary.

Notes

1. In the case of the Osten and Rai film, "Buddhist film" designates a film that is in some sense a proponent, rather than one that includes Buddhism as a mere reference point. Whereas the 1925 film offered an explanation of Buddhism, an earlier mention of Buddha in American cinema, perhaps the first, occurred in the 1918 film *The Soul of Buddha* (which, according to a webpage specializing in information about silent films, is now considered lost: http://www.silentera.com/PSFL/data/S/SoulOfBuddha1918. html). This silent film, which featured one of cinema's first sex symbols, actress Theda Bara, asserts in its title that Buddha had a soul and so shows little or no knowledge of actual Buddhism. Why does the film mention Buddha at all? Buddhism would appear to function in this case as a mere backdrop. A few years later another silent film would advertise Buddhism: *The Silver Buddha* (1923) was a crime drama centered on the famous Orientalist character Dr. Fu Manchu. Once again, a Buddhist object

directs the viewer's attention to things exotic and strange. In the following decade Buddha showed up in yet another crime drama, starring Lon Chancy Jr. and variously titled *The Secret of Buddha* and *A Scream in the Night* (1935). Turner Movie Classics webpage has information: http://www.tcm.com/tcmdb/title/561646/Scream-in-the-Night/, accessed 1 November 2012. The film, which appears to be set in the Middle East but which turns on the theft of jewels known as the "Tears of Buddha," can be seen on YouTube. http://www.youtube.com/watch?v=rGt2MD0drc0, accessed 1 November 1012.

2. When I interviewed Mr. Penpa Tsering, the speaker of the house of the Tibetan government-in-exile's parliament, about "soft power," I asked about American celebrities who had been helpful to the Tibetan cause. He said that Richard Gere was more helpful than all the others combined. Personal communication, 20 November 2012.

3. The Dalai Lama visited the United States between September 3 and October 21, 1979. http://www.dalailama.com/biography/travels/1959–1979, accessed 1 November 2012. Tenzin Tethong, who is president of the Dalai Lama Foundation, helped organize the Tibetan leader's first visit to the United States in 1979, working with Congressman Charlie Rose. As the United States had recently regularized relations with the PRC, this event required extensive diplomatic negotiations. See LeFevre, 2013, n.p.

4. Before the 1990s, literature was the most important conduit of Buddhist imagery and theme from Asia into the American imagination. Jack Kerouac's roman à clef about Beat generation Buddhists, *The Dharma Bums*, Allen Ginsberg's Vajrayana-inspired poetry such as "Wichita Vortex Sutra," and Gary Snyder's entire oeuvre—especially his 1986 masterpiece *Mountains and Rivers without End*—all helped increase America's "cultural literacy" such that words like "karma" and "dharma" are no longer foreign words.

5. Martial arts films have often had a meditation component, usually occurring in the period when the broken hero (Steven Seagal, Jean-Claude Van Damme, etc.) has been recovering both physically and mentally. After meditating a long time, usually under the supervision of a mentor and while also kicking his

way through several banana trees, the hero can then proceed to kill the people who killed the hero's sister or wife or brother or girlfriend or whomever.

6. Transcendentalist flirtations with Asian religion and philosophy flavor the work of Emerson, Thoreau, and Whitman and modernist writers, inspired by the haiku (or *hokku*, as it was called [Higginson 1985: 20]). Three land wars in Asia and an impressive body of belletristic literature are important precursors to Hollywood's embrace of Buddhist signs and symbols. Future cultural historians will have to decide when, if ever, Buddhism ceased to be "exotic."

7. See "What Is a Buddhist Film?" *Contemporary Buddhism* (May 2014), for a full discussion of the phenomenon of the Buddhist film festival as a global event. I have borrowed some passages from that article.

8. The last film is by the Bhutanese director who mainly resides in India named Khyentse Norbu—and who is at least as well known as an internationally famous Buddhist teacher under the name Dzongsar Jamyang Khyentse Rinpoche. Although the director is by no means American, the films just mentioned must invariably be discussed together for reasons that become clear in the essays.

9. "Reincarnation" can indicate a one-to-one correspondence between the person who died and the person who is born into a new life, but Buddhism denies that there is an immutable soul that is transferred from body to body. Often, the term "rebirth" is used to signify a continuity between lives that is not understood as the repetition of the same personality or soul within a new body.

PART I

Representation and Intention

Buddhism and Authenticity in Oliver Stone's *Heaven and Earth*

HANH NGOC NGUYEN AND R. C. LUTZ

The daily wars that occur within our thoughts and within our families have everything to do with the wars fought between peoples and nations throughout the world. The conviction that we know the truth and that those who do not share our beliefs are wrong has caused a lot of harm. When we believe something to be the absolute truth, we have become caught in our own views. If we believe, for instance, that Buddhism is the only way to happiness, we may be practicing a kind of violence by discriminating against and excluding those who follow the other spiritual paths. When we are caught in our views, we are not seeing and understanding in accord with reality. Being caught in our views can be very dangerous and block the opportunity for us to gain a deeper wisdom.
—Thich Nhat Hanh, *Creating True Peace*

Oliver Stone's *Heaven and Earth* (1993), the third feature film in his Vietnam War trilogy,[1] straddles the cultures of Vietnam and America as faced by the Vietnamese American heroine Le Ly[2] (Hiep Thi Le). In the sweeping epic tradition of Hollywood cinema, the film chronicles the trials and tribulations of Le Ly from childhood to adulthood. It ranges, in the words of critic Rebecca Stephens, from "poor Vietnamese peasant girl in black pajamas to California millionaire who sports a sophisticated hairdo and multiple gold chains" (Stephens 663). *Heaven and Earth* is an impassioned film about one Vietnamese woman's personal perspective on a war she has lived through, and her life, survival, spirituality, and success in America—all of which is guided by her religion of Vietnamese Buddhism.

In our analysis, we first focus on Buddhism and Buddhist forms of worship as practiced by the Vietnamese people of a central

Vietnamese village like Ky La, as well as by Le Ly's family, especially her father. Next, we analyze Buddhism as practiced by Le Ly herself as she tries to adapt in America, as she attempts to resolve the difficulties of family life and finances. Finally, the chapter explores her attempt to negotiate the experience of war in Vietnam with her life of peace in America. *Heaven and Earth* achieves its purpose in not only dramatizing the experience of a young Vietnamese woman caught in a bitter war but also emphasizing how she survives because of her firm grounding in lived, traditional Vietnamese Buddhist beliefs and practices.

A constant presence onscreen, Le Ly is seen struggling to survive the pillage and plundering of her village of Ky La in central Vietnam, first by the French, then by the Viet Cong.[3] She is also victimized by South Vietnamese government soldiers, who are covertly aided by their American advisors. She works as a house maid for a rich Saigon family, but Le Ly is seduced by her master, suffers unrequited love, and bears an illegitimate son. She becomes a petty hustler on the city streets of Da Nang, a major U.S. base in the war. As a black marketer and drug dealer of marijuana, she prostitutes herself to an American soldier hours away from returning home. After being wooed by an older U.S. sergeant (Tommy Lee Jones), Le Ly moves with him to America. There, their marriage turns sour, leaving Le Ly as a battered wife. After her husband's suicide, she is a widowed mother in America before finally becoming a self-made woman and returning for a visit home to Ky La.

Before Stone's film, relatively little attention was paid to the two volumes of Le Ly Hayslip's[4] autobiography on which the movie is based, *When Heaven and Earth Changed Places* (1989) and *Child of War, Woman of Peace* (1993). In both volumes, with the first even subtitled *A Vietnamese Woman's Journey from War to Peace*, Le Ly Hayslip offers the reader her perspective on the Vietnam War. The film *Heaven and Earth* catapulted her to wider attention, including that of the Vietnamese community in southern California. There, Le Ly Hayslip was widely condemned, even hated, for her conciliatory attitude toward the Communist government of Vietnam, since anger against the Communist regime was prevalent among the Vietnamese in the diaspora in the 1990s. In America, much scholarly interest has centered on her two memoirs and, particularly, Stone's film.

The Critical Reception of *Heaven and Earth*

Criticism of the film has been especially negative. This invites the following critical revaluation. Traditionally, the film is often accused of distorting the history of the war, Orientalizing the image of the Vietnamese woman, romantically dramatizing historical fact, and essentializing the immigrant experience in America. For example, Matthew A. Killmeier and Gloria Kwok write:

> The Vietnam proposed by Stone and Hayslip is still a myth, a romanticized vision that the West and United States, in particular, would like to see. This is the Vietnam that Le Ly, now a *Viet Kieu* (Vietnamese expatriate), and most *Viet Kieu* remember before they left their country in the 1970s . . . such idealizations are part of the mentality of Vietnamese peasants. . . . Indeed, Le Ly has romanticized her memory of Vietnam with time, and she offers both nostalgia and desire for a Utopia, a wonderful but non-existent place. . . . Today's Vietnam is not the nation that the Vietcong fought for. Vietnam is rife with corruption, poverty, and prostitution; capitalism triumphs over Marx, Mao, and Ho Chi Minh. The powers have changed hands in Vietnam; the Communists and transnational corporations have replaced France and the United States. (Killmeier and Kwok 265–66)

Such criticism ironically identified Hayslip with the Viet Kieu, who despised her for her cooperation with Communist Vietnamese when seeking bureaucratic help in facilitating her first visit home in 1986. This was a time when the United States still enforced a trade embargo against the Socialist Republic of Vietnam. Killmeier and Kwok's conclusion is particularly inappropriate for the historical context of the memoir. When author Le Ly Hayslip returned to Vietnam in 1986, Ho Chi Minh (or "Bac Ho," Uncle Ho), Karl Marx, and Chairman Mao were still the ideological mainstays of a Vietnamese Communist party that only in that year passed the policy of đổi mới (renewal/ renovation) that allowed for a modest acceptance of capitalism. This policy would eventually transform Vietnam along the lines the critics describe from the vantage point of 2005, over a decade after the time of Le Ly Hayslip's memoirs.

Other analyses of the film pointed out the supposed superficiality of Buddhism as depicted in the movie. These critics accused Stone and Le Ly Hayslip of co-opting Buddhism and refashioning the religion to be more in tune with the Western/American Christian understanding of spirituality and the concept of God. Particularly harsh words were voiced by Julia L. Foulkes:

> [O]nly a superficial, Americanized veneer of Buddhism emerges. . . . *Heaven and Earth* uses Buddhism only to provide truisms rather than to explore the vast difference between Vietnamese and America cultures. . . . Most incongruous is the casual use of the word "God" by proclaimed Buddhists, even in the early village scenes. (Foulkes 1273)

Foulkes argues that the depiction of Buddhism in the film is especially offensive because it is reductive, simplistic, and Westernized—a kind of "New Age" version of Buddhism that strips the religion of its seriousness.[5]

Yet despite these detractors, the question must be asked: to what extent has Oliver Stone captured some truths of Buddhism *as practiced and experienced by common Vietnamese laypeople*? As we demonstrate, Stone's chronicle of Le Ly's life from a young girl born and raised in a wet-rice agriculture village to an adult in suburban America incorporates important and recurrent aspects of Vietnamese Buddhism as experienced by Vietnamese of Le Ly's peasant background. Within the film, allusions to folk Buddhist beliefs and practices are cinematically visualized through the mise-en-scène and articulated by Le Ly's voice-over narration. Through her voice-overs, Le Ly offers a view of Buddhism as a set of religious beliefs and practices that serve as a highly spiritual, morally inclined guide by which she lives her life.

Vietnamese Folk Beliefs and Buddhism

To accentuate authentic Vietnamese folk beliefs tied to Buddhist religious teachings, despite an occasional conflict with formal Buddhist theology, the film opens with a rolling prologue:

This film is based on the true life story of Phung Thi Le Ly Hayslip, from Ky La, a rice-farming village in Central Vietnam. It is the early 1950s and Ky La has been under the domination of France for nearly seventy years as part of the country's vast Indochinese colonial empire. The French rulers are far away in Saigon, Hanoi or Paris, but in Ky La, life goes on as it has for a thousand years, protected by Father Heaven, Ong Troi, and Mother Earth, Me Dat. Between Heaven and Earth—Troi va Dat—are the people, striving to bring forth the harvest and follow Lord Buddha's teachings. (Stone)

This juxtaposition of the Vietnamese folk belief in Father Heaven and Mother Earth with Buddhist theology is apparent from the very beginning of the film. Of course, in Buddhism the idea of heaven and earth is not anthropomorphized, nor has this folk approach any place in Christianity. To give visualization to the folk ideas expressed in the prologue, Stone cuts immediately to long shots of lush rice fields. He adds the ringing of a gong from the village temple and gives a medium shot of a village monk lighting incense and praying toward an altar, leading to the medium zooming shot of a bronze statue of the Buddha. Through editing, we get a long sequence of various shots depicting life in the village of Ky La at the time: for example, people go about their various activities, two monks in orange robes with orange umbrellas walk across the vast and lush rice field, and an elderly man kneels and prays at an ancestral altar. In his introductory collage of images, Stone succeeds in capturing Vietnamese folk religious practices as inexorably wedded with Buddhist teachings. As Philip Taylor has observed, "ancestral altars can be found in most houses of the Viet ethnic majority . . ." (Taylor 19).

From this sequence, we are cinematically oriented toward the pastoral, idyllic milieu of a simple and religious peasant life. For as Stone's film captures Le Ly's childhood memories of her past, the focus is by degrees subjective and unapologetically idyllic. It is Le Ly's subjectivity that gives *Heaven and Earth* its structure and content, and in her memory of village life, the positive and peaceful momentarily outweigh the negative and brutal—a nostalgia that Stone expresses with lyrical visual imagery. As a recurrent thread

holding together this subjective yet authentic experience, the emphasis on Buddhism as perceived by the Vietnamese of Le Ly's peasant class is foregrounded, taking precedence over more formal, doctrinal Buddhist theology. By examining the historic and cultural practices of peasant Buddhism, we see that Stone's depiction of Le Ly's beliefs, practices, and moral code as contextualized by a Buddhist framework is much more nuanced and realistic than understood by most American film critics. Its portrayal is actually very much in line with the form of Buddhism that is lived, practiced, and followed by lay Vietnamese people, both in Vietnam and in America. Le Ly's self-avowed Buddhism, as portrayed in the film and in her own memoirs, does not follow a strictly philosophical or theoretical mode of that religion. Her form of Buddhism is a practical, village-based religion that has been influenced by Vietnam's culture, its traditions of animism and ancestor worship, and its agrarian culture.

Buddhism, the Agrarian Family, and Vietnamese Ancestral Beliefs

The film makes clear that Le Ly derives her spiritual teachings through the oral folk tradition passed down by her father when she was a young girl. This practice is commensurate with the traditional experience of Vietnamese village people. Seldom does the Vietnamese peasantry receive theological instructions in Buddhism from monks at a temple seminary. Early in the film, we see Le Ly's father (Haing S. Ngor) telling his daughter, "You understand that a country is more than a lot of dirt, rivers and forests? . . . See this land? Vietnam is going to be yours now. If the enemy returns . . . you must be both a daughter and a son now" (Stone). The father's sentiment will resurface again and again as Le Ly makes sense of the violence in her country, even as she tries to maintain her patriotism. From her father's words spring folk traditions and customs that are syncretically aligned with Buddhism.

In a voice-over, Le Ly narrates, "From my father, I learned to love God and the people I could not see . . . my ancestors" (Stone). Though the film uses the word "God," Le Ly's God is actually Buddha. This terminology, foreign to doctrinal Buddhism, has troubled

some critics. However, one should bear in mind the history behind this (mis)translation. I. Pyysiäinen explains that

> the Westerners that first came into contact with Buddhism, guided by their Christian background, identified the Buddha and the buddhas as god(s). In due course it, however, dawned on them that the Buddhists did not consider buddhas as gods (*devas*). . . . But neither are they mere human beings . . . the simple dichotomy man-God is not enough to account for the special status of the Buddha and the buddhas in the Buddhist religion; buddhas rather are beings *sui generis* and thus form a third category, in addition to "man" and "God." (Pyysiäinen 149)

In her memoirs, Le Ly Hayslip herself uses the word "God," and Stone's screenplay follows her lead. The difficulty is also based on the nature of translation: It is unknown what term Hayslip would have used had she written her memoir in her native Vietnamese, and for a purely Vietnamese audience, instead of in English. In English, she was assisted first by a professional editor and later by her American-born son. Faced with the lack of an indigenous English term for the third category of being but willing to choose one nevertheless, Hayslip (and Stone) settled on "God." Arguably, Hayslip felt a need to indicate to her American readership that the concept of Buddha is closer to that of a god than to a human. She may have felt reluctant in 1989, writing for a mainstream U.S. audience, to use the potentially alienating term "Buddha" itself. For doing so may have led to exoticizing and othering her spiritual beliefs to the point where a Western audience refuses to take seriously her narrative's spiritual values.[6]

The scene depicting a male wizard or fortune-teller coming to Le Ly's parents indicates the danger of an audience reducing sincere folk beliefs to caricature. The wizard visits Le Ly's parents to tell of her two brothers' fates after they joined the Viet Cong in North Vietnam. Reliance on such fortune-tellers is an aspect of Vietnamese practice, specifically village-based practice, of Buddhism in that it mixes a traditional custom of believing in fortune-telling with religious principles. In the film, the spirits of Le Ly's brothers could be called forth if they died away from home, since their lost and unburied bodies were

to become a source of much sorrow in her family. They want to give the men a proper burial if they died. This could be done in a spiritual fashion regardless of recovering the actual bodies, in a process akin to Western rituals to finalize grieving in such circumstances.

The need for a proper burial rite for the dead is one of the oldest of Vietnamese spiritual beliefs preceding the introduction of Buddhism. Buddhism as practiced in Vietnam has accommodated this ancient practice. As Suzan Ruth Travis-Robyns writes, "What heaven had in store for the Vietnamese was horrifying. The Vietnamese believe that the soul cannot rest until the body receives a proper burial" (Travis-Robyns 155).

The family's urgency to complete the ritual explains the need for the wizard, for the family must bring closure to the unknown fate of the brothers. The wizard explains that the shrine in the house is too small for the soul of one of the brothers, who is revealed to be either dead or missing, to come in. He advises the parents to build a bigger shrine outside their hut, which should solve the problem of ongoing unrest for the family. To a Western viewer, the fact that a so-called superstitious element has been assimilated and embedded in overall Buddhist beliefs and practices here may appear ridiculous and unreasonable.

However, to lay Vietnamese people, especially rural people who follow the customs of their village, this practice is not at odds with a more encompassing belief in a Buddhist religious faith system. Philip Taylor explains:

> Among the most pervasive beliefs in Vietnam is the view that the spirits . . . co-inhabit alongside the living. Willful, sometimes retributive beings, they have the power to influence the course of life. The wealth and security of the living depend on maintaining with them relations of mutual care assistance. Each day in homes throughout Vietnam, millions of invitations are whispered to ancestors . . . to partake of family meals. Every . . . communal house in Vietnam resonates annually with the invocation for prosperity and peace. . . . Twice a month, householders and shopkeepers strew food offerings and burn votive paper by the side of the road to appease the restless souls of those who have died unjustly or away from home. Sacrifices are made to the nature spirits

that inhabit trees, mountains, caves and coastlines. Altars
bear offerings to the sky . . . the earth . . . the five elements
. . . and to the animals that guard the forest and the seas. Pil-
grims undertake journeys to acquit debts to the spirits that
patrol the nations' frontiers and the legendary heroes who
watch over the community of the living. (Taylor 15–16)

Heaven and Earth seeks to cinematically portray the Vietnamese
folk Buddhist beliefs of Le Ly as practiced by her indigenous cul-
ture, and so Stone risks the misunderstanding of some viewers. Yet
he certainly does not co-opt Buddhism to promote his film. The film
does not distance itself critically from folk religious traditions. How-
ever, Stone must run the risk of exoticization as a price for maintain-
ing the authenticity of Vietnamese agrarian Buddhism. Stone's film
intends to create an atmosphere where folk beliefs are accepted in
their natural historic and social setting.

Another key scene exemplifies how, under extreme duress, Le
Ly turns to a deeply visualized image of the Buddha. As the village
of Ky La is situated in a constant battle zone between the South Viet-
namese soldiers who rule the day and the Viet Cong who rule by
night, Le Ly is quickly caught in between the two forces. Suspected of
being a Viet Cong collaborator (a "VC cadre girl"), Le Ly is captured
by the South Vietnamese soldiers and tortured (Stone deviates from
Hayslip's memoir by adding the presence of an American military
advisor). When a slithering snake is put under her shirt, Le Ly is too
traumatized to scream. Instead, she closes her eyes, and the black
flashback shot of her brother Sau (Dustin Nguyen) comes to her,
followed by a shot of the bronze Buddha that we saw earlier. These
few seconds of montage shots suggest that because of the trauma of
her torture, her relief is to call forth the image of Buddha, indicat-
ing the strong foundation of her (folk) Buddhist beliefs. Here, the
film effectively shows where, for a practicing Buddhist, final solace
may lie, just as a Christian may visualize Jesus on the Cross. On a
deeper level, the scene expresses how religion functions at the folk
level across various faith communities.

Her eventual release by the government soldiers raises the suspi-
cions of the Viet Cong about Le Ly's political convictions. One night
she is abducted, and a Viet Cong cadre rapes her at the freshly dug
grave meant for her burial after execution. After such a violent and

life-altering ordeal, Le Ly's mother (Joan Chen) decides to leave the village with Le Ly and disappear into Saigon. Her father, however, chooses to stay behind because he does not want to leave the village of his ancestors. The father's refusal to move away from the ancestral land is indicative of the Vietnamese tradition that has merged into common Vietnamese Buddhist practices to guard and honor ancestors. This is accomplished by not leaving the land where the ancestors' graves are located but caring for their gravesites as a symbolic act of ensuring their well-being in the afterlife. The wartime need to evacuate villages threatened by the Viet Cong brought much pain to the Vietnamese population in the South, especially when confronted with American military authorities who were dismissive of these ancient beliefs. Taylor explains the seriousness of these ancestral commitments:

> The cult of the spirits . . . extends back to the origin of the race, preceding imported philosophies such as Buddhism. . . . Often described as animism, spirit worship has been described by many writers as a Southeast Asian cultural substrate, an "endemic religion" tied to place and enduring through time . . . foreign influences were selectively incorporated into the indigenous belief system of the people of Southeast Asia in a manner consistent with local ecological conditions and cultural conventions. . . . The collective fortune of a village required offerings made by its representatives to its tutelary spirits. The well-being of a family rested on diligently maintaining sacrifices to the ancestors. Sentimental attachments to the ancestors were thought to act as a spiritual hedge against mobility, the Vietnamese peasant was loathe to venture beyond the perimeter of the village within which the graves of the ancestors were located . . . (Taylor 16)

As the movie unfolds, Le Ly's voice-over narration offers more clues into the many complexities of the everyday Buddhism of typical Vietnamese village people. While Le Ly comments on how monks were being arrested in the city, we see a brief shot of a brown-robed monk being arrested and dragged away by South Vietnamese policemen. From this seemingly unimportant or random visual detail,

Stone's film challenges the viewer to understand the significance of such details. In fact, the arrest of Buddhist monks alludes to real historical events of the Southern government's persecution of Buddhists in favor of the Catholic Victnamese minority power elite.[7]

This religious and political conflict also touches on Le Ly's life in a circumstantial fashion once she arrives in Saigon. *Heaven and Earth* gives intriguing visual details of indigenous Vietnamese religious practices. Impregnated by the Catholic master in whose house she serves, we see Le Ly kneeling, holding burning incense sticks, and kowtowing in front of the master's ancestral altar, seemingly praying but more likely silently imploring Buddha for a way out of her ordeal, only to be questioned by the household mistress. Here, the film shows Vietnamese ancestor worship was so strongly held that even Catholicism had to accommodate it. Ancestral worship has been tolerated with the official explanation that the veneration of ancestors is merely honoring them rather than worshipping them, thus defusing a severe theological conflict with Christianity's First Commandment, "Thou shalt not have other gods before Me." This syncretic solution satisfied Catholic authorities, clearly unwilling to lose Vietnamese converts. Stone's filmic reference here is very much in line with the customary practice of animist/ancestor worship that many Vietnamese practice, despite their religious affiliation. For as Vietnamese scholar Thien Do writes, "any history of Vietnamese Buddhism also needs to account for issues closer to its daily manifestations at grass-roots level" (Do 256). In this quotation, "grass-roots level" daily practice is a syncretic merging of Buddhist theological teachings with traditional ancestral worship. Even the Catholic Church has accommodated the practice of ancestral veneration.[8]

After Le Ly's journey from Saigon to Da Nang, which is close to her home village, she confesses to her father the failings of her young life. Here, true to the historical events and expressing a profoundly Buddhism-inspired love for all sentient beings, her father tells her that the principles of right and wrong are ultimately in one's heart. She must continue to live and be a mother to her son—to be a strong and responsible person. This advice is entirely consistent with what an enlightened, loving, and nonjudgmental Vietnamese villager would assume as correct moral guidance from his or her Buddhist-inspired spiritual belief system. Some reviewers have criticized an apparent patriarchal and misogynist societal assumption of

a Vietnamese woman's role. Yet this criticism of Vietnamese Buddhism ignores the feminine aspect of the religion. Thien Do comments on the feminine emphasis in Vietnamese Buddhism:

> Another commonly seen arrangement also involves Amitabha Buddha, but with two female emanations of Avalokitesvara Bodhisattva, popularly known as *Phat Ba Quan Am*. . . . This representation touches on the feminine aspect of Vietnamese religion, which has its roots in images of motherhood, gentle compassion and sacrifice, converging in the cult of goddesses and fertility linked to an agrarian past. (Do 265)

Thus, Vietnamese Buddhism as amalgamated with older Vietnamese beliefs is much *less* misogynistic than the Confucian-influenced Buddhism practiced in traditional Chinese folk communities. There, a father could hardly be expected to show this amount of compassion and love to his "fallen" daughter. This Buddhist-inspired, fatherly love from Le Ly's father once again demonstrates the indigenous Vietnamese religious beliefs based on agrarian wet-rice culture and village life. Buddhism is clearly adjusted to a level commensurate with village life and its people. Few village people are Buddhist theologians, and even the monks sharing their lives with the villagers accommodate the spiritual needs of the people of their communities.

The death of Le Ly's father reveals another reality of living Buddhist traditions in Vietnam. His funeral is portrayed as a very public and performative act in all its theatrical aspects, just as it would have been held in a Vietnamese village in the late 1960s. The film shows in stark visuals the long funeral procession, wild crying and mourning, and images of placing the coffin into the ground. Family members wear white mourning garb and openly mourn their dead, as is the custom of burying the dead in Vietnam. It is believed in such funeral processions that the dead and living are in spiritual harmony. As Taylor explains,

> The rituals that summon the ancestors and the living to return . . . celebrate moments of togetherness premised on a normative separation. It is a faith that is consistent with

mobility, migration and the widening of cultural horizons, for it endorses the movement away . . . at the very time it encourages regrouping and the meditation on shared origins. (Taylor 20)

Given episodes like the funeral and burial of Le Ly's father, which seek to recreate Vietnamese religious practices deeply steeped in an overall Buddhist tradition, it is hard to agree with Julia Foulkes's statement that

> *Heaven and Earth* uses Buddhism only to provide truisms rather than to explore the vast difference between Vietnamese and America cultures, much of which is shaped by their different religious traditions. . . . Eliding differences between Buddhism and Christianity serves the thematic end of the film . . . but it is a distressing misrepresentation of religious rituals and their crucial role in Vietnamese culture and the Vietnam War. (Foulkes 1273)

Heaven and Earth uses its vantage point as a quintessentially visual medium to acknowledge a difference between Vietnam and America and includes—risking caricature and exoticization—such scenes as the ones discussed here that demonstrate the non-American-ness of traditional Vietnamese Buddhist-embedded beliefs. As a feature film rather than as a theological discourse, Stone chooses to show, rather than discuss, difference. If, at moments we discussed, striking similarities to Christian religious practices and beliefs emerge, they seem to point more to a universal human interaction with religion than a co-optation of Buddhism.

A final scene may show how this difference between American and Vietnamese religious beliefs operates on the level of the Vietnamese laypeople, even if it may contradict doctrinal understandings of Buddhism. Le Ly meets her future husband, U.S. Army Sergeant Steve Butler (Tommy Lee Jones).[9] With sincerity in her voice, Le Ly tells Steve that her relationships with men have been marked by bad karma, but Steve dismisses her, joking that karma cannot be bad with a little girl like her. This perfunctory exchange suggests both how many Vietnamese laypeople interpret karma but also how many

Americans have only a vague understanding of karma. Steve may view karma as something akin to sin accumulated in life, a very rudimentary and reductionist notion.[10] Le Ly's use of the term is more nuanced and draws on her traumatic life's experience, even though it obviously still falls short of a strictly theological understanding. Yet she uses this Buddhist term in the Vietnamese traditional sense: actions are followed by consequences, and thus far her karma with men has resulted in a rape and an illegitimate child with a married man. Because of bad karma, Le Ly seriously doubts that her relationship with Steve will end happily.

When Le Ly decides to follow Steve to America, her confrontation with her traditionally minded mother highlights again the religious issue of remaining in ancestral lands, emphasized earlier by her father. Her mother refuses to leave Vietnam on the grounds that she has to remain there to care for their ancestors and be close to the grave of Le Ly's father. Her mother has pragmatic reasons for staying in Vietnam as well, explaining how she can't just leave like typical Americans who think too much about freedom and individuality. In her view, Americans lack a concept of being tied to the land and their ancestors. Again, the film exposes the cultural differences between common Vietnamese and American people. Many of these differences are grounded in different religious beliefs as practiced everyday by common people, not only influencing their daily behaviors but also partly determining their major life decisions.

Village Buddhism Transplanted to America

Once in America, Le Ly tries vigorously to adapt to a whole new life, society, and culture—so removed from Vietnam, especially her ancestral village of Ky La. Stone's visuals beautifully show Le Ly's initial disorientation, yet these visuals have sometimes been misunderstood. Contrary to some critics' misgivings, who emphasize Le Ly's supposedly incipient consumerism, Stone presents Le Ly as being overwhelmed by America's materialism. She is literally dwarfed by an American refrigerator, for example, or baffled by her first supermarket experience. As with many immigrants, Le Ly initially feels lost in a world that she never anticipated or has emotionally prepared for. To imply that Stone is suggesting anything but Le Ly's apprehensiveness

and confusion seems to disregard a common immigrant experience, especially that of an immigrant from war-torn Vietnam.

Of particular interest for this analysis, however, is how Le Ly's village Buddhism also becomes a difficulty for her once she arrives in America. Her Vietnamese folk Buddhist beliefs, for instance, lead to instances of marital discord. One night, Steve tells her as he carries the children from their marital bed to another bed that their bedroom is not Vietnam. Le Ly explains to him that it is better for the children to sleep with their parents so they can be protected from evil spirits. Here Stone demonstrates how deeply rooted Le Ly's spiritual thinking is; how consistently she behaves with her folk Buddhist beliefs, even though these beliefs are not Buddhist tenets themselves. Far from implying Le Ly's superstitious nature, the sleeping arrangement that Le Ly wants for their children can be traced back to the traditional living arrangement of Vietnamese daily cohabitation culture, especially in village and rural life. There, living space is limited and extended families share rooms and beds. The concepts of privacy and the luxury of separate bedrooms were seldom available to people who lived in poor, agrarian Vietnamese villages. More importantly, these beliefs were not essential or of primary concern for a spiritual life; nevertheless, a religious dimension was added to further legitimize and sanction this sleeping arrangement. Because of her tortured past, Le Ly understandably has a hard time relinquishing her beliefs.

Le Ly and Steve's bedroom conversation quickly turns into a discussion of money, and the materialism of everyday life in America suffuses the scene. She asks Steve if he ever takes what she has to say seriously. He just turns around and automatically assumes whatever she says has to be "that Buddhist stuff." Here, Steve unconsciously performs an act akin to what academics would call an instance of Buddhism being Orientalized—that is, Steve does not take her seriously, and he rationalizes his reactions to her by thinking of her beliefs as irrelevant to America and the contemporary world. Ellen Goldberg explains Steve's reaction in more graceful detail:

> One major purpose of Orientalism is to make the Orient knowable—but a living cultural reality continually contradicts what can be known. Living Buddhism has proven this time and again in its transplantation throughout Asia.

What is clearly evident in the history and development of Buddhism is that its mechanisms and strategies for adaptation and transplantation have proven successful. Living Buddhism, it seems, is equipped to deal with projections, abstractions, mystifications, false dualisms, essentialism, and so forth which characterize the Oriental project to create a knowable stable subject. But, then, Buddhism itself is about bursting through such characterizations since there is, according to Buddhist doctrine, no stable subject. (Goldberg 354)

Many of Le Ly's spiritual assumptions worked well enough in Vietnam as shored up by the kind of "Living Buddhism" Goldberg mentions here. However, their summary dismissal in America by her own husband contributes to her utter sense of dislocation. Stone wishes the viewer to understand the utter isolation Le Ly feels after having ventured to this alien place—but not to minimize or Orientalize Buddhism itself!

Soon there are more fights and marital problems as Le Ly tries to be her own woman in southern California, all the while continually embracing her Buddhist beliefs. She adapts rather efficiently to new modes of female self-actualization in contemporary America; this seemingly rapid adaptation is Stone's effort to compress the passage of time in the film. However, Le Ly's adjustment causes even more marital problems. It seems that Steve is not handling his new family life too well as he complains that money is being drained from him with the five children he has from his first wife, two more with Le Ly, and Le Ly's one illegitimate child from Vietnam. He resents how Le Ly tries to talk to him and again dismisses her in an Orientalizing fashion when he proclaims, "Buddha don't know shit" (Stone). Fights erupt. Steve's potential for violence breaks out as he points a rifle to the back of Le Ly's head and threatens to end her life because of his fear of divorce. At this moment all the ordeals in her youth come flashing back to Le Ly as her voice-over narrates on screen, "I felt my soul would go then, any moment. God is not cruel . . . just practical. In this life sometimes against all knowledge we're paying back for a lot of bad past lives" (Stone). This is of course an essential, popular, and widely held core Buddhist belief, which Le Ly expresses in a moment of severe trauma.

As Le Ly escapes death when Steve lowers his rifle, she tries to comfort Steve and herself by talking about her karma, his karma, and how both of their karmas are now tied together. She concludes that they have "different skin . . . same suffering," but they must make the best of it (Stone). Again, this exemplifies how a traditional Vietnamese woman of Le Ly's background, level of education, and village experience applies Buddhist terms and concepts to guide her, helping her make sense out of life's often senseless encounters. It also expresses her love and compassion for Steve as a troubled man, so that her married life with him becomes endurable. In America, unlike in traditional Vietnam, Le Ly has the option of divorce, and she adapts to her new country by availing herself of that alternative, implicitly following the Buddha's teaching that for all the transience of human life, one also has a responsibility to take care of the life given in this incarnation. When their divorce is in process, one Sunday Steve shows up abruptly and takes their two children to Mass, to Le Ly's strenuous objection. Then the film cuts to a close-up shot of the statue of Christ nailed to the Cross, followed by a close-up shot of a stained glass image of his face in the church. Within its medium, the movie clearly expresses the contrast in the two religions yet also focuses on the idea that both Christianity and Buddhism emphatically acknowledge human suffering. And now, both Le Ly and Steve have to suffer horrifically.

Stone uses Buddhism in this episode not to magically end their suffering but to imply that while suffering may be great, Buddhism may offer spiritual consolation. Steve kidnaps their two sons and threatens that Le Ly will never see them again if she doesn't drop the divorce. Faced with Steve's malice and threats, Le Ly seeks the help of an orange-robed Buddhist monk, a fact that some critics of the film find improbable and condescending: "Some aspects of Vietnam have traveled with Le Ly to America, most notably Buddhist monks, who seem to be as populous in southern California as they were in Southeast Asia" (Foulkes 1273). However, Foulkes's objection betrays cultural ignorance. In the Vietnamese exile community of southern California where Le Ly lives, there is actually a considerable number of Buddhist monks, especially after the second wave of refugees who came as "boat people" in the late 1970s and 1980s following the fall of Saigon and Communist repression at home. Furthermore, it is not uncommon for Buddhist men to become temporary monks, partly

accounting for a relatively large and conspicuous presence of monks in the community where Le Ly lives—admittedly, not the same as vast areas of midland America.

In her discussion with the Buddhist monk, Le Ly laments her fate with men and how men in general are cruel to women. To visualize her Buddhist environment, the film gives us a shot of the Buddhist altar/shrine during Le Ly's outburst. She expresses her worries for her sons and how the children are ripped from her womb by Steve's action, to which the monk replies with karmic reasoning,

> If I show you a baby killed by a bayonet and say it is his karma . . . we may cry for the baby . . . for his karma and the bad karma of the soldier who killed it. But we must never use our emotion to deny the wheel of incarnation that caused the act. It is as natural as the movement of the sun and moon. (Stone)

This dialogue is a Buddhist monk's teaching as it was historically delivered to Le Ly Hayslip, and Stone's screenplay includes it in the movie. This should counter the critic's charge that "[e]liding differences between Buddhism and Christianity serves the thematic end of the film" (Foulkes 1273), for here the difference between Buddhist and Christian teaching is starkly and significantly expressed.

The monk continues:

> [Steve] has created much soul debt for himself. But if you fail to give him the opportunity to redeem himself you will only increase your own soul debt. The man-hate that blinds you will blind any man you find in a future life. If you turn Steve away you will be rejecting your own redemption. Child, you have forgiven the man who raped you . . . destroyed your country . . . harmed your family. This is how it should be. Your karma is mixed with Steve and [your sons]. The future . . . the past are all the same. If you divorce you will only have to come back and work it out again. The path to Nirvana is never being safe but tricky and steep. And if you walk only on rainy days you'll never reach your destination. (Stone)

As the monk gives his counsel to her, Le Ly sees the close-up of the bronze statue of Buddha again, a filmic way to indicate that her

thoughts focus on her religious beliefs. It is worthwhile to note that throughout the film it has consistently been a *male* monk or wizard fortune-teller who dispenses advice to Le Ly's parents in Vietnam and now to her in America. Why the importance of the male figure? Alexander Soucy explains, "The performances of women are based more in a desire to show piety and concern for the family, whereas the performances of men try to present sagacity and learning in a manner that reflects the valued image of a Confucian scholar and de-feminizes the pagoda as a locus for male practice" (Soucy 368). While there are Buddhist nuns and increasingly women Buddhist scholars and teachers, in traditional Vietnamese Buddhist practice it has been men who provided spiritual leadership.

Le Ly accepts the monk's spiritual leadership unquestioningly, as would be predictable given her cultural background. Acting on the monk's advice, Le Ly pleads with Steve to come home. She tells him she will go to his church and put the Buddhist shrine away, willingly accepting her own self-abnegation. She tells him on the phone that she loves the man she saw in Vietnam, but Steve is no longer the same person.

Steve, however, almost automatically rejects Le Ly's compassionate offer of reconciliation and chooses suicide instead—an act not condoned by his Catholicism either. After Steve's suicide, Le Ly sets up a floor-level shrine of him, burning incense and making some other fruit offerings in front of a black and white picture of him in his army uniform in Vietnam. In death, Steve thus is honored in Buddhist fashion.

Because Le Ly is worried about the peacefulness of his soul, she has a wizard fortune-teller come to her house; fortunately for her, she has many of the same Buddhist resources in her Vietnamese American community in southern California as she would have had in rural Vietnam. The wizard tells Le Ly to welcome Steve's spirit so his soul can enter the Buddhist temple, but Le Ly has reservations about this advice because Steve was such a strong Christian. Yet the fortune-teller assures her, implicitly accepting the mutuality of religions, just as the Buddhist Thich Nhat Hanh has written:

Just as a flower is made from non-flower elements, Buddhism is made only from non-Buddhist elements, including

Christian ones, and Christianity is made only from non-Christian elements, including Buddhist ones. We have different roots, traditions, and ways of seeing, but we share the common qualities of love, understanding, and acceptance. (Nhat Hanh, *Living Buddha, Living Christ* 11)

Thich Nhat Hanh points toward a convergence of Christian and Buddhist religious practices, underpinned by a theological comparison and transcending co-optation. Indeed, Buddhism welcomes syncretism, unlike Catholicism. Yet even a Christian thinker like Alan Pope concedes the existence of some convergence: "[T]he images of Christ on the cross and Buddha under the tree reflect different aspects of the same principle of transcendence through transformation" (Pope 249).

On a personal level, Le Ly's building of a shrine for Steve's soul also furthers her own spiritual development away from hatred and vengeance toward a more compassionate view advocated by the Buddhist monk. This aspect of self-development has been rather popular in Vietnamese Buddhist practice, as Thien Do has written:

To many Vietnamese who claim to be Buddhists, the project of perfectibility is also imbued in one way or the other with supernaturalism. It is important to recognize that through this trope of self-cultivation, Vietnamese Buddhism and other popular religions derive their familiar psycho-social configurations through the putative interaction between the spirit realm and the world of the living. (Do 254–55)

As Le Ly finds peace within herself, her voice-over narrates that her father finds no more need to visit her in her dreams. And she sees the close-up of the bronze statue of Buddha one more time. In this way, Le Ly summarizes her belief in a Vietnamese folk adaptation of Buddhism, which is guiding her on a path of forgiveness and compassion. The narrative's depiction of Buddhism, while it does not correspond to all aspects of Buddhist doctrine, is nevertheless an expression of the authentic beliefs of a practicing Buddhist from the country of Vietnam seeking healing and reconciliation. Critics may thus forgive Le Ly the term "God" when referring to Buddha throughout her concluding narration:

It is my fate to be in between heaven and earth. When we resist our fate, we suffer. When we accept it, we are happy. We have time in abundance, an eternity to repeat our mistakes. But we need only once correct our mistake and at last hear the song of enlightenment with which we can break the chain of vengeance forever. In your heart you can hear it now. It's the song you have been singing since your birth. If the monks were right and nothing happens without cause, then the gift of suffering is to bring us closer to God: to teach us to be strong when we are weak, and be brave when we are afraid; to be wise in the midst of confusion and to let go of that which we can no longer hold. Lasting victories are won in the heart on this land or that. (Stone)

Far from co-opting a faked version of Buddhism for American mass-movie-market consumption, *Heaven and Earth* reveals instances of living Buddhism among traditional Vietnamese Buddhists of the peasant class. Seeking to express the subjective version of the film's historic heroine, Le Ly, *Heaven and Earth* dramatizes a personal vision of a peaceful past shattered by a bitter anticolonial resistance and later a civil war in the context of the world's Cold War struggle. Risking but never succumbing to the dangers of exoticization and othering, Stone shows images of Vietnamese Buddhist practice and folk beliefs, rituals, and ceremonies at the village community level.

Once the film's central character of Le Ly moves to America, *Heaven and Earth* shows the difficulties and dangers of her assimilation. Confronted with personal spousal violence, Le Ly finds recourse in her Buddhist beliefs when a sincere attempt at reconciliation with her husband fails. Grounded in a Buddhist faith community arising in her diasporic Vietnamese American community, Le Ly finds the spiritual strength to find closure to traumatic past events. She can live for compassionate healing on a path as close to enlightenment as possible in this world full of suffering—a belief shared by both Buddhism and Christianity. In the end, what theologian Dale Wright praises about Im Kwon-taek's Buddhist film *Mandala* (1981) could be said about *Heaven and Earth* as well without any reservations: "Cinema, like certain forms of literature, possesses the cultural power to broaden and to make more vivid the language of ethical deliberation. . . . And like theatre, film has the power to make transcendence in

the ethical dimension visible in ways that other domains of human culture do not" (Wright 319). As a movie with a deeply ethical central character, who is guided by Vietnamese Buddhist practice and beliefs, *Heaven and Earth* offers a portrayal of a woman who made the successful transition from a world of war and personal suffering to that of inner peace and compassion even for her former enemies. As such, the film is a celebration of a Buddhist woman's path through a challenging life.

Notes

1. The other two feature films are *Platoon* (1986) and *Born on the Fourth of July* (1989).

2. Stone wrote the screenplay for the film based on Hayslip's two memoirs *When Heaven and Earth Changed Places* (1989, cowritten with Jay Wurts) and *Child of War, Woman of Peace* (1993, cowritten with her son James Hayslip).

3. The term means Vietnamese Communists; American soldiers referred to Viet Cong as Victor Charlie or VC, which carried derogatory connotations.

4. Her formal name is Le Ly Hayslip, but in Stone's film she is known as Le Ly. For uniformity, we refer to her as Le Ly when discussing the character of the film while using her full name when referring to the author.

5. Although the consensus of critical opinion is that Stone oversimplifies and cheapens Buddhism, not all critics have agreed. For example, Janet Maslin writes in the *New York Times*: "*Heaven and Earth* incorporates an element of Buddhist acceptance and serenity, particularly in the thoughts that end the film on a philosophical note."

6. Hayslip's quandary may be compared to Ralph Waldo Emerson's, who, struggling with a term to define his sense of an overarching spiritual unity, settled on the somewhat clumsy word "Oversoul" to distinguish his meaning from the traditionally Christian "God."

7. During the Vietnam War (1954–1975), Thich Duc Quang (1897–1963), a Vietnamese Mahayana Buddhist monk, set himself ablaze at a busy Saigon street intersection on June 11, 1963,

in protest against the persecution of Buddhists by President Ngo
Dinh Diem's government in South Vietnam. Malcolm Browne
won a Pulitzer Prize for his famous photo of the monk's self-
immolation. Thich's heart remained intact though his body was
re-cremated. Many Vietnamese Buddhists revere him as a bod-
hisattva. His self-immolation was ridiculed by Madame Nhu,
Ngo's sister-in-law, as a "monk barbecue," which ironically was
a phrase that Madame Nhu's daughter Le Thuy Nhu cribbed
from American journalists at Saigon's Rex Hotel who coined the
appellation. Great betrayal was felt by Vietnamese Buddhists at
the time because the thoughtless and insensitive remark came
from someone who was a Buddhist before converting to Roman
Catholicism upon marriage into the Ngo family.

8. This syncretism is also one of the various interfaces of Catholi-
 cism and Buddhism as has occurred in historic Vietnam. As
 Courtney Bender and Wendy Cadge explain,

 > Catholic and Buddhist interaction nonetheless actively
 > articulated and shaped various constructions of "Bud-
 > dhism." These various constructions are not unique to
 > the dialogue itself, but were rather mobilized within it
 > in ways that allowed us to better understand how Bud-
 > dhism is lived and constructed by religious professional
 > [and lay people] in both traditions. (243–44)

9. This character is actually an amalgamation of the two husbands
 of Le Ly Hayslip, neither of whom were military men (Den-
 nis Hayslip was actually British), and her onetime lover, Major
 Dan Parma, as well as a Vietnam Veteran she had a love rela-
 tionship with in southern California; his stories of supposed war
 atrocities he committed in Vietnam were later revealed to be his
 inventions. As Oliver Stone explained to Le Ly Hayslip, for the
 sake of his movie's narrative flow, he had to create this compos-
 ite character. Ironically, Tommy Lee Jones dominates the official
 film placard.

10. For a thorough discussion of the varieties of karma in Vietnam-
 ese Buddhism, see our chapter "A Bridge between Two Worlds:
 Crossing to America in *Monkey Bridge*" (Nguyen and Lutz
 177–206).

TWO

Buddhism, Children, and the Childlike in American Buddhist Films

EVE MULLEN

As evidenced so clearly in this volume, Buddhist images and themes are common in Hollywood films. Being in the American limelight, however, often means subjection to the American culture. Memorable quotations, rapid montages of images, and the crafting of simplistic stories are commonplace, both in contexts of fictional entertainment and nonfictional news. Constructions of Buddhism and Buddhists now permeate our media-oriented culture. To what ends are such presentations crafted, and why does the American public so readily accept them? How have filmmakers appropriated Buddhism? How do effects of Hollywood films that utilize Buddhism partly control our understandings of Buddhism? How does the entertainment industry's depiction of Asian cultures advance, undermine, or colonize Buddhism? To begin to answer these questions, this chapter discusses some romanticized attitudes toward Buddhist traditions found in American culture in general and explores such constructions and commercializations of Buddhism in American films in particular. Buddhism is shown to occupy an idealized place in the minds of American audiences: at various times, Tibet, Japan, China, and other cultures have served in that role. In general, Asia has been a repository for European and American projections.

My focus in this chapter is three popular film examples of such Western projections: *Little Buddha*, *Seven Years in Tibet*, and *Kundun*. All three films are made for an American audience, explicitly deal with Tibetan Buddhism and Tibetan Buddhist characters,

and include children as prominent characters as well. The structural framework for my discussion is based primarily upon the scholarly work of Donald Lopez. In particular, emphasis is placed upon what Lopez calls "new age Orientalism," a distortion of Asian cultures characterized in part by exaggerated roles of villains and heroes, European or American rescuers, and Asian victims, and by mis-appropriations of Asian histories (16). Special attention is given to constructions of the innocent and childlike in Orientalist schemas of Buddhism. In short, the chapter shows how fantasies involving Buddhism are constructed and also exposes their limits, concluding that in American popular film, Buddhist cultures are distant utopias in which to escape for a short time, but they are utopias that must be kept distant for the projected fantasy to be perpetuated.

Orientalism and Tibetan Buddhism

We are not the first to be entertained by crafted presentations of Tibetan culture and Tibetan Buddhism, the Vajrayana. James Hilton's *Lost Horizon* was first published in 1933 at a time of chaos and war in the Western world. The popularity of the novel and 1936 film indicates a wish among people at that time: It is no surprise that a downward-spiraling civilization faced with its own horrors and impending world war would embrace a story of a peaceful utopia nestled in the Himalayan mountains, a fantasy locale in which both social and physical ills were nonexistent and where eternally youthful citizens knew nothing of the waste brought on by violence. This was Hilton's Shangri-La, a fictional land reflecting Hilton's under-standing of the Tibetan Shambhala as a mysterious nation of esoteric people who occupy a "hidden" region on the highest plateau in the world.[1] We now can see Shangri-La and nostalgia for a lost culture making popular appearances again, this time in the context of the near-extinction of Tibetan culture itself. Films focusing on Tibetan religion and history such as *Little Buddha*, *Seven Years in Tibet*, and *Kundun* provide moviegoers with visions of Shangri-La. We are drawn to stories about perfect Tibetan heroes and evil Chinese vil-lains. The lamas (Tibetan Buddhist monks) often are portrayed as beatifically smiling, even superhuman beings. The Westerners fea-tured in the popular stories are inevitably depicted as heroes, first

recognizing the value in Tibetan religion for themselves and then gallantly rescuing the doomed culture of Tibet. Do such patterns in our entertainment speak to our unconscious wishes?

Thanissaro Bhikkhu places simplifications of Buddhist dharma within a historical framework of "Buddhist Romanticism," the phenomenon of using Buddhist teachings as an element of Romantic psychology such as is found in the works of European Romantic philosophers. His concern is the misappropriation and misunderstanding of the Dharma, by Americans and others, as a path toward psychological health and self-cultivation, not as *nibbana*-oriented denial of self. He writes in "The Roots of Buddhist Romanticism,"

> The question here in the West is whether we will learn . . . and start using Buddhist ideas to question our dharma gate, to see exactly how far the similarities between the gate and the actual dharma go. If we don't, we run the danger of mistaking the gate for the dharma itself, and of never going through to the other side.

In short, mistaking one cultural interpretation of the Buddha's teachings for truth itself is a grave error. Appropriations of Buddhist teachings that do not include the Buddha's radical prescriptions for realizing no-self fail the American or other practitioner and can only offer a lesser path without meaningful, nonegoistic transformation. The psychotherapeutic version of the Buddha's teachings, that which Thanissaro Bhikkhu charges Western cultures with propagating, is "Pollyannaish" and "too facile" to ensure an effective dharma practice. All that remains is a popular psychological therapy, not a Buddhist path at all. It is just such a danger of misappropriating cultures or religions for selfish (non-Buddhist) gains that post-Orientalist scholars wish to expose. Buddhist dharma, often misappropriated as Thanissaro Bhikkhu notes for psychotherapeutic gains or cultivating greater self-esteem, is also a prey to Orientalism.

Orientalism can be defined briefly as exaggerations, made purposefully or not, of Asian traditions and culture, exaggerations that can be patronizing and damaging to the studied peoples. In the field of religious studies, Orientalism's inaccurate portrayals, salvage paradigms, and gross generalizations have been denounced for decades in postcolonial scholarship. In a May 1994 article in *Tibetan Review*,

"New Age Orientalism: The Case of Tibet," and in the subsequent 1998 *Prisoners of Shangri-La: Tibetan Buddhism and the West*, Tibetologist Donald Lopez recognizes persisting elements of Orientalism in scholarship and describes what he calls "new age orientalism" in Tibetology. Lopez's four characteristics of Orientalism in scholars' works are clearly defined.

First, he defines the classic orientalist "play of opposites," in which Tibet and Vajrayana Buddhism, emerging as objects of European and American fantasies, are deemed polluted, derivative, and even demonic in opposition to an original root tradition, in this case the ancient Sanskrit texts of India, pure, pristine, authentic, and holy ("New Age" 17). Scholars projected their own cultures' past history onto these objects of study, thus setting up the Indian past as something to be recovered and salvaged as valuable to them. Asian histories were assumed to represent a pristine, primal version of Western societies, resulting in what James Clifford and Edward Said identify as "nostalgia for ourselves."[2] This play of opposites still operates in new age Orientalism; the positions, however, are changed, creating anew the fantasy of Shangri-La. Tibet becomes the perfect civilization, unpolluted, timeless, harmonious, and holy as the home of true Buddhism and a peaceful utopia. Tibetan people are characterized as superhuman, perfect citizens under a perfect leader. The new opposition becomes China, the violent invader, godless and demonic, despotic and polluted. Chinese soldiers become subhuman murderers following the inhuman orders of their leaders. The rescue roles of Westerners are still in place as well. This time, however, the contemporary goal is not the rescue of Asia for the West, but the rescue of Tibet from China, of Asians from Asians. The second of Lopez's characteristics of Orientalism in the case of Tibet is the self-aggrandizement of the rescuers. The Tibetans themselves become voiceless nonagents in their own struggle for independence or survival. Instead, the Western rescuers are allowed to be the heroes of the Tibetan cause, exemplifying the American self-portrait as one of a strong, moral, champion nation in which equality and justice are forever upheld. As this portrait elevates European or American heroes, it damagingly lowers the Tibetans to a position of monopolized voicelessness.

Self-aggrandizing of the rescuers leads to the third and fourth of Lopez's characteristics for Orientalism: the third is the gaining of

authority or control over Tibet, and the fourth is the justification of that authority. The Orientalist at once transforms the Tibetan people into nonagents and points to their nonagency as justification for taking control. In general terms, this means control over Tibetan religion, art, and history as areas of academic study and of asserted philanthropic preservation and control over Tibetan survival in exile. Yet this process is not limited to academe and philanthropy. Examples of new age Orientalism pervade entertainment, including contemporary American films in which Tibetan history, images of Tibet, and portrayals of the Tibetan people are crafted. I now turn our attention to the films in which Tibetan Buddhism is overtly the subject matter, *Seven Years in Tibet*, *Kundun*, and *Little Buddha*.

Tibetan Buddhists Portrayed in Film: The Childlike and the Mature

All of Lopez's characteristics of new age Orientalism are found in recent feature films focusing on Tibet. American films are mediums through which to project, both literally and psychologically, the Orientalist play of opposites, the rescue paradigm, the Western authority over Asia, and the justification of that authority. *Seven Years in Tibet* recounts the story of Heinrich Harrer's years in Tibet and indeed parallels the history of Tibet-focused Orientalism. When Harrer (Brad Pitt) first enters the country, he exhibits the behavior of an authoritative father to the Tibetans' childlike innocence. Tibetans are depicted as simple primitives without social graces, education, or guile. They stick out their tongues at the outsider Harrer, as children on a playground might taunt a new classmate. The audience is entertained by the Tibetans' lack of technology, automobiles, and especially movie theaters. Harrer is an arrogant Aryan from Nazi-era Austria, barely tolerant of having to exist in this primitive society, his only other option the Indian prison camp from which he just escaped. The play of opposites here is that of classic Orientalism: Tibet is belittled as only an intermediate means to salvation for Europeans—in Harrer's case, as a temporary hindrance to finding final escape back to his home, Austria. As the story progresses, Harrer takes control in a parental role and seemingly teaches the Tibetans all they need to know. He befriends the boy Dalai Lama (Jamyang Wangchuk)

and becomes his mentor, teaching him about the outside world—
its wonders and its wars. The audience soon discovers that Harrer's
teachings are vital for the regent's preparation against the Chinese
invasion of Tibet. For short periods of time, he helps the Dalai Lama
escape from the confines of his Lhasa palace and from what is surely
the primitive religion that has imprisoned him there. And, yes, Har-
rer even builds him a movie theater in the Potala.

Harrer, however, is later humbled, his parental role usurped,
resulting in a change in the play of opposites. The psychological
drama unfolding in the character of Harrer revolves around the
abandonment of his child, a son he has not met. China's invasion
of Tibet and Tibet's struggle to survive are only the backdrops for
the main events of Harrer's emotional maturation and his return to
the Western culture of Europe. Harrer is humbled when the play of
opposites unexpectedly becomes inverted; in the turning point of the
film, the boy Dalai Lama recognizes Harrer's longing to see in him
his abandoned son. The Dalai Lama tells Harrer that he was never a
father, nor will he ever be a father to him. Harrer is reduced to tears
by the young regent's words, his vulnerable, childlike state now over-
seen by Tibetan authority embodied in the Tibetan boy and exem-
plified in his very parental speech. Harrer's inner scars, exposed by
the Dalai Lama, begin to be healed. Harrer is finally broken of his
egotistical behavior as well. The man who carried newspaper articles
about his athletic successes and who himself laughed at Tibetan ways
and customs is now an adult who leaves such arrogance behind and
embraces the Vajrayana's virtues. He fully exhibits Buddhist selfless-
ness and humility, the result of a growing-up process witnessed in
small increments throughout the film. At this main turning point in
the film, Tibet becomes the exalted, valuable culture in contrast to a
puerile Austrian's culture and to a murderous, demonic China. The
European who has played his part in the defense of pristine Tibet is
cured of his emotional ills by Tibet's Buddhist wisdom and can now
return a whole man to his own life in Vienna.

The same pattern of egotistical pride transformed by Buddhism
to an accepting maturation is found in director Bernardo Berto-
lucci's *Little Buddha*. The film alternates between the story of Gau-
tama Buddha's (Keanu Reeves) life in the sixth century BCE and
the story of a contemporary American family whose son Jesse (Alex

Wiesendanger) is recognized by Tibetan monks living in the United States as the possible reincarnation of an important lama. As Reeves acts out the trials and victories of the Buddha, the small boy's parents make the difficult decision to let their son go abroad to take part in a distant, Buddhist world. Dean (Chris Isaak), Jesse's father, is skeptical about his son being identified as a possible incarnation of a lama and suffers with grief over a friend's death. He must travel to Bhutan's context of Vajrayana Buddhism with his child, learn about the life and teachings of the Buddha Siddhartha Gautama, and overcome his own fears and angers. Simply put, he matures. He becomes understanding, compassionate toward others, and reconciled to death and loss. Once again, the Tibetan Buddhist story is a mere backdrop for the real focus of the film, the growth and projected heroism of one American. And he, too, learns from a child. His son, Jesse, tells him upon the death of the teacher Lama Norbu (Ying Ruocheng), "Lama Norbu just said, no eye, no ear, no nose, no Jesse, no lama. No you. No death. And no fear!" He echoes the Heart Sutra.[3] The gentle words, delivered with a mature, knowing smile by the small boy, soothe the father and seemingly solve the mystery of death's meaning for him.

Rites of Passage, Binary Divisions, and the Play of Opposites Observed

The maturation process observed in the stories of Heinrich Harrer in *Seven Years in Tibet* and the father in *Little Buddha* is that of a classic religious rite of passage—a Campbellian hero's adventure—and follows distinct stages of progression. Arnold van Gennep in the classic *Rites of Passage* interpreted religious life-cycle rituals, rituals that most commonly mark a religious adherent's new status as an adult, as having three stages: separation, transition, and reincorporation. Joseph Campbell in *The Power of Myth* similarly referred to the functional stages within archetypal hero myths. First, the religious initiate or hero of the story leaves his or her familiar surroundings to exist in a liminal or marginal state of being. This transitional stage can be experienced in an otherworldly or foreign territory, or through difficulties such as physical or intellectual trials. To use perhaps a

more familiar example for Americans, a Jewish child preparing for a bar mitzvah or bat mitzvah studies Hebrew and the Torah in order to become an adult. While in the student stage, the person is neither child nor adult but in a difficult marginal state between childhood and adulthood. In both the ritual and mythological triads, a return to community marks the completion of one's transformation, and the treasures, new perspectives, or simple lessons learned are brought back to the hero's home to be shared with others. Once the liminal period is over and the trials are overcome, the person ideally is welcomed back into the community. The child who was successful in a bar or bat mitzvah is welcomed into the congregation as a recognized adult.

Similarly, the stories of *Seven Years in Tibet* and *Little Buddha* begin with a separation from the characters' familiar world, as they enter a new, exotic world. Heinrich is thrust into Tibet as an accident of war, while Dean volunteers to accompany his son to Bhutan. Both are changed by the trials they encounter in exotic locales; Heinrich by physical and emotional ordeals, Dean primarily by inner emotional trials. The stories also end with a return, specifically, a return to the West from Buddhist Asia. Like Heinrich in *Seven Years in Tibet*, Dean in *Little Buddha* returns home to be a better father and to reap the benefits of having learned a lesson in humility in an alien, Buddhist setting. Such endings may simply follow the hero myth pattern and may be satisfying to audiences with that simple adherence. But this common denouement may also be typical of a distanced attitude toward Asian utopias: Utopia exists in these foreign places, but in keeping with that distancing, Westerners may visit but must not stay there. Westerners like the idea of a Shangri-La that can provide a space where incarnations and magical events occur and like to dream of being there, but Westerners are not so open to inhabiting that space on a permanent basis. For a Westerner, perhaps it is nice to visit a nonmaterialist culture of selflessness, but it is nicer to return home to comfortable luxuries and familiar individualism. Thus, Thanissaro Bhikkhu's charges against Western adaptations of the Buddha's dharma may be, particularly with such analyses in mind, valid. Without a radical idea of no-self, selfish action is a threat. The Buddhist path may be partly accepted in America, but without the dramatic rejection of self, the path is not Buddhist at all,

only Romanticist, and it therefore is an inadequate representation of the Buddhist Way.

Through both *Seven Years* and *Little Buddha*, the audience experiences European and American rescues of Tibetan culture for the benefit of Europe or the United States, recorded for posterity in text and Technicolor. This recurring theme would not be possible if not for what Chandra Talpade Mohanty calls the "binary divisions" that place the subjects of Western colonial discourses into tidy, clearly delineated categories. Mohanty, whose own work focuses upon women in feminist discourses, lends support to Lopez's observations regarding Tibetans in Orientalist discourses. Mohanty criticizes Western monolithic notions of sexual differences that result in damaging, exploitative characterizations of women, especially of women in developing nations. She writes in "Under Western Eyes: Feminist Scholarship and Colonial Discourses":

> Because women are thus constituted as a coherent group, sexual difference becomes coterminous with female subordination, and power is automatically defined in binary terms: people who have it (read: men), and people who do not (read: women). Men exploit, women are exploited. Such simplistic formulations are both historically reductive; they are also ineffectual in designing strategies to combat oppressions. All they do is reinforce binary divisions between men and women. (207)

Lopez's play of opposites is echoed in Mohanty's binary divisions. In both assessments, Orientalism and colonial discourses are exposed as having a significant flaw: they overlook real diversity within groups in order to favor an unrealistic, homogenizing depiction of subjects. Simplifying characterizations of peoples do indeed reinforce binary divisions and plays of opposites, themselves unhelpful and even counterproductive to goals such as feminist empowerment or Tibetan autonomy. Whether between the innocent and polluted, good and evil, or childlike and adult, representational simplifications have the power to distort and damage. The harm done is not only to the subjects of the Western gaze but also to the gazers themselves via the false perceptions of the reality Hollywood promotes.

The Limits of Hollywood Appropriations of Tibetan Buddhism

Constructions of Tibetan Buddhism hinder the very cause that their creators sometimes claim to champion. Consider director Martin Scorsese's *Kundun*, a depiction of the fourteenth Dalai Lama's discovery, installment, and eventual flight to India after the Chinese invasion. Scorsese's film is, uncharacteristically for the director, respectful of the religious and political institutions it depicts. As *Philadelphia City Paper* film critic Cindy Fuchs writes: "Where most previous Scorsese films took dead aim at various social and religious institutions, expectations or rituals, *Kundun*'s attitude is absolutely un-ironic: the Dalai Lama is good, the Chinese are bad, the spiritual life is unfathomable, and the material life is fraught with peril" (65). Scorsese has succumbed to the fantasy of a utopian Tibet and a perfect leader. He even depicts the rats in the Potala as cute, even though the Dalai Lama remembered them as frightening in his autobiography on which Melissa Mathison's *Kundun* script was based. Scorsese pans sweeping landscapes to the repetitive music of Philip Glass; the characters quote Buddhist texts, often incomprehensible to American, non-Buddhist audiences. Scorsese shows us a faceless China, her waves of soldiers led by a Mao played with creepy villainy bordering on pedophilia toward the young Dalai Lama and his innocent nation. Protagonists and antagonists, good guys and villains, are firmly established. He depicts the Dalai Lama as a perfect being with supernatural powers of intuition and prophecy, fulfilling the Orientalist's projection of the superhuman. Tibetans become perfect citizens under a perfect leader. The initial motivation of the filmmakers is to aid in the Tibetan cause, perhaps to raise awareness about human rights abuses against the Tibetans. But cinematic idealizations pose the danger of ultimately disappointing people and defeating any Tibetan cause that originally may have motivated the filmmakers. For Tibetans, the true horrors of their history become film mythology, a passing interest on movie screens for Americans.

The attempt to rescue Tibetan culture is certainly considered heroic. It is this one, classic ideal of America as the land of the free, and as the land of the strong willing to fight in order to free the world from injustice, that is most evident in American activism surrounding the Tibetan cause. As Lopez points out, rescuers also become an authority; in their roles as heroes, they assume control in order to

be most effective. With this control, however, comes an appropriation of the culture being saved, reflected in the selective salvaging of artifacts and texts the authoritative rescuer has deemed worthy of being saved. And part of this control is the crafting of history to suit one's own goals and to motivate others. As we have seen in the films we have examined so far, Hollywood's expert storytellers shape the Tibetan story to fit specific expectations and agendas of American pop culture.

But it would seem that such appropriations of culture have limits. In the decade that *Seven Years in Tibet* and *Little Buddha* were released, an Oprah Winfrey show ("The Boy on the Throne") featured Carolyn Massey, the Seattle mother who gave up her son as the incarnation of a lama. Massey, a Vajrayana Buddhist herself, lived in Seattle, while her six-year-old son lived in a Nepalese monastery. This separation of parent and child is common to Tibetan monastic life, in which children installed as reincarnated teachers live studiously from a very early age. While most American audiences of Oprah's show seemed to idealize this life when Tibetans are the subjects, as in *Kundun* or *Seven Years in Tibet*, they usually scoffed at it when the subject becomes an American child. For example, Massey was met with an onslaught of irate audience members, voicing their horror at Massey's "irresponsibility" and "lack of love and support" for her son. Massey's family spoke angrily about her abandonment of Catholicism and her "cop out" from motherhood. Others during the *Oprah* program chastised Massey for her distance from her son, with one person asking, "Why can't she move there and be with her son and give up her American materialism, too?" While the television studio audience was admittedly a specific one with particular gender, class, and other compositions, this example of reactions on the show might raise a question for a critical viewer: is American zeal for Tibet, or for a romantic preconception of it, limited? Giving up materialism is a virtue seen in Tibetan Buddhism, even one that pleases and renews, but is not one easily incorporated by Americans in general. The idea of a nonmaterialist culture is quixotic and entertaining, but to act upon this idea for most Americans may be unacceptable. It is important to note that Jesse in *Little Buddha* returns home to Seattle with his father; he is not installed as the reincarnated lama his teacher Lama Norbu sought. Little Jesse is not Little Buddha after all. One may venture to the East to regain innocence or find

Buddhist peace, but in the Shangri-La fantasy, both the children and
the childlike must return home.

An End to the Play of Opposites

The fascination with Tibet is well documented in American culture.
If Americans and Europeans in 1933 embraced Hilton's Shangri-La
to escape the horrors of world war, for what maladies do we seek
a cure today? Hilton's contemporaries suffered feelings of helpless-
ness amid escalating violence. Many viewers just as adeptly project
needs onto Tibetan culture today and enjoy those projections as they
are, in turn, reappropriated in the commercial media. To avoid the
darker realities, or at least the more materialistic and egoistic sides,
of American selves, many Americans seek those things that would
permit not only an escape from these realities but also a transcen-
dence of them. It is fitting, then, for Hollywood to turn American
attention to the other side of the world, to the East and to Buddhism.
The racism, oppression, and genocide contained in Tibet are not
American created, and Americans are thus safe from being impli-
cated as villains there. In this foreign land, Americans can be heroes.
Even though American racism is entangled in layers upon layers
of an American pluralistic society, the racism of the East is readily
identifiable: Chinese against Tibetan. If some Americans doubt that,
they need only go to the movie theater to see the Tibetan Shangri-
La, a perfect civilization where everyone is, or was, equal, and where
the Chinese now create inequality. It is not enough for truth to moti-
vate many viewers to be concerned about the injustices of the East,
for Hollywood depends upon the idealized exaggerations in popular
films. Only the underdog will capture hearts, and the villains sate a
hunger for clear divisions between good and evil.

There is a Zen saying that pertains to Buddhist enlightenment.
To paraphrase: In ignorance, one sees a mountain as a mountain; in
beginning wisdom, one sees the mountain is no longer a mountain;
at enlightenment, a mountain is a mountain once again. To pen-
etrate the meaning of this, one must realize that Buddhist thought
avoids dualism. An enlightened view in Buddhism means that one
must reject the way one has been conditioned to perceive the world
and look again upon reality with new eyes that see only unity and

interdependence. A mountain is not a permanent object existing in itself; it is an impermanent part of a fluctuating whole. Nothing, in fact, exists inherently, including a person. Such a realization, which brings with it a realization of no-self and ideally cultivates virtues such as compassion, humility, and selfless behavior, is the Buddhist definition of maturation. This is not, as Thanissaro Bhikkhu points out, a maturation of progress for the sake of self-cultivation but has a radical goal of realizing no-self. One leaves behind childish egotism and arrogance for an enlightened egolessness. As in the films discussed here, this growth is often interpreted as a return to innocence—in a sense, a return to the childlike. Buddhist wisdom moves one from conditioned dualistic thought to a new mode of perception in which opposites and divisions are exposed as illusory. In short, Buddhist thought is anti–binary division and anti–play of opposites.

Perhaps a lighthearted look at two excerpts from popular films, although they do not deal explicitly with Buddhism, will help enlighten us. In *The Empire Strikes Back* Master Yoda (Frank Oz) says to Luke (Mark Hamill), "No different! Only different in your mind. You must unlearn what you have learned." In *The Matrix* the spoon-bending boy (Rowan Witt), conspicuously dressed in what looks like monk's robes, tells Neo (Keanu Reeves), "Do not try and bend the spoon. That's impossible. Instead only try to realize the truth: there is no spoon." Yoda is not overtly a Buddhist master, and the robed boy in *The Matrix* is only similar to a Buddhist novice, but the lessons they impart can easily be translated into Buddhist terms: dualistic thought is but an unenlightened perception of reality, and the illusions dualistic thought fosters must be overcome. And once again, the wisdom of Buddhist maturity is scripted to come from the mouths of the small and childlike. If only the previous film examples discussed in this chapter dealt with Buddhist dharma so playfully, without attempts to portray the political and cultural reality of Tibet, the criticisms launched against them might not be so grave. But new age Orientalism, most notably the plays of opposites defined by Lopez and supported by Mohanty's concepts of binary divisions, is evidenced in popular films in America that deal with overtly Buddhist subjects. And the potential harm both to viewers' perceptions of Asia and to the cultures depicted and appropriated is unfortunately real. Just as Buddhism teaches one to reject false dualism, one must be mindful regarding the construction of Tibetan history and

culture, as these constructions are often by-products of the Western gaze on Tibet. As American films focus on the very real, urgent, and tragic Tibetan situation, too often they project American fantasies, simplifications, and desires for human perfectibility onto the Tibetan people and history. And our master storytellers sculpt truth to fit the roles that the American audience demands to see.[4]

Notes

1. For more on diverse interpretations of the mythical-geographical Shambhala, see Edwin Bernbaum, Peter Bishop, Frank J. Korom.
2. See, particularly, James Clifford and Edward Said's *Orientalism* and *Culture and Imperialism*.
3. The Heart Sutra indicates emptiness, which is understood to be ineffable, with the following phrases: "in emptiness there is no form, nor feeling, nor perception, nor impulse, nor consciousness; no eye, ear, nose, tongue, body, mind; no forms, sounds, smells, tastes, touchables or objects of mind; no sight-organ-element, and so forth . . ." (Conze 163). The Heart Sutra is an example of the Buddha's explicit teachings on the inherent emptiness of existence.
4. This chapter is based on "Orientalist Commercializations: Tibetan Buddhism in American Popular Film" (Eve Mullen, in the *Journal of Religion and Film* 2, no. 2 [1998]). My sincerest thanks go to William L. Blizek and the editors of the *Journal of Religion and Film* for their kind help with that precursor to this chapter.

THREE

Consuming Tibet

Imperial Romance and the
Wretched of the Holy Plateau

JIAYAN MI AND JASON C. TONCIC

In 1900, Arthur Conan Doyle, who created the character of famous detective Sherlock Holmes, perhaps due to his boredom with this cult figure, killed off his intelligent hero in a mortal combat with the archrival Professor Moriarty in "The Final Problem." According to Mr. Doyle's original plot, during the final battle with Moriarty, Holmes plunged into the Reichenbach Falls and then disappeared. The death of Sherlock Holmes shocked readers. They asked, begged, and even threatened Mr. Doyle to bring back Holmes, who was then the icon of the highest wisdom, intelligence, and talent in rescuing unfortunate people from the attacks of evil criminals. Perhaps to meet the readers' demand or to soothe the broken hearts of Holmes fans, Doyle decided to resurrect Holmes in "The Adventure of the Empty House," published in *Collier's Magazine* on September 26, 1903. In recounting his tale of survival, Holmes told his dear side-kick Watson that in the three years of absence he had disguised himself as a Norwegian explorer named Sigerson and gone to Tibet: "I traveled for two years in Tibet, therefore, and amused myself by visiting Lhasa and spending some days with the head Llama [sic]" (Doyle 337). It was from Tibet that Doyle had Sherlock Holmes reborn. Hence, in the mind of the Western public, Tibet marked the last sanctuary for the hero, a place that exists outside time and space.

As such, the return of Sherlock Holmes exactly matched the popular Western fantasy of Tibet as a land of miracles, transcendence, promise, and spiritual wisdom.

Tibet as the Other of Imperial Fantasy

It is true that for centuries Tibet has been inscribed into the Western imagination as the place of the sacred and the magical, the last Arcadia on earth: a land of a utopian Shangri-La, white clouds, purest snow, great promise, the most secret places of the earth, the mystic and fascinating seclusion and with Lhasa the holy city, the eternal sanctuary, the forbidden shrine, and so on. However, this fantastic codification of Tibet as the secret holy place, I would argue, does not reflect the disturbing identity of Tibet itself but the changing interests of Western imperialism. In other words, the sacred image of Tibet itself is invented by imperialist fantasy. Under the construction of the imperialist imaginary, Tibet finally emerged as a heterotopia, a no-man's-land—a site of peace, simplicity, naturalness, and the "Noble Savage"—standing between a preindustrial but culturally sophisticated China and an already industrialized and urbanized West. As E. Chandler described it, "We looked down on the great river that has been guarded from European eyes for nearly a century. In the heart of Tibet we had found Arcadia" (Chandler 227).

At the core of the imperialist fantasy of Tibet is the mythologization of its landscape—a romanticizing process of the cultural and visual representation of Tibet's landmark, the Himalayas, invested with and mediated by imperialist ideology. From W. J. T. Mitchell's point of view, landscape is a particular historical formation reflecting internal politics and national ideology as well as an international, global tendency, and it is "intimately bound up with the discourses of imperialism" (Mitchell 5–9). According to Edward Said, geography has played a crucial role in providing a coherent narrative for Western fantasies in the process of recreating the Orient as an "absolute" silent Other: "Geography was essentially the material underpinning for knowledge about the Orient. All the latent and unchanging characteristics of the Orient stood upon, were rooted in, its geography" (Said, *Orientalism* 216). Thus, the secluded, unknown

Tibetan landscapes provided a kind of *tabula rasa* for the fantasies of European imperialism, an empty space in which the European conventions of an ideal, romantic landscape—be it the beautiful, the sublime, and the picturesque—were projected and inscribed. As a result, the proliferating literature of Tibet and accounts of Himalayan travel are characterized by the rhetoric of "grand prospects, solemn majestic views, picturesque scenes and glorious landscape" (Bishop, *Myth of Shangri-La* 70). A short passage from George White's description of Tibet might illustrate this particular rhetoric of landscape: "There is no possibility of conveying to the mind of the reader the gratification which we experienced in some new burst of scenery, when, emerging from the somber labyrinths of a thick forest, we come suddenly upon one of those glorious landscapes which fill the whole soul with ecstasy" (White 177). However, this romantic celebration of Tibetan landscape as a pristine natural beauty and an unspoiled paradise is most problematic because it reveals the ideology of pictorial colonization of the native landscape under the imperial gaze. Such imperial gaze is derived from the violent erasure of differences in its homogeneous representation of the Other, leading to the production of a kind of visual pleasure that fulfills most intensely the desire of its hegemonic unconscious. To decode how the fantasy of such a landscape was produced and consumed by the imperialist gaze, and particularly to reveal the mechanism that manipulates the production of this imperialist fantasy, Edward Said's critique of Orientalism is most revealing for us to appropriate here.

In his seminal work *Orientalism*, Said pointed out that the discursive formation of the Orient is the product of an overall operation of the power/knowledge created by Western imperialist ideology for serving its own interests, confirming its own self-identity, and representing the needs of a specifically European agenda. The imperialist invention of the Orient as a "significant Other" serves to establish Europe's superiority and right to rule. From Said's point of view, Orientalism is never a form of objective, disinterested knowledge but is always wrapped up in the imperial ideology of domination and colonization. In this case, the representation of the Orient is usually systematic *mis*representation, the usual means by which the conqueror naturalizes the conquered. As Said wrote, "Orientalism . . . is not an airy European fantasy about the Orient, but a created body of

theory and practice in which . . . there has been considerable material investment" (Said 6).

It is true historically that the West's interest in Tibet was dominated by a strong imperialist will to unravel the mysteries of the Other, starting at the completion of the Western colonization of Africa, South America, and Asia by the end of the nineteenth century; and at the finish of the exploration of the world's great mountains such as the Alps, the Carpathians, the Rockies, and the Andes. "Tibet," remarked Peter Fleming, "was the only region of the world to which access was all but impossible for white men and concerning which the small sum of existing knowledge served rather to tantalize than to instruct" (Fleming 49).To explore the only remaining virgin land, the Himalayas, the British Royal Geographical Society played a catalyzing role; it offered funding, coordinating, training, and publishing for the Himalayan mountaineering adventures by enforcing prevailing values for selecting, controlling, and confirming the discourses of the explorations. Thus, by the end of the nineteenth century, a legitimate genre of Tibet travel writing was well established, which can be witnessed in the inflation of the "material investment" of botany, geology, philology, ornithology, anthropology, archaeology, theology, folklore, and travel narratives. Suddenly, Tibet became a site of imperial aspirations, dreams, and power that not only helped to redraw the boundary of scientific knowledge but also to define the very identity of Western imperialism itself.

In the process of inventing Tibet as a sacred place, two important events transformed the West's imagination of Tibetan landscape: the publication of John Ruskin's five-volume work, *Modern Painters*, in 1854; and Charles Darwin's epochal book, *The Origin of Species*, published in 1859. Ruskin's work, which emerged at the "Golden Age" of Alpine exploration, initiated a new aesthetics for understanding, perceiving, and experiencing the mountain landscape, "systematizing the quintessence of advanced Victorian ideas about mountain landscape aesthetics" (Bishop, *Myth of Shangri-La* 100).

Darwin's theory of evolution through natural selection helped to change the popular attitude that the untrodden higher mountains were a backward, bleak, and horrible wilderness; on the contrary, as Darwin's theory holds, they belonged to the same evolutionary family with the so-called civilized West. In this light, Tibet and the Himalayas "suddenly became positioned on a trajectory that

involved fantasies about sources and origins, missing links, evolutionary directions and goals, and about the survival of the fittest" (Bishop 118). At last, Tibet as the eternal sanctuary of a sacred landscape was invented for the West. From Lieutenant George White's peculiar account of his experience in crossing the threshold of the Himalayas, an aesthetic shift in observing the landscape from the negative view to the ideal view can be explicitly discerned:

> The view of the Himalayas from a spot in the vicinity of Saharunpore, is of that dreamy, poetical description, which, though full of beauty, presents little that is definite . . . the pyramidal snow-capped heights, which seem to lift themselves into another world, crowning the whole with almost awful majesty. From this site, the mountain ranges have all the indistinctness which belongs to the land of fairy, and which, leaving the imagination to luxuriate in its most fanciful creations, lends enchantment to the scene. The pure dazzling whiteness of the regions of eternal snow, give occasionally so cloud-like an appearance to the towering summits, as to induce the belief that they form a part of the heaven to which they aspire. (White 94)

White's perspective of the Himalayan landscape precisely reflects the typical Ruskinesque conception of the landscape characterized by noble sublimity, sinless beauty, and uplifting perfection that in the final analysis celebrates the purity, dignity, and glory of morality and spirituality.

In the process of the imperialist invention of Tibet as the sacred landscape, two particular modes of representation can be thus identified: the mode of conquering Tibet and that of being conquered by Tibet. These two modes can be found in the two works depicting Tibet—the first, in Swedish explorer Sven Hedin's travel narrative *A Conquest of Tibet*, published in 1934; the second, in British novelist James Hilton's fiction *Lost Horizon* in 1933. As we show in the following analysis, the two modes, though appearing different on the surface, are ideologically based on a shared fantasy that seeks to homogenize the difference of the Other under the power of imperial gaze.

The Logic of Conquest

Conquest is an operation of particular hegemonic power that takes over the territory of the other and appropriates the other's property as its own, and makes the other submissive to its norms and values. To conquer the other is the dominant ideology of Western imperialism that has succeeded in its global expansion. The most obvious form of conquest is carried out by force, such as the imperialist venture led by the British colonel Francis Edward Younghusband who invaded Tibet and conquered the heart of the mysterious Lhasa in 1904. However, there is another form of conquest that is more subtle, more surreptitious, and thus needs careful investigation to reveal its masked nature. In this case, the conquest is not deployed by force but by ideological, cultural, and aesthetic codes, functioning to naturalize the foreign wonders into familiar conventions. Sven Hedin's account of his travel in Tibet represents this kind of logic of conquest.

Sven Hedin, author of several travel books about Central Asia, including *Across the Gobi Desert, Jehol: City of Emperors*, and *Riddles of the Gobi Desert*, had, when young, read "the accounts of the immortal Marco Polo," devoured "Abbe Huc's and Prshevalsky's descriptions of journeys in Tibet," and "dreamed about the opportunity of seeing that country" (Hedin 12). His expedition to Tibet, the unknown "Forbidden Land," began with a strong consciousness of conquest: "I felt like a Tamerlane on an expedition to conquer new empires" (Hedin 15). First of all, to conquer, one needs to create a greater, nobler, and more majestic rivalry, a sacred land worthy of conquering, so that its final victory can be honorably celebrated. In other words, to create an ideal landscape, an Arcadia, is not to embrace it but to conquer it: to create is to destroy. So at the very beginning of Hedin's travel narrative, he created a fantastic ideal mountain landscape that was inaccessible and sealed off from the rest of the world. As he wrote:

> In the heart of Asia the snow-crowned peaks of the highest mountain area on earth rise toward sun and stars. It is known as Tibet or the "Snow-land." Himalaya, "The Abode of Winter," forms a rampart at the southern boundary, and also fixes the northern limit to India's eternal summer. From

that part of Central Asia which is covered by the suffocating
sand deserts of Chinese Turkestan, Tibet is separated by the
Kuen-lun gigantic mountain system. The interior of Tibet
is also filled with mighty mountain chains, almost without
exception ranging eastward and westward. . . . The forbid-
ding mountains have provided this land with an unyielding
defense. For this reason Tibet has remained one of the least
known and most inaccessible sections of the earth even up
to our day. (Hedin 11)

On the surface this description sounds like a general geographical
report, semi-scientific fieldwork, but what is hidden in it is precisely
the creation of a fantasized Tibet as the most majestic place existing
outside time and space. It is a place that is most difficult to reach, as
he later admits, "I had learned that Tibet is one of the most difficult
countries on earth to conquer for purposes of human research and
knowledge" (Hedin 71). Such fantasy-making provokes the desire to
explore and conquer this forbidden land: "With clenched teeth, we
were now ready to defy all obstacles that Nature had raised in our
way" (Hedin 72).

Once an ideal land was constructed, the next task was to endow
its landscape with all the qualities that match its fantasy-making
desire so as to foreground the values of the subsequent conquer-
ing. First, Tibet is claimed to preserve "the fairy-like, gorgeous scen-
ery" (Hedin 335). "No scenery on earth can rival this in magnificent
beauty" (Hedin 333) that, most significantly, has never been trodden
by any white man: "In the beginning of August we started our march
to the unknown. Every day presented us with a new stretch of land,
upon which no white man had ever before set his foot" (Hedin 18).
Hence, Tibet is a virgin land with all its natural beauty waiting to be
conquered by the explorer. Second, the landscape is pristine, pure,
holy, and picturesque, arousing a kind of coherent visual pleasure for
the imperial eyes. Hedin observed:

In this thin, clean air the mountains were decorated in pure,
changing colors. . . . On peaks and crests the fields of snow
expanded in dazzling white and in the center of the depres-
sions the lakes glittered like turquoises in a sea of stone and

gravel. In the magnificent surroundings one experiences the same attunement to worship as in entering a cathedral. (Hedin 28)

Traveling in this fantastic landscape surrounded by "the crystal-clear water" and "the eternally snow-clad mountains," the explorer achieved a kind of thrilling experience such that he couldn't help yelling out: "It was a solemn and wonderful experience to stand on this spot of the earth!" (Hedin 332). Third, the wilderness in Tibetan landscape opens up a kind of natural beauty and noble sublimity that produces mysterious powers and passions. In Hedin's point of view, "The wilderness has its secrets. Spirits soar over the mountain of Tibet" (Hedin 74). Rather than being "naked, sterile, desolate," bleak, and dreary, for Hedin, "a wild life thrives here, which in beauty and power corresponds to the grandeur of the landscape" (Hedin 28). Especially, one can enjoy a "pure light" that possesses a spectacular luminosity in Tibet. According to Ruskin, the purity of light is intimately related to "a type of sinlessness" in nature (Ruskin 2: 230). The luxuriant light in Tibet often makes one feel dreamlike, even hallucinatory:

> The peaks are shaped like pyramids and cupolas with shining caps of eternal snow and in the valleys between the mountains, blue and green glaciers extend their armors of ice toward the lake. The sky is turquoise blue; not even the slightest breeze ruffles the lake, whose smooth surface reflects the fantastic contours and brilliant colors of the mountains. . . . The sinking sun resembled a ball of glittering gold. Scarlet skies were driving eastward. As if illuminated from within, the mountains glowed like rubies. (Hedin 195–96)

Hedin was so intoxicated with the strong pure light and colors that he felt as though he were "gliding along in a landscape of dreams" (Hedin 195). Perhaps due to the influence of Romantic landscape aesthetics opened up by John Ruskin, Hedin showed a very subtle appreciation of light and color. The following passage shows his sensitivity to particular changes in the light:

The night was advancing. There was light over the mountains in the east. Light white clouds became rosy in color and their reflections on the smooth surface of the water resembled those gardens. Gurlas's crown glowed in the first rays of the rising sun, while the snow-clad sides of the mountain still were in the shadows of the earth. (Hedin 335)

This fascination with the beauty and sublimity of light and color foregrounds the unreal experience of the Tibetan wilderness; in the light of this fascination, Tibet as a transparent Other was represented. As Bishop aptly pointed out, "The celebration of uncanny luminosity and unearthly colors reinforced Tibetan Otherness, its place above the demands and stresses of the modern world, outside space and time" (Bishop 163).

With respect to the preceding, we can see that Hedin's representation of Tibet masks imperialist ideology. The derivative Tibetan landscape under the imperial gaze is always subject to the self-interests of the conqueror, to the fulfillment of the imperialist's dream of conquest. As Hedin said to himself, "I was dreaming of new conquest and strange adventures. My life had been wonderful, but still was not closed. Here was Tibet, a land full of mystery and riddles!" (Hedin 173). However, the conquering does not encounter any resistance in Tibet because there is nothing to be conquered there; the ideal Tibet does not exist but is invented by a privileged fantasy. Thus the operation of conquest is a struggle against itself; what happens in the final analysis is that the victor is also the victim at the same time.

Shangri-La: Elegy of Utopia

When Tibet was first discovered and opened to Western explorers, the savage splendor and natural sublimity of its mountain landscape shocked them, even frightened them. In Hedin's travel narrative, we can see that although he fantasized Tibet into an ideal land, an absolute other that he must conquer, yet when he looked at the majestic mountain landscapes, he felt detached, dizzy, and his vision was filled with great awe and fear. But once Tibet was made known to the West, because of its relative isolation and peripheral place, it became

a free space for the unrestrained imagination, producing yet another different form of representing Tibet: Tibet as a utopia free of fear, terror, and contradiction that has obsessed the West.

These two modes of conquest marked the fundamental shift toward landscape in Western fantasizing of the other. As Michael Le Bris pointed out, "A whole age that was coming to an end shunned mountains because they were horrible, while the . . . [next] sought out their ravines and waterfalls precisely in order to be carried away by their thrilling horror" (Le Bris 24). In this context, James Hilton's novel *Lost Horizon* (1933) represents the model of being carried away, or conquered by Tibet.[1]

The plot of the story is quite simple. Conway, the main character of the novel and one-time student at Oxford University, mountaineer of the Alps, veteran of the First World War, and noted explorer of China, together with another three passengers embarking on a cabin machine to withdraw from Peshawar, landed among the Himalayan mountains, in a valley called Karakal, which in Tibetan means "Blue Moon." There they discovered a wonderful lamasery named "Shan-gri-La," which was not marked on any maps (Hilton 116). During his stay in Shangri-La, Conway, after several long meetings and esoteric conversations with the High Lama who was then already more than one hundred years old, underwent a dramatic spiritual initiation and was identified as the reincarnation of the High Lama. Thus, this novel is explicitly a narrative of Conway's initiatory experience, his spiritual quest, his pilgrimage, and his grand tour of Shangri-La—a place of utopia. However, in the process of Conway's initiation and spiritual journey in Shangri-La, landscape plays a significant role in guiding the spectator's fantasy.

First, Shangri-La was imagined as the *axis mundi*, the sacred center of the world—"an extraordinary place—a lost valley in the midst of unexplored mountains" (Hilton 249), a secluded world protected from the outside world by gigantic mountain walls. This is what Conway described:

Hardly less an enticement was the downward prospect, for the mountain wall continued to drop, nearly perpendicularly, into a cleft that could only have been the result of some cataclysm in the far past. The floor of the valley, hazily distant, welcomed the eye with greenness; sheltered from

winds, and surveyed rather than dominated by the lamasery, it looked to Conway a delightfully favored place, though if it were inhabited its community must be completely isolated by the lofty and sheerly unscalable ranges on the further side. (Hilton 82)

What characterized this *axis mundi* was tranquility, harmony, and peacefulness: "all was in deep calm. In a moonless sky the stars were lit to the full, and a pale blue sheen lay upon the dome of Karakal" (Hilton 152). For Conway, "Shangri-La was always tranquil, yet always a hive of unpursuing occupations" (Hilton 227). Conway was intoxicated in this serene world of paradise that was "pacified rather than dominated by its single tremendous idea" (Hilton 226).

In the eyes of Conway, the serene purpose of Shangri-La could transcend all color and race prejudice but also "embrace an infinitude of odd and apparently trivial employments" (Hilton 228). The air was pure, clean, and uncontaminated; the atmosphere was "pleasantly warm even out of the sun" (Hilton 129), "that thin air had a dream-like texture, matching the porcelain-blue of the sky; with every breath and every glance he took in a deep anesthetizing tranquility (Hilton 83).

Besides, Shangri-La was a land abundantly provided with everything necessary for life: "For the valley was nothing less than an enclosed paradise of amazing fertility, in which the vertical difference of a few thousand feet spanned the whole gulf between temperate and tropical. Crops of unusual diversity grew in profusion and contiguity, with not an inch of ground untended" (Hilton 129). After Conway met with the High Lama and listened to his teachings, he came to see that Shangri-La actually preserved the source of wisdom, the elixir of youth and new hopes for the world's future. He finally found contentment and being at home in Shangri-La and achieved what the High Lama revealed to him: "calmness and profundity, ripeness and wisdom, and the clear enchantment of memory" as well as the real meaning of Time—"that rare and lovely gift that your Western countries have lost the more they pursued it" (Hilton 186). Conway was totally conquered and carried away by the majestic power and beauty of Shangri-La. The initiation of Conway was subtly reflected in his changing attitudes toward the landscape in Shangri-La; in other words, Conway's grand tour of the mystic

kingdom also brought about his final enlightenment concerning the truth of Shangri-La.

Conway's experience of the landscape underwent a fundamental shift from what John Ruskin called "mountain gloom" to "mountain glory" (Ruskin 4: 309–74), that is, from the strength and immensity of the mountains that frighten and provoke horror, the "sadness of the hills" (Ruskin 4: 327), to the sublimity, superb beauty of the mountain that purifies, and produces the power of anima, the "healthily mountainous" (Ruskin 4: 337). At the very beginning when the plane was flying above the Himalayas, Conway gazed out at the mountains below. He was frightened by the majestic ranges and suddenly felt an unspeakable horror. He was so shocked by the monstrous vast wilderness and showed a strong distaste for it:

> The surrounding sky had cleared completely, and in the light of late afternoon there came to him a vision which, for the instant, snatched the remaining breath out of his lungs. Far away, at the very limit of distance, lay range upon range of snow-peaks, festooned with glaciers, and floating, in appearance, upon vast veils of cloud. They compassed the whole arc of the circle, merging towards the west in a horizon that was fierce, almost garish in coloring, like an impressionist backdrop done by some half-mad genius. . . . Conway was not apt to be easily impressed, and as a rule he did not care for views, especially the famous ones. . . . To watch the sunrise upon Everest, he found the highest mountain in the world a definite disappointment. But this fearsome spectacle beyond the window pane was of a different caliber; it had no air of posing to be admired. There was something raw and monstrous about those uncompromising ice-cliffs, and a certain sublime impertinence in approaching them thus. (Hilton 46–47)

When he continued to stare at the superb mountain, he felt extremely detached, "distant, inaccessible," and "remote," and the mountains showed him "a chill gleam," a "sinister," "unhumanized," and "most unhospitable" face (Hilton 52–53). Before entering Shangri-La, though his attention was always kept on the awe-inspiring "virgin splendors" of the majestic landscape, Conway still considered the

dazzling Karakal "the most terrifying mountainscape in the world" (Hilton 81). However, after his entering into Shangri-La, Conway's perspective of looking at the mountain landscape was commanded gradually by his initiatory journey in it, and that gave rise to a dramatic change of his point of view of experiencing the landscape. Rather than feeling detached from the gigantic mountain, Conway felt quite "a welcome familiarity" (Hilton 86): "He was gazing upward to the gleaming pyramid of Karakal. . . . Indeed, as Conway continued to gaze, a deeper repose overspread him, as if the spectacle were as much for the mind as for the eye" (Hilton 97), and "Shangri-La was lovely then, touched with the mystery that lies at the core of all loveliness. The air was cold and still; the mighty spire of Karakal looked nearer, much nearer than by daylight" (Hilton 122). Shangri-La appeared to him no longer inhospitable, monstrous, and wild; on the contrary, he felt himself quite at home there: "He felt an extraordinary sense of physical and mental settlement. It was perfectly true; he just rather liked being at Shangri-La. Its atmosphere soothed while its mystery stimulated, and the total sensation was agreeable" (Hilton 151).

The most dramatic moment, which totally transformed Conway after several long talks with the High Lama, is marked by a corresponding vision of the magical landscape. In other words, the moment when he reached his final initiation was the moment when he was totally conquered by the power of Shangri-La. After his surrendering to the power of the High Lama—"but suddenly a deep impulse seized him, and he did what he had never done to any man before; he knelt, and hardly knew why he did," (Hilton 191–92)— Conway has a new view of his surroundings in Shangri-La: "Never had Shangri-La offered more concentrated loveliness to his eyes; the valley lay imaged over the edge of the cliff, and the image was of a deep unrippled pool that matched the peace of his own thoughts" (Hilton 191–92). His initiatory bliss became more intense after the High Lama recognized him as his reincarnation ("I have waited for you, my son, for quite a long time. I have sat in this room and seen the faces of new-comers, I have looked into their eyes and heard their voices, and always in hope that some day I might find you" [Hilton 236]). He found himself part of the landscape: "He often felt a living invasion of a deep spiritual emotion, as if Shangri-La were indeed a living essence, distilled from the magic of the ages and miraculously

preserved against time and death" (Hilton 205). In Conway's spiritual quest, Shangri-La took a new face: the shrine of anima that cast an irresistible spell over him, one in which one could achieve Nirvana:

> As the days and weeks passed he began to feel an arche of contentment uniting mind and body. . . . He was falling under the spell. Blue Moon had taken him, and there was no escape. The mountains gleamed around in a hedge of inaccessible purity, from which his eyes fell dazzled to the green depths of the valley; the whole picture was incomparable. (Hilton 213–14)

Thus Shangri-La offered Conway the hope and cure for his identity crisis, which finally led to his salvation from spiritual disillusionment with Western culture. Shangri-La "proved the perfect antidote to a gathering global fear of the collapse of the civilized world" (Schell, *Virtual Tibet* 242). Since Conway had a traumatic experience of the loss of value in the First World War, and his despair in the postwar situation of spiritual emptiness, his pilgrimage to Tibet provided him with all the power of wisdom that could save him from his postwar sense of loss. As Michael Le Bris, in his study of the Westerner's fantasy of the East in the Romantic era, pointed out: "That Elsewhere, that yearned-for realm where it was supposed that a man might get rid of the burden of self, that land outside space and time, thought of as being at once a place of wandering and a place of homecoming" (Le Bris 161). Conway's fantastic journey in Shangri-La exactly illustrates the imaginary creation for the West of a safe and timeless utopia in the East.

Seen in this light, the mythologizing of Tibet does not reflect the reality of Tibet but the profound crisis of values haunting the West (seen in the Great Depression and rise of Nazism). Therefore, Tibet, believed to rise above the global catastrophe, was not only linked to Western identity but also to the survival and continuation of world civilization and even of humanity itself. James Hilton's Shangri-La was the chief symbol of this fantasizing of Tibet. At the final stage of Conway's initiation, the High Lama revealed for Conway his vision of what would happen to the world: the coming of an unprecedented storm called the Dark Ages would destroy the whole world, its "every flower of culture" and "all human things." No arms, no authority, and

no science in the world could prevent it from happening, but Shangri-La could alone offer a way out: "The Dark Ages that are to come will cover the whole world in a single pall; there will be neither escape nor sanctuary, save such as are too secret to be found or too humble to be noticed. And Shangri-La may hope to be both of these" (Hilton 237). Only Shangri-La could offer the hope and spiritual wisdom needed in the impending world crisis. In the High Lama's apocalyptic prophecy, it is only in Shangri-La that the seeds for the world's future would be preserved and nourished: "I see, at a distance, a new world stirring in the ruins, stirring clumsily but in hopefulness, seeking its lost and legendary treasures. And they will all be here, my son, hidden behind the mountains in the valley of Blue Moon, preserved as by miracle for a new Renaissance" (Hilton 238). Ironically, the High Lama's vision was proved true. The subsequent Second World War and the explosion of the atomic bomb in Japan were dark storms that almost destroyed the whole world. Yet what emerged from the ruins was not a New World but a Cold War world order that only brought about more disasters to the human world. And when in 1950 the Red Army marched into Tibet, occupied the *axis mundi*, Lhasa, and the Potala, and drove away the Anima-God the Dalai Lama, to exile in India, Shangri-La, the Blue Moon in which the last seed of hope for the future was believed to be preserved, was also destroyed. Here lies the biggest irony of the High Lama's vision and the West's fantasy of Tibet. The feeling of this irony prevailing in the Western psyche was melancholic, elegiac, tragic, and even nostalgic, but it is true, and mostly real.

So far, we have discussed two forms of representing Tibet in the Western imagination: literally conquering Tibet and being figuratively conquered by Tibet. Both of these forms are the fantastic constructions of Tibet as the other. The first creates Tibet as a sacred place in order to conquer it, while the latter creates Tibet as a land of utopia in order to be conquered by it. However, they share a single ideological ground in that their fantasy *mis*represents Tibet. In Roland Barthes's point of view, the creation of any myth is not to hide anything, but "its function is to distort, not to make disappear" (Barthes 121). From the fantasy of conquering to that of being conquered, a fundamental shift of representing Tibet took place, namely, Tibet from *a* place transformed to *the* place or *non*-place (as the Greek word "u-topia" indicates).

To conquer Tibet is to take it as a physical and geographical place, especially an unknown place so as to discover it and explore its mystery. To fantasize Tibet as a utopia of hope, promise, and spiritual salvation that makes one surrender is to construct it as the place that only exists outside time and space. Thus its cultural and landscape identity in the real world have to be distorted in order to maintain its symbolic meaning. As Peter Bishop pointed out,

> Tibet was not just *any* place, not just *one* among many within the Western global imagination. For a few years at the turn of the century it became *the* place. . . . The acclaim given to explorers of Tibet and Central Asia was exceptional; it was as if Tibet touched some fundamental surface of the Era's imagination. (Bishop 143)

Certainly, on the one hand, the fantasy of Tibet as the only sacred place touches its own identity crisis of Western culture and, on the other hand, touches the ideology of the imperialist gaze, that is, its erasure of the cultural differences and the other by its master narrative of imperialism.

Recreating Tibet in Post–Shangri-La Hollywood

Ever since Tibet was discovered and made known to the West, the image of Tibet has been inscribed not only in literary but also in visual representations. Explorers of Tibet have tried to capture it visually, and, the visual/pictorial representation of Tibet is a fundamental factor in constructing the visual literacy of Tibet and the fantasy of its landscape. However, I would argue that the visual discourse of Tibet produced by the imperial gaze is always problematic and thus must be called into question. No visual narrative is free of values and conventions, because the visual representation of culture is mediated by networks of ideology.

In the imperial gaze of Tibet (and the Orient), a series of scopic binary oppositions have been produced: the one who sees and the one who is seen, the perceiving subject and the perceived object, the primary eye and the secondary/derivative eye, the commanding viewer and the commanded one. The imperial gaze is always the one

who sees, views, and commands, exerting hegemonic power over the one who is viewed as the derivative object of desire. As a result, all natural and cultural differences of the other are tailored to the visual pleasure of imperial eyes. On the one hand, Tibetan landscape became a visual display for the projection of imperial landscape aesthetics—the beautiful, the sublime, and the picturesque—and on the other, it disrupted the visual pleasure of imperialist power deriving from the coherence of its visual narrative, thus reformulating its landscape aesthetics.

As Western imperialism was a global phenomenon, its conquest went beyond the British Empire and its literary representation was not limited in English novels. Yet, despite Edward Said's argument that "only England had an overseas empire that sustained and protected itself over such an area, for such a long time, with envied eminence" (Said, *Culture and Imperialism* 697), the liminal boundary that separates the English novel with other imperialist countries is in no regard rigid. American imperialist attitude emerged after the 1898 Spanish-American War and placed areas (Hawaii, the Philippines) under American suzerainty—or, perhaps euphemistically, supervision. American contact with Tibet was first established in 1942 through a correspondence from President Franklin D. Roosevelt to the Dalai Lama on July 3, 1942. Aside from introducing the two emissaries he had sent with the letter, President Roosevelt discusses the current state of world affairs: "As you know, the people of the United States, in association with those of twenty-seven other countries, are now engaged in a war which has been thrust upon the world by nations bent on conquest who are intent on destroying freedom of thought, of religion, and of action everywhere" (Roosevelt 113). The conflation of American-Tibetan politics with war is symbolically constructed within the theater of the Second World War where President Roosevelt's scheduled bombing raids over Tokyo allegedly originated from "Shangri-La"—the utopia imagined in James Hilton's *Lost Horizon*. While American political entanglement with the "roof of the world," Tibet, began in 1942 and was symbolically referenced during the Tokyo bombing raids, American culture addressed the issue of Tibet with the 1937 release of Frank Capra's film version of *Lost Horizon*.

Predating American political contact with Tibet by five years, the film interestingly depicts a Western view of Tibet *as* Shangri-La

that departs rather noticeably from Hilton's novel. The construction of this Tibet, however, occurs within the mythical landscape of the imagined, the dream world, so to speak, of the unknown. It is the consummation of the American romance with images and travel spectacle, of the scopic eye that gleans little insight into the culture itself, and it is, ultimately, a mirror of the self in its construction of a fantastical space outside the realm of existence. Within Edward Said's statement that "[t]o think about distant places, to colonize them, to populate or depopulate them: all of this occurs on, about, or because of land" (Said, *Culture and Imperialism* 698) resonates the American consumption of the "image" of Tibet. The American filmic treatment of Tibet has neither grounded itself on the political handling of Tibet nor on the landscapes that compose the Tibetan plane—American filmic consumption of the Tibetan image has consistently maintained the trope of prolonged life, immortality, or, in Freudian terms, that "the organism wishes only to die in its own fashion" (Freud in Brooks 290). Since Arthur Conan Doyle's resurrection of Sherlock Holmes, the mythos of Tibet has operated as a veritable philosopher's stone or fountain of youth for the psyche of the dream world. Drawing on Freud's death drive, Tibet functions as a space in which the organism not only eludes death but approaches the end through means of its own choosing. The visual, scopic dimensions of Tibet are limited by the physical and political realities of modern politics and, rather than being depicted in American film, are substituted with mythical/spiritual symbolism. Essayist Dorothy Hale comments that "[g]eography, in other words, has no point of view" (Hale 655). Tibet is no exception. The limited American knowledge and political relationship with Tibet before 1942 and the subsequent acquisition of Tibet by the People's Republic of China has left the American eye with a ghost country, erected by and through the image of America itself.

Frank Capra's 1937 release of *Lost Horizon* can be seen as a recreation more so than a reworking of the original Shangri-La. Where Hilton's Shangri-La could be read as a less than reputable society, the Shangri-La of the 1937 film loses the novel's insinuations of drug culture, geriatric hegemony, and, to a lesser extent, inescapable imprisonment. Tomoko Masuzawa, in her article "From Empire to Utopia: The Effacement of Colonial Markings in *Lost Horizon*," locates the negative aspects of Hilton's Shangri-La:

Shrouded in secrecy, it is a scheming mini-empire comprising a veritable gerontocracy far more extreme than Deng Xiaoping's China, a fantastic economic base in a clandestine gold trade, and an upper-crust population who rely for their well-being on altogether unproductive occupations beginning with, basically, doing nothing, not going anywhere, practicing yoga, and taking unidentified drugs. (Masuzawa 544)

The transformation of Shangri-La from the seedy establishment of the novel into the lavish utopia of the film occurs through a subtle alteration of context. The film opens with narration via an open storybook. Rather than construct the film based on the novel, the film rather opts to base its apotheosis on myth and fantasy. The storybook opening operates to recall the source of the work as well as to pervert it and distort it, changing the novel into fable. This technique is furthermore seen throughout American dealings with Tibet in film and is echoed in Bernardo Bertolucci's 1994 film *Little Buddha* and Paul Hunter's 2003 *Bulletproof Monk*, both of which depict a visible mythical book/scroll in the mise-en-scène of the film. "What distinguishes the novel from the story (and from the epic in the narrower sense)," writes theorist Walter Benjamin, "is its essential dependence on the book" (Benjamin 87). American filmic treatment of Tibet concentrates on the removal of the physical book as the precursor to focusing on the landscape within which the film occurs; and since Tibet itself is either fabricated or inaccessible on the screen, it is the mythologized image of Tibet that emerges in the filmic context.

Frank Capra's *Lost Horizon* alters the seedy, "utopian" society of drug-induced stupor within the umbrage of Karakal ("Blue Moon") to an Elysian paradise, brimming with uninhibited happiness and prosperity, and, ironically, destined to fall into the hands of the main character Robert (Hugh in the novel) Conway. The relevant political status of the main character is drawn into question; wherein in the novel he is a lowly consul, the film depicts him as the next foreign secretary. The change can partially be attributed to the American desire for celebrity within film. Yet this change is also crucial in highlighting the illusory nature of Shangri-La. When Chang tells Conway in the film, "Shangri-La is Father Perrault," a metonymic relationship is established between the Western world and the Eastern utopia of

Shangri-La, despite its utopian landscape. Shangri-La is a European construct. The metaphor, in fact, extends further. Conway's love interest in the film is a young English girl named Sondra (a fractured version of the novel's Lo-Tsen, who is also present in the film as Maria, a Russian girl). Sondra reveals that she specifically requested Conway's presence at Shangri-La after reading one of his books. In the novel Conway's arrival in Shangri-La (and the forthwith development of his relationship with the High Lama) was by chance, but the machinations that play into his arrival at Shangri-La in the film are physically controlled by Sondra, Chang, and the High Lama. Sondra ruminates to Conway, "Perhaps you've always been a part of Shangri-La without knowing it." Her association of Conway with Shangri-La is telling not only of the metonymic relationship that was established with Father Perrault and Tibet (extended to Conway) but, through juxtaposition, also of the apparent establishment of a relationship between Conway's Shangri-La and the book by which Conway—for Shangri-La—comes to exist. If for Benjamin the distance between the story/epic and the novel is the physical book itself, then the film locates Conway outside of the epic through his association with the novel since in the film the signifier of the novel is no longer Shangri-La (as it was in Hilton's version) but Conway himself, the surrogate of the American eye.

The alignment of the American perspective with the physical book and of Shangri-La with the story/epic inverts the paradigm of Hilton's *Lost Horizon*, wherein Shangri-La was the untouchable, fantastic location that was feasible only within the novel itself. The visualization of Shangri-La in Capra's *Lost Horizon* places the mountain retreat into the epic plane through its disassociation with the utopia of the novel. But Shangri-La is not the only fictional city of *Lost Horizon*—although many incorrectly assume it is—rather, it exists contrapuntally to Capra's reimagined Baskul, relocated into the heart of a Chinese rebellion. The political reasons behind this change are manifold. The 1937 film was released amid jockeying for power between the Kuomintang and the Chinese Communist Party. The rebellion within Baskul (China) is not only easily identifiable, but it's also encumbered with macabre insinuations of Communism and the not-yet-forgotten first Red Scare. If Shangri-La is indeed a Freudian escape from death, then it also functions as the inverse of the fictional Baskul in which Conway and company flee

for their lives from the spread of Communism. Ironically, however, there are strong insinuations of Communism that exist within supposedly "utopian" communities. Additionally, in reading Shangri-La, Tomoko Masuzawa writes, "Shangri-La embodies the ideals of the eighteenth-century European imagination whose fantasies included appreciative and appropriative musings about what was then considered to be the classical culture of the Orient" (Masuzawa 556).

The attempt to preserve the ideals of the eighteenth century in the wake of World War I, the stirrings of international communism, and the beginnings of World War II requires a location that exists *sans* international community. The positioning of Baskul as a war-torn Chinese city is telling, furthermore, in the casting of both Chang (H. B. Warner) and Sondra/Maria (derived from Lo-Tsen); the traces of Chinese leadership in Shangri-La are replaced by Caucasian roles. Shangri-La is not only an escape from death for its elderly prisoners, but it is a museum preserving a type of civilization soon to be extinct. Tomoko Masuzawa notes that "Theodor Adorno conjured up the word association of *museum* and *mausoleum* and offered us the first analytic insight into that 'unpleasant overtone' we hear in the word *museumlike* (*museal*)" (Masuzawa 557). The binary established between the inner turmoil of Baskul and the tranquility of Shangri-La accents the outlandish state of decay within the American filmic depiction of Shangri-La. What *Lost Horizon* offers the American viewer is not an indefinite utopia but rather a retreat from the contemporary—an attempt to stave off the wars, rebellions, and advent of communism occurring in the international world. By transferring the concept of the novel from Shangri-La to Conway (by means of Conway's book), Capra delineates Shangri-La's escape from the connotations of the novel—the new—and separates the utopia from contemporary society.

Because of the previous assertion of its function as the American scopic eyepiece into Shangri-La, certain inconsistencies appear when the character of Robert Conway's British ascendancy is brought into question. While such a statement does deserve merit and consideration, the argument is mitigated by a few defining factors. Frank Capra's casting of Ronald Colman as Robert Conway is interesting as Colman, originally from England himself, became a leading actor in American films—this recasting of an English/American actor to play the role of an English foreign secretary under the eye of the American

people is telling of the role Capra wished for Conway to play. Conway's first name was also changed from Hilton's version from Hugh to Robert, a more easily identifiable name to the American people. There may be another, lesser known justification for the portrayal of American viewpoints within the leading British role. In Hilton's *Lost Horizon*, Hugh Conway dictates his story to his eager classmate aboard a vessel bound for San Francisco, and realizing with clarity the story he has just recounted, Conway escapes from the vessel and never arrives in San Francisco. Capra's Robert Conway never makes it to San Francisco in the film either. But, in a rather symbolic manner, the premiere of *Lost Horizon* occurred in San Francisco (1937) representing the metaphorical arrival of Conway to America. What occurs to Hilton's Conway, furthermore, is never made clear. Capra's Robert Conway, on the other hand, successfully navigates back to the paradisiacal sanctum of Shangri-La thereby relieving the audience of any uncertainty. Frank Capra's Shangri-La is undeniably an American phenomenon, transferred to the romanticized landscape imagery of a mythic Tibetan landscape as a scopic viewpoint of a Western preservation of its past. Shangri-La is less a utopia than it is propaganda, a clandestine conservative playground for Caucasian, right-wing supporters. As such, Shangri-La has developed in tandem with the United States political situation abroad.

The evolution of *Lost Horizon* and Shangri-La can be summarized as follows: *Lost Horizon* (1933, James Hilton), *Lost Horizon* (1937, Frank Capra), *Lost Horizon of Shangri-La* (1942 rerelease of Capra's original), *Lost Horizon* (1952, edited version of the original film), *Lost Horizon* (1973, Charles Jarrott, musical), and the restoration of the original 1937 film (1973). Capra's aforementioned original release was edited numerous times and for numerous reasons. In 1942, a fifteen-minute speech by Conway protesting the horrors of war was removed in fear the public would negatively receive it during World War II. Similarly, the 1952 edit omitted many of the Communist insinuations and much of the positive screening attributed to the Chinese. Shangri-La is not a static utopia (or perhaps a utopia whatsoever), but its mutability speaks to its function as a manifestation of the dominant, conservative American ideology of the time. Shangri-La, and thus Tibet, is a landscape that is colored by the American yearning for preservation, mummification, and stagnation—it is the museum *and* mausoleum of American history and

the Western ethic. A striking dialogue occurs between Conway and the High Lama,

> High Lama: Yes, my son, when the strong have devoured each other, the Christian ethic may at last be fulfilled, and the weak shall inherit the Earth.
> Conway: I understand you, Father.
> High Lama: You must come again, my son.

The imposition of Christian values within the framework of Shangri-La and Tibet should come as no surprise to the active reader. Certainly Shangri-La is a representation of what America wishes to claim and preserve as its own—this offhand insinuation of the Second Coming of Christ carries the aforementioned Freudian death drive by placing the Christian context within an American construct. Moreover, one cannot understate the importance of both Father Perrault's seemingly selective passing and Conway's younger brother's suicide. Shangri-La is established based on the mythical landscape of Tibet, but it does not exist as its own entity. The difficulty in locating American treatment of Tibet in film is caused by land or, rather, the lack thereof. Shangri-La is imagined even before American political ties with Tibet were opened in 1942, and further contact with Tibet was stymied by the ascendancy of the People's Republic of China and its claims to Tibetan lands. In defining the difference between a utopia and a sacred space, Eric Ames writes, "Utopias, by definition, lie outside of time and space (they are designed to accommodate future dwelling, not regular visits by actual pilgrims, for example), whereas sacred landscapes are grounded in geographical place and situated in time" (Ames 62). American filmic treatment of Tibet, however, can locate neither utopia nor sacred landscape within the country itself; ultimately, Tibet becomes infused with the echo of America.

The evolution of Tibet in political context is a point of much debate and contention. Suzerainty over Tibetan lands claimed by the People's Republic of China has stymied Tibetan leadership and led to the Dalai Lama's exodus from Tibet, seeking refuge from the West and, in particular, the United States. In *Ethics for the New Millennium*, the Dalai Lama writes, "we Tibetans had chosen—mistakenly, in my view—to remain isolated behind the high mountain ranges which separate our country from the rest of the world" (Dalai Lama

3). The segregation of Tibet from Western influences has become troublesome in recent American attempts to represent Tibet in film; since the doors to Tibet are symbolically closed, much of what is gleaned from and about Tibet is based on the testimony of refugee Tibetan Buddhist lamas. Tomoko Masuzawa notes,

> On account of its particularly difficult condition as an "autonomous region" of the People's Republic of China, Tibet has become a virtual nation of uncertain political status and, at the same time, something of a hyper-nation, as it is now believed by some people to be the very embodiment of, or if not quite that, the closest approximation to, a nationhood essentially predicated on a spiritual principle rather than on the usual base material reality of power . . . it is considered a "dharma nation." (Masuzawa 541)

Locating Tibet as a "dharma nation" may be the only way to functionally pinpoint Tibet within modern geopolitical climates. In *The Location of Culture*, Homi K. Bhabha posits, "The entitlement of the nation is its metaphor" (Bhabha 718). The metaphor that controls Shangri-La, "Blue Moon" (Karakal), is unique in its application of ironic stillness as the operating function of an ambulatory satellite; the metaphor aligns with readings of Shangri-La as a reserve of the past and brings with it connotations of somnambulation apropos to the dream world.

Bernardo Bertolucci's *Little Buddha* (1994) locates the spiritual as the basis for Tibetan culture and demonstrably characterizes Tibet as a "dharma nation." The film acknowledges the Tibetan lamas' refugee status and characterizes Lama Norbu and the other lamas as sagacious globetrotters, scouring the world for the reincarnation of their deceased teacher, Lama Dorje. Their quest brings them to Seattle, Washington, where they scout out a young American boy, Jesse Conrad, a potential reincarnation of Lama Dorje. The juxtaposition of the Tibetan monks and the American city is rather fascinating (in a dream, Lama Dorje is even seen walking around Seattle in blue jeans) and acknowledges the rather palpable "homeless" status of the refugees. The monk's trials within America are indeed amusing to watch, but their presence within America is quite "real" insofar as the film depicts the American perspective on the plight of the

Tibetan monks. Yet in the confabulation of the image of the Tibetan monk, the mythic landscape of Tibet is lost. Eric Ames writes,

> Tracing its distinctive visuality through a range of media (including travel writing, painting, and cartography), [Peter] Bishop shows that landscape images gave Tibet its imaginary coherence throughout the nineteenth and early twentieth centuries—ending in 1951, with China's invasion and the resulting exile of the Dalai Lama. Since then, it is no longer landscape that has served to organize Western fantasies of Tibet, but rather its esoteric religion. (Ames 63)

Little Buddha ends with the appraisal of three different reincarnation candidates, all of which are ultimately deemed separate incarnations of Lama Dorje—body, speech, and mind (the three *vajras*).

Little Buddha is not comprised of a solitary tale. Rather, it is the combination of Jesse's story and the history of Siddhartha Gautama (the Buddha) as mediated by Jesse's picture book. Bertolucci cast Keanu Reeves in the role of Gautama. Initially a puzzling choice, the decision establishes a dichotomy between the two distinct stories in both space and time. In Jesse's story the lamas travel to (and become part of) American society, the Americanization of Gautama's maturation coupled with the exodus of the lamas to America functions in a similar way to the depiction of Chang in Capra's *Lost Horizon* by the English H. B. Warner and the establishment of Shangri-La as an American retreat. *Little Buddha* opts for the infusion of Tibetan religious culture within American framework, whereas *Lost Horizon* re-created American ideals within a mythologized Tibetan landscape. The cinematic focus on the three *vajras* in *Little Buddha* extends beyond Jesse's story and has specific, albeit symbolic, relevance within the retelling of Gautama's path to enlightenment. In *The Twilight Language*, theorists Roderick S. Bucknell and Martin Stuart-Fox introduce and explicate the Tibetan "twilight language" that was "preserved mainly in Tibetan sects, [and] it has long been recognized that certain important teachings are expressed in a form of secret symbolic language known as *samdhyā-bhāsā*, 'Twilight Language'" (Bucknell and Stuart-Fox vii). The language—if it can indeed be called that—functions more closely to a codex used to decrypt certain passages of Buddhist texts and requires the simultaneous use

of speech, body, and mind to convey the true message. In simpler terms, the written text can be deciphered only with the assistance of a lama trained in the language. Thai monk-scholar Buddhadasa notes "that certain aspects of Buddhist teaching are unintelligible, or at least lacking in useful content, unless they are assumed to be symbolic" (Bucknell and Stuart-Fox 11). He calls attention to Māra's attempts to beguile Gautama—particularly through his three daughters, Tanhā, Arati, and Rati (whose names are "Pali terms meaning 'Craving,' 'Discontent,' and 'Desire'")—and notes that these accounts are symbolic images for the internal pathway to enlightenment. Bertolucci's screening of the Gautama/Māra paradigm, in lieu of the three *vajras*, suggests that the film functions to exceed a written account; that is, the manifestation of Tibet *must* occur onscreen as the country itself is politically unmappable and the "sacred locations" associated with Tibetan Buddhism are codified by the twilight language. American filmic treatment of Tibet in a contemporary geopolitical climate is primed to fuse the spiritual aspects of the Tibetan "dharma nation" with the physical, geographic settings of America. By utilizing the twilight language, Gautama's story is positioned as metaphor, allegory, a mythic space in which the story of the Buddha is presented—in comparison to *Lost Horizon*, the American audience is once again presented with a Tibet that is nonexistent, existing only within the fantastic worlds imagined by American filmmakers.

Contemporary American filmic portrayal of Tibet has flirted with the postmodern with the release of Paul Hunter's *Bulletproof Monk* (2003) and Roland Emmerich's *2012* (2009). *Bulletproof Monk* introduces the audience to an ancient Tibetan scroll, magically imbued with a script that will grant "power" to either save or destroy the world. The scroll also imbues its protector with the magical ability to remain youthful and achieve inhuman fighting ability. As Sherlock Holmes was revitalized through Tibet and as Shangri-La elongated the lives of its geriatric citizens, *Bulletproof Monk* continues the trope of a cure to aging existing through Tibet. Pursued by an aging Nazi officer, the nameless monk (Chow Yun-Fat) escapes to New York City where he meets and trains his successor, Kar (Seann William Scott). *Bulletproof Monk* is an interesting example of the irrelevance of historicity and/or cultural relevance in regard to Tibet within contemporary Hollywoodesque films. The plotline of *Bulletproof Monk* aligns closely with that of a Chinese martial arts film,

even casting the well-known Hong Kong actor Chow Yun-Fat in the lead role. Furthermore, Kar, whose name is (as he describes) derived from the Cantonese word for family, learns martial arts through his employment at The Golden Palace, a Chinese martial arts cinema run by an elderly Japanese man.

In *Kung Fu Cult Masters*, Leon Hunt states, "Buddhism was a 'foreign' influence in China, but it converges with 'Chinese' martial arts in the figure of the Indian monk Bodhidharma" (Hunt 49). Hunt actively blends Asian cultures in a postmodern pastiche that acknowledges its own irony—yet, removed from the physical country of Tibet, this is not surprising in the least. The magical scroll may be *from* Tibet, but its powers are not linked to the country itself; rather, the scroll functions as an objective correlative representing Tibetan Buddhist spirituality and religion itself. Simply put, despite the scroll's dislocation from home, it maintains its magic overseas in America and is pursued by the malignant Nazi officer, a despotic ghost from the past that recalls the relationship between Tibet and China. Despite its popular culture references and postmodern tone, *Bulletproof Monk* can ultimately be read as an allegory of the exiled Tibetan lamas and the non-locationality of their spirituality—it is a rather potent testament to the further diminished importance of Tibetan landscape within American filmic depiction.

In Capra's *Lost Horizon* (1937) a connection between Christianity and Tibet was established through Father Perrault's Shangri-La. Nearly seventy years later, Roland Emmerich's *2012* once again combines Christian ethic and Tibetan landscape. As a veritable modernization of the biblical story of Noah and his ark, *2012* presents the preservation and survival of the Western world through a safe haven (arks capable of withstanding an apocalyptic flood) built within the mountain ranges of Tibet—a rather familiar storyline, indeed. While the bulk of the plot focuses on the exodus of struggling writer Jackson Curtis (John Cusack) and his family to the arks, there are a few key scenes where Tibetan landscape (firmly in the hands of China) is highlighted as the production ground of the arks. In one such scene, a young lama discusses the end of the world with an older lama, presumably his teacher, who seems to dismiss the idea of apocalypse. At the climax of the film, however, the elderly lama overlooks the torrent of water rushing over the mountains—this image, interestingly, was selectively chosen as the theatrical poster for the film. But

perhaps the centrality of this minor Tibetan image on an American blockbuster film's poster can be explained. American film has gradually diminished the importance of Tibetan landscape and focused instead on the extant spirituality that has achieved worldwide recognition. As the controlling image of *2012*, the Tibetan lama staring out over the landscape of Tibet as it is erased below him is, perhaps, the allegory American film was searching for all along—the complete and utter removal of Tibetan landscape influences altogether.

To conclude, in this essay we try to appropriate and actualize Said's critique of Orientalism and Mitchell's conception of the ideology of the imperial landscape in an attempt to show how the fantasy of Tibet as the other was constructed by the narrative and visual technologies of imperialist ideology in the service of its own interests. We have argued throughout this essay that both the mode of conquest and that of being conquered by the Tibetan landscape have misrepresented and distorted the nature of Tibet, thus actually reflecting the effect of imperialist hegemonic power over the indigenous people.

Between Western imperialism and the communists, Tibet has been consumed and becomes a "contact zone" in which contending powers and interests play against each other. As Bishop has aptly examined, Tibet is now a broken shell: "already substantially empty of heightened, living, imaginative resonance for most Westerners . . . Tibet itself was left abandoned . . . like an old dream, almost forgotten" (Bishop, *Myth of Shangri-La* 244). The disappearance of Tibet into an unknown, inaccessible, distant place is a trauma, a wound that not only haunts the Tibetan exiles but also the whole world, a loss capable of provoking another resurgence of dream and fantasy as seen in the recent Hollywood spectacularization of Tibet. To conclude this essay, we would like to quote a fine passage from Laurie Anderson that describes how Tibetans draw a map:

> In the Tibetan map of the world, the world is a circle and at the center there is an enormous mountain guarded by four gates. And when they draw a map of the world, they draw the map in sand, and it takes months and then when the map is finished, they erase it and throw the sand into the nearest river. (Anderson 229)

This fantasy about the cartographic utopia of Tibet might be read as an incisive allegory of representing Tibet as an ideal other. Throughout the long river of history, the Western world has tried to draw a map of Tibet. However, just as the Tibetans draw their own maps, which are erased once done, the drawing of the Tibetan map by the West can never be accomplished: Tibet only exists in a dream, in the imaginary unconscious of those who strive to reach it. The sad news is that for those who have touched its land(scape), its aura disappears immediately. As a result, Tibet recedes once again into an unknown world of mystery.

Notes

1. According to Orville Schell, *Lost Horizon* was the first novel published in paperback in 1939 by Ian Ballantine. Frank Capra made a successful movie in 1937, which won two Academy awards (Art Design and Editing). A musical remake of the film was produced in 1973.

FOUR

Politics into Aesthetics

Cultural Translation in
Kundun, Seven Years in Tibet, and *The Cup*

FELICIA CHAN

The Orientalist imaging of Buddhism, notably Tibetan Buddhism, in Hollywood cinema has been documented and analyzed as ultimately stifling the authentic Tibetan voice, catering to Western idealizations of a premodern, preindustrial Shangri-La, of which Frank Capra's 1937 reverential adaptation of James Hilton's *Lost Horizon* (1933), described by William Elison as "equal parts Kansas and Over the Rainbow" (Elison 63), is often held up as an example. In this chapter, I recast the charge of Orientalism made against Martin Scorsese's *Kundun* (1997), and to a lesser degree, Jean-Jacques Annaud's *Seven Years in Tibet* (1997), through a comparison with Khyentse Norbu's *The Cup* (1999), with the intent of taking the analysis beyond dialectical representations of Tibet and its cultural practices as necessarily authentic or inauthentic, exotic or naturalistic, imagined or real.

Through the imaging of Tibetan and/or Buddhist culture in these films, I address the processes of cultural translation that can take place through the medium of film. This chapter seeks not to emphasize an ethnological sense of culture, such as "American" or "European" or even "Tibetan" or "Buddhist" culture, but rather to address the concept of *film culture*, which encompasses production, presentation, and reception. Although ostensibly made by directors

of different nationalities (American, French, and Bhutanese, respectively), each film negotiates implicitly or explicitly with American culture by virtue of Hollywood's domination of international cinema. Martin Scorsese is an iconic and influential American director, known for a brash and abrasive style in films like *Raging Bull* (1980) and *Casino* (1995), although he has also made more studied features like *The Age of Innocence* (1993). French director Jean-Jacques Annaud has worked in Hollywood and is known for auteurist projects like *The Name of the Rose* (1986) and *The Lover* (1992). *Seven Years in Tibet* is produced and distributed by American companies (notably Columbia TriStar Pictures) and casts Brad Pitt in the central role. Of the three, Khyentse Norbu stands apart in that he is a Buddhist lama, and his film is a small-scale, independent production, shot on a miniscule budget (from Australian funding) with nonprofessional actors. Nevertheless, *The Cup* comments directly on its own relationship with American and Western cultures, both in terms of story and style. I focus on four main areas of discussion: 1) the role of the child; 2) the remote landscape of Tibet; 3) the historical and political aspects of Tibet's relation to the international community; and 4) the role of film form in the translation of politics into aesthetics in film culture.

The Child in Translation

In each of the three films, the role of the child is central to its thematic concerns. In *Kundun* and *Seven Years in Tibet*, the focus is on the life of the fourteenth Dalai Lama before his exile to India, and the child in each case is the figure of the Dalai Lama as the theocratic ruler of the ancient kingdom. *The Cup* focuses on the antics of boy monks as they seek a variety of ways to watch the final match of the World Cup at the monastery. However, the different treatment of childhood in each film is significant in that they convey different positions regarding the popular perception of Tibetan Buddhist culture as necessarily childlike and innocent.

In *Kundun* the story of Tibet is told entirely through the child's perspective. The directness and simplicity of the child's gaze attracted Scorsese to the narrative; the director recalls: "I read the script and liked its simplicity, the childlike nature of it . . . what you really dealt

with was the child and the child becoming a young boy and the boy becoming a young man" (Smith 22). The choice of adopting the child's perspective was a conscious one; Scorsese notes that "we see everything through the eyes of the young boy as he grows, and we know only as much as he did" (Christie and Thompson 210). The main implication of this approach aligns what we can safely assume to be a predominantly Western audience's point of view with the child's innocence and ignorance of what is going on around him. As a narrative strategy, it allows the story to unfold incrementally to the audience, who presumably does not know much about Tibet, and it also allows the audience to identify with the position of innocence and childlike ignorance. Like the child, the spectator begins to feel that the events are larger than himself or herself, and beyond his or her comprehension. Even when the child who is to be the Dalai Lama (played by Tenzin Yeshi Paichang, Tulku Jamyang Kunga Tenzin, Gyurme Tethong, and Tenzin Thuthob Tsarong) grows up, he continues to be isolated from his environment, and is seen mainly peering through his telescope on the roof of the enormous Potala Palace, or sitting by himself in the gardens of Norbulingka (the Dalai Lama's summer residence). To a large extent, he passes through history in the film as if in a proverbial bubble, right through his visit to Mao Zedong and through the final passage to India. There is a sense, throughout the film, of a young boy thrust into a big seat, for whom sympathy is clearly elicited, but at no point is the spectator provided with a more objective perspective that may allow for more personal and individual conclusions about the political situation in Tibet (see Daccache and Valeriano).

In *Seven Years in Tibet*, the child is used as a means of redemption for the central character of Heinrich Harrer, played by Pitt. Although Harrer's own memoirs make no mention of his child—that information, as with his Nazi past, is apparently revealed after its publication—the film establishes his character at the beginning as classically flawed, in that he is a man who abandons his pregnant wife in favor of a climbing expedition. Through his experiences in Tibet and his meeting with the young Dalai Lama (Jamyang Jamtsho Wangchuk), he is made to face his demons and manages to redeem himself by playing surrogate father to the isolated boy, who for everyone else in Tibet is a god-king. After his seven years in Tibet, Harrer returns to Europe by the end of the film to face the son he left behind and to

finally come to terms with his role as a father and responsible adult.
Eve L. Mullen notes:

> Harrer's inner scars, exposed by the boy regent, begin to be
> healed. Here, Tibet becomes the exalted, valuable culture in
> contrast to the murderous, demonic China. The Westerner
> who has played his part in the defense of pristine Tibet is
> cured of his emotional ills by Tibet's wisdom and can now
> return a whole man to his own life in Europe. (Mullen n.p.)

Tibet and the simple representation of Tibetan Buddhism become an
unabashed extension of Hilton's Shangri-La, in that it is not just the
fountain of youth but also the spring of second chances.

Where the child in *Kundun* signifies prelapsarian innocence
and wisdom (itself a cultural emblem in the Judeo-Christian tradi-
tion) in *Seven Years in Tibet*, the child functions in the background,
obscured largely by Pitt's own boyish charm and willful playfulness,
as the condition of Tibetan culture itself. Mullen quarrels with the
film's depiction of Tibetans "as innocent primitives without social
graces, education or guile. They stick out their tongues at the out-
sider Harrer, as children on a playground might taunt a new class-
mate" (Mullen n.p.). While Mullen seems to have misread the
traditional Tibetan greeting of sticking out the tongue to passing
travelers as a gesture of goodwill (see Dresser), her interpretation of
their behavior as lacking "social graces, education or guile" will no
doubt be shared by other viewers unfamiliar with Tibetan customs.
Although Mullen may have misinterpreted the scene, she accurately
argues against the sense in which is used: "The audience laughs at
their lack of technology, automobiles, and especially movie theaters"
(Mullen n.p.). A direct comparison can be made with Hergé's famous
comic book, *Tintin in Tibet* (1962), in which the irascible Captain
Haddock, when faced with a score of young children sticking their
tongues out at him in greeting, retaliates with playground taunts.
Haddock is quickly made to face his ignorance when the custom is
explained (Hergé 53). In *Seven Years in Tibet*, neither Harrer nor the
spectator is made to confront his or her ignorance, and consequently
the infantilized stereotype of Tibetan culture is perpetuated rather
than refuted. Likewise, Marc Abramson notes Tibetan political

activist and writer Jamyang Norbu's objection to this mode of representation. According to Abramson, Norbu "lambastes a scene where Tibetan workers and monks rescue earthworms from the site of the movie theater Harrer is building for the Dalai Lama ("In past life, this innocent worm was your mother. Please, no more hurting!") as one that Tibetan viewers would find ridiculous" (Abramson 10).

To charge *Kundun* and *Seven Years in Tibet* with nothing more than Orientalism is to oversimplify the issues, for indeed, even the Dalai Lama emphasizes Tibetans' lack of sophistication as one of the causes of their present troubles. In one of his memoirs, *Freedom in Exile* (1990), he confronts his own lack of guile in the world of international politics and regrets, for example, not listening carefully to the Chinese radio broadcasts that were being made about Tibet in order to learn what he had to deal with (Dalai Lama, *Freedom* 181–82).

The Dalai Lama has published two autobiographies: *Freedom in Exile* (1990), written in English, and an earlier one, *My Land and My People* (1962), dictated in Tibetan and translated into English. It is significant that Melissa Mathison's screenplay of *Kundun* was adapted not from the more recent *Freedom in Exile*, with its longer period of hindsight, but from the earlier *My Land and My People*, which was published in 1962—twelve years after the recorded invasion of Tibet by Communist China and only three years following the Dalai Lama's flight to India in 1959. While *Freedom in Exile* divides into roughly equal proportions the events that took place before and after the flight to India, the latter half recounts in some detail the arduous attempts to set up a government-in-exile and appeals for international recognition. *My Land and My People*, in contrast, is vivid with the memories of his childhood and teenage years. In *My Land and My People*, the story is not told by the Dalai Lama with years of political campaigning behind him but by a younger self who was still coming to grips with establishing Tibet's, and his own, international identities. *Kundun* draws on that struggle, offering up a personage who by virtue of youth is slightly bewildered but nonetheless by compulsion of circumstance is resolute. In *Seven Years in Tibet*, the role of the boy Dalai Lama serves more as a foil to Harrer's personal development than as a character in his own right. He is a reminder of the child Harrer left behind, and it could be said that the true "child"

in *Seven Years in Tibet* is, in effect, Harrer himself, who learns to grow up through interacting with the real child possessing the wisdom of a sage.

In the act of translating the complexity of Tibetan culture, history, and politics to a Western audience, the films have resorted to familiar frames of reference. One referential frame is the concept of childhood, so well developed in Victorian literature, and its capacity not just for purity and innocence but also truth and integrity, and therefore spiritual transcendence. The Orientalism lies not in rendering Tibetans like children but in not establishing the complex differences in Tibetan culture from Western attitudes and perceptions. Instead, Tibetans are imagined as purer and simpler than Westerners. This emphasis on purity and simplicity is commensurate with more than one critic's view that Buddhism remains fascinating for Western audiences because of its emphasis on selflessness. Becky Johnston, screenwriter for *Seven Years in Tibet*, laments that "Hollywood is one big altar to artifice and greed," and that "what's drawing people to Tibetan Buddhism is a yearning to reduce the self. And a desire to escape the vulgarities of commercialization" (Schell, "Between the Image" 80).

The treatment of childhood in Norbu's *The Cup* may help to triangulate the issue. Although not a biography about the Dalai Lama, the film gives us a glimpse into the lives of boy monks in a Tibetan monastery-in-exile and a sense of the consequences of the political conflict. Unlike the story of the Dalai Lama, which is set in a relatively distant past, the events that inspired *The Cup*, the 1998 World Cup, are relatively recent to the time of the film's release. Instead of utilizing childhood as a metonym for a nostalgic past, childhood in *The Cup* is very much of the present. That the cast themselves are acolytes in a working monastery—both *Kundun* and *Seven Years in Tibet* had sets built in Morocco and the Andes, respectively—reinforces this sense of contemporaneity as well as naturalism. Notes from the film's official website recount that

> Turning a full time monastery into a feature film set required that all monastery activity be suspended for two months in order that the entire monastic community could join in the production. To maintain the commitment of their daily practices, most members of the community rose at 4 am

every morning to complete their prayers before the day's shoot began. ("About the Production")

Through the whimsical story of the boy monks initially sneaking out of the monastery to watch the games in town, and later trying to set up a satellite dish at the monastery itself to catch the final game live, the film manages to weave in subtle commentary about the politics of Tibet. As the words are uttered from the mouths of children, they may sound far less threatening, though no less resonant. Here is an extract from the dialogue in the film between the boys:

Orgyen: Lodo, are you coming tonight?
Lodo [while shaving Palden's head]: Are you nuts? Geko will
 punish us.
Orgyen: Then you must come tomorrow.
Lodo: Why?
Orgyen: France is playing.
Lodo: So what?
Orgyen: France is the only country that loyally supports
 Tibet.
Lodo: How about America?
Orgyen: They're scared shitless of China.
Lodo: No, I don't mean politics. Are they playing football?
Orgyen: You're just asking that because your American
 sponsor sends $3 a month.
Lodo: Does India play?
Orgyen: They were kicked out. They got caught bribing a
 referee.
 . . .
Lodo [after finishing shaving Palden's head and dressing him
 in robes]: Let's send this back to China. Now you're free.
[Lodo hurls Palden's cap into the distance.]

The children in *The Cup* are not protected by their childhood from the realities of the world and are presented as complex characters, neither wholly innocent nor entirely recalcitrant. Orgyen (Jamyang Lodro), the principal character, is orphaned and has not known life outside the monastery, though he is not insulated from the wider world: he knows about the "rubber sweet" (chewing gum) from

America and the apparently "rubber breasts" of American women he has seen in glossy magazines. He is also a big fan of soccer and the World Cup. Orgyen is mischievous and often instigates his friends to break monastic rules; he bullies them into giving him the money for the TV rental and even pawns a friend's watch without consent. In the end, however, he redeems himself by trying to recover the watch at the expense of watching the final game. By presenting Orgyen as possessing a mix of naïve optimism and practiced perspicacity, *The Cup* avoids a dialectical portrayal of childhood innocence as the panacea to the evils of the adult world. In *Kundun* and *Seven Years in Tibet*, the child who is the Dalai Lama acts as a symbol of spiritual purity in the face of the ugliness of worldly politics. In *The Cup*, children are not exempt from that world; in fact, their lives are precisely the consequence of that worldly life. The two styles of representation suggest that it may not be that *Kundun* and *Seven Years in Tibet* intend for Tibetans to be rendered as children, but that in so doing, these two films reveal the cultural stakes of such representation.

The Landscape in Translation

One of the most attractive aspects about making a film about Tibet is undoubtedly the landscape. The harsh mountainous terrain of the Himalayan region that has played a part in Tibet's political isolation lends itself well to cinematic spectacle, but the inhospitable landscape is also a metaphor for the nobility of the human spirit. Scorsese's *Kundun* transforms the Moroccan landscape—filming in Tibet is forbidden—into what Gavin Smith calls "a uniquely metaphysical spectacle" (Smith 22). Smith argues that "Kundun is the first [of Scorsese's films] that exists in the mind's eye from the beginning, that locates the art of vision in a realm where exterior landscape (Tibet, history) and interior landscape (a sand-painting mandala, an infinite capacity for compassion) unite in an epic of the psyche and the spirit" (Smith 22). *Seven Years in Tibet* likewise utilizes the Andean landscape to full effect, and Harrer's attempt to conquer the mountain becomes a metaphor for his spiritual journey.

The Cup is set in a Tibetan refugee village in the Indian Himalayas and uses the remoteness of the landscape to serve as a different perspective on the developed world's culture of mediatized

globalization. Rather than present the landscape as isolated, different, and dissociated from the rest of the modern world, *The Cup* presents life in the monastery in a naturalistic fashion, going out of its way to depict life as ordinary for the boys. At the same time, because the film is made for Western festival audiences, it is deliberately anchored in certain areas of familiarity. One is the boarding school setting in which the strict disciplinarian teacher is at odds with young charges determined to thwart him by sneaking out at night. The second is the use of the global event of the World Cup tournament as an emblem for the global circulation of media images and capital, from which even the remotest regions may not escape for long. There are a number of visual juxtapositions that contrast the traditional with the modern in the film—for example, the availability of satellite TV in the mountainous and sparsely populated region. Although the technology makes it possible to overcome the monastery's remote location, the film presents the acquisition of that technology, which urban residents take for granted, as a quixotic journey along which many hurdles have to be overcome.

First, the boys must haggle with the owner of the rental shop, and having secured the items—a black and white television set (color costs more) and an unwieldy satellite dish—they must wire and point the dish in the right direction ("North"). During the final match between Brazil and France, the question of access to such technology becomes evident when the electricity goes out. The monks entertain themselves in the intervening time with the ancient pastime of shadow play, using candles and shadows cast by hand patterns to tell a story. This sequence lasts for some time and breaks up the rhythm of the film, slowing it down and forcing us to give up our own commitment to the action and the story. However, as soon as the power is reconnected, the monks abandon the shadow game and their attention is once again riveted to the television set. This competition between the traditional and the modern is not placed in dialectical tension insomuch as they are presented as coexisting—if not in complete harmony, then certainly not in conflict. Their coexistence is simply a reality of life. Thus, the physical isolation of the monastery does not detach its inhabitants from global consumerism, the ubiquitous symbols of which are offered up as detritus, to be reused in an alternate context. For example, the monks use a discarded Coca-Cola can as a makeshift soccer ball, which later winds

up on the local fortune-teller's shrine as a candleholder. Of the three films, *The Cup* creates the smallest division between East and West, as it allows the Western viewer to perceive a global consumer world through the other end of the telescope. In other words, rather than deliver a didactic message about how Buddhist spirituality may help overcome the excesses of consumerism, *The Cup* adopts the Buddhist approach of intimating its effects without condemning it.

Translation of Politics and History

There can be few films on Tibet that are not about its political situation, in part because Tibet came to the world's attention largely as a result of its political occupation by the People's Republic of China. Since then, what is known about the country remains, at least in the Anglo-American world, in the domain of scholars, activists, and folk memory. Because Tibet lacked its own media technology at the time, Tibet's story has had to be told by others, who often did not have access to the country, to the extent that, as Aislin Scofield notes, "[Tibetan] cultural identity through film has been largely constructed by non-Tibetan cultures" (Scofield 106). She charts the range of films from 1928 to 1990, from which the bulk of narrative films about Tibet and Tibetan culture has come from either the United States or the People's Republic of China. In this section, I explore the question of "authenticity," through the treatment of politics and history, in the way Tibet is imagined in each of the three films.

One of the ways in which the films attempt to achieve authenticity is through the use of "actual" Tibetans in the cast of actors, though with different effects and implications. Scorsese, for example, consciously decided to cast the entire film with Tibetans in exile, and one of the issues the producers faced was that not all of the Tibetans had passports. Scorsese found this to resonate with the subject of the film "creating a Tibetan community against all the odds outside Tibet" (Christie and Thompson 212) and locates the political intervention of *Kundun* beyond the filmic presentation of the Chinese occupation. The effort to recruit Tibetans in exile not only appears to authenticate the depiction of Tibet in the film but also validates the project as worthwhile to the Tibetan cause, especially in the casting of the Dalai Lama's niece (Tencho Gyalpo) in the role as

his mother. Yet Scorsese's desire for authenticity seems at odds with the curious depiction of Mao Zedong (Robert Lin) as plastic and cartoonlike; Stephen Holden of the *New York Times* notes that the meeting with Mao is the film's "most jarring sequence," where Mao is "a shrill, campy caricature" (Holden). The choice to film the dialogue in English could be part of the problem. Holden suggests that the "careful, heavily accented English" adds to the "distance" he feels from the subject. This is perhaps where authenticity finds itself faced with reality, and in this case, it is the reality of commerce. Scorsese is the first to admit the choice of the use of English was strategic, in order to "give it some chance of being seen in the West, even if only for a few weeks in the theatres, thanks to my name on it. If we had gone for Tibetan with English subtitles, no one would have seen it" (Christie and Thompson 212). So rather than school the audience in the conventions of an unfamiliar culture, concession is made to the power of the American consumer, who is generally expected to shun subtitled foreign-language films.

The tension between the drive for authenticity and the pressures of commercial reality plays out quite clearly in the conversation that screenwriter Melissa Mathison has with the Dalai Lama before the making of the film. I reproduce a substantial part of it here to show the extent to which Mathison's dramatic envisioning of the film comes up against her obvious desire to please the Dalai Lama. She is reading part of her screenplay out to the Dalai Lama and inviting his comment:

> Mathison: "Interior—tent. Night. Lhamo [the boy who became the Dalai Lama] is very still as a monk carefully finishes cutting the boy's hair."
> Dalai Lama: Probably my hair was cut short.
> Mathison: "The monk is cutting his hair. And the monk says, 'Do you go homeless?' The boy looks at the monk and repeats his short memorization. 'Yes, I go homeless.' Lhamo is now wearing the maroon robes of a monk."
> Dalai Lama: No, still in yellow.
> Mathison: So the yellow robe you wear would be just like Tibetan robes.
> Dalai Lama: Yes, that's right.
> Mathison: What I wanted to show here was the monks

beginning to try to teach you to repeat, saying memorizations. And I say that the little phrase somewhere, "Do you go homeless?" And I thought it was quite a beautiful phrase, so I used it. And it may be totally incorrect. But I wanted the monk who was cutting your hair to give you a little saying that you have to repeat back. Can you think of some little phrase that would be better than that?

Dalai Lama: "I take refuge in the Three Jewels."

Mathison: Is there another line after that? I think to help understand the process of memorization, we should have a prayer that has more than one phrase so that the monk would say the first phrase, and then the boy would say the second phrase, and they would build. We would then understand that this was a process of memorization without having to talk about it. But whatever the prayer is, when the hair is finished: "Lhamo stands and looks at the older men around him and calmly says, 'I want my mamma.' Lhamo runs to the tent flap and pulls it open, and standing outside the tent is a bodyguard, a huge, burly man."

Dalai Lama: Monk bodyguard.

Mathison: Okay, monk bodyguard. "Wearing sheepskins and a fur hat."

Dalai Lama: No sheepskins. Monk's clothes.

Mathison: Okay. "He turns to the boy. In one hand he holds a sword."

Dalai Lama: No sword. Big stick.

Mathison: This is the man with one eye.

Dalai Lama: No, not one eye. On one eye he has a big bump.

(Mathison 68)

Most of the conversation carries on in the same vein, with Mathison seeking approval for a certain presentation of a scene and the Dalai Lama correcting some detail. Her insistence on the fabricated pidgin expression "Do you go homeless?" which she inexplicably finds "beautiful" but which she also acknowledges may be "totally incorrect," reveals the extent to which the imagination of Tibet as childlike and innocent has taken hold. In contrast, the more authentic "I

take refuge in the Three Jewels," which is an important commitment for a Buddhist practitioner, is dismissed for not having a dialogic counterpart.

Authenticity, in many of Hollywood's contemporary historical epics, is weighted in favor of the mise-en-scène, primarily in terms of costume and setting. Where Mathison is able to compromise, she does so with costumes: the yellow robes, the monk's clothes, the big stick in place of the sword. Indeed, many of Tibet's customs are preserved on screen in painstaking detail, from the opening close-up of the sand-painting mandala to the gruesome dismemberment of the corpse of Lhamo's father in accordance with custom. Scorsese says, with complete sincerity, in the documentary *Dreams of Tibet*: "We had this sense that this may be, this [*Kundun*] and the Jean-Jacques Annaud film, *Seven Years in Tibet*—they may be the only records left of this culture," and yet he concedes: "It's not the culture because it's a movie, but it's an impression, a dream-like image." Even so, some rituals, when not translated for foreign audiences, can be incomprehensible. Abramson notes that "the dance performance outside of the Potala witnessed by the Dalai Lama [in *Kundun*] is actually satirizing the Nechung oracle [the state oracle of Tibet]" and that the scene "gives a whole new understanding of the role of prophecy in the film (which is significant) and adds a different dimension to Tibetan Buddhism, which . . . is rather solemnized and sanitized, but here it comes across to the typical viewer as merely added spectacle" (Abramson 11). It is not clear if Scorsese himself was aware of the satire.

Seven Years in Tibet pursues authenticity to a similar degree and casts the Dalai Lama's sister (Jetsun Pema) to play her own mother. Orville Schell, narrating for *Dreams of Tibet*, notes that for the film, "A hundred and fifty Tibetan extras, including real monks and an entire herd of yaks, were flown in to achieve a sense of authenticity." In addition, Annaud dispatched "secret" crews to shoot some footage of the sacred mountain, Mount Calache, and the Potala Palace in Lhasa. About twenty minutes of footage made it into the actual film, either "integrated in its entirety or intercut with other images shot in Argentina or Canada" (Nesselson). Annaud muses: "I got a big kick out of reading that the scenery in my film didn't bear the slightest resemblance to the real Tibet" (Nesselson). In that sense, *Seven Years in Tibet*'s claim to authenticity, in spite of radically altering Harrer's

narrative—his friend, Aufschnaiter (David Thewlis) never married a Tibetan woman, for example—comes from having been able to enter the forbidden land.

The Chinese government also has its own claim to authenticity, and their vehement objections to both films have been well documented. A government spokesman argues that the films "twist the history of Tibet and glorif[y] the Dalai Lama, [and are] mistaken and contrary to the facts" (Cui Tiankai of the Chinese Foreign Ministry, quoted in *Dreams of Tibet*). Not only were the films banned from the mainland, a blacklist of Hollywood personnel restricted from entering the country was also produced and pressure was put on the distribution companies, like Disney, to divest their interests in the films. And so the film that Scorsese had initially said was not about politics had nonetheless provoked intense political reactions. Although Disney initially held its ground, it subsequently tried to distance itself from the film and its director. The cynicism in the response that Disney's then-chief executive officer Michael Eisner offered on the talk show *Charlie Rose* speaks for itself: "Well, in this country [the United States], you put out a movie, it gets a lot of momentum for six seconds and is gone three weeks later" ("In Conversation").

The Cup, although not ostensibly about Tibet, has different claims to authenticity. The first lies in India's/Bhutan's relative proximity to Tibet, geographically, culturally, and spiritually. The second lies in the director's apparent inside knowledge of the culture, being a Buddhist lama himself. And the third lies in the casting of young monks essentially playing themselves. Although there are depictions of arcane temple rituals, their treatment is more naturalistic. While the costumes may appear exotic to Western audiences, they are not exoticized by the frame of the camera in the way that *Kundun* enhances the gold jacket of the Dalai Lama against the red robes of his advisers, for example. In *The Cup*, the clothing is part of the daily attire of the monks and treated as such. In one scene, Orgyen is sent to wash the robes by hand. Also, the colors are rendered in far more muted tones than the rich saturation of color in *Kundun*. Indeed, the film goes out of its way to establish the familiar rather than the exotic, and this naturalism exists in contrast to Hollywood's stylized realism, bearing closer resemblance to the visual quality of neorealist cinema. Although not formally trained in film, Norbu worked on the set of Bernardo Bertolucci's *Little Buddha* and incidentally was

hired because Bertolucci wanted him to give "advice on authenticity, aspects of philosophy and story and customs and all that" (Wachs). Curiously, Scorsese cites neorealism as a primary inspiration for the film, although the studied meditativeness and stylized visuals of *Kundun* would suggest otherwise: "I felt comfortable thinking of the picture in terms of Italian neorealism. I don't need to look at a De Sica picture again, or the Rossellinis, but I did, just to put me in a frame of mind" (Smith 26).

What we are seeing expressed by Scorsese and Annaud is *visual* authenticity manifested as a *cultural value*. In their films, it is the visual authenticity of a different culture, toward which extra care had to be taken, and there is the sense that if the culture is treated with extreme delicacy, any perceived transgression will somehow be repudiated. In other words, it is the thought that counts. Scorsese says that the film "was about giving a gift back to their culture, putting together the beauty and the compassion that they represent" (Christie and Thompson 224)—a statement that implies that the film, made with Disney's money for largely Anglo-American audiences, is really *for* Tibet. Abramson notes, not without reason, that

> While neither of the films deserves to be saddled with the label of "Tibetan chic," both *Seven Years in Tibet*, because it is only partially about Tibet at all, and *Kundun*, because it transcends its subject to become a cinematic meditation on memory and transcendence, fails to render Tibet as a real place with a history of its own. The mystery and romance live on. (Abramson 12)

This "mystery and romance" are enhanced by celebrity activism from Hollywood heavyweights, like Brad Pitt opining, "A man who betrays his culture should not preach about its customs"; and Richard Gere proselytizing, "The West is very young. We're not very wise. And I think we're hopeful that there is a place that is ancient and wise and open and filled with light" (quoted in *Dreams of Tibet*). In contrast, Elison writes that: "Neither *Kundun* nor *Seven Years in Tibet* exposes the feudal underbelly of Tibet, a hierarchical society of whose inequities the Dalai Lama himself has been an outspoken critic" (Elison 64). Ironically, Harrer's memoirs recall some of the more medieval practices of flogging and amputation as punishments

for crimes (Harrer 170), and folk medicine in which "[*tsampa*], but-
ter and the urine of some saintly man . . . [are] administered to the
sick" (Harrer 178). Mullen explains that the American fascination
with Tibet sustains America's own self-image as "rescuers" to the
weak, where "rescuers . . . become authority: in their roles as heroes,
they assume control in order to be effective." In so doing, Mullen
further argues, these rescuers retain the power to decide selectively
what to save in Tibetan culture, and this power is motivated by the
"specific expectations and agendas of American pop culture" (Mul-
len n.p.).

The *Cup* approaches authenticity from a diametrically opposite
standpoint. The costumes and the rituals just *are*; in fact, as I have
argued, the film goes out of its way to show how similar the Tibetans
are in their passion for soccer to the rest of the world. For Norbu, the
cultural stakes invested in authenticity are of a different nature. To
be "authentic" in *The Cup* means to be ordinary and connected, not
isolated and exotic. The director indicates in an interview that he had
never directly intended for the film to counterpoint Western expec-
tations, but that it was simply "a big bonus" if the film "demystifie[d]
certain ideas and expectations of for [*sic*] the rest of the world in
general about Tibetan lamas and monasteries" (Wachs). This is not
to say that *The Cup* elides the politics of Tibet. There are numerous
references to the conflict between Tibet and China, though these are
embedded in everyday conversations: for instance, the boys moan
about the poor quality of Chinese rice and support the French soc-
cer team because France supports Tibet. In other words, the state of
being in exile is a daily reality for these children, not a portentous
event to be realized in Technicolor. The abbot of the monastery, also
playing himself, and longing to return to Tibet, adds a particularly
poignant dimension to the film, and there may be a sense of grati-
fication for the audience when the closing titles reveal that he man-
ages to return home in the end.

The Translation of Tibetan Buddhism

The final section of my chapter addresses how Tibetan Buddhist
culture has been framed within the form of film and the context
of an international film culture. Although film is often viewed as a

"universal" medium, one that transcends cultural barriers, the way we understand films in fact also comes from our knowledge of other films. The continued popularity of Hollywood films around the world has much to do with its market domination, but this domination is also continually perpetuated by adapting to changes in the market and making its products accessible and relevant to audiences already familiar with its products (see Decherney).

Mainstream Hollywood film, with its emphasis on the single (usually male) protagonist and linear storylines with a strong sense of closure, may be said to reflect the largely American ethos of individualism and individual effort in overcoming obstacles. The Buddhist ethos of the egoless self, however, appears almost antithetical to such representation. This underlies Scorsese's main difficulty in filming *Kundun*. He struggles to articulate the "something" that he feels and acknowledges that conventional Western film narratives find no framework for "inaction":

> Yet you feel something, I think I felt something very strongly, and it has to do with inaction as action. Now how do you show that dramatically? In terms of Western dramaturgy, I couldn't do it, so you have to find other ways, and it was through the faces of the people in the film; their size in the frame, the texture of the costumes, and also the reverence in their ritual. (Christie and Thompson 214–15)

Scorsese's solution was to fall back once again on the tangibility of the mise-en-scène in order that he might *show* something, which is essentially "no-thing," an abstraction, a feeling, a way of perceiving and being. Perhaps it is this sense of discomfiture with the material that Richard Alleva senses when he criticizes the director's choice of actor. He says that "when the Dalai Lama must express his anguish, Scorsese can only have Tsarong hide his face and shake his shoulders. These heavy-handed directorial tricks are meant to cover the fact that the nonprofessional can't really produce the requisite emotion" (Alleva 22). However, Smith points out that *Kundun* is a radical departure for Scorsese:

> Scorsese's films are almost always constructed around narcissistic protagonists who typically deny or defy reality in

order to inhabit increasingly lonely, paranoid fantasies of supremacy and control, sustained by forces of both repression and anarchic violence. . . . By contrast, *Kundun's* Dalai Lama is not so much outside this pattern as its benign negative or mirror image. . . . his selfhood is the calm at the eye of the hurricane . . . (Smith 22)

In other words, Scorsese's characters are usually *doers*: they act upon impulses and events, as do most Hollywood film protagonists. In *Kundun*, the character of the Dalai Lama is seen to be acted upon; he is the passive recipient of others' impulses and events.

Seven Years in Tibet largely avoids this conundrum by focusing on Harrer's character and casting Pitt in the central role. Harrer in the film is the conventional flawed hero, entering the story with a clearly defined goal (to climb a mountain), the achievement of that goal hampered by obstacles (the war). Later, his goals change (to enter Lhasa) and are prevented by new obstacles (the initial hostility of the Tibetan people); his final goal is fulfilled (to see his son) when the last obstacle (his own insecurities) is overcome through his friendship with the fourteen-year-old Dalai Lama. The only modification Annaud makes to the model is the absence of the romance-related line of action that usually intersects with the protagonist's task-related line of action. Yet romance is not entirely suppressed, merely transferred onto the secondary character of Aufschnaiter, who falls in love with a Tibetan woman. While this event never took place in Harrer's account, Annaud manages to stay true to Harrer's half of the story (that he remained without a love interest), while sacrificing Aufschnaiter's story in favor of maintaining some semblance of the Hollywood structure. Indeed, their lines of action intersect when it is Harrer's eventual loss of the woman to his friend that teaches him a lesson about his own arrogance.

The Cup, in contrast, locates the boy monk Orgyen as protagonist, and it is his goal (to watch the World Cup final) that motivates the others. Yet the narrative is not wholly centered on him. One of the characteristics of Hollywood protagonists is psychological plausibility, in which the protagonist displays a set of self-consistent character traits, which may later serve to motivate or explain his actions and reactions within the story. In *The Cup*, we are given very little

background information about the characters. We know that Orgyen is an orphan, but where, how, and when, we do not know. Similarly, our knowledge of the two new arrivals from Tibet is limited: What was their experience? Was there any hardship? Were they pursued? What happened to their parents? The film does not ask many questions. It is concerned with the present as it exists in all its uncertainty, not with the present as having developed out of a known past. In this way, *The Cup* avoids prioritizing linear causality. As Norbu explains: "Buddhism always places so much emphasis on expressing the now-ness, the present-ness, this moment. Although film is a new language, it is a modern language and I can see how one could use film as another medium" (Wachs n.p.).

Linearity and causality are also two of the most entrenched qualities of mainstream film. Casual coincidence is often omitted, and even minor events will frequently lead into the main line of action. This economical structure makes stories relatively easy to follow and characters relatively easy to identify with. Scorsese insists at several turns that in *Kundun*, he does not "know where to aim the camera to tell the audience what the plot is, what they should be looking at" (Smith 25), yet *Kundun*'s narrative structure adheres more strictly to the protagonist-driven structure than the director allows. The entire film is about the Dalai Lama; he rarely leaves the frame of a shot and is almost always located at the center. The camera is unwavering in its focus on him. While it is true we do not always understand his motivations or feelings, it is more because of the relative unfamiliarity with the culture and its use of unspoken cues. In most American movies, the actor will act, if not physically then emotionally. *Kundun*'s answer to the Buddhist principle of nonaction is to present the actor's face as a mask, and as a result we never really know how he feels or what he thinks. At the same time, Scorsese argues that it was his intention "to throw you into the middle of a culture and let you sink or swim" and in order to swim "you hook on to the *people*, which is what it should be" (Smith 26, emphasis mine). In other words, the film finds its anchor by being character driven.

There is also a clear sense of closure at the end when the Dalai Lama looks back upon Tibet from the Indian border, and the sand-painting mandala (which opened the film) is swept away. Linearity and causality have worked in the film toward the resolution of the

ultimate goal. As the Dalai Lama enters India for the next stage of his life, his journey in *Kundun* ends at the border; the young boy is now a man. Likewise, *Seven Years in Tibet* achieves closure when the protagonist returns to Europe, where he may begin to put right his wrongs. *The Cup*, on the other hand, whimsically eschews endings. Long after the goal of watching the final is achieved, the film follows with a lengthy lesson on the importance of wearing leather sandals. The closing scene of the film has one of the monks refusing to provide an ending to the shadow story he had begun during the power failure. "Who cares about the end?" he says, "All this fuss about endings. All this fuss . . ." The story in the here and now has not ended, and the film underscores this with dry humor by announcing that "the Chinese are still serving rice in Tibet," without having to state explicitly that the Tibetan staple grain is barley.

Archie J. Bahm's observations made in 1957 about the differences in Western and Buddhist aesthetics apply to my argument. Bahm argues that while "Westerners tend to prefer realism and to locate both reality and intrinsic value within the self, many Oriental aestheticians conceive intrinsic value in such a way that the distinction between subject and object is not only irrelevant but even a hindrance to its enjoyment" (Bahm 250). In Western aesthetics, the pleasure in beauty tended to be derived from the object, whereas in Eastern (or Buddhist) aesthetics, another term was designated to describe "the enjoyment of self, or enjoyment in which the distinction between subject and object is irrelevant," this term is "Nirvana or Nibbana" (Bahm 250). Bahm concludes that there is no separation between Buddhist aesthetics and Buddhist life:

> If Buddhist aestheticians find beauty in enjoyment of whatever is as it is, do they have no interest in line, shape, color, theme and variations, vividness, interestingness, expressiveness, or principles of harmony? The answer is that they have no objection to concern for such things so long as they do not distract from life's basic business. . . . If a Buddhist aesthetician is asked about the place of harmony in his view, he will not discourse about ratios and relationships. . . . The ultimate aesthetic harmony is that harmony found in willingness to accept things (including desires) as they are. (Bahm 251)

Bahm's discourse on Buddhist aesthetics offers a useful framework to my comparison of the three films. Insofar that *The Cup* is concerned with harmony, it is not the harmony of rational lines and symmetry that are the legacy of the eighteenth-century Western Enlightenment. That concern lies with the carefully composed scenes of *Kundun* and *Seven Years in Tibet*.

Where Scorsese's film is praised for being one that "exists in the mind's eye . . . , that locates the art of vision in a realm where exterior landscape (Tibet, history) and interior landscape (a sand-painting mandala, an infinite capacity for compassion) unite in an epic of psyche and spirit" (Smith 22), a "pure film" (Abramson 12), it is a purity achieved, as Bahm would argue, by the *extension* of this concept of beauty over the established structure of what makes a "complete" film. Therefore, the scenes of abstraction are located within the larger narrative and clearly marked out as nightmares or visions. In one vision, the camera brings a koi pond into view, the clarity of its water displaying the vivid colors of the fish. In a second, the purity of the spectacle is tarnished by the gushing of blood into it, its symbolism evident. In another vision, the camera pulls back to find the Dalai Lama anguished amid a sea of dead monks, the red of their robes mingling with the red of their blood. This scene is reminiscent of the famous overhead shot in *Gone with the Wind* (1939), which pulls back to reveal Scarlett O'Hara (Vivien Leigh) in the middle of a sea of wounded soldiers. Scorsese thereby calls on the long tradition of Hollywood cinema, even as the subject of his film may be from a different culture.

In the end, given the structures of production and reception under which he has to work (see Hozic), it is not easy to break away completely. Because film is an industrial-capitalist product, it is impossible to talk of a film culture without considering the circumstances of its production and reception. *The Cup*, as a small independent film, albeit backed by Australian funders, is aimed at film festival audiences, who are more open to alternative modes of filmmaking, and even expectant of something different and unusual. At the Pusan International Film Festival in South Korea in 1999, it won the FIPRESCI Prize for "an irreverently humorous and still respectful portrayal of a Buddhist community, presenting a simple story in an arresting manner while avoiding the usual tools of commercial filmmaking" ("Awards"). "The usual tools of commercial filmmaking"

are what *Kundun* and *Seven Years in Tibet* fall back on due to the pressures of funding from major studios, whose commercial concerns tend to precede artistic ones. A director with Scorsese's clout may have a greater measure of freedom, but as noted earlier, even he is subject to some of its priorities.

Given the relative rigidity of storytelling in commercial filmmaking, reinforced by its continued popularity and market demands, it may be fair to say that a Buddhist aesthetics may be fundamentally incompatible with American film, even as Buddhist culture may be successfully depicted in American film. Perhaps, in time, with a sufficient body of work, the reverse may be true—that a "Buddhist film" with a more fluid structure may prove more successful at incorporating aspects of American culture without subjecting either to the old dialectical paradigm of dominant versus other.

Allegories of Shadow and Light

FIVE

Momentarily Lost

Finding the Moment in *Lost in Translation*

JENNIFER L. MCMAHON AND B. STEVE CSAKI

With its recurrent scenes of Tokyo blanketed in neon signs and its emphasis on Japan's importation of both western products and people, it would appear that the film *Lost in Translation* has more to say about the West's influence on the East than on how the East might shape the West. Indeed, the film does have much insight to offer with respect to the influence of western culture in Japan and what Japan has perhaps "lost" as a result of Westernization. However, this essay focuses on what *Lost in Translation* offers its largely Western audience that is Eastern in character. Specifically, this essay addresses the Buddhist notion of momentariness and how it finds expression in, and is celebrated by, the film *Lost in Translation*.

The Buddhist Attitude toward the Moment

Before turning our attention to *Lost in Translation*, it is useful to examine the notion of momentariness and the Buddhist doctrines that are particularly relevant to it, namely, impermanence, relational origination, and emptiness.[1] While these doctrines are relevant to Buddhism generally, our focus will be upon Zen Buddhism because momentariness plays a more significant role in it than most other forms of Buddhism (Kasulis, *Zen Action, Zen Person* 141). Like other Buddhists concepts, impermanence, relational

origination, and emptiness cannot be adequately explained independently of one another as they are related. Impermanence is not a complex notion. Indeed, one might argue that it is existentially obvious. Things change. Nothing lasts forever. Observation informs us that all physical entities are subject to decay and cease to exist over time. Given the ubiquity of change, it is not difficult to see why Buddhism "den[ies] that anything substantive or unchanging exists at all; [instead it asserts that] everything is impermanent" (Kasulis, *Zen Action, Zen Person* 26). Though the phenomenon of change is readily observable, many philosophers have denied impermanence. Indeed, denial of impermanence is characteristic of some well-known Western philosophies. Even Plato, commonly regarded as the father of Western philosophy, maintained that change is mere appearance whereas permanence is absolute. In contrast, Buddhists assert that true understanding entails that people abandon the pursuit of permanence and acknowledge change as an existential fact.

Though impermanence is a central tenet of Buddhism, most people actively or passively resist accepting the impermanent nature of reality.[2] As Heidegger and others have suggested, one of the main reasons that people resist accepting the fact of impermanence is that impermanence reminds them that they will not exist forever.[3] Accepting impermanence is difficult because admitting it implies not only that things in the external world change but also that nonexistence, in the form of death, is an unavoidable subjective fact. This admission is, to say the least, painful. Few people want to be reminded of their mortality. Most would prefer to deny it. However, Buddhists argue that to deny one's own impermanence is to live in delusion of one's true nature. Such delusion precludes enlightenment. Enlightenment involves seeing all things, the self included, as they are. From a Buddhist perspective, this means seeing that there is no self.

According to Buddhism, by virtue of the fact that all things are impermanent, they lack essential self-nature or essence. This is true not only of inanimate things but also animate ones, such as persons. Rather than endorse the notion of an eternal self or soul, Buddhists deny the existence of essential personhood. They use the term *anatman*, or no-self, to convey this point. Thus, seeing one's self clearly would involve seeing that there is no enduring self. While any serious thought about the true nature of life ought to result in the conclusion that things are impermanent, Buddhists recognize that

individuals all too often resist coming to grips with impermanence at a general and personal level because of the psychological discomfort it generates.

In addition to resisting impermanence, the Western position differs from the Eastern one in that it tends to privilege entities over the relations that exist between them.[4] Individuals are essential, whereas relations are secondary. In contrast, the Buddhist notion of relational origination suggests the relations between things are primary when it comes to defining what any given thing actually is.[5] The doctrine of relational origination goes hand in hand with impermanence. The doctrine of relational origination holds that things do not exist, never have existed, or will exist, for that matter, independently of one another. Kasulis states that in Zen Buddhism, "the context is given primacy over the individual; the context defines and elaborates the individual rather than vice versa" (Kasulis, *Zen Action, Zen Person* 8). In effect, the Buddhist view reverses the traditional Western philosophical position, a position that locates absolute "being" in entities and tends to see individual substances as the primary building blocks of experience.[6]

An example illustrates the difference between the Western and Eastern views nicely. A traditional Western philosophical approach to defining a person would likely begin with a physical description of the body of an individual. Personality traits and mental characteristics might then be added to complete the description. Together these details would serve to identify the person as unique from others.[7] While the Buddhist recognizes uniqueness, the Buddhist approach emphasizes the relations a person has and defines the person primarily through those relations. In other words, Buddhists assert that we are who we are because of the connections that exist between us and by virtue of relations including, but by no means limited to, our parents, spouses, friends, and environment. If these relations were altered, quite literally a different person would exist as a result of these changes.

If one accepts the notion of relational origination then a significant shift occurs with respect to understanding what a thing is. Suddenly the notion of a thing must be understood as one that is extremely fluid.[8] Keeping with the example used previously, rather than assert that individual identity remains constant, a Buddhist would instead argue that who and what a person is changes

constantly. Granted, many of these changes are imperceptible and it often takes a great many changes for them to be noticeable, but sometimes (say, for example, in the case of divorce or a death) just one change in relations can have devastating (or equally positive) effects on who someone is or will become. At this point it should be easy to see how impermanence is unequivocally tied to relational origination. Impermanence is a necessary consequence of relational origination. If the "essence" of a thing is truly fluid, then it cannot remain in stasis. If it cannot remain the same, then it cannot exist in any permanent way, and thus we arrive at the Buddhist notion of impermanence.

The concept of emptiness is tied both to the doctrine of impermanence and linked to another necessary consequence of relational origination. From a Buddhist perspective, emptiness refers to the "substance" of things. Contrary to the Western approach, this doctrine suggests that things have no inherent substance, and that, in essence, what we call things are empty. Emptiness is often explained as the "flip side" of relational origination because by claiming that relations are the primary aspect(s) of a thing, the substantive elements are removed, or more accurately, cease to exist. Thus, even though something appears to have real substance (a substance that superficially appears to endure) the actual state of affairs is that there is nothing of essence there at all.[9] There exist only relations that when dissected emerge as emptiness or nothingness.[10]

To put this in less abstract terms, we can turn once again to the nature of the self. Certainly, myriad relations merge to make us who we are. From the Buddhist perspective, these relations should take precedence in terms of defining individuals. Though we might like to think that there is something inherent in our being, some essential core that sits independently of the contingencies of experience, Buddhists remind us that if we could somehow sequentially strip each relation[11] from the individual, at the end we would be left with nothing, or emptiness.[12] For Buddhists, the individual is nothing other than the sum of a continually changing set of relations. The same is true of reality. It has no inherent nature, no predetermined end toward which it strives. It is a complex totality, an intricate collection of mutually influential, and always mutable, processes.[13]

The doctrines of impermanence, relational origination, and emptiness all relate to the idea of momentariness. For Zen Buddhists,

enlightenment is the achievement of a sustained and lived awareness of the true nature of reality. A complete understanding of these doctrines and others is required in order to achieve enlightenment. The Zen Buddhist holds that one important method for attaining a true understanding of these (and other) doctrines is to master "being in the moment."

The Buddhist term "momentariness"[14] usually refers to being focused on the moment at hand. In order to be in the moment, conceptualization of any kind must be put away. As Buddhist practitioners assert, conceptualization reinforces the erroneous view that the world is made up of discrete substances, permanence, among other things. Conceptualization is also often associated with thoughts of the future and past. Buddhists are clear that these too must not take precedence over the immediate moment as they are concepts themselves.[15] To reach enlightenment, one must become mindful of existence and live in the present. Zen monks often take part in a very orderly and mundane routine that does not vary in order to help them become attuned to momentariness. Because their routine is repetitive, novel activity does not become a source of mental distraction. Rather, monks are free to develop an appreciation for each individual moment, particularly moments that might normally pass unnoticed because they are seen as mundane. The monk's goal is to perform each task with absolute attention and in doing so to give each moment full regard. The idea behind this type of behavior is that it is the first necessary and essential step toward enlightenment, namely, seeing reality as it is. As Kenneth K. Inada states, when we achieve an appreciation of momentariness, our "perception of things has fuller, wider, and deeper dimensions than norma[l]," revealing life's "natural fullness and completeness at all times" and affording the individual the opportunity to "be in rhythm with it" ("A Theory of Oriental Aesthetics" 122–23).

It is important that we understand momentariness as a first step on the road to enlightenment, not by any means an end point. By embracing the "mundane" and recognizing that life is comprised of moments that are "necessarily unique [and] unrepeatable" (Raud 157), it is possible to get a glimpse of the true nature of reality. Indeed, by virtue of each moment's connection to every other, Buddhism emphasizes that in discovering the primacy of the moment, the individual connects to the totality of experience insofar as "the

totality of time is . . . accessible from within each single moment" (Raud 162). Moreover, Buddhist theorists emphasize that the realization of the moment restores "fluidity [to] experience . . . because . . . moments have no intervals. . . . [and] each moment is an entire existence for the observer" (Brown 270).

Though suspicious of conceptualization, Zen Buddhists are clear that being in the moment does involve being mindful of one's actions. Being mindful involves being focused on the activity at hand without being lost in the *idea* of the activity. For example, a person who is mindful should not walk into a room only to stand there wondering why he went into it. Indeed, this mode of behavior might be seen as the antithesis of mindfulness. This usually happens because the mind is so full of other thoughts that what is actually being done is momentarily forgotten, or the person is so ahead of herself that she has forgotten what she's actually gone into that room to get. Zen Buddhists recognize that people are very rarely truly focused on the moment at hand.[16] Kenneth K. Inada aptly coins the term "ontological lag" ("A Theory of Oriental Aesthetics" 124) to refer to habits of perception and cognition that put us out of the moment and create a certain level of dissonance with, and thereby an inability to apprehend, the ambient "fullness of experience" (121). Thus, focusing on the task of the moment, or momentariness, is a good starting point toward enlightenment and often a better way to get things done.

Finding the Moment in *Lost in Translation*

Lost in Translation illustrates and celebrates the value of the moment. After its release, some people were mystified at the acclaim that *Lost in Translation* received. It wasn't that the acting wasn't good, or that the scenes weren't shot beautifully, it was just that not a whole lot happens in the film.[17] After all, *Lost in Translation* is anything but an epic. Rather, it is—in some ways—more like a cinematic version of *Seinfeld*. That is, it is "about nothing," or at least things many Westerners tend to regard as having negligible value. Specifically, the Oscar-winning film *Lost in Translation* is about a chance encounter[18] in Tokyo between an unlikely pair of people and the short but powerful friendship that follows. For reasons that are addressed shortly,

many Westerners do not attach great significance to such incidental encounters.

In the film, Bob Harris (Bill Murray) is a middle-aged American actor. While Bob's career is waning—or worse—in the states, such is not the case in Japan. Rather, the airing of his old films on Japanese television has earned him celebrity status. On his agent's direction, Bob is in Tokyo capitalizing upon this unforeseen notoriety; namely, he is in Japan doing a series of endorsements for Suntory, a Japanese brand of whiskey, endorsements for which he will receive the tidy sum of two million dollars. Charlotte (Scarlett Johansson), whose last name the audience never learns, is in her early twenties, a philosophy major[19] and recent graduate of Yale. She is traveling with her husband, John (Giovanni Ribisi). While John is absorbed in the task of carving out a career as a photographer, Charlotte has yet to find her true calling. Instead, she tags along with her husband, endeavoring to use the long hours he spends on photo shoots to discern her proper course. Unable to sleep as a result of jet lag, Bob and Charlotte go to the bar at the hotel at which they are staying in order to pass the time. There, they meet. This chance meeting begins the unlikely friendship upon which the film focuses.

The first way *Lost in Translation* draws our attention to momentariness is by compelling us to focus for an hour and forty-two minutes on a relationship that most viewers would regard as trivial primarily because it is brief. It lasts about a week. For better or worse, people in the West tend to place a higher value on things that endure than on things that do not.[20] With some exceptions, Westerners like things that last. Typically, longevity is seen as indicative of quality. If a thing lasts, it has value. If it does not, it is cheap, disposable, or even worthless. This preference for longevity functions not only with respect to objects but also relationships. In the West, people tend to attach more value to relationships that have longevity. Where long-term relationships are commended for their duration and depth, short-lived ones are characterized as superficial or insignificant. Often, short-term relationships are deemed failures precisely because they did not achieve longevity. Indeed, short-lived relationships might not even be recognized as warranting the designation "relationship," precisely because they are too brief. This tendency invites application of the Buddhist notion of relational origination.

Specifically, because Buddhists place a greater emphasis upon, and define relations more broadly than, people in the West, they might be more inclined to acknowledge the existence of salient relations, whereas people from the West will not.[21]

The Western preference for longevity suggests that culturally Westerners tend to aspire to permanence both in things and in relationships. This aspiration is likely an unconscious reaction to our recognition of, and anxiety concerning, impermanence. Basically, we want what we cannot have, a life where nothing we cherish ends, our self included. Certainly, we do value longevity in things for practical reasons. It is more economical to buy something that lasts. However, we also favor longevity in things because things that endure appear to defy the law of impermanence. In doing this, they fuel our fantasy of an escape from existence's inevitable cycle of life, decay, and death.[22] In resisting change these things appear to have something we want, namely, an inviolable essence rather than embodying emptiness.

When it comes to relationships, Westerners predictably value relationships like marriage largely because of the enduring bond it purports to create. Indeed, in numerous religious contexts, marriage is claimed to be an eternal bond between two immortal souls, thus denying both the inevitability of change and absence of an enduring personal essence, or impermanence and emptiness, respectively. We value longevity in relationships so highly that we often do not bother getting to know someone we know isn't going to be around for very long. Likewise, we might not be comfortable identifying someone as a friend unless we have known him or her for some time.

Ultimately, the preference Westerners have for longevity has some deleterious effects. Obviously, it predisposes us against things and relationships that do not endure. It causes us to deny their value and significance, if not their existence altogether. Importantly, it also tends to compel dissatisfaction with ordinary life because change is a characteristic of existence. To the extent that our everyday existence manifests this property we dislike, we try to dissociate from it. Though we are bound to it physically, we turn away mentally from the everyday in a quest to achieve enduring states. When we do this, we lose touch with, and any appreciation for, the moment. This is problematic to the extent that our lives are comprised of nothing but a series of moments, each one contributing to who we are. If we cannot learn to appreciate these moments, we cannot understand

ourselves. If we cannot learn to live more fully in these moments, we effectively forfeit a good portion of our lives.[23] If we accept our conditioning and unconsciously write off the value of the moment, we deny ourselves access to a million joys, condemn ourselves to existential dissatisfaction, and from the Buddhist perspective, preclude our chance for enlightenment.

Interestingly, the Western preference for longevity predisposes viewers against the relationship upon which *Lost in Translation* focuses.[24] This predilection might incline Western viewers to regard Charlotte and Bob's relationship as trite, and perhaps even tawdry, due to the marital status of its participants, their mutual attraction, and their age difference.[25] Despite the impulse to dismiss the significance of the relationship that emerges between its main characters, *Lost in Translation* ultimately forces us to challenge the preconceptions we have about it. In doing so, it also forces us to challenge the cultural bias we have against relationships of short duration, and of moments generally.

The primary way the film reminds us of the value of the moment and the potential significance of short-term relationships is through the contrast between the powerful relationship that develops between Charlotte and Bob and the lackluster character of their respective marriages. In their first real conversation, Bob tells Charlotte that, among other things, he is in Tokyo "taking a break from his wife."[26] We never meet Bob's wife, Lydia. However, we get a sense of her and of the quality of her relationship with Bob, when, having just arrived in Tokyo, Bob receives a fax from her. Ingeniously crafted to be inflammatory yet innocent, Lydia's fax reads, "You forgot Adam's birthday. I'm sure he'll understand. Have a good trip." As we learn, the impersonal fax is Lydia's preferred mode of communication with Bob. While one could argue that she may have opted for this form of communication out of convenience—even sensitivity—due to the time difference, the terse, impersonal, and occasionally accusatory nature of their content suggests otherwise. Moreover, the tense, often truncated, cell phone exchanges between Bob and Lydia reinforce that Bob and Lydia's marriage is far from happy.

For example, in a call placed by Lydia to discuss the carpet swatches she sent to the hotel, Bob tries to talk to her about something more substantive than floor covering. He tells her he wants to "get healthy" and make some changes. Unconsciously reverting to a

more superficial level himself, Bob suggests they stop eating so much pasta and eat more like the Japanese. Thinking Bob is attacking her cooking, Lydia barks back, "Why don't you just stay there?" When Bob gets more to the point and confesses, "I'm completely lost," Lydia thinks he is referring to the carpet swatches. When he tells her it is not the carpet that is upsetting him, she asks in an irritated tone, "Do I need to worry about you Bob?" to which Bob responds, "Only if you want to." Lydia answers, "Bob, I've got things to do, I've got to go," ending the conversation. Bob is left, lost. Clearly, this sort of exchange coupled with Coppola's decision to foreground imper-sonal modes of communication like the fax message, cell phone, and FedEx pouch as the exclusive modes of contact between Bob and his wife make a powerful statement about the quality of their rela-tionship.[27] Though Bob says that he and Lydia "used to have a lot of fun," he now characterizes marriage as "hard" and says that Lydia doesn't "need [him]." He tells Charlotte that one of the main reasons he survived twenty-five years of marriage is because he slept through a third of it.

For many viewers, Bob's unfulfilling marriage is unfortunate, but also unsurprising. More unexpected is the dissatisfaction evi-dent in Charlotte's marriage, or at least in Charlotte. Charlotte and John have been married for just two years. Most people would like to think that couples are still in the honeymoon phase at this point; however, Charlotte and John are not. Charlotte is clearly dissatisfied with her marriage. Contributing to Charlotte's discontent is the fact that John is too absorbed in his career to be at all concerned about his relationship with her. Indeed, he is so preoccupied with achieving success at work that he is often out of the moment when he is with Charlotte. Rather than engage fully when they are together, John is typically shown either ahead of the moment anticipating his next gig or behind it pondering the day's shoot. This leaves him unaware of Charlotte's unhappiness and blind to her blatant attempts to garner his attention. Though not physically separated, John and Charlotte are depicted as quickly becoming as distant from one another as Bob and Lydia.

In the first scene where we see Charlotte and John together, we are witness to this distance. John sleeps undisturbed as Charlotte, suffering from jet lag, lies next to him awake. She tries to wake him, to bring him to consciousness of her, but is unsuccessful. While he

wraps his arm around her affectionately and mumbles, he doesn't waken. Humorously, she ends up locked under his arm, in a more uncomfortable position than she was previously. She frees herself to look out the window searchingly. Though the situation rendered seems innocuous at first, we see later that it is symbolic of John and Charlotte's relationship. John and Charlotte are on completely different wavelengths.[28] She is grappling with the meaning of her life and with the recent intuition that "[she] doesn't know who [she] married." As her comments to Bob, her CD titled *Soul's Search*, and the recurrent image of her looking out the window suggest, she is searching. She tells Bob that she is "stuck," stuck at a sort of existential crossroads.[29] She is conscious that something is awry but is not sure what. Transitioning into a new phase of her life, she tries to figure out what to do with her life and who to be.

Importantly, while Charlotte is not always in the moment, she is in a position to be. She is becoming mindful of her existence and ready to appreciate life as she is living it. In contrast, John—symbolic of most people—is not mindful of existence.[30] Rather, he whirls in and out, frenetically packing and unpacking his camera bags, too busy to appreciate the moment or recognize that anything is out of the ordinary. Preoccupation with his work makes John oblivious to Charlotte's efforts at decorating the room, her obvious attempt to get his attention by walking seductively around—and over—him in her underwear, and her invitation to spend the morning in bed with a bottle of champagne. In fact, when John runs into his actress friend Kelly, he is so out of touch he is disturbingly flirtatious with Kelly, behaving as if Charlotte is not even there. As these examples show, John is thoroughly absorbed in his own affairs. He exemplifies a sort of myopic narcissism. He is like a boy entranced with a new game who—if he thinks about it at all—assumes that everyone is as happy as he is. He is not a terrible guy. He loves Charlotte. His insensitivity to her is unintentional. He is simply thoughtless.

In contrast to the dissonance evident between Bob and Charlotte and their respective spouses, when Bob and Charlotte meet, there is an instantaneous synchronicity between the two. Though Charlotte says she normally "scowl[s]" at people, she smiles when she and Bob first make eye contact with one another. Later, she smiles at Bob again when they see each other at the hotel bar for the second time and share smirks over the lounge singer's overly dramatic

rendition of "Scarborough Fair." Though they do not even know each other, when Bob and Charlotte meet at the bar later that night, they converse with one another with an ease and comfort unseen in any other conversation thus far in the film. We see this ease manifest even more sharply in the bar the next night. In this scene, Charlotte leaves the table where she was seated with John, Kelly, and a musician, to go talk to Bob. She leaves the table, quite simply, because she finds their conversation intolerable. Her discomfort is obvious in her body language and sullen expression. When the opportunity arises, she escapes her table to engage in a brief, but comforting, exchange with Bob who is at the bar anesthetizing himself after another insufferable photo shoot. Feeling as if they are both captive in a situation where no one around them thinks about anything of substance, Bob and Charlotte commiserate with one another. When Bob jokingly proposes "a prison break," Charlotte aligns herself with him, saying, "I'm in."

While circumstances throw Bob and Charlotte together, the ease and comfort that they experience in their initial contacts is what compels them to pursue a more intentional relationship. They start spending time together. They go out to clubs with her friends, sing karaoke, go to a pachinko parlor, drink sake, and watch movies. Importantly, during the course of these activities, they talk intimately about life. They discuss their feelings and their choices. Rather than talk at—or around—each other about bookcase styles or rock star attire, Bob and Charlotte talk openly with one another about things that matter to each of them. Clearly, this type of communication has been lacking in their relationships with others, and it both gratifies and unites them. Arguably, it also makes them attractive to one another. Influenced by Charlotte's presence, Bob decides to stay in Tokyo longer than he originally planned.

The depth of the connection between Bob and Charlotte is shown in the scenes that document the time they spend together. While dialogue like Charlotte's admission that she will "miss" Bob after he leaves is suggestive of the intimacy they share, it is shown more powerfully in other ways. One way is through Bob and Charlotte's expressions and gestures. For example, Bob's affection for Charlotte is evident when, in fatherly fashion, he carries Charlotte back to her room after she falls asleep in the taxi. In addition to positive gestures like laying her head on Bob's shoulder, Charlotte's depth

of feeling for Bob is also shown negatively. Her attachment is evident in her reaction to her discovery of Bob's affair with the lounge singer. Here, her sarcastic tone, pout, crossed arms, and resistance to eye contact, all betray the fact that she has been wounded by the event. In the scene where the two fall asleep together on his bed, we see evidence of their mutual affection. She curls next to him, childlike, and gently pushes her toes against his leg as she falls asleep. As he too falls asleep, he places his hand on her foot tenderly.

Another important vehicle through which the audience is made to appreciate the significance of the relationship that exists between Bob and Charlotte is the presentation of their relationship as simultaneously romantic and filial. As two of the examples already cited indicate, Bob often acts in a fatherly manner toward Charlotte. He takes her to the hospital. He buys her a stuffed toy. He offers her fatherly advice. He makes sure she has her keys. He tucks her in bed. Charlotte is also frequently presented as childlike or girlish. Her youth is accentuated by her recurrent fetal pose, her dressing up, and by the final scene where she stands on her tiptoes to embrace Bob. At the same time, a romantic attraction between Bob and Charlotte is also made very evident. The awkwardness with which she cuts the tag from his shirt, their fumbling "platonic" kiss in the elevator, the looks they share as they sing karaoke, her anger and his regret over his one-night stand with the singer—all these are suggestive of sexual attraction.[31]

Arguably, characterizing Bob and Charlotte's relationship as at once erotic and as one between a parent and child is a bit risky. With an audience already predisposed to see the relationship as superficial due to its short duration, such characterization could easily lead viewers to dismiss the relationship as degenerate. Though some viewers might think it unwise to render Bob and Charlotte's relationship in a manner reminiscent of *Lolita*, invoking both the paternal and romantic model is important because these relationships epitomize depth of feeling. They are archetypal. It is precisely because Charlotte and Bob's relationship is alternatively likened to the relationship between a father and a daughter and to the relationship between lovers that the audience comes to appreciate the profound significance of their connection. The filial aspect is crucial because it highlights their tender and unconditional affection. The romantic aspect is necessary because it helps viewers appreciate the intimacy that develops

between Bob and Charlotte, namely, a reciprocal openness to one another that is more characteristic of lovers than a parent/child relationship. Though alluding to an erotic connection between Bob and Charlotte does have the potential to reduce a viewer's estimation of Bob and Charlotte's relationship to a tawdry affair, Coppola is sensitive to this possibility and deftly forestalls this reaction by precluding her characters from acting upon their sexual attraction, instead creating the impression that they are made uncomfortable by it.[32] Thus presented, the romantic connection effectively symbolizes the depth of the connection between Bob and Charlotte rather than cheapening it. The portrayal of their connection as both romantic and filial is essential to the viewer's apprehension of its poignancy.

A final method through which viewers are made to appreciate the significance of the encounter between Bob and Charlotte is the contrast between the quality of their exchanges and the encounters they have with others. As already discussed, there is a sharp contrast between the quality of the relationship Bob and Charlotte have with one another and the quality of their marriages. This contrast fuels our appreciation of the value and incommensurability of Bob and Charlotte's relationship. To sharpen this appreciation, Coppola extends this contrast to their encounters with other people and their environment. Throughout the film both Bob and Charlotte are represented as being out of sync with other people and with their surroundings. For example, the awkwardness evident between Bob Harris and his Japanese hosts contributes greatly to the humor of the film. The dissonance is particularly evident in the scene with the "escort" and the scenes that document Bob's two photo shoots. In each case we are witness to obvious—and quite humorous—communication gaps. These rifts become so exasperating that when the second photographer asks whether Bob is drinking, Bob exclaims emphatically, "As soon as I'm done." In addition to being out of sync with everyone but Charlotte, Bob is also portrayed as being out of place. He is too tall for the shower and his feet are too large for the hotel slippers. The complimentary razor looks like a matchstick in his hand. In a room that is huge by Japanese standards, he nonetheless looms like a giant on the hotel bed.

Like Bob, Charlotte too is estranged from other people and her surroundings. With the exception of her stubbing her toe, her estrangement is portrayed a bit more subtly than Bob's. Her pensive

nature and current predicament cause her to exhibit a sort of inertia that contrasts sharply with the busy urban lifestyle of those who surround her. Whether on the bullet train or in the video arcade, she is cast repeatedly as a voyeur, a quiet onlooker upon the activity of others.[33] Scenes that juxtapose Bob and Charlotte in silence while others are immersed in noise further the audience's impression that Bob and Charlotte are out of sync with everyone but each other.[34] Importantly, it also furthers the impression that Bob and Charlotte, by virtue of their silence, are poised to listen to life and to hear the sound of the moment, a sound to which most people are deaf.[35] By creating general dissonance between the relations Bob and Charlotte have with others, and the relations they have to their surroundings, Coppola augments the viewer's sense of their connection and illustrates how profoundly the relationship affects each.

Though it is short-lived, Bob and Charlotte's relationship is not at all inconsequential. Rather, it has a penetrating effect on both of them. It puts them back in touch with the moment and with themselves. Before they meet, Bob and Charlotte are in what might be called a state of existential ennui. Catalyzed by jet lag and reasons largely unknown to themselves, they feel out of sorts with virtually everyone and everything that surrounds them.[36] Charlotte is clearly looking for something whereas Bob seems to have lost it. Both question what they are doing and why they are doing it. They both feel dislocated, unable to lose themselves in activity in the way everyone else around them does.

While many would regard the situation in which Bob and Charlotte find themselves unfortunate, we suggest that they are lucky. For reasons too varied to enumerate here, most people are too absorbed in life to be mindful of it. Instead, smart phones in hand, we catapult ourselves through existence. We rush from one minute to the next, always multitasking, always doing so much and looking so far forward we often miss appreciating where we are. As Suzuki suggests, we are typically so absorbed in "frivolous habits of living" (Suzuki, *Zen and Japanese Culture* 249) that we frequently miss the moment. Under normal circumstances, Bob and Charlotte would be no exception. Like most others, their busy routines stateside forestall any sustained critical consideration of life. However, once in Tokyo, jet lag coupled with linguistic and cultural barriers to reengagement[37] combine to create a heightened sense of dislocation in both individuals.

This heightened sense of estrangement is fortuitous because it jars them out of their respective routines enough to create an opportunity for an awakening, an awakening to the moment and to "the signifi-cance of all" (Suzuki, *Introduction to Zen Buddhism* 85). Importantly, while both Bob and Charlotte are moving toward an appreciation of momentariness before they meet, they find the moment together. This is to say, it is the relationship that they share with one another that helps them fully appreciate, and reconnect with, experience. Together, they overcome the discontinuity with life that had affected them.[38] In the scenes that document them diving into the night together, it is as if they are diving into the sea. Both emerge enliv-ened. Rather than use each other as yet another means of escaping the awareness that life is nothing but a series of moments,[39] the two bring one another to recognition of this fact. In the words of Roxy Music, words that are mouthed by Bob, both individuals learn "more than this—there is nothing." Charlotte confirms she has learned the incommensurable value of the here and now when she says to Bob, "let's never come here again because it could never be as much fun." Though Bob and Charlotte part with one another at the end of the film, audiences are left with the general impression given that their brief relationship will have a lasting impact on them both.[40]

In a way, the relationship viewers have with the film *Lost in Trans-lation* is a little like the relationship upon which the film focuses. Specifically, it is not likely a relationship to which viewers would attach much significance. We expect to be entertained by movies, not to be transformed by them. However, by drawing viewers' attention to, and celebrating the significance of, an encounter they might nor-mally disregard, *Lost in Translation* has the potential to make viewers more mindful of existence. By foregrounding two individuals who learn to savor the little things life has to offer, *Lost in Translation* can make viewers more attuned to, and appreciative of, each and every moment, not merely the ones they are predisposed to regard as spe-cial.[41] Moreover, by highlighting the impact a chance meeting has on its two protagonists, it reminds viewers to be alert to the power that moments, and momentary relationships, hold. *Lost in Transla-tion* might help us learn what Zen Buddhism teaches, namely, that "meaning [is] . . . in our daily experiences . . . not something added from the outside. It is in being-itself" (Suzuki, *Zen and Japanese*

Culture 16). Like the haiku of the famous Basho,[42] it draws our attention to what we commonly regard as "irrelevant" (*Zen and Japanese Culture* 280) and reveals that these things have significance. It shows us that even "one minute, or one second . . . is just as important as one thousand years" (*Zen and Japanese Culture* 314). Though it is an unexpected source, *Lost in Translation* can help teach us to value "the concrete things of our daily life" and savor "life in the midst of its flow" (Suzuki, *Introduction to Zen Buddhism* 83, 132).

Ultimately, the film *Lost in Translation* conveys several extremely important messages, messages that have a decidedly Eastern quality. Specifically, the protagonists' relationship illustrates that our lives are composed of a series of incommensurable, irretrievable moments. It also illustrates that while we may choose to value certain moments more than others, each moment is unique, irreplaceable, and worthy of our appreciation. Instead of valuing all experiences, Westerners tend to value experiences that endure. In contrast to the positive assessment given to enduring states, Westerners tend to see experiences that are fleeting as superficial and of little value. This is particularly true of relationships. Consequently, those in the West often miss the "moment" in their pursuit of enduring states. Serving as a corrective to this conventional view, the contrast evident in *Lost in Translation* between the main characters' unfulfilling marriages and their poignant short-lived relationship is the primary vehicle through which the film conveys the point that longevity is not what gives an experience its worth. From the Buddhist perspective, nothing truly endures, and it is a mistake to assume that duration is a measure of something's existential significance. By foregrounding the significance of the short relationship between the two main characters, *Lost in Translation* reminds its audience to appreciate the value of moments.[43] It is an Eastern message that isn't lost in translation.[44]

Notes

1. The Japanese characters, the Pali, and the English equivalents for these three Buddhist terms are as follows: impermanence, 無情 *mujo* (Japanese), *anitya*; relational origination, codependent arising, dependent origination, and so on, *pratītya-samutpāda*

(we offer only the Pali for this term as the Japanese equivalent is not succinct); and nothingness or emptiness, 無 *mu*, sometimes 無地 *muji, sunyata*.

2. For example, as Rein Raud states, "Western philosophy has traditionally postulated a continuous identity of things . . . and thus preferred the durational mode of being to the momentary, while most Buddhist philosophers have stubbornly refused to give up [the primacy of] immediate existence" (Raud 154).

3. It is worth mentioning that many forms of religion (including certain schools of Buddhism such as Pure Land) rely on the resistance that people have to impermanence. Both in the East and the West, the promise of an afterlife has provided a perfect solution to impermanence and the anxiety it generates. Insofar as it implies that impermanence is apparent but not absolute, impermanence is defeated, or simply denied, depending on your point of view. Notably, social psychologist, Ernest Becker (1924–1974) and contemporary Terror Management theorists such as Jeff Greenberg, Sheldon Solomon, and Tom Pyszczynski examine this phenomenon in detail. Articles outlining Terror Management theory include Rosenblatt et al., Greenberg et al., and Pyszczynski et al.

4. Indeed, not only do Buddhists reject the primacy of entities or substances but also their existence. As Rita Gupta asserts, Buddhist philosophers "have almost unanimously rejected concepts like substances . . . on the contrary, [they] have tried to explain the whole stream of phenomenal existence in terms of impersonal factors and relations of conditionality" (Gupta 178). Contrary to the Buddhist position, Kenneth K. Inada states that most individuals "falsely adhe[re] to [the appearance of] permanent characteristics in the experiential dynamics and . . . the presence of these characteristics not only impedes [understanding] but drastically distorts the natural holistic flow of experience" ("A Theory of Oriental Aesthetics" 117).

5. Jay L. Garfield states, "What we are . . . confronted with in nature is a vast network of interdependent and continuous processes, and carving out particular phenomena . . . depends more on our explanatory interests than on joints which nature presents to us" (Garfield 223). Garma C. C. Chang confirms this interpretation stating, "the so-called single object . . . is actually only an

expedient way of expressing something for a practical purpose. In reality, each and every one of these things is an operational complex and a relative structure brought into being by the coordination and mutual dependence of various factors. Things do not exist; only events exist momentarily under relative conditions" (Chang 81).

6. Atomistic models are particularly illustrative of the traditional Western view. Admittedly, while atomistic models vary, to the extent that they contend that all existing things are comprised of, and can be reduced to, particles of discreet types (particles that are themselves irreducible), these models maintain that there are essential substances that are the foundation of reality.

7. We realize that this is an oversimplification of extremely complex processes that occur in various Western philosophical traditions. We are also aware that there are exceptions to this "rule," process philosophy and some schools of feminism come to mind. We simply point out that the orientation in terms of both the starting point and emphasis is quite different with respect to a Western versus a Buddhist approach.

8. It is worth noting that Heraclitus recognized this fact long ago: "It is not possible to step twice into the same river" (91 F), but it never became a prominent feature of Western thought.

9. As Francis Cook states, if we "scrutinize this apparently really existent thing, we will discover that it is completely lacking in any nature of its own. In Buddhist terminology, it lacks *svabhava*, which can be translated as 'own-being' or 'self-nature'" (Cook 406). Similarly, Garma C. C. Chang states, "although things in the phenomenal world appear to be real and substantial outside, they are actually tenuous and empty" (Chang 60).

10. It is worth noting here that in Japanese the same character *mu* (無) is often used to refer to both emptiness and nothingness.

11. Obviously we are back in the realm of the abstract here. This is probably possible only on a theoretical level.

12. At this point we must mention another Buddhist notion that we have chosen not to deal with in depth. For Zen Buddhism it is extremely important to note that nothingness or emptiness extends to all things, especially the self. No-self or no-mind is an idea central to Buddhism but particularly to Zen. As Tom Kasulis points out (*Zen Action, Zen Person* 40–46), when one enters

the monastery the self is stripped away and that is a first step in recognizing that selfhood is, in actuality, an insubstantial aspect of existence. The further goal is to act and think in a manner that belies a more profound understanding of this fact. This is to act and think without conceptual thought, without interference from one's self. Momentariness is an aspect of this type of thought.

13. Rein Raud offers an engaging account of this complexity in "The Existential Moment: Rereading Dōgen's Theory of Time."

14. Admittedly, while there is general agreement among scholars regarding the significance of the moment in Buddhism, there is ongoing debate concerning the precise nature of the moment. Clearly, it is outside the scope of this chapter to offer a sustained account of the divergent historical and contemporary positions on the nature of the moment. Instead, we focus on what seem to be points of agreement between primary texts, historical sources, and contemporary scholarship on the subject.

15. As Kenneth K. Inada states, "the neat division [of time] into past, present, and future . . . is a mental construction, a fiction as well as a hindrance, in the final analysis, when it comes to grasping the dynamic nature of being" ("Time and Temporality" 173).

16. Some might argue that the reason that professional sports are so popular (on a worldwide level) is that in order to compete at the highest possible level an athlete must have more than ability and talent. To perform at the highest level of competition in the world an athlete must be able to focus completely on the task at hand. Perhaps spectators are more fascinated by this ability than the sport itself, and that explains the appeal of sports at large.

17. For example, in his review in *The New Yorker*, David Denby states, "nothing much happens in the film" and speculates that *Lost in Translation* could have been directed toward something more definite.

18. Indeed, in *Entertainment Weekly*, L. Schwartzbaum describes *Lost in Translation* as a "subtle, wise, and often funny . . . study of chance encounter" (65).

19. It is probably not accidental that Charlotte is a philosophy major. As discussed, coming to an appreciation of the moment requires mindfulness. Whether or not it is true, to the extent that

philosophers are assumed to be more reflective, more focused on discerning the true nature of things, they are thought to be more mindful than your average person. Thus, it makes sense to cast Charlotte as having a predilection for philosophy.

20. As mentioned earlier, Rein Raud examines this preference for durational time in "The Existential Moment: Rereading Dōgen's Theory of Time."

21. It should be noted that throughout the remainder of this essay the authors contrast the Western view with the Eastern view, sometimes using the pronoun "we" to refer to the Western view. This is not meant to marginalize or demean the Eastern view as should be evident from the essay itself. The authors adopt this language as a matter of convenience given the fact that they are Westerners and the audience for the text is largely Western. The authors recognize that there are Buddhists who live in the West and that the countries where Buddhism has the greatest number of adherents are increasingly subject to Westernization and will thereby have members who exhibit a more "Western" view.

22. See Jennifer L. McMahon's "Icons of Stone and Steel: Death, Cinema, and the Future of Emotion" for a fuller examination of how certain cinematic works are expressive of this fantasy.

23. As works of literature like Leo Tolstoy's *The Death of Ivan Ilych* (1886) and Akira Kurosawa's *Ikiru* (1952) demonstrate, an unfortunate consequence that can come from living life in this manner is the realization, typically coming at the end of one's life, that one has wasted life or not lived at all.

24. While offering a positive review of the film, J. Hoberman unconsciously exhibits this Western bias when he describes the relationship between Bob and Charlotte as the "personification of foreclosed opportunities." For Hoberman, the "poignan[cy]" of the film lies in its "bittersweet" portrayal of a love that is denied longevity. The bitterness Hoberman attributes to the film comes precisely from the fact that the relationship between Bob and Charlotte does not endure.

25. Indeed, though most did not subscribe to this view, numerous reviewers acknowledge the potential that audiences of *Lost in Translation* have to interpret the relationship depicted as a superficial and opportunistic affair rather than a more meaningful

relationship. For example, James Verniere says that despite appearances, the relationship between Bob and Charlotte is "less 'Lolita' than intense longing and attraction."

26. *Lost in Translation*, DVD.

27. Elvis Mitchell goes so far as to suggest that the exchanges between Bob and Lydia create a "chilling layer of passive-aggressive horror" in the film ("An American in Japan"). While Mitchell does credit Coppola with not allowing these exchanges to "overwhelm" the audience, we think it a bit of an exaggeration to characterize the effect created as "horror."

28. In her review, Stephanie Zacharek attests to this, stating, "the two float in parallel spaces that never intersect."

29. In her review for the BBC, Stella Papamichael rightly describes both Bob and Charlotte as being at a "crossroads."

30. While few would dispute this claim, some might contend that it is characters like John, or even Kelly, who are in the moment. Certainly, to the extent that they do not seem compelled to analyze their existence, they seem to "live" the moment rather than let thought disrupt the continuity of their experience. As Buddhists recognize, reflective thought can be an encumbrance, and an obstacle to enlightenment, to the extent that it obstructs a fluid engagement with experience. Indeed, as is discussed later, Bob and Charlotte illustrate how thought can create a rift between individuals and their experience. However, because Buddhists do not believe enlightenment can be achieved without mindfulness, the goal is not to annihilate thinking. Rather, it is to preclude it from having a dissociative effect. Thus, John does not illustrate the Buddhist ideal. Here, Kasulis's distinction between thinking, not-thinking, and without thinking prove useful (see *Zen Action, Zen Person*). Whereas the meaning of thinking and not-thinking are fairly obvious, the meaning of without thinking may not be so clear. With this notion, Kasulis seeks to capture the spontaneous, yet focused, quality of the enlightened person. Such an individual has severed her attachment to thinking, and to the self generated through reflection. She is mindful of existence but not monopolized by thought. Thinking links her to existence rather than separating her from it. We contend that at the end of the film, Bob and Charlotte seem to have achieved this state.

31. James Verniere confirms our assessment, describing Bob's feelings for Charlotte as "attraction tinged ambiguously with paternal interest."

32. By precluding her protagonists from consummating their relationship, Coppola is likely also capitalizing on our cultural fascination with, and idealization of, unrequited love. In her review of the film, Stella Papamichael demonstrates the pervasive influence of this ideal when she suggests that Bob and Charlotte's relationship is representative of "the most memorable love of all, [in that] it is bittersweet, beautiful, and immaculate." Clearly, special attention should be paid to the term "immaculate" insofar as it suggests that ideal love is chaste. Elvis Mitchell likewise notes that "unrequited love" is a theme in the film ("An American in Japan"). Because of the cultural interest viewers have in unrequited love, they are likely to hold Bob and Charlotte in higher esteem, and find their relationship that much more poignant, because there is a romantic element that goes unrealized.

33. Indeed, in his review, J. Hoberman describes both Charlotte and Bob as "essentially observational" ("After Sunset").

34. Scenes that make this evident are the scene at the hotel pool where Bob swims silently while others are engaged in a water aerobics class and the scene at the video arcade where Charlotte's silence and stillness contrast sharply with the noise and activity that surround her.

35. In *Being and Time*, Heidegger discusses the call of being. While he asserts that everyone has the potential to hear it, he indicates that most people cannot because they are too entrenched in inauthentic modes of living, namely, modes of living that cover over and distract them from acknowledging the true nature of existence. Moreover, because really listening to being involves hearing truths about the nature of existence that most individuals find unpalatable, Heidegger contends that most people actively strive to anesthetize themselves to the call of being, even though the call remains ever available. Kenneth Inada echoes Heidegger, stating that despite people's ordinary tendency to manifest a deluded perception of reality, one that wrongly attributes substance and permanence to the things of the world, they can "still perceive the Buddhist nature of reality within the selfsame [situation]. In other words, the path to the enlightened

realm is always open; it is never closed. In fact, the closure is of one's own making" ("Time and Temporality" 175).

36. Clearly, being in a foreign country also contributes to the dislocation that Bob and Charlotte experience. In his review of the film, David Edelstein states, "removed from the city, the culture, and the language, Bob and Charlotte feel their lack of connection more fiercely than on their home turf." Similarly, Peter Travers contends Coppola captures "the disconnect that comes from being a stranger in a strange land." It must be noted, however, that being in Tokyo is not the cause of either Bob's or Charlotte's sense of displacement, it merely accentuates it.

37. Here, we are referring to the tendency that people have to flee opportunities for existential realization by immersing themselves in activities that are distracting. While Bob and Charlotte certainly attempt to do this, they are precluded from doing this with ease (or great success) by virtue of the fact that they are unfamiliar with the language and customs of Japan.

38. Here, Kenneth Inada's notion of an "ontological lag" ("A Theory of Oriental Aesthetics" 124) bears mentioning again. As Inada notes, the deluded nature of the average person's understanding of experience puts him or her out of sync with the moment and thereby unable to experience the fullness of existence. Indeed, as Inada notes, this dissociation from the moment is what actually gives rise to the conventional notion of linear, or measurable, time. Importantly, however, being out of sync with the moment does not normally generate any conscious awareness of dissonance on the part of the individual; rather it simply amplifies the individual's unconscious desire to chase, as it were, being through time, time that is always fleeting. Interestingly, in the case of Bob and Charlotte, we see the two individuals put out of sync with conventional life and conventional time (e.g., jet lag). This engenders a sort of double dissonance that we argue operates like a double negative, negating the dissociation from experience and reconnecting the two individuals to the moment, the fundamental unit of existence, a unit that lacks restriction by virtue of its integral connection to everything else that exists. For Buddhists, the moment is quite literally a window to the world to the extent that it is continuous with all that is. As such, discovery of the moment engenders a hitherto unavailable "tranquility"

(Inada, "Time and Temporality" 177). This tranquility is elusive as long as one remains confined to the conventional understanding of existence and the carving up of experience the conventional view requires. This carving up assumes that things have self-nature (*svabhava*) and thereby places all things at a distance from one another. By establishing separation, this view exacerbates desire. As the Noble Truths of Buddhism remind us, suffering originates in desire and desire is predicated on lack. Lack presumes separation. To the extent that being in the moment dissolves separation from existence, it disarms desire and engenders tranquility. This tranquility is evident in both Bob and Charlotte at the conclusion of the film.

39. Though it is beyond the scope of this chapter to examine here, this is an extremely common phenomenon. Namely, people often use relationships with one another as a means to avoid confronting disturbing truths. Indeed, short-term "romantic" relationships like the one upon which *Lost in Translation* focuses are commonly assumed to serve such an end.

40. Peter Travers writes, "Bob and Charlotte's encounter is built to last, if only in their memories."

41. M. San Filippo asserts that in *Lost in Translation*, it "is the monotonous and mundane rather than the monumental that rings true."

42. Basho (1643–1694) is the Japanese poet known as the founder of the modern style of haiku. Basho is famous for focusing upon commonplace subject matter, namely, things or events most would consider prosaic—or even vulgar—and thus unworthy of aesthetic appreciation. Examples include horses urinating and prostitutes sleeping.

43. Both Elvis Mitchell and Roger Ebert attest to this point. Mitchell asserts that *Lost in Translation* is "about a moment of evanescence that fades before the participants' eyes" ("An American in Japan"). Referring explicitly to the Japanese notion of *mono no aware*, a term that expresses the joy and sadness that come from an appreciation of momentariness, Ebert describes the film as a "bittersweet reference to the transience of life" ("Lost in Translation").

44. This essay is dedicated to our children, Gabrielle and Caleb, who have made us appreciate moments and relationships more

keenly, and to Dr. Kenneth K. Inada (1924–2011), whom we had
the tremendous good fortune to study under during our grad-
uate work at the State University of New York at Buffalo. Dr.
Inada's extraordinary insight and compassionate nature shaped
everyone who encountered him, leaving them not merely wiser
but also better. Dr. Inada helped us develop our understanding
of Buddhism and our understanding of life, and for that, we are
thankful.

SIX

Dying to Be Free

The Emergence of "American Militant Buddhism" in Popular Culture

RICHARD C. ANDERSON AND DAVID A. HARPER

When we first developed the concept of what we have termed "American Militant Buddhism" in late 2003 and 2004, the American reaction to the events of September 11, 2001, was unfolding before us. We were both faculty members in the English and Philosophy Department of the United States Military Academy, West Point, teaching cadets who would join the then-named "Global War on Terror" in a few short years.[1] The news from Iraq, Abu Ghraib, and Guantanamo Bay constantly permeated our discussions with students, colleagues, and friends. Michael Moore had just released the controversial film *Fahrenheit 9/11*, extending the thesis from his 2001 film, *Bowling for Columbine*, which examined the Columbine school shooting and posited something was awry in American culture. With hindsight, it is clear how profoundly that time and that place influenced our developing ideas about how American popular culture was expressing a uniquely American brand of redemptive violence framed by ostensibly Buddhist images and concepts. In the decade that has passed since we first noticed and named this phenomenon, we've seen increasing evidence that it is here to stay. For better or worse, American popular culture has appropriated an enlightenment ideology that is primarily identified as "Buddhist" and reworked it in a way consistent with an American mythos that

often attempts to alleviate suffering and provide liberation through violence. It is this resulting mash-up of philosophies and ideologies that we termed "American Militant Buddhism" (AMB) in 2003 and that we often find as we tune in to American popular culture today.

Buddhism has proven highly adaptable to every culture it touches, producing various vehicles that all strive in common for the cessation of *dukkha*, or suffering, while emphasizing compassion toward all sentient beings. Even in its many forms found throughout the various vehicles, Buddhism adheres to its primary precepts summarized in the Four Noble Truths, which maintain that 1) life is suffering, 2) suffering arises from attachment, 3) liberation from attachment brings the cessation of suffering, and 4) it is possible to bring about the cessation of suffering. Moreover, the Buddha provided his followers with teachings of the Eightfold Path, which are directions for relinquishing attachments and eliminating suffering. Among the paths taught to Buddhists, a most notable one is the path of "right livelihood," as it encodes one of the main tenets of Buddhism that one should not intentionally cause harm to any living being. The Buddhist belief in karma, or the law of causation and return, demands that one would pay a heavy price in future existences for killing another being.

However, unique aspects of American cultural heritage seem to have combined with traditional Buddhism to produce what appears to be a paradoxical and potentially virulent misinterpretation of the Dharma within popular culture. We suggest that this development is the natural result of introducing Buddhist doctrine into a society steeped in ideas of Manifest Destiny, millennialism, and Puritanism. Collectively, these aspects of the American ethos produce a radical-individualist mindset prone to find "liberation" or redemption through violence. When combined with the relatively recent introduction of Buddhist concepts, the result is an American form of enlightenment ideology that actually embraces violence as the means of liberation. The emergence of AMB signals that Buddhist ideals in America, initially introduced as a peaceful alternative for those alienated by the violence of the Vietnam War era, may have evolved to embrace the brutality they were supposed to remedy.

The resulting message of American Militant Buddhism is that "Life is suffering, and only violence alleviates suffering." AMB

distinguishes itself from other Buddhist vehicles by embracing violence to the self or others as the primary means of liberation. This counterintuitive fusion of Buddhist philosophy and violence seems increasingly prevalent in American popular culture, where it sometimes appears as a puzzling episode or odd aspect of a text. As we examined these texts, we came to realize that we were seeing nascent and more-or-less coherent portrayals of a uniquely American enlightenment process. Because enlightenment ideologies are most often related to Buddhist versions of awakening, and because so often we found cinematic representations of this Americanized enlightenment ideology decked out with Buddhist imagery and terminology, we named what we saw "American Militant Buddhism." This is not to be confused with less complex representations of Buddhists acting out violence, as in traditional Asian (and American) martial arts films. There are many popular films with incidental moments or characters appearing to combine violence and Buddhism. It is important to note that these traditional Kung Fu movies (or modern versions like *Kill Bill*) tend to have vaguely Buddhist trappings but rarely evince any of the philosophy. For these films, Asian mysticism is simply a backdrop for the martial arts; they do not incorporate an enlightenment ideology. One instance of what we are *not* talking about in AMB is the episode in the 2003 Adam Sandler and Jack Nicholson film, *Anger Management*, when Sandler's character confronts a former childhood bully who is now a monk at a Buddhist monastery. The scene climaxes in a fistfight between Sandler and the monk and concludes with a mob of angry, garden tool–brandishing monks chasing Nicholson and Sandler off the monastery grounds. Clearly, Buddhist philosophy (conventional or unconventional) is not important to this comedy film. The portrayal of violent monks is merely comic, although we might make something of a film where the aim of anger management is to learn how to *be* angry. Perhaps even here, where there is no coherent reference to Buddhist or any other enlightenment process, there are hints that in American society it is impossible to escape violence and anger. But AMB is not concerned with Buddhist window-dressing in violent films, whether for comic or exotic effects. AMB texts are those that portray enlightenment as a definite good or a necessary goal and violence as the very mechanism of such liberation.

The distinction we make in the prior paragraph may be subtle, but it is important. Those encountering the unique fusion of ideologies that is American Militant Buddhism for the first time will struggle to reconcile what they see as disparate and incoherent elements of plot. For instance, it is difficult for anyone with even a passing familiarity with the Dharma to attend a film like *Star Wars: Episode III* and not hear the echoes of Buddhism in Yoda's discussions of "the Force" and the role of the Jedi. In fact, a 2005 book review in *Tricycle* magazine recognized that "for better or worse, Yoda has become the archetypal Zen master in the popular imagination, embodying both the positive traits of wise Buddhist teachers and some more unfortunate stereotypes" (Zigmond 102). And yet the Jedi is a military organization that produces terrifyingly efficient killing machines. Yoda himself hacks away at his enemies with great skill and zeal when required. As with many films portraying AMB, the apparent collision of violence and traditional Buddhism frustrates most conventional analyses. In his book *The Dharma of Star Wars*, Matthew Bortolin wrestles with the violence of the Jedi in his afterword, formulating an uncomfortable theory of "compassionate violence" to excuse the saber-slinging Knights:

> Acts of violence can be motivated by anger, hatred, ambition, and jealousy—all factors of the dark side. But can they ever be motivated by compassion? The traditional Buddhist answer is an unequivocal "No," . . . yet I think there is something important to be learned about ourselves and the nature of violence by looking at the way violence is used by the Jedi Knights. Can we accept the wise and venerable Jedi, the so-called "guardians of peace and justice," as beings of understanding and love when they use their powers to destroy others caught in the web of ignorance and suffering? If their acts of violence are committed out of anger, hatred, or aggression can we say the Jedi have transcended the dark side, that they act from a place of compassion? (Bortolin 190)

In its review of *The Dharma of Star Wars*, the magazine *Tricycle* noted the awkward discussion of violence and warned that the afterword, while "thought-provoking . . . highlights some of the limits of

using the films to explicate Buddhism" (Zigmond 102). Such is often the conclusion of those faced with the violence of AMB in a text they attempt to analyze as traditionally Buddhist. Often and understandably, critics conclude that such texts are inconsistent in their portrayal of Buddhism. We suggest a different approach. Instead of dismissing the violent Buddhism portrayed in these texts as the result of benighted or inconsistent artists, we see it as epitomizing a variation of enlightenment ideology uniquely adapted to American culture and consistent in its very paradox. The "dharma" of *Star Wars: Episode III* becomes more understandable if one realizes that it is only as Buddhist as American Militant Buddhism is.

We return to the aspects that make *Episode III* a portrayal of AMB later when it will be clearer, after we've looked at earlier, more obvious cases of the pop-culture phenomenon we trace. The exemplar of AMB is the 1999 blockbuster movie *The Matrix*.[2] One cannot help but notice the film's overt use of Buddhist philosophy, symbols, and allegory. A depiction of an illusory world from which people could escape through a process of "awakening" was neatly packaged in a modern action movie meant to appeal to mass audiences. *The Matrix* portrays a future in which humanity is trapped within a computer-generated simulation of reality indistinguishable from the "real world." Those who have "awakened" from this dreamlike illusion, and perceived their actual situation, endeavor to free all of humanity from the delusion of the matrix. The main character, Neo, reluctantly accepts his role to fulfill prophecy and become "the One" who not only experiences reality as it is but uses his enlightened status to save those trapped in the delusion of the matrix.

While it was refreshing to see an accessible allegory of Buddhism on the big screen, the violence that coexisted with the movie's potentially Buddhist message was deeply troubling. Most disturbing were the violent methods employed by Neo as he began to fulfill his bodhisattva or Buddha role. In his excellent essay on the Buddhism in the film, "There Is No Spoon: A Buddhist Mirror," Michael Brannigan notes the conflict between the film's violence and its Buddhism. In a section that asks, "Just how Buddhist is *The Matrix*?" Brannigan points out how "[s]cenes of excessive violence seem to contradict Buddhist teachings regarding nonviolence All of this no doubt demonstrates the film's commercial aim in appealing to our culture's

audience. In selling out in this fashion, the film contradicts some fundamental Buddhist principles" (Brannigan 108). He goes on to reject any paradigm that attempts to fuse Buddhism and violence:

> Given American culture's fascination with violence, one may therefore call the film's use of it as signifying American Buddhism. With this I disagree. Regardless of how various cultures have adapted Buddhist teachings, these teachings are Buddhist only to the extent that they remain faithful to the core of Buddhist teachings. And the core of Buddhism does, and will always, abhor violence and the deliberate perpetration of unnecessary suffering. (Brannigan 109)

Brannigan's reaction is another typical response of those confronting American Militant Buddhism. As with *Episode III*, it is far more comfortable to characterize *The Matrix* as inconsistently incorporating violence while pandering to American culture than to see it as a consistent portrayal of an American version of Buddhism. This approach threatens to demote the film to the level of just another martial arts film, of the same category as *Kill Bill* (2001), which uses "Buddhist" imagery and trappings despite having only a flawed Buddhist philosophical grounding. However, *The Matrix* is not selling out to culture; it is a product of culture and consistent with other popular American texts that portray, in similar manners, Buddhist ideals coexisting with violent means of liberation. These cultural products don't simply use Buddhist terms and images to add mystique but instead employ and modify tenets of Buddhist belief. Alongside *The Matrix*, the music of the now-disbanded rock group Rage Against the Machine and the movies *Fight Club* (1999) and *The Last Samurai* (2003) best demonstrate that the troubling fusion of violence and Buddhist philosophy in American popular culture is not an isolated aberration. In the United States, AMB is the emerging new "vehicle" of Buddhism.[3]

The Awakening: "Your Anger Is a Gift"

Before *The Matrix*, the first readily identifiable and successful instance of AMB was the 1992 debut self-titled album from Rage Against the Machine, a rap metal band led by charismatic singer-songwriter Zack

de la Rocha. The eponymous album signaled the emergence of AMB as the music challenged listeners to "wake up" from the illusion created by the America's materialistic consumerism. However, according to Rage Against the Machine, it was not enough that listeners just wake up; the group demanded that their awakened audience rebel, often advocating violence as the means both to rouse others and to fight against oppression.

The group's lyrics and aggressive musical style relegated them to the fringe of mainstream music, and some critics labeled them as nothing more than just another group exploiting the youthful need to rebel against authority. But upon closer inspection, lyrics from their music contain a much more substantial and appealing message. The album was certified platinum in 1994, double platinum in 1997, and the band garnered a Grammy Award and five Grammy nominations for their first two albums. Within the lyrics of their songs such as "Bomb Track," "Know Your Enemy," "Wake Up," and "Township Rebellion," Rage Against the Machine describes the pitfalls of American culture as stemming from corporate greed, consumerism, and the subversion of individuality by the illusion of American "freedom."

The first track on that album, "Bomb Track," serves as a weapon to shatter the audience's view of the existing paradigm of American culture and also targets the main cause of delusion: American consumerism. De la Rocha exposes the myth of American culture as he sings, "see through the news and views that twist reality / enough / I call the bluff / [of] Manifest Destiny" (de la Rocha). While explicitly challenging the validity of American news and media sources, he points to the cause of American delusion and suffering: the mythic foundation of Manifest Destiny. Emphasizing the ephemeral and destructive nature of American culture in their song "Know Your Enemy," Rage Against the Machine states, "yes I know my enemies / they're the teachers who taught me to fight me / compromise, conformity, assimilation, submission / ignorance, hypocrisy, brutality, the elite / all of which are American dreams" (de la Rocha). According to Rage Against the Machine, the "American Dream" is just that—a dream that lulls us into accepting an illusory existence while relegating us to a life of suffering.

Once the ensnaring yet ephemeral nature of American life is exposed, Rage Against the Machine issues its challenge for listeners

to "wake up" from the system and reject the dominant paradigm. The song "Wake Up" further lists American illusions and misconceptions and demands that the listener awaken. De la Rocha asks, "Whadda I have to do to wake ya up / To shake ya up, to break the structure up?" (de la Rocha). The song ends with a screaming chorus demanding we "Wake up! Wake up! Wake up!" (de la Rocha). However, Rage Against the Machine is not content simply to alert listeners to the nature of reality; they also prescribe action. They seem to claim that their audience must not only recognize reality, they must resort to violent rebellion in order to liberate others. This is best articulated in the song "Township Rebellion," where de la Rocha sings, "Raise my fist and resist / Asleep, though we stand in the midst / of the war / Gotta get mine / Gotta get more / Keepin' the mic warm against the norm / 'cause what does it offer me / I think often it's nothin' but a coffin. / Why stand / on a silent platform / Fight the war / Fuck the norm!" (de la Rocha). Indeed, the entire album attempts to alert listeners to the nature of American society and at the same time advocate violent rebellion. By challenging their audience to question the merits of the American *maya* or illusion, Rage Against the Machine embodies the role of a militant *bodhisattva*, enlightening individuals while also arming them for battle.[4]

The message of the album is much more complex than Marxist political discontent or teen angst. It is the precondition of awaking to the illusory nature of American ideals, combined with a call to violent action, that makes Rage Against the Machine's message unique. Indeed, de la Rocha claims we are "born with insight and a raised fist" (de la Rocha). The combination of enlightened awakening and violent action is signaled even in the cover photo depicting the self-immolation of the Buddhist monk Thich Quang Duc. In the 1963 photo, Quang Duc appears to meditate serenely while flames engulf his body. Though a reflexive act, his self-immolation served as a violent protest against the Catholic Diem regime in control of South Vietnam at the time. The problematic nature of this gesture epitomizes the album's fusion of Buddhist enlightenment ideology with violent resistance. It is perhaps no surprise that the Wachowski brothers, directors of *The Matrix*, chose a song from this album ("Wake Up") to summarize and reinforce the message of their movie as the closing credits scrolled.

Free Your Mind: *The Matrix*

The Matrix fused cutting-edge special effects and filming techniques with a genre that resists labeling. Written and directed by Andy and Larry Wachowski, the movie combines traditional action movie or martial art film tropes with complex philosophical and spiritual inquiry. The Wachowskis describe their epic trilogy as "a chop-socky flick that comments on the Hegelian dialectic while having a guy who can fly and stop bullets," and as a story that "reflect[s] our thoughts on the nature of truth, the reliability of dogma as well as the importance of individual feeling in the exploration of consciousness" (Wachowski and Wachowski). The movie quickly garnered both critical acclaim and a cult following, and in 2000 it won four Oscars and twenty-eight other awards.[5] The packaging of box-set DVDs and the marketing of its products from sunglasses to videogames and lunchboxes made the franchise a formidable icon of American popular culture. However, the movie and its sequels can be approached as an undeniably Buddhist text, among other things. In one interview, Larry Wachowski even acknowledged that Buddhism did, indeed, inform the film's portrayal, particularly "the search for the reincarnation of the Buddha" (Corliss 76). The crucial revelation of the first film is an echo of the Buddha's critical realization of the impermanence of all things. The main character, Neo, undertakes a process of exploration, achieving increasingly higher awareness of the reality of things until he is finally shown that his mid-1990s American existence is nothing but a computer simulation, run by artificially intelligent machines maintaining crops of human beings in order to harvest their bio-electrical energy. All of Neo's life, or at least what he perceived as his life, until this point has been a fantasy created by the machines to keep humankind under control. It is a powerful portrayal of the Buddha's notion of impermanence, as found in the *Lankavatara Sutra*:

> All that is seen in the world is devoid of effort and action because all things in the world are like a dream, or like an image miraculously projected. This is not comprehended by the philosophers and the ignorant, but those who thus see things see them truthfully. . . . The world as seen by

discrimination is like seeing one's own image reflected in a mirror, or one's shadow, or the moon reflected in the water, or an echo heard in a valley. (*Lankavatara Sutra*)

Neo's awakening is facilitated by others who have escaped the illusory world of the simulation (the "matrix") before. Ultimately, they offer Neo the choice of pursuing the truth or remaining ignorant of the nature of reality. Upon choosing to wake up, he is informed of his destiny to achieve a higher attainment than those who have awakened so far. He is to be "the One," a savior figure that will end the ongoing war between man and machine. It becomes clear through the course of *The Matrix* and *The Matrix Reloaded* (2003) that Neo is a bodhisattva or a sixth incarnation of a Tathagata, or fully enlightened one.

Throughout *The Matrix*, Neo becomes increasingly able to discern and manipulate the reality of the computer matrix that is enslaving humanity. A key moment in his development of awareness is an encounter with another "potential," or bodhisattva, a young boy wearing monk's robes who teaches him that the key to manipulating reality (specifically spoon-bending) is to remember that "there is no spoon," thereby reinforcing Neo's awareness of the dreamlike nature of the computer-generated reality. By the end of the film, Neo can fully manipulate the computer world and see the computer code underlying "reality" in a way unlike any other awakened human, confirming his more enlightened state. His prophesied role, to free those humans who remain ignorant of reality and trapped in the matrix, clearly echoes Mahayana tenets of Buddhism, according to which one attains enlightenment in order to liberate all sentient beings.

Despite his status as an awakened being and his fairly clear identity as a Buddha figure, Neo's actions in his "war of liberation" are troubling for those tracing the Buddhist tenets underlying the movie's plot. Specifically, in *The Matrix*, Neo and his compatriots demonstrate a callous disregard for the lives of those enslaved in the matrix, and for the lives of the sentient machines as well. In a climactic scene, Neo and his partner storm an office building to rescue Neo's mentor, the man who had awakened Neo to reality. Neo reenters the computer simulation that was formerly his prison, summons up countless virtual weapons by asking for "guns, lots of guns," and goes on a killing spree that ends the virtual and physical existence of

no less than thirty sentient beings. Throughout much of the trilogy, those endeavoring to free the minds trapped in the matrix do not seem able to affect liberation without the use of overwhelming fire-power and martial arts prowess. Neo's apparent willingness to kill the deluded souls he is supposed to liberate demonstrates the fusion of "Buddhist" enlightenment ideology and violence that defines AMB.

You Are Not Your Khakis: *Fight Club*

In another box-office smash and "cult" favorite, *Fight Club*, violence is the means to sever one's attachment to modern American consumerist existence. The main character in *Fight Club*, a nameless antihero referred to as "Jack," is deluded about the nature of his life in a way distinctly different from Neo. Jack suffers from multiple personality disorder and becomes best friends with his eccentric alter ego and hallucination, Tyler Durden. While viewers remain ignorant of these characters' essential identity, Tyler seems to serve as the agent of Jack's enlightenment. Like Rage Against the Machine, Tyler preaches self-awareness through antimaterialism. Before meeting Tyler, Jack attempts to fill the voids in his life through the consumption of IKEA furniture and trendy clothes. After Jack's apartment blows up (later revealed as an act of Jack/Tyler), Tyler begins his mentorship of Jack:

> You buy furniture. You tell yourself, this is the last sofa you'll ever need in your life; no matter what else goes wrong, you've got the sofa issue handled. Then the right set of dishes. Then the right bed. The drapes. The rug. . . . This is how you fill up your life. (*Fight Club*)

Throughout the movie, Tyler demands that his other followers and Jack renounce their consumerist attachments and accustom themselves to a more visceral experience of life. He challenges Jack to confess to the police that he blew up his own Ikea-laden apartment, demanding he tell them "the liberator that destroyed my property has realigned my paradigm of perception" (*Fight Club*).

Jack and Tyler move to a dilapidated old house that seems emblematic of the state of Jack's psyche. In several cities around the country, they start "fight clubs," places where men engage in

underground fighting matches and find some sort of "liberation" in the process. These intense and bloody fights seem to offer the participants a brutal Zen-like experience of the "now" while reducing their attachments to their corporeal selves. These are crucial moments of the movie that emphasize the Buddhist underpinnings of the film, while at the same time highlighting the connection between violence and enlightenment. Tyler and Jack steal human fat from liposuction clinics and turn it into soap that they then sell in upscale department stores. In the process of making the soap, Tyler provides Jack with an enlightenment experience by burning his hand with lye. As Jack attempts to use meditation and other coping mechanisms to escape the pain, Durden hisses, "Don't deal with this the way those dead people do. Deal with it the way a *living* person does. . . . what you're feeling is premature enlightenment. [He slaps him to regain his attention.] This is the greatest moment of your life and you're off somewhere, missing it" (*Fight Club*). Before allowing Jack to neutralize the acid and end the pain, Durden preaches to him about impermanence and transience: "First, you have to give up. First, you have to know that someday you are going to die. Until you know that you will be useless" (*Fight Club*). Jack finally accepts the pain and transience of existence while remaining focused on the now, becoming one with the enlightenment experience produced by Tyler's violence.

As the film moves toward its conclusion, Tyler builds a private army called "Project Mayhem" that will blow up the headquarters of major credit card companies in order to force society at large to give up its attachments and level the playing field by freeing the population from their debts. When Project Mayhem gets underway, the Buddhist elements of the film again emerge as the house that Jack and Tyler live in on Paper Street is recast as a Zen monastery. Recruits stand outside the door for hours or days, being verbally and physically abused by Jack, before they are turned away or allowed to enter. Brian Victoria describes a similar practice used at Japanese Zen monasteries:

> To be allowed to enter a monastery as a trainee, a monk is expected to prostrate himself in supplication before the entrance gate for hours, if not days, depending on the monastery. When asked why he wishes to enter the monastery,

the monk should reply, "I know nothing. Please accept my request!" indicating that his mind is like a blank sheet of paper, ready to be inscribed by his superiors as they wish. If a monk fails to give the proper answer, he is struck repeatedly... until his shoulders are black and blue and the desired state of mind is achieved. (Victoria 183)

In the case of *Fight Club*, the desired state of mind is one that rejects the status quo, manifesting that rejection in rebellion and violence. Tyler's project to enlighten Jack eventually leads Jack to realize the truth: that he and Tyler are one in the same. But this ego-smashing revelation that things are not what they seem is not the end of Jack's awakening. In the final scene, just before Project Mayhem's bombs wipe out the financial district and "return everyone to zero," Jack liberates himself from himself. In a fitting end to a movie rife with themes of forced liberation, Jack's liberation requires a culminating gory act of violence. As he puts the gun in his mouth and pulls the trigger, Jack is symbolically relinquishing his control and his attachment to self while attempting to destroy his "other self," Tyler. If Jack manages some sort of Jungian integration by shooting himself, he also blows a ragged hole in the concepts of self, ego, and attachment to the physical world.

Though unrelentingly violent and darkly comedic, the Buddhist underpinnings of *Fight Club* are fairly clear both in details, such as the recruitment system, and in the larger message emerging from those details. To be free, one must relinquish his or her attachments to the empty and transitory things of this world. In *Fight Club*, as in *The Matrix* and the songs of Rage Against the Machine, violence is not only the means to wake up and liberate the deluded people of the world; it is the means for achieving enlightenment. While the allusions to Zen training techniques in *Fight Club* are thought provoking, the violence in this film, and in AMB, differs markedly from the occasional physical violence encountered during Zen practice. The most marked difference is that the violence extends beyond the bounds of a voluntary master-pupil exchange. In AMB awakenings may be forced upon unwilling participants, by the bombs of Project Mayhem or by shock techniques such as the "human sacrifice" scene where Tyler uses a gun and a death threat to force a convenience

store clerk to admit to and promise to pursue his true path. Indeed, in AMB violence is the means to awaken and liberate even those who express no desire to be freed.

A Culture of Regenerative Violence

American popular culture has thus produced texts uniquely fusing an enlightenment ideology and violence, a fusion seemingly contradictory to the primary tenets of Buddhism itself. In order to understand the nature of this new hybrid, one must examine the culture that is at once receiving and transforming the elements of Buddhist thought. The nature of the American psyche, informed by a cultural mythos born of beliefs in divine election and Manifest Destiny, provides the media in which AMB arises. Integral to this American mythos is an ingrained belief in salvific violence sanctioned by divine providence. To examine the fertile soil that nurtured the development of this uniquely American enlightenment vehicle, we need to trace the providential view of American history. While we haven't time to develop evidence for this in full here, we can at least trot out the main exhibits that we find relevant to understanding the nature of AMB.

In 1630, John Winthrop sermonized that the Massachusetts Bay Colony represented a "city upon a hill." Indeed, the Puritans often cast their mission and plight in the New World using religiously charged terms. Through trials by hardship in the American wilderness, the Puritans hoped to forge a more perfect society and religion that would redeem not only the New World but also the Old World. That this project required violence against the land and its native inhabitants was not only evident but also was considered clearly sanctioned by Providence. Richard Slotkin, in his intensive study of the foundations of the American myth, argues that the American mythos centers on an idea of "regeneration through violence" that developed out of the struggles of these first colonists. By encountering, battling, and ultimately defeating the wilderness and its inhabitants (which often represent evil and temptation) the protagonist/hunter of the American myth gains self-knowledge and furthers the aims of providence. Prefiguring the later belief in Manifest Destiny,

the Puritans often cited divine sanction even for the most brutal of crimes against indigenous peoples.

Later, in the early years of the Republic, buoyed by the notions of divine providence and desiring to expand its boundaries, America embraced the concept of Manifest Destiny.[6] The ideals of Manifest Destiny were perhaps first codified in print by the words of John L. O'Sullivan in the November 1839 *United States Democratic Review*:

> We are the nation of human progress, and who will, what can, set limits to our onward march? Providence is with us, and no earthly power can. . . . In its magnificent domain of space and time, the nation of many nations is destined to manifest to mankind the excellence of divine principles . . .

The concept of Manifest Destiny encapsulated the latent concept of American identity rooted in the Puritan foundations of the nation. America was proclaimed a unique nation possessed of particular virtue and grace, destined by divine providence to spread these institutions and fated to expand westward. Manifest Destiny not only legitimized the expansion of the nation but was employed to justify, or excuse, the ruthless persecution of the Native Americans and other nonwhite inhabitants. In his book *Race and Manifest Destiny*, Reginald Horsman explains the racist and exclusionary implications of Manifest Destiny:

> By the 1850s it was generally believed in the United States that a superior American race was destined to shape the destiny of much of the world. It was also believed that in their outward thrust Americans were encountering a variety of inferior races incapable of sharing in America's republican system and doomed to permanent subordination or extinction. (6)

Once again, violence was employed as the means to achieve (and, perversely, to bestow) liberty. As the Illinois senator Stephen A. Douglas put it in 1854, "you cannot fix bounds to the onward march of this great and growing country. . . . He will expand, and grow, and increase and spread civilization, Christianity, and liberal principles"

(Johannsen 16). However, the liberty and civilization offered by the progress of Manifest Destiny was not extended to all, for it excluded those not blessed by divine providence. Senator Thomas Hart Benton had clearly articulated this in an 1846 speech to Congress when he claimed, "It would seem that the white race alone received the divine command to subdue and replenish the earth!" (Benton 139–42). The belief in Manifest Destiny and the successful westward expansion solidified and legitimized the American reliance on violence to secure liberty and fulfill God's aims.

The American mythos, grounded in Puritan ideals of providential (violent) redemption and divinely blessed expansionism, continued to mold American self-concept and policy far beyond the expression and execution of Manifest Destiny. One can trace a series of national doctrines from these Puritan roots all the way to the current national political landscape. Although the Monroe, Truman, and Reagan doctrines ostensibly protected American national interests, they also aimed to facilitate the spread of liberty and freedom—often with the assistance of armed force. The continued presence and influence of the foundational American belief in liberty through violence is evident in recent political rhetoric and the Bush doctrine of 2002. In his 2005 inaugural address, President George W. Bush proclaimed that "[a]dvancing these ideals [of liberty] is the mission that created our nation. . . . is the urgent requirement of our nation's security, and the calling of our time" (2005 Inaugural Address). Further, in his 2005 State of the Union Address, against the backdrop of the ongoing Iraq War, President Bush promised to continue to "spread the peace that freedom brings" around the globe and closed with words hearkening back to those of Manifest Destiny: "The road to Providence may be uneven and unpredictable—yet we know where it leads: It leads to freedom" (2005 State of the Union Address). It is in this richly prepared ground of myth and cultural identity that AMB takes root.

Adaptations and Manipulations of Buddhism

The emergence of AMB is no doubt aided by the adaptable nature of Buddhism itself. Throughout the centuries Buddhism evolved as it spread throughout Asia and the world. The Theravada school of

Buddhism, emphasizing the individual's capacity for enlightenment, has been joined by Mahayana and Vajrayana vehicles, adding the mandate to liberate all beings through varying methods. Zen Buddhism, often the first type of Buddhism encountered by Westerners, is a relatively recent development of Buddhism, arising as it moved through China and Japan. Despite these adaptations, the primary tenets of Buddhism, the Four Noble Truths and the Eightfold Path, have remained relatively unchanged, as has the prime tenet forbidding harm to other beings.

It is important to note, however, that this isn't the first time Buddhism has been adapted in such a way that results in an embrace of violence. The collusion of Zen and mainstream Buddhism with the nationalistic aims and imperial expansion of Japan prior to and during World War II is well documented in Brian Daizen Victoria's fascinating books *Zen at War* and *Zen War Stories*. Victoria explains how the Mahayana concepts of "skillful means" were perverted to justify killing in the name of Buddhism. The concept of skillful means, as perhaps best illustrated by a story in the *Upayakausalya Sutra*, allows beings on the bodhisattva path to kill if they do so with compassionate intent and are prepared to accept the karmic consequences of their action (Tatz). It is noteworthy, however, that the killing still has negative karmic effects and must be undertaken only by one who can clearly see the consequences of such action due to their advanced state of enlightenment (Harvey 136).

One of the more shocking passages in *Zen at War* illustrating the Japanese defense of "skillful means" is a quote from Meiji-period Buddhist scholar Inoue Enryo writing about the Russo-Japanese conflict of 1905:

> It goes without saying that this is a war to protect the state and sustain our fellow countrymen. Beyond that, however, it is the conduct of a bodhisattva seeking to save untold millions of living souls throughout China and India from the jaws of death. Therefore, Russia is not only the enemy of our country, it is also the enemy of the Buddha. (Victoria 29)

Despite the apparent similarity between the adoption of violence by Japanese Buddhists prior to World War II and the emergence of AMB, it is important to note one major difference. The metamorphosis of

Japanese Buddhism was affected by a largely *intentional* manipula-
tion of the philosophy to further nationalist aims. An example of this
process can be found in Furukawa Taigo's book, *Japan and the New
Mahayana Buddhism*, written in 1937. Furukawa claimed that his
goal in "providing spiritual education for the imperial army's offi-
cer training program" was to "modify Buddhism, the greatest leader
of the nation's thought, from its passive Indian-style attitude to an
aggressive Japanese attitude" (Victoria, *Zen at War* 91). His project
was apparently successful and may have provided the impetus for
a Buddhist justification of Japanese imperialist aggression. In con-
trast to the modification of Japanese institutional Buddhism by what
appears to have been an intentional and conscious process of mil-
itarization and change, the emergence of AMB in popular culture
seems a natural consequence of introducing Buddhist ideals and
enlightenment ideology into the preexisting American culture that
professed liberation through violence.

The Dangers of a New Vehicle

A system that claims all beings can acquire liberation only from self-
knowledge must inevitably be transformed by assimilation into a
culture that inextricably links liberation and freedom with violence.
The meeting of Buddhism and American culture was an encounter
between radically opposed belief systems: an exclusionary religion
that required the grace of an external deity for salvation encountered
an inclusive system requiring no grace and no deities. Buddhism's
claim that enlightenment requires renouncing attachment to the
material world and to the concept of an individual self explicitly pre-
cludes dualist notions such as divine providence and fate. Moreover,
Buddhism requires acknowledgment of the interconnected nature of
all beings and therefore prohibits harming them.

The inconsistency between Buddhism and the American mythos
is obvious. The resulting hybrid is perhaps not so obvious. Given
American culture's predisposition toward pursuing liberty and
freedom through violence, it is little wonder that the means of lib-
eration depicted in popular culture representations of Buddhist ide-
als are themselves violent. The phenomenon of AMB has retained
some key aspects of Buddhist belief while incorporating the most

identifiable aspect of the American psyche: the belief in violent liberation. Therefore, the new truths formulated in this popular culture creation are: 1) Life is suffering; 2) Suffering is caused by attachment to an illusory reality; 3) Suffering can be alleviated, 4) The alleviation of suffering is only possible through the violent severing of attachment. That life is suffering is self-evident in the popular culture texts we've looked at. The deluded dwellers of a simulated world in *The Matrix*, the benighted and manipulated consumers described by Rage Against the Machine, and the emasculated and used working-class of *Fight Club* are all merely suffering through their existence. They suffer because they are attached to an illusory world or at the very least chase an "American dream" that is indeed a constructed and manipulated fantasy. The means to escape these illusory worlds and the attachments they engender are clearly violent: Rage Against the Machine advocates violent rebellion, Neo indiscriminately guns down the matrix-dwellers while fighting to liberate them, and Jack finds enlightenment in underground fighting clubs, acid burns, blowing up New York's financial district, and finally in putting a gun in his mouth and pulling the trigger.

Although our analysis has chronicled the rise of AMB using texts from 1990s America, there is plenty of evidence that AMB continues to influence American popular culture in the post-9/11 era. For example, let's return to *Star Wars: Episode III*, where the light-saber-wielding Yoda reflects on his failure to defeat the Sith in a meditation session wherein he communes with his deceased master. In a voice-over, Qui-Gon tells him that one can "defy oblivion. . . . It is a state acquired through compassion, not greed. You will learn to let go of everything. No attachment no thought of self. No physical self" (*Star Wars: Episode III—Revenge of the Sith*). If this insight is in stark contrast to the rage of Vader, who has completely abandoned himself to ego and passion, compassion seems curious advice for a Jedi who has just cut such a swath of death and destruction through his enemies. The Jedi are a corps of efficient killing machines who liberate and protect the galaxy by upholding republican (small *r*) values through political intrigue and the effective application of extreme violence. While this fusion of violence and apparently Buddhist ideals might confuse commentators such as Bortolin, it is perfectly understandable if one realizes the text is not traditionally Buddhist but AMB. Violence is the very means of liberation. To realize how this operates

in the *Star Wars* series, one need only remember Luke's confrontation with himself in the tree-test on Dagobah, or the resolution and liberation afforded by chucking Palpatine into that reactor shaft and restoring balance to the Force.

Hollywood, it seems, is quite comfortable with AMB, as further demonstrated by its tacit acceptance in the popular film *The Last Samurai*, starring American icon Tom Cruise. Set in 1870s Japan, *The Last Samurai* tells the story of a disgruntled American Indian Wars veteran's journey toward enlightenment. Captured by the Samurai warlord Katsumoto, Cruise's character, Nathan Algren, comes to appreciate the culture in which he has been unwillingly immersed. Powerful visual imagery, such as Katsumoto's meditation in a Buddhist temple, serves to cue the audience about the Buddhist nature of the Samurai culture. Indeed, in this movie, Buddhism is inseparable from the Bushido samurai-warrior identity of Katsumoto, and later, Algren. Katsumoto and Algren embark on parallel paths toward enlightenment. The movie's portrayal of the role of violence in attaining this goal is manifest and arresting.

During his captivity, Algren studies the samurai art of warfare and "the way of the sword." During a swordsmanship training session, Algren is taught to rely on the ostensibly Zen concept of "no mind" while fighting. After an unsuccessful bout, his teacher explains that Algren lost because he had "too many mind." This becomes the key insight for Algren, repeatedly demonstrated as he whispers "no mind . . . no mind," in several battles. He is also introduced to the Bushido code of honor that governs the lives of the samurai. In an important moment between the two characters, Katsumoto instructs his captive, Algren. Contemplating the cherry blossoms in his temple garden, Katsumoto says, "A perfect blossom is a rare thing. You could spend your life looking for one, and it would not be a wasted life." He also uses the blossom as a symbol of the transience of life, telling Algren that he comes to the garden to remember that "like these blossoms . . . we are all dying. To know life in every breath, every cup of tea, every life we take. The way of the warrior." Algren repeats this, clearly beginning to understand: "life in every breath," he whispers, and Katsumoto exclaims, "*that* is Bushido."

It is important to note that the movie makes no distinction between the potentially contradictory codes of Bushido and Buddhism. It seems to accept uncritically a fusion of violence and Zen

reminiscent of that detailed by Victoria in his study of Zen's appropriation and adaptation in prewar Japan. In *The Last Samurai*, this conflation culminates in the battlefield enlightenment of Katsumoto. As he dies in the arms of Algren on a field littered with the victims of his "glorious defeat," Katsumoto has an epiphany about his earlier conversation with Algren. It seems that the reflection on the blossoms has been serving as a Zen *kōan* for Katsumoto. As he commits ritual suicide with Algren's help, he sees the blossoms blowing off the trees that line the field and he whispers his last words: "perfect . . . they are all perfect." Classic imagery of ripeness and death, the blowing blossoms both symbolize and contrast with the field of corpses. Katsumoto's life thus concludes with the realization of perfection—specifically realizing that all blossoms are perfect and that one would waste one's life chasing some ideal of perfection. Spontaneously, all the imperial soldiers ringing the battlefield bow down to honor Katsumoto, and perhaps his enlightenment, on the field of death.

The violence inherent in the enlightenment process found in *The Last Samurai* demonstrates the pervasive influence of AMB. Hollywood, and perhaps America at large, seems to have accepted a vehicle of "Buddhism" employing violence as a means of liberation. We may have already seen one result of AMB's influence on notions of Buddhism and enlightenment in the days leading up to the 2003 Iraq War. The *New York Times* ran an article on September 18, 2003, headlined, "Dalai Lama Says Terrorism May Need a Violent Reply." The Dalai Lama's representative then sent a letter to the editors, complaining:

> Your headline, as well as the report on the interview with His Holiness the Dalai Lama by Laurie Goodstein, gives the misleading impression that His Holiness is endorsing violence as a way to confront terrorism. I am sure, as many of your readers are aware, His Holiness has always advocated nonviolence as the most effective method for dealing with conflict. (Rabgyal)

While this specific exchange may be the result of a simple misunderstanding, the prevalence of violence in American representations of Buddhism may enable an understanding of an enlightenment ideology in which violence is not eschewed but is embraced. Perhaps

drinking one's coffee on the morning after watching *The Matrix* or *The Last Samurai*, one wouldn't find it odd that the Dalai Lama would advocate a "violent reply." While AMB may be a natural result of Buddhism's assimilation into American culture, it is a disturbing development that might result in some dangerous consequences. At the very least, AMB appears to be promulgating an impression of Buddhism that strips it of its essential character of compassion. At worst, AMB might be legitimizing or further reinforcing the dangerous idea that Americans can attain, or even spread, liberation through violence. In the decade since we first noted the phenomenon, we've seen evidence that redemptive violence, whether dressed as Buddhism or not, is on the rise in America as well as beyond its borders. The implicit ironies of spreading freedom at gunpoint, or demanding "guns, more guns," when faced with a plague of gun violence, seem unlikely to be rectified in a society that not only glorifies violence but sees it as a legitimate, and sometimes only, path to true enlightenment.

Notes

1. The views expressed in this chapter are those of the authors and do not purport to reflect the position of the Department of the Defense or the United States Military Academy.
2. *The Matrix* films demonstrate AMB throughout the entire trilogy, and the theme of the series is, arguably, brought more in line with traditional Buddhism in the resolution of the plot in the later movies. However, because of its sheer impact on American pop culture and its clear portrayal of the tenets of AMB, we focus on the original 1999 movie here.
3. Note that this new adaptation of Buddhism is a popular culture artifact, not part of institutional Buddhism in America. You will not find military training or stockpiles of weapons at your local temple. However, representations of Buddhism in popular culture will likely be more influential in the reception, understanding, and adoption of Buddhism than anything happening at American Buddhist temples. As such, the emergence of AMB is both noteworthy and troubling.

4. Recent books on Zen by Brad Warner use both American punk music and Japanese monster movies as vehicles to discuss awakening. This new "shock jock" of American Buddhism seems to tap into the mood we've termed AMB. Warner's 2007 *Sit Down and Shut Up* is an in-your-face commentary on Dōgen's *Treasury of the Right Dharma Eye*, including a chapter entitled "Kill Your Anger" that evokes memories of de la Rocha's refrain, "Your anger is a gift!" closing the song "Freedom." Both advocate embracing anger as a means to liberation, although ultimately Warner's treatise turns into a more traditional take on dharma despite its punk music trappings.

5. As of 2013 it remains one of the top one hundred all-time box office hits in the United States, grossing $171,383,253 in theaters alone, and for non-U.S. audiences, it ranks at thirty-eight for the biggest gross receipts (IMDb).

6. The Puritan beliefs and myths about the providential taming of the wilderness set the stage for the American Revolution, as well. Indeed, Thomas Jefferson is often quoted in defense of the liberating and regenerative qualities of violence: "The tree of liberty must be refreshed from time to time with the blood of patriots and tyrants. It is its natural manure."

SEVEN

Buddhism, Our Desperation, and American Cinema

KARSTEN J. STRUHL

Speaking of his fellow Americans in the late 1840s, Henry David Thoreau wrote that "[t]he mass of men lead lives of quiet desperation" (Thoreau 6). In the year 2009, as I write this essay, the desperation in America is not so quiet. The financial system is near collapse, people are losing their homes and their jobs, pensions and savings are vanishing. There is a general consensus that part of what has caused the problem is the greed of key players in the banks and Wall Street. On a deeper level, we may be confronting a global economic crisis.

Perhaps the desperation was not so quiet in Thoreau's time either. Indeed, the United States has long been a culture of greed, acquisitiveness, competition, and selfish individualism. Added to this today is a culture of hedonistic spending and overextended credit. Wall Street and the banking system only make the problem worse. When the system threatens to collapse, it reveals itself as lacking a solid foundation. But the problem is not only external. It is also internal. How do we create a sense of a meaningful life? Can our inner life ever have a solid foundation? Can we find a way to connect our inner lives with one another? And so we continue either to lead lives of quiet (or not so quiet) desperation or, if the desperation becomes too intense, we commit suicide. American film often explores this desperation with varying answers. In this essay, I explore several cinematic portrayals of our desperation through a Buddhist approach

to the problem. I use this approach to focus on four films—*Wall Street* (1987), *Annie Hall* (1977), *Leaving Las Vegas* (1995), and *It's a Wonderful Life* (1946). Each of these films is an icon of American cinema. Each of these films highlights how the desperation that pervades American culture is produced by specific cravings fostered by that culture. *Wall Street* focuses on the cravings for money, status, possessions, and power that are so intimate a part of the fabric of our capitalist society. *Annie Hall* explores the way in which the craving for sex and relationships is used to fill the sense of emptiness that we feel at the core of our being. *Leaving Las Vegas* shows the main character in the grip of a craving that we would all identify as addiction (to alcohol) and the way in which this craving generates a craving for nonexistence. *It's a Wonderful Life* further develops this last theme and reveals that sometimes paradoxically the craving for nonexistence can be intimately bound up with a sense of responsibility and justice. By putting these four films together we see an array of cravings—for money, status, possessions, power, sex, relationships, alcohol, for being and also for nonbeing—and, through a Buddhist analysis, we can come to understand the way in which these cravings implicate at a deeper existential level the problem of the illusion of the self. The overall point of this essay is to demonstrate how a Buddhist analysis of these films can help us understand the cultural and existential roots of our desperation and, in so doing, become part of a larger project of Buddhist film criticism.[1]

The Buddhist Diagnosis of Our Desperation

Buddhism is perhaps best understood as a form of therapy. The first of the Four Noble Truths is that life is *dukkha*, often translated as suffering but which is perhaps better translated as a sense of dissatisfaction, of unease, or of emptiness. Two points need to be made immediately. The first is that Buddhism does not claim that existence ultimately has to be *dukkha*. The whole point of the third Noble Truth is that it is possible to reach a level of understanding that overcomes *dukkha*, that it is possible to attain *Nibbana* (*Nirvana*). Thus, that life is *dukkha* may be best understood as the claim that life as we generally tend to live it is *dukkha*. The second point is that Buddhism is not claiming that we never experience pleasure or even moments

of happiness. Rather the claim is that even our pleasure or happiness has at its core a lack of solidity, that there is emptiness at the core of our being, and, thus, a sense of something being deeply unsatisfactory and insubstantial. As such, it permeates the whole of our being.[2] In other words, our suffering is not simply ordinary suffering but existential suffering. We may attempt to cover this up with any number of diversions—money, fame, possessions, sex, even relationships. If we do not get what we want, we are dissatisfied. But even when we get what we want, loss or the threat of loss remains an ever present possibility. Our reputation may be ruined. We may lose our money and our possessions. The relationship we cherish may end, and even if it doesn't, it will not remain the same. In fact, nothing we have will remain the same. From the Buddhist perspective, impermanence is a fundamental fact of all existence. Everything that is will eventually cease to be. And we will eventually lose everything, and, as much as we may try to avoid thinking about it, we know that it will all end in old age, illness, and death. Hence, life has at its core a deep existential anxiety; hence our sense of quiet, and sometimes not so quiet, desperation.

For Buddhism, the possibility of overcoming our desperation depends on a clear diagnosis of the cause of *dukkha*. The cause of *dukkha* is *tanha*, which is translated as "thirst," "craving," or "desire." When we desire something, we want to hold on to it. But since everything is impermanent, this is impossible. The problem, then, is not the impermanence as such but the desire that would have the impermanent be permanent. Thus, desire itself is the problem. Desire sets up the cycle of *dukkha*. If we do not obtain that which we desire, we immediately suffer. But we perhaps suffer even more when we obtain the object of our desire, for when we obtain it, we experience a hit of pleasure. This hit of pleasure leads us to crave that which gave us pleasure, and then to cling to whatever gives us pleasure and to want even more of it. We are, in effect, all junkies who continually crave more of the object of our desires and are worried about its loss. And the more we crave, the more we are attached to the object of our craving; the more we worry about its loss, the more we chase after the object that we crave. Thus, it is our craving that is the source of our existential anxiety and of our desperation. "This is the origination of unease. . . . It is . . . craving for sensual pleasure, craving for being, and craving for non-being" (Wallis 37).[3]

At a deeper level, the problem implicates our understanding of ourselves, specifically, the idea that at the core of our being is a permanent, independent, separate self that controls our thoughts and actions throughout our lives. But since nothing is permanent, there cannot be an enduring permanent self. This idea that we have within us some permanent core, which we call the self, is, from the Buddhist perspective, only a mental formation. There is nothing within us to which it refers. And if there is nothing permanent within us, there is no independent self, nothing that forms the boundaries between myself and others, no self that executes orders to the rest of the mind and body, no self that unifies our mental dispositions and thoughts, no self that can possess the things that are the object of our cravings. Thus, the idea of a permanent, independent, separate, executive, unitary, possessive self is an illusion, and it is this illusion that is at the root of *dukkha*. It is not desire as such that causes our suffering, but desire that derives from the illusion of a separate self.[4] The problem is the triad self-desire-object of desire and the illusion that we are each with our self-encapsulated desires separate from each other. The desires that set up the cravings and attachments are rooted in our sense of separateness from other beings, from which it follows that the cessation of *dukkha*, which is *Nirvana*, requires dispelling the illusion of separateness. As the Vietnamese Buddhist monk and teacher Thich Nhat Hanh has said, "we are here to awaken from the illusion of our separateness" (Loy, *Money, Sex, War, Karma* 103). However, until we awaken from this illusion, we are trapped in the cycle of craving that can find no fulfillment or satisfaction—the craving for sensual pleasure, for being, and, when the desperation becomes overwhelming, for nonbeing.

Wall Street: A Parable of Greed

I began this essay with a reference to our present economic crisis. But this economic crisis did not begin recently. It began in the 1970s and 1980s with a set of high-tech and financial bubbles, with huge amounts of money being made by buying and selling companies rather than producing anything, with a failure of savings and loan associations, and with a worldwide debt crisis. During this time key players on Wall Street were extolling the virtue of greed, as they

manipulated the stock market and often flouted the insider trading rules. It was during the end of this period that Oliver Stone produced and directed *Wall Street*, which he also cowrote with Stanley Weisser.

Wall Street is a morality tale. The main protagonists are Gordon Gekko (Michael Douglas), a corporate raider who uses inside information to take over companies, to strip them, and then to sell off their assets at a huge profit; and Bud Fox, a Wall Street broker who is an all-too-willing protégé of Gekko. Bud initially approaches Gekko with a birthday present of Havana cigars and an analysis of some industries that he thinks will make a good investment. Gekko responds, "Come on, tell me something I don't know. It's my birthday, pal, surprise me . . ." Bud at that point provides Gekko with some information, which is not yet public, concerning Blue Star Airlines, and which he has recently learned from his father, Carl Fox (Martin Sheen), who is an aircraft mechanic for Blue Star and also a union representative. From there, it is a slippery slope into illegal activity, and Gekko soon has Bud spying on competitors and passing along inside information to which he has access in his capacity as a broker. In return, Bud gets enough money to buy an apartment on the Upper East Side of New York City, complete with a lover, Darien Taylor (Daryl Hannah) who is a decorator and art buyer for Gekko.

Gekko is a ruthless player whose goal is to make as much money as he can without regard to the social consequences. He loves winning and going for the kill in any transaction. At Teldar Paper's stockholders' meeting, Gekko, who is now the largest shareholder and is about to control the company, makes his values and, by implication, the values of Wall Street clear. "Greed is good. Greed works, greed is right. Greed clarifies, cuts through, and captures the essence of the evolutionary spirit. Greed in all its forms, greed for life, money, love, knowledge, has marked the upward surge of mankind."

But there are signs of disquiet. As Bud overlooks Central Park from the parapet of his East Side apartment, a look of confusion and despair crosses his face, and he says to himself, "Who am I?" The sense of desperation increases when Bud, who has urged Gekko to buy the controlling shares of Blue Star, soon learns that Gekko intends to liquidate Blue Star, selling off its main assets, which will ultimately result in the workers, including his father, losing their jobs. When Bud confronts Gekko and demands to know why he has decided to wreck the company, Gekko callously replies, "Because it's

wreckable. I took another look and changed my mind. . . . It's all about bucks, kid. The rest is conversation." With a sense of anguish, Bud responds, "Tell me, Gordon—when does it all end? How many yachts can you waterski behind? How much is enough?"

Because this is a morality tale, Bud finally succeeds in turning the tables on Gekko. However, as this is a morality tale, Bud's change of heart must not go unpunished. The Securities and Exchange Commission arrests him and has him wear a wire to incriminate Gekko. In the last scene of the film, Bud is walking up the courthouse stairs knowing that he is going to jail. We presume that Gekko is also going to jail. However, they are going to jail only because they clearly broke the law. The Wall Street manipulators, the bankers, the insurance company CEOs who live by the same values that Gekko expresses and that permeate American culture will not go to jail. Is there a karmic payback? The Buddhist analysis would say yes.

Let us begin with Gekko. He seems to have everything he wants— a wife, lovers, expensive art objects, more money than he can ever use, and power. Yet, as we watch him in his office, he seems to drive himself beyond endurance, answering phone calls, shouting at his assistants, and taking his blood pressure. He lives for winning, and nothing he can win will ever be enough. And when he loses, he is in a rage. Yet, he admits that the whole process is an illusion, an illusion that becomes more real than reality, and the more real the illusion, the more he desperately wants it. The sense of desperation is built into the game. Who is Gordon Gekko? He would be hard-pressed to answer, just as he cannot really answer how much is enough. He is a player and that is all, for if he is not a player, then he is nothing. And who is Bud Fox? At the height of his wealth and social status, he can still be disconsolate and ask plaintively, "Who am I?" When he looks in the mirror, he doesn't like what he sees.

Neither Gordon Gekko nor Bud Fox can know who they are, caught in the cycle of craving for money, status, possessions, and power. Money in particular becomes a way to evade *dukkha* and, at the deepest level, a way to evade the recognition that there is no self that can provide a permanent ground of our being, the recognition that there is nothing within us to which we can cling. We interpret this lack of self as a feeling that there is something missing to which money may supply the answer:

> In modern developed . . . societies such as the United States,
> I am likely to understand my lack as not having enough
> money—regardless of how much money I already have.
> Money is important to us not only because we can buy any-
> thing with it, but also because it has become a kind of collec-
> tive *reality symbol*. The more money you get, the more real
> you become. (Loy, *Money, Sex, War, Karma* 19–20)

However, since money does not provide any genuine reality, since
it cannot fill the emptiness within us, it simply increases the crav-
ing and attachment, which produces *dukkha*. Our response, unfortu-
nately, is the typical response of the junkie. We must need even more
money. No amount can ever be enough. Wall Street feeds on *tanha*
or craving.

Annie Hall: Craving Sex and Relationship

It is not only money that provides us with a reality symbol that
attempts to evade *dukkha*. We also often use sex and the search
for relationships to fill the emptiness at the core of our being. Per-
haps the best American film to explore this issue is Woody Allen's
Annie Hall.[5] Produced ten years earlier than *Wall Street, Annie Hall*
is still emblematic of the dilemmas of intimate relationships in con-
temporary urban America. In the opening scene of the film, Alvy
Singer (Woody Allen), the film's main protagonist, speaks directly
to the film viewers and tells us a joke, attributed to Groucho Marx:
"I would never want to belong to any club that would have someone
like me for a member." Alvy then adds, "that's the key joke of my life
in terms of my relationships with women." The paradox in the joke
can be presented as a Zen *kōan*. How can we form a relationship
without bringing ourselves into the picture? How can we get into a
relationship when the self always gets in the way?

Upon telling the joke, Alvy announces that he has broken up
with Annie Hall (Diane Keaton) but that he cannot get her out of his
mind, and the rest of the film is a dark comic examination of what
happened. Through a series of flashbacks, the film shows us Alvy's
recollections of childhood, his past relationships with his wives and

lovers, his first encounter with Annie on a tennis court, an uncomfortable meeting with Annie's family, problems in their sex life, their breakups and reconciliations, to his futile attempt to get Annie to leave her Hollywood lover and join him in New York and finally (after some time) to a chance meeting with Annie who is now living in Soho with another lover.

Alvy is a neurotic, politically liberal, Jewish New York intellectual who works as a stand-up comedian for television. Although he frantically craves a satisfying sexual and loving relationship to cure his existential dissatisfaction, he nonetheless cannot commit himself to Annie, insisting that even while she is living with him, she keep her own apartment as "a free floating life raft" so that "we know that we're not married." On a deeper level, Alvy is so self-centered that he is incapable of relating genuinely to anyone or anything. Toward the end of the film, Annie observes, "Alvy, you're incapable of enjoying life . . . I mean, your life is New York City. . . . You're like this island unto yourself."

When Alvy first meets Annie, she is a confused, insecure, zany women from Chippewa Falls, Wisconsin, who dreams of being a singer. While the sexual relationship seems satisfying at first, it isn't long before sex becomes a battlefield, and sex becomes a barrier between them. In one sadly funny sex scene, Annie's spirit arises from the bed and decides to do some drawing while her body is having sex. When Alvy, sensing the distance, protests that she seems removed, she responds nonchalantly, "Oh, you have my body." Annie has changed. Alvy, trying to remake her to fit the relationship he thinks he should be having, encourages her to take adult education classes and to go into therapy, through which she gains a sense of self-confidence and the recognition that she has a right to assert her own needs. The Pygmalion story is reversed, and she soon finds that she is outgrowing Alvy, which becomes the underlying motive for their last breakup.

From a Buddhist point of view,[6] the problem that emerges so far in *Annie Hall* is ultimately the same problem as what we have seen in *Wall Street*. Just substitute "sex and relationship" for "money and power" and we can make the same diagnosis of Alvy's problem, and, by extension, the problem of American culture. The Groucho Marx joke as a paradoxical Zen *kōan* finds its solution in the recognition of the illusion of self from which our cravings and attachments are

born. For the illusion self becomes a barrier to any authentic rela-
tionship. The way to form a relationship without letting ourselves get
in the way is to form a relationship without this illusion. However,
this is precisely what Alvy cannot do, since he clings to his illusion of
separateness the way he clings to the island of New York. He cannot
ever commit himself to a relationship, because this would disturb his
sense of separation, and yet, vaguely aware of the emptiness within,
he tries to fill it with a frantic search for sex and relationships. The
result is that sex itself, instead of becoming a loving interconnection,
becomes a battlefield between two entities driven by their separate
needs or at best an exchange of need for need, desire for desire. And
as Annie changes, Alvy who craves the permanence of self cannot
accept the reality of impermanence within the relationship and, ulti-
mately, of the relationship itself. The result is a sense of the impossi-
bility of relationships alongside a continual craving for relationships.
At the end of the film, Alvy again turns to the film audience with a
joke:

> . . . this guy goes to a psychiatrist and says, "Doc, uh, my
> brother's crazy. He thinks he's a chicken." And, uh, the doc-
> tor says, "Well, why don't you turn him in?" And the guy
> says, "I would, but I need the eggs." Well, I guess that's pretty
> much how I feel about relationships. You know, they're
> totally irrational and crazy and absurd . . . but, uh. I guess we
> keep going through it because, uh, most of us need the eggs.

Given the illusion of self, we must first separate from others and
then try to reconnect by collecting imaginary eggs. The strategy is
doomed to failure, and most of us can sense it. However, as we don't
know any other way to connect, we keep desperately searching for
the eggs.

The desperate search for sex and relationships is also an attempt
to give our lives a sense of meaning in the face of the emptiness of
dukkha. However, any attempt to confront the meaning of life as
a whole must confront its inevitable ending, at least in its existing
embodied form, and the possibility of its ending at any moment.
Thus, to confront the meaning of our existence is simultaneously to
confront the meaning of our nonexistence. It is not surprising, then,
that alongside the themes of sex and relationships, the theme of death

and suicide makes its appearance in *Annie Hall*.[7] Alvy buys books on death for Annie and explains, "I'm obsessed with—with, uh, with death . . . big subject with me, yeah." When Alvy visits Annie's family, her brother Duane takes him aside and confesses that when driving, he often has a "sudden impulse to turn the wheel quickly, head-on into the oncoming car." In one of his stand-up comedy routines, Alvy says, "I was . . . in analysis, I . . . was suicidal; as a matter of fact, uh, I would have killed myself but I was in analysis with a strict Freudian and if you kill yourself . . . they make you pay for the sessions." Perhaps most significant is the portrayal of Alvy as a young boy in Brooklyn seeing a psychiatrist, because he is depressed. The reason— the universe is expanding and "if it is expanding, someday it will break apart and that would be the end of everything." Alvy's mother shouts at him, "What is that your business," and turning to the doctor says, "he's stopped doing his homework." Alvy, with a shrug, replies, "What's the point?" What, indeed, is the point to life if everything we encounter and even the universe as a whole is impermanent? If everything is impermanent, then it would seem that human existence has no intrinsic meaning. How do we find meaning in the face of impermanence? The Buddhist answer is to accept and even embrace life's impermanence. However, this is easier said than done. To be able to accept impermanence requires systematic attention to the ways in which our craving for permanence causes us to suffer.

The French existential philosopher Albert Camus wrestled with this problem in *The Myth of Sisyphus*. In traditional Western theology, God provides the permanence that provides the ultimate justification for human existence and for the universe. If, on the other hand, there is nothing permanent to provide an ultimate justification for existence, then life as a whole is meaningless and absurd. In other words, if the universe and human life has no meaning beyond itself, then it makes no ultimate difference whether I was born or whether I continue to live. Why, then, should it matter if I die? Thus, for Camus, "there is only one truly serious philosophical problem, and that is suicide" (Camus 3). If there is no ultimate point to life as a whole and if life becomes burdensome, then why should I not end it? Camus's answer is to confront, acknowledge, and live the contradiction between the desire for everything to be rational and the ultimate meaninglessness of the world, in effect, to accept the limits of reason and to confront the absurd with courage. For Buddhism,

the answer cannot be found in the attempt to either give or deny life philosophical meaning. The problem of life is *dukkha* and its solution is to extinguish *tanha* and the illusion of self.[8] For Buddhism, the desire to kill oneself is also *tanha*, and it equally implicates the illusion of self.

As I have indicated earlier, *tanha* is not only the craving for sexual pleasure and for existence but also for nonexistence. The illusion of self continues to play the motivating role, since when the craving and attachments generated by the illusion become too painful, we seek to kill the self. It is as though we are saying to ourselves that this thing, the self, is too much of a problem and must be extinguished. But we can never do this, since there is nothing within us corresponding to the false idea of the self. Hence the desire to kill the self only increases *dukkha*. We now examine two films in which the theme of suicide plays a predominant role.

Leaving Las Vegas: Craving Nonexistence

While our craving is grounded in the illusion of self, craving also reinforces the illusion, since it produces a feeling of "me" who craves and a "mine" that is the object of the craving. From this it follows that we need to protect both the "me" and the "mine." However, craving can reach a point of desperation where the "me" feels empty of any value and the object of the craving can become a means to destroy the "me." This is often the case with what we specifically term "addiction,"[9] since the addict's craving tends to produce a self-loathing and a desire for self-destruction. The self-destruction, in turn, can often take the form of the addiction itself. This is the theme that is powerfully explored in *Leaving Las Vegas*.[10] The film's protagonist is Ben Sanderson (Nicolas Cage),[11] an alcoholic whose addiction has reached the point where he is embarrassing to his friends and can no longer function reasonably in his job as a Hollywood screenwriter.

Shortly after the film begins, Ben is fired and given a large severance check. After that we see him divesting himself of most of his possessions, burning the photographs of his past (including one of his wife and son), throwing out records, tapes, clothing, and even medical records as well as birth and marriage certificates. He seems, then, not only to be giving up his possessions but even his sense of

identity. His goal, however, is not enlightenment but to use the last of his money, which we can assume is his severance pay, to literally drink himself to death, a task that he calculates with precision—$250 to $300 per day for about four weeks.

Once in Las Vegas, he meets Sera, a prostitute, whom he offers $500 to go to his seedy hotel room. It is here that the film moves in another direction, exposing Ben's intense loneliness, for what he wants from Sera is not sex but simply someone with whom he can talk. Sera somehow sees Ben as a kindred soul with whom she can empathize. They soon form a relationship that has one important ground rule: they are not to try to change each other. In other words, Ben must accept Sera as a prostitute, and Sera must not try to talk Ben out of killing himself. Sera soon convinces Ben to move into her apartment and, in spite of Ben's alcoholic episodes, becomes increasingly attached to him and, in fact, eventually comes to believe that she loves him. And Ben sees her as "some sort of angel visiting me from out of my drunken fantasies." If this were a film with a typical Hollywood ending, we could assume that their love would overcome this initial agreement and that they would somehow save each other. But this is not the direction of the film. Eventually, as Sera confronts how Ben is destroying himself, she insists that he see a doctor, to which Ben responds, "Sera . . . I'm not going to see a doctor. Maybe it's time I move to a hotel." Ben makes his break with Sera cruelly. That evening, while Sera is working, Ben brings a prostitute back to her apartment. Sera is furious and Ben leaves, without indicating where he is going. They see each other only one more time in Ben's motel room. They make love for the first time, and Ben says, "You know I love you," and then, "I'm so sorry." And with those last words, he dies.

Why cannot love save Ben? From a Buddhist point of view, no one can ever save another. Buddha, in his last talk to his disciples, insists, "be ye lamps unto yourselves. Rely on yourselves. . . . Look not for assistance to anyone besides yourselves" (Burtt 49).[12] We each have within ourselves the capacity to overcome *dukkha*. Other people may offer useful suggestions. They may help us to reconsider what we are doing through their concern, empathy, and love. They may provide emotional support, but they cannot relieve us of the responsibility to confront the emptiness at the core of our being. They cannot fill that emptiness.[13] Ultimately, each of us must decide

what path to take. Ben's path has been chosen from within his crav-
ing—both the craving for alcohol and the craving for nonbeing. The
two are so intertwined that they cannot be separated. When Sera
specifically asks him, "Are you . . . drinking as a way to kill yourself?"
Ben answers, ". . . or killing myself as a way to drink." Underlying
Ben's choice is his assumption that there is a real self that needs to
be annihilated. His decision to give up his possessions and the exter-
nal documents of his identity is symbolically his decision to make
himself nothing. Thus, the craving for alcohol is now reinforced by
the craving to extinguish the self, and the craving to extinguish the
self reinforces the craving for alcohol. Sera's love can move Ben so
long as she does not disturb the cycles of his twin cravings, and she,
therefore, remains for him a visiting angel from his drunken fantasy.
And Ben's love for Sera is still a narcissistic love trapped within these
same cycles of craving.

The craving for nonbeing also reveals the flip side of the illusion
of self. The illusion of a permanent self is termed, within Buddhism,
the "eternalist" illusion, for it assumes that there is some permanent
self, which will endure. The opposing illusion, what Buddhism terms
the "annihilationist" illusion, is that I am nothing or that I must
be made nothing. Buddhism posits the middle way between these
extremes. While there is no permanent self, I am at any moment the
result of what I have been in the previous moments of my life. My
thoughts, desires, intentions, sensations, memories, anticipations,
feelings, and so forth, at this moment are the result of these same ele-
ments the moment before, which in turn produces the result of these
psychophysical processes throughout my life.[14] In other words, what
establishes our identity is not a self behind these processes but the
causal continuity itself. Therefore, to assume that I am nothing is to
deny this continuity, which, for Buddhism traditionally, will extend
beyond the death of my body. Thus, as Chan Master Sheng Yen has
noted, "suicide is pointless. When one's karmic retribution is not
exhausted, death by suicide only to leads to another cycle of rebirth."[15]
We may think of rebirth literally, as reincarnation, or we may think
of it as something that happens moment to moment, each moment
being a rebirth.[16] In either case, suicide cannot solve the problem of
dukkha. Whether or not we will be reincarnated in another bodily
form, seeking our own nonexistence does not address the problem of
dukkha, as it does not eliminate the cravings that produce it. In other

words, death cannot be a solution, since the craving for death is part of the problem. The attempt to run away from the object of our suffering—in this case ourselves—is, nonetheless a form of craving that produces suffering. It only continues the cycle of pain and suffering for oneself and, as the portrayal of Sera makes clear, for others. I cannot kill the self, since there is no self that can die.

It's a Wonderful Life: The Illusion of the Dream Self

The desperation that motivates suicide does not depend on an identifiable substance addiction or an overt narcissism. It may also paradoxically, as *It's a Wonderful Life*[17] demonstrates, coexist with a sense of responsibility, a sense of justice, and even altruism. The film begins with scenes of a snowy Christmas Eve in the little town of Bedford Falls and the sounds of various people praying for George Baily (James Stewart), who is the film's hero. It is clear from these voices that he is much loved but also that he is in serious trouble. The camera then moves from the town to a shot of the earth and then to the stars, where we hear heavenly voices discussing the need to send an angel down to earth to help George, who is about to kill himself. The angel turns out to be Clarence (Henry Travers), angel second class, with "the IQ of a rabbit" but the simple "faith of a child." If he succeeds in saving George, he may yet get his wings. But first he must review George's life, and much of the film goes back in time showing scenes of the main events of George's life.

We see George as a twelve year old in 1919 saving his younger brother from drowning beneath the ice, which causes him to lose hearing in his left ear. We see him as a young boy, risking and ultimately enduring a beating in order to prevent his employer Mr. Gower (H. B. Warner), a pharmacist, from mistakenly sending poison medicine to a sick child. We see George, who has already put off college to work in his father and uncle's Building and Loan business for four years until his brother Harry (Todd Karns) can graduate high school, now excited about a long awaited trip to Europe and then college. But his father, Peter Baily (Samuel S. Hinds) dies of a sudden stroke, and George, who by now is desperate to leave Bedford Falls, is faced with the prospect of the business being dissolved

at the instigation of the villain of the movie, Henry F. Potter (Lionel Barrymore).

Mr. Potter owns most of the economic institutions in the town, including the main bank, and is also one of the members of the Board of Directors of the Building and Loan Company. George argues at the meeting to save the company, as it is the only institution to which ordinary working people can turn for reasonable loans so that they can purchase decent homes. The members of the board agree on the condition that he takes his father's place as head of the company. George, then, sadly forfeits his plans for travel and college once again and gives the money he has been saving to Harry so that he can go to college, the assumption being that Harry will take over the business when he has graduated. Four years later, Harry does graduate but has now married someone who wants to have him work in her father's business. Although George is still desperate to leave Bedford Falls, he decides once again to sacrifice his own needs and dreams in favor of Harry's new life and marriage.

George is now resigned to what seems his fate and marries Mary Hatch (Donna Reed), a sweet woman who has loved him from childhood. But more sacrifices seem to be required. Just as he and Mary are about to leave for their honeymoon for a trip to New York and Bermuda (this might be the first real vacation that George has ever had), there is a run on the Building and Loan Company, and Mr. Potter is about to use this occasion to take over the company. George, with Mary's help, once again saves the company by using their honeymoon money to cover what their depositors temporarily need. George and Mary eventually have four children, and Mary proves to be a very devoted and caring wife. But George is clearly not happy. He often comes home with a disgruntled look. Although he does enormous good for people in the town, it would seem that his own life is one of quiet desperation.

When World War II begins, George cannot enlist because of his deaf ear, and so he remains in Bedford Falls. One day, George's uncle, Billy Baily (Thomas Mitchell), who now assists George in the Building and Loan Company, absentmindedly misplaces $8,000 of the company's money, which he is about to deposit. On that same day the bank examiner comes to examine the records of the Building and Loan Company. George confesses that he cannot find the money,

and Mr. Potter, as a stockholder of the Building and Loan Company, threatens to have George arrested for misappropriating funds. Now all George's demons seem to be unleashed. He goes home in utter despair, screams at Mary and his children, and storms out of the house in a fury. He goes into a bar, gets into a fight, crashes his car into a tree, and is finally about to jump from a bridge to kill himself. At that moment, Clarence, angel second class, jumps into the water first and pretends to be drowning. George wakes from his desperation and saves Clarence, who then reveals his true identity to George. After an initial disbelief, George tells Clarence that he wishes he had never been born. Clarence grants him that wish and creates an alternative reality for George in which he has never existed.

In this alternative reality, George has no worries or obligations but also no identity. In this alternative reality, no one recognizes George, not his friends, not his mother, not even Mary. Furthermore, in this alternative reality, the town is completely changed. Potter completely runs things, as there is no competing Building and Loan Company, and the town is now called Pottersville. People are more impoverished, meaner, and generally more aggressive. Mr. Gower has been in prison until just recently and is now an alcoholic because George was not there to stop him from sending poison medicine to an ill child. Mary never got married. George's mother runs a boarding house. Uncle Billy is in an insane asylum. Harry died at the age of nine, and so did the men that Harry, had he lived, would have saved in the war. George begins to understand what his life has meant to others, and Clarence sums up his awakening: "Each man's life touches so many other lives, and when he isn't around he leaves an awful hole." George's reality is restored, and George comes to realize that he has a wonderful life. Although, he is eventually saved by donations from the town, it no longer matters to him that he might have gone to jail. He can now affirm that his life is wonderful. From a Buddhist perspective, Clarence is a dharma teacher and George, if not enlightened, is at least now awake.

What George now understands is that he has made a real difference in people's lives. But why didn't he understand that before? Why didn't that give him a sufficient sense of personal worth? Why couldn't Mary's love or his children's love save him? After all, he does not sacrifice his personal desires and dreams just out of a sense of family responsibility. He does it also to prevent Mr. Potter from

controlling and oppressing the ordinary citizens of the town, which is to say that he is motivated, in part, by a sense of justice. Furthermore, throughout his life he seems to be motivated by a genuine caring for other people. Then why this dark side?

The answer to these questions requires a deeper look at George's ambitions and his sense of self. His sense of self is tied up with a dream that he tells Mary just before he learns that his father has had a stroke:

> I'm shaking the dust of this crummy little town off my feet and I'm going to see the world. Italy, Greece, the Parthenon, the Coliseum. Then I'm coming back here and go to college and see what they know . . . and then I'm going to build things. I'm gonna build air fields. I'm gonna build skyscrapers a hundred stories high. I'm gonna build bridges a mile long. (*It's a Wonderful Life*)

And this inflated dream self keeps emerging. As George waits for Harry to return from college to take over the Building and Loan Company, he takes some travel folders out of his pocket and says to Billy, "Look at this . . . Venezuela oil fields—wanted, man with construction experience. Here's the Yukon, right here—wanted, man with engineering experience." Thus, we might say that George's dream self cries out in desperation so that he cannot see his real importance, which is his importance to other people. George is kind and giving and responsible and has a sense of fairness. But he cannot see the achievements that flow from these traits, because he is too wrapped up in the self of the dream. While George is not addicted to alcohol or drugs, he too has a master craving. It is a craving for a self that is somewhere else. It is only by giving up this dream self that he can begin to understand his interdependence with others. Has George given up the illusion of self? American cinema is not generally able to go that far. But he is now on the path.

Concluding Thoughts: Buddhist Echoes in American Films

The themes of these four films intersect in a way that makes the Buddhist perspective all the more significant for understanding the

desperation of American culture. The craving for wealth and power that is examined through the characters of Gekko and Bud in *Wall Street* is repeated in the character of Mr. Potter in *It's a Wonderful Life*. The craving for relationship and the simultaneous inability to form relationships is the dilemma of both Alvy in *Annie Hall* and Ben in *Leaving Las Vegas*. Both *It's a Wonderful Life* and *Leaving Las Vegas* provide a way of understanding two faces of suicide.

Nevertheless, I have no reason to think that the screenwriters or directors of these films were conscious of the Buddhist diagnosis of *dukkha*. Why, then, are these iconic films so amenable to Buddhist analysis? The answer, I believe, lies in the potential of American cinema to capture the underlying social, psychological, and existential dynamics of American culture. Since American society is especially hyper-individualist, competitive, possessive, and consumer oriented, it displays many obvious signs of self-oriented cravings and attachments. As the kinds of films that I have chosen reflect this culture and reveal the underlying desperation that it produces and that it tries simultaneously to evade, Buddhist film criticism can offer a way of understanding how the cultural and existential roots of this desperation interact. The point of doing so, however, is not merely to add to a growing body of film criticism. The larger project is to develop a Buddhist cultural criticism that can offer a social critique and upon whose basis a Buddhist social theory can be constructed. Such a project would have as its goal not only personal transformation but also social and political transformation. Such a project would recognize that the problem is not only individual *dukkha* but also social *dukkha* and would seek to confront and to change the social and political conditions that foster *tanha* and the illusion of a separate self. In other words, Buddhist film criticism can be used not only to interpret those films that reflect our existential anguish but to become part of an engaged Buddhism that would change the world. Hopefully, this essay can make a small contribution to this project.[18]

Notes

1. I am not claiming that Buddhism is the only or even the best method for analyzing the causes of the desperation that pervades American culture. Other theoretical perspectives—for

example, Freudian, Marxist, feminist, postmodern—can each help us understand the significance of our desperation as manifested through these and other iconic films. The ideal film criticism to accomplish this task would be an integration of several theoretical perspectives. However, before such an integration can take place, it is necessary to develop each method of analysis in its own terms. Since a Buddhist approach to film is only beginning to emerge, the point of my analysis here is to contribute to a uniquely Buddhist film criticism.

2. Mark Epstein, a Buddhist psychotherapist, has, therefore, suggested that perhaps the best translation of *dukkha* would be "pervasive unsatisfactoriness" (46).

3. From "Turning the Wheel of the Teaching," *Dhammacakkappavattana Sutta.*

4. In fact, not all desires present a problem. Desire that derives from compassion, desire to help others, desire for Enlightenment does not bring about *dukkha*.

5. At the Academy Awards of 1977, *Annie Hall* won Best Picture, Woody Allen won Best Director, Allen and Brickman won for Best Original Screenplay, and Diane Keaton won Best Actress.

6. Buddhism is hardly monolithic. There are, of course, many kinds of Buddhism, in effect, many Buddhisms, and there is significant disagreement between them about such metaphysical issues as karma and rebirth, about the relation between *Nirvana* and our everyday life, and about the significance of sexuality and personal relationships in attaining Enlightenment. Whatever the differences, however, there is a core agreement that *dukkha* arises from *tanha* and that *tanha* is bound up with the illusion of self. My use of the phrase "from a Buddhist point of view" should, therefore, be understood as my attempt to apply these core concepts and their implications to the films and issues under discussion.

7. The connection between love, sex, and death reoccurs often within Woody Allen's films, one of which is appropriately entitled *Love and Death* (1975).

8. While *Nirvana* is sometimes described as something ultimate, it is not ultimate in the sense that it gives, like the Judeo-Christian conception of God, some ultimate philosophical meaning to the universe or human existence. *Nirvana* is the extinguishing

of *tanha*, which would include extinguishing the desire to give life or the universe some ultimate rational foundation. Since, for Camus, the absurd arises from the conflict between the desire that the world be reasonable and its ultimate lack of reason, the extinguishing of this desire would also be the extinguishing of the absurd.

9. All craving, in fact, produces an addiction in that it produces an attachment; that is, we are all addicted to possessions, money, food, power, sex, relationships, among other things. However, the term "addiction" is usually reserved for specific substances, or, when applied to more ordinary substances, it suggests a craving so powerful that it eclipses most other concerns (and cravings).

10. Figgis's screenplay is based on a novel by John O'Brien, who killed himself before the movie was made. His father said that he regarded his son's novel as a suicide note.

11. Cage won an Academy Award for Best Actor for this role.

12. Although there are some schools of Buddhism that regard Buddha as a savior, Buddha himself always insisted that he was simply a human being who through his intense effort became Enlightened. "Instead of presenting himself as a savior, the Buddha saw himself as a healer" (Batchelor, *Buddhism without Beliefs* 6).

13. "We anticipate that our partner will somehow make us feel complete, but that never happens, because no one else can ever do that for us" (Loy, *Money, Sex, War, Karma* 75).

14. Buddhism groups these physical and psychological events and dispositions into five aggregates, but the point of what establishes our identity does not depend on the specific way we group these processes.

15. Quoted in http://www.theemotionmachine.com/morals/buddhism-and-suicide (accessed 23 September 2009).

16. Buddha did believe in reincarnation, and certain schools of Buddhism consider reincarnation fundamental. Tibetan Buddhism, for example, has developed an elaborate narrative about the stages of disembodied life prior to reincarnation in another bodily form. However, as Stephen Batchelor in *Buddhism without Beliefs* argues, "in accepting the idea of rebirth, Buddha reflected

the worldview of his time" (35). Our modern Western scientific worldview is generally uncomfortable with this idea, and Western Buddhism has often reflected this discomfort. Furthermore, reincarnation seems to presuppose the idea of an enduring self, whereas Buddhism regards the idea of the self as an illusion. How to reconcile these two concepts has haunted Buddhism for centuries, and different schools of Buddhism have offered different kinds of solutions to the problem. Batchelor's own solution is to be agnostic. "We neither have to adopt the literal versions of rebirth nor fall into the extreme of regarding death as an annihilation" (38). Other Western Buddhists have rejected the idea entirely. Steve Hagen argues that the idea of rebirth be distinguished from reincarnation.

> The Buddha spoke of rebirth (the full term is "rebirth consciousness"), not reincarnation. Rebirth consciousness is the awareness that *this moment* is not *this* (new) *moment*. The person *here now* is not the same person *here* (in this newly formed moment) *now*. . . . Each moment is fresh, new, unique—impermanent. (Hagen 45)

In other words, rebirth occurs continually in this life, from moment to moment. There is no need to posit another life after death.

17. Directed by Frank Capra. The final screenplay was a collaboration of Capra with Philip Van Doren Stern (the film was base on his short story, "The Greatest Gift"), Francis Goodrich, Albert Hackett, Jo Swerling, and Michael Wilson.

18. I am indebted to David Loy for the concept of "social *dukkha*." In *Money, Sex, War, Karma*, Loy argues for a socially engaged Buddhism that will address "the institutionalized social *dukkha* perpetrated and perpetuated by our globalizing, corporation-dominated economic system" (152). For other discussions of socially engaged Buddhism, see the writings of Thich Nhat Hanh, Sulak Sivaraksa, the Dalai Lama, Robert Thurman, and Ken Jones, which are mentioned in the bibliography of this volume.

EIGHT

Christian Allegory, Buddhism, and Bardo in Richard Kelly's *Donnie Darko*

DEVIN HARNER

In his *New York Times* review of Clint Eastwood's *Hereafter* (2010), A. O. Scott notes that "persuasion is not really the point, though if anyone could make [him] believe in ghosts, it would be Clint Eastwood" (Scott). Scott is referring to the fact that, *Every Which Way but Loose* aside, Eastwood's films are typically sparse, plausible, and realistic. Although most of its action centers on protagonists attempting to come to terms with what happens to us after death, and it posits no answers, as *Hereafter* meanders tentatively and briefly into a depiction of the afterlife, it is representative of Hollywood's steadily evolving treatment of life after death over the course of the last twenty-five years. Indeed, contemporary American filmmakers are increasingly addressing complex theological and philosophical ideas in mainstream dramas, and their efforts are no longer relegated to the horror and comedy genres.

Such progress was made possible through stories about angels that transitioned out of horror or fantasy and into a sort of realism. Both the staid 1980s television melodrama *Highway to Heaven*, in which Michael Landon and Victor French play an angelic odd couple who travel through America and help people in times of crisis, and Wim Wender's deep, Rilke-inspired *Wings of Desire* (1987), where the angels Damiel and Cassiel bear witness to the lives of ordinary Berliners during the last days of the Cold War era in divided Germany, put the ethereal into play with realistic supporting characters.

Furthermore, *City of Angels* (1998), Brad Silberling's American remake of *Wings of Desire*, and *A Life Less Ordinary* (1997), directed by Danny Boyle, turned angels into pop culture commodities more realistically hewn than earlier flat two-dimensional depictions, and less terrifying than those represented by poets like John Milton and Rainer Maria Rilke. In Hollywood, the angels of ruined cities and flaming swords persist in the horror genre, as in Christopher Walken's Old Testament–style portrayal of Gabriel in Gregory Widen's apocalyptic film, *The Prophecy* (1995).

Even as Hollywood has repositioned the angel for mass consumption, and rendered a realistic treatment of theology, it has also moved toward Eastern philosophies and commoditized and adapted the Buddhist idea of reincarnation for the American palate. Historically, mainstream cinema has depicted reincarnation as something to be laughed at, terrified of, or anticipated—in that it represents a second chance in life and the opportunity to get things right. Reincarnation is not a belief that is overtly present in Christian dogma, seeing that it was banned by the Council of Nicaea in 325 AD. Still, a 2009 Pew poll concluded that approximately one in four Americans believe in reincarnation and, perhaps more surprisingly, 24 percent of Catholics and 10 percent of Evangelical Christians count themselves among the believers.

Given the Church's perspective on reincarnation, it is likely that this believing comes not from a careful and ecumenically minded study of the world's religions but from yoga teachers who routinely pepper their directions to try difficult poses with reassuring disclaimers like "you're not going to get this pose right in this lifetime," and from popular film and television. As a consequence, the typical American take on reincarnation is a perversion of Buddhist doctrine that is driven, paradoxically, by ego, in which the self likes his or her life and wants to keep on living. We live in an age where t-shirts extolling mottos such as "Life Is Good" override Buddhist teachings like the First Noble Truth, "existence is suffering." The preference to "Life Is Good" is telling of the West's attachment to the perceived sensations of the "good" in life, and the realization from the First Noble Truth that these sensations are ultimately fleeting and lead to suffering is a bitter pill to swallow. "Life Is Good" does not only prevail over American society but also is emphasized by the distorted perception of reincarnation as a second chance in life as a far

more appealing thought than going to heaven. It is logical, then, that American cinema has reflected our collective cultural desires and articulated a vision of the afterlife that is paradoxically more self-indulgent and more Eastern.

As envisioned by Hollywood, reincarnation is often a strange cosmic mix-up that provides slapstick laughs or an occasion for ill-conceived déjà-vu and romantic melodrama. Blake Edward's *Switch* (1991), in which Jimmy Smits's womanizing character is reincarnated as a woman in a massive oversimplification of "instant karma," and Carl Reiner's *All of Me* (1984), starring Steve Martin and Lily Tomlin, about a lawyer who is hit in the head with an urn containing the ashes of a dead woman who takes over half of his body, are examples of the former. Kenneth Branagh's *Dead Again* (1991), a film noir involving love and murder over the course of two lifetimes, is a prime example of the later.

The most recent and realistically drawn of these reincarnation films, Jonathan Glazer's *Birth* (2004), is like *Good Will Hunting* (1997) meets *Little Buddha* (1993). The plot centers on a ten-year-old boy from the wrong side of the tracks, who appears uninvited to a birthday party in uptown Manhattan and claims to be the reincarnation of a woman's long-dead husband. The film ultimately retreats into a rational ending. It is revealed that the boy is a fraud who found a cache of buried love letters, which enabled him to know things that a stranger would not know. Nonetheless, *Birth* is important, philosophically, as something of a baby step toward the plausibility that Scott assigns to Eastwood's *Hereafter*, because it represents Hollywood treating reincarnation in a manner that is essentially realistic and outside of the realms of horror, comedy, or science fiction.

In addition to reincarnation, American filmmakers have also begun to explore the Buddhist idea of the transitional state between death and the next incarnation, in which the karmic tally is settled. When we refer to bardo as it is commonly understood in the West, and as it is treated in cinema, we are actually considering the state that *The Tibetan Book of the Dead* differentiates as *chosnyid bardo*, or the intermediate state of reality that occurs after the intermediate state of the time of death and before the intermediate state of rebirth. There are six intermediate states, or bardos, in total. The repetition of the word *intermediate* in these definitions is not redundant, as much as instructive, in that within both the Nyingma and Kagyu schools,

all of these states, including our waking life itself—the intermediate state of living or the *rangbzhin bardo*—are liminal and transitory.

In *The Tibetan Book of Living and Dying*, his interpretive companion to *The Tibetan Book of the Dead* geared toward Western readers, Sogyal Rinpoche refers to the *chosnyid bardo* as the bardo of becoming, or the *sipa bardo*, and describes it as ghostlike. According to Rinpoche, in the *sipa bardo*, we become a formless "mental body" able to "pass through solid barriers such as walls or mountains" (Sogyal Rinpoche 288–89). Yet, we are rudderless, and our vector through space is the result of our past karma, rather than our conscious, in the moment, intent. In this state we may not be fully aware that we are in fact dead; we can see the living, only they cannot see us unless they happen to be clairvoyants or yogis; and we can see and communicate with others in this post-death state.

Much of the Western understanding of karma is represented in what we see and feel in the *sipa bardo* as described by Sogyal Rinpoche:

> The whole landscape and environment is molded by our karma, just as the bardo world can be peopled by the nightmarish images of our own delusions. If our habitual conduct in life was positive, our perception and experience in the bardo will be mixed with bliss and happiness; and if our lives were harmful or hurtful to others, our experiences in the bardo will be ones of pain, grief, and fear. So, it was said in Tibet, fishermen, butchers, and hunters are attacked by monstrous versions of their former victims. (291)

Although the aforementioned ideas and images seem particularly appropriate to the horror genre, filmmakers exploring the bardo state often employ the generic conventions of mysteries and psychological thrillers.

Bardo films include: Mary Lambert's *Siesta* (1987), a cult classic or highly derided "art film" depending on who you ask, with Gabriel Byrne, Ellen Barkin, and Jodie Foster among the cast; Eric Stahl's *Final Approach* (1991), in which an amnesiac stealth bomber test pilot survives a crash and is debriefed by an Air Force psychiatrist for almost the entire movie; and M. Night Shyamalan's *The Sixth Sense* (1999), where Bruce Willis is a psychologist who treats a young boy

who suffers from anxiety and sees ghosts. Perhaps the most terrifying and effective bardo film is Adriane Lyne's *Jacob's Ladder* (1990), which stars Tim Robbins as a Vietnam veteran who also sees ghosts and who is under the care of a sympathetic chiropractor, played by Danny Aiello. Screenwriter Bruce Joel Rubin, of *Ghost* (1990) fame, was inspired by Meister Eckhart, William Blake, and *The Tibetan Book of the Dead* (1994). His script for *Jacob's Ladder* was considered brilliant, yet unproducible, and was shelved for over a decade because of its philosophical and aesthetic complexity.

In fact, bardo films, as they are typically constructed, depend on this plot-based sleight of hand, and when we see them a second or a third time, we are likely to notice inconsistencies that break continuity. Richard Kelly's *Donnie Darko* (2001) is a bardo film that employs a cyclical structure, and overt science fiction and explicitly Christian plot elements, to problematize these conventions. [1] Although it was screened at the International Buddhist Film Festival in London in May of 2009, given its over-the-top Christian allegory with Donnie-as-Messiah, it does not seem obviously Buddhist at first glance. Philosophically, the film mixes Christianity, seemingly superficial references to Buddhism, and science fiction themes like relativity and time travel.[2] Like *Jacob's Ladder*, *Donnie Darko* takes place in a figurative bardo state. Both protagonists deal with ego attachment and battle literal and figurative demons with the help of a sympathetic doctor. The films differ, though, in that at the end of *Jacob's Ladder*, it is revealed that Jacob has died in Vietnam and has spent the entire film in bardo. Given *Donnie Darko*'s structure, and the fact that Donnie cheats death at the beginning of the film, the bardo state is implicit. Although *Donnie Darko* is full of references to science fiction and time travel, its realistic elements are central to its power, and both its characters and its philosophical open-endedness are compelling enough that it does not depend on a structural gimmick involving a protagonist who is unaware of the fact that he or she has died.

Donnie is a troubled teenager growing up in an obsessively reconstructed 1988. He sleepwalks, hallucinates, and commits various acts of heroic vandalism under the direction of Frank the Rabbit, an apparition darkly reminiscent of Elwood's imaginary best friend rabbit, or Pooka, in Henry Koster's *Harvey* (1950). The opening panoramas of cliffs and fog at dawn, and the carefully wrought scenes

of nondescript suburbs passing on the left and the right as Donnie bikes home after waking up in a field next to his bike, quickly suture the viewer into a reality that is comfortable and familiar to anyone who has lived through the eighties.[3] These scenes, and others involving dinner table conversations, bullies, and neighborhood kids on bicycles, allude to eighties films like *The Lost Boys* (1987), *The Goonies* (1985), and *E.T.* (1982). Much of our empathetic engagement and interest stems from *Donnie Darko*'s similarities to eighties coming-of-age films: its choice of cars—the Porsche 911 and the practical Ford Taurus— parked in the Darkos' driveway, its allusions to the earlier films, and its successful reconstruction of 1988's election year reality.

Reviewers have noted that the film owes a great debt to John Hughes, Howard Deutch, and to the "brat pack" actors whose films Kelly grew up watching. It is also based on Kelly's real-life experiences in junior high in Virginia.[4] Elvis Mitchell called *Donnie Darko* "a wobbly cannonball of a movie that tries to go Mr. Hughes one better; it's like a Hughes version of a novel by Gabriel Garcia Marquez" (Mitchell, "Sure, He Has a 6-Foot Rabbit"). As Kelly alludes to his favorite eighties movies reverently, and seems to lift their soundtracks of INXS, The Church, Tears For Fears, and Joy Division, he uses *Donnie Darko* to set the record straight, and to suggest that his version of adolescent life in the eighties is more authentic than that of his historical forbearers. From the discussion of Graham Greene's "The Destructors" and *Watership Down* in English class to the continuity-breaking dance montages of Sparkle Motion, Kelly's recreation of 1988 provides an ideal laboratory in which to try out and test theology and philosophy as a gifted, troubled teenager might.[5] We are intuitively comfortable in the film's world because, in a sense, we have seen it, or a version of it, before—either in our own teenage lives or in the aforementioned films— and, as a consequence, Donnie's experience in the bardo state is all the more harrowing.

Supernatural elements aside, *Donnie Darko* is, essentially, *Ferris Bueller's Day Off* (1986), run through a reality filter. Actor Jake Gyllenhaal's dinner table bickering scene with his real-life sister, Maggie Gyllenhaal; his paranoid schizophrenic "soliloquies" with Frank the Rabbit; the clichéd scenes of adolescent boys bullying the fat girl and making fun of their siblings; the discussion of Smurfs' sexual

activities; hanging out in the woods and drinking beer—all of it seems to be culled from Hughes's playbook.

Specifically, the first two examples bring to mind Matthew Broderick and Jennifer Grey in *Ferris Bueller's Day Off*. In a memorable scene in *Donnie Darko*, where Donnie's sister talks to a friend on the phone about her brother's exploits, she is half-jealous and half-impressed in a way that evokes Grey's portrayal of Bueller's sister and a parallel scene in the earlier film. Donnie's episodes in front of the mirror talking to Frank the Rabbit are also reminiscent of Bueller's direct address to his teenage viewers in the eighties. Of course, Donnie is a much more typical teenager than Bueller's cartoon caricature of one. Donnie loves his family, but is bright, alienated, and acts out because of his hallucinations. He is not interested in ditching school and making fun of inept parents and teachers as in Hughes's movies. Instead, he is talking to his science teacher about Stephen Hawking's *A Brief History of Time* and talking to his therapist about his fear of dying alone. In this scene, Donnie is more typical than the clichéd "typical" wise-guy protagonist of eighties movies. And he is a lot like us.

It is as if Kelly, by proxy, is obsessed with death and oscillates energetically as a teenager might, as he looks for answers at a great ecumenical theological buffet. He juxtaposes latent Buddhism with scenes in the film that invite the viewer to read Donnie as messianic within a Christian context. After Donnie cheats death by sleepwalking on the night that a jet engine crashes into his bedroom at the beginning of the film, his father and mother worry that when he finally dies, it will seem preordained. Then his father states that he dodged a bullet and decides, half-heartedly, that someone must be watching out for Donnie. This conversation both foreshadows the film's ending and invites a deterministic New Testament reading. In a later scene Donnie and his girlfriend, Gretchen, hide out at a movie theater showing a double feature of Martin Scorsese's *The Last Temptation of Christ* (1988) and Sam Raimi's *The Evil Dead* (1981).[6] The former's significance is obvious, given the events of the movie. The latter is ironically appropriate, as well, due to Donnie's violent hallucinations and the film's figurative blurring of the line between life and death. In his aptly named essay, "The Last Temptation of Donnie Darko," Gregg Rickman discusses the parallels between the two

films. James Walters delves into Kelly's allusions to Scorsese's film in greater detail and suggests that both films are inversions of the narrative put forth by Frank Capra in *It's a Wonderful Life* (1946). Although the bulk of his essay is spent exploring the film's Christian allegory, Walters suggests that Kelly is prone to writing off the film's overt use of such themes as tongue-in-cheek. In regard to the afore-mentioned scene at the double feature, "Kelly states that this shot was included as a 'sight gag' to reference the fact that 'any time you are dealing with a hero who has to save the world there is going to be a link to Christian mythology'" (Walters 111).

Both tonally and stylistically, though, there is little to suggest that Kelly's employment of explicitly Christian themes is meant to be ironic. In fact, his tendency to describe complicated philosophical elements of his films as either alternately open to interpretation or adhering strictly to fictional philosophical schemes is simultaneously baffling and refreshing. Critics have suggested that because he recuts his films after they are shown at festivals, or after their initial releases, even Kelly does not always know what his films are about, and that he edits for the sake of clarity. In a contemporaneous review of the film, the *New York Times'* Elvis Mitchell noted that "the actors' loy-alty to the director's vision is evident; the director just hasn't figured out what that vision is" (Mitchell, "Sure, He Has a 6-Foot Rabbit"). Roger Ebert was similarly confused. Although his review was not entirely unfavorable, he hedges his bets and offers a sort of apology,

> I could tell you what I think happens at the end, and what the movie is about, but I would not be sure I was right. The movie builds twists on top of turns until the plot wheel revolves one time too many, and we're left scratching our heads. We don't demand answers at the end, but we want some kind of closure. (Ebert, "Donnie Darko")[7]

Ebert's comments here are indicative of movie-goers' lax expec-tations regarding generic norms. Mainstream viewers may believe that films should contain easily digestible lessons rather than ambig-uous, open-ended meditations on contemporary American reality. However, Kelly suggests, instead, that if films are to be both instruc-tive and entertaining, then the answers that they provide will only appear through contemplation and debate. In *Donnie Darko*, Kelly

is actively engaged in such contemplation himself, and he is more than eager to pass both his confusion and his revelations on to the viewer. In an interview coinciding with *Donnie Darko*'s rerelease, Kelly articulated his intent, "What I tried to do is come up with this pop, sci-fi comic-book tale that could resonate on a spiritual level" (Levine). In another interview, he reveals, seemingly succinctly, "My intention was this: Either it's an elaborate parallel universe or it's all a dream. Maybe those are the same thing, or they're interchangeable" (Churner). His films are compelling because they are philosophical works in progress, and his seemingly pat answers regarding their "meaning," as well as his over-the-top philosophizing, are designed to throw the critic off the trail. Kelly also dissembles and employs irony and pastiche to distract viewers from the fact that he is philosophically curious, and to encourage post-film debate.[8]

Kelly's inconsistencies suggest, inferentially, that although science fiction sells well at the box office, it is a means to an end and is not ultimately what is important. Fans have noted that regardless of how the speculative physics theories line up or not, they are essentially a *deus ex machina*. Given that when the film's cyclical structure allows the airplane engine to fall again at film's end, and this time kill Donnie asleep in his bed, the incident allows the film to resolve its plot and the universe to continue to exist (or to revert to its normal state). At the same time, though, Donnie's seemingly easy Christian martyrdom is difficult for the viewer to accept, because it brings Donnie little peace. He is not the adult, fully actualized, though fallible, messiah of Nikos Kazantzakis's book as envisioned by Scorsese. He is a confused teenager who cannot find solace in Christianity or in physics, or in some variant of the two, despite his best efforts. In fact, the film's climax, in which Gretchen is killed, is set in motion by Donnie's ego-driven need to save the world. His shooting of Frank the Rabbit is the result of vengeance, not selflessness, and it ultimately makes more sense symbolically than it does within the film's primary plot thread. Nor do Donnie's actions or motives in the bardo state exactly parallel Jesus's in *The Last Temptation of Christ*, who was fooled by Satan in the guise of an angel, and who ultimately went back to Bethlehem and begged God to symbolically reverse time and to let him sacrifice himself as he was destined.

Donnie is not fooled by Jim Cunningham, the film's motivational speaker "antichrist," played by Patrick Swayze, nor by Frank the

Rabbit, who, while scary, is ultimately helpful, despite representing ego and attachment.[9] The result of Donnie's sparring with Cunningham and Frank the Rabbit is a philosophical and symbolic doubling in which many key characters and scenes simultaneously function in both the Buddhist and Christian traditions. In one such scene, Donnie asks Frank the Rabbit, "Why are you always wearing that stupid rabbit suit?" To which Frank responds, "Why are you always wearing that stupid man suit?" That Donnie does not answer is significant because, given his ambivalence regarding the existence of God and the film's overall theological uncertainty, the notion of the body being temporary is not necessarily obvious to him. This scene could be a reference to the Christian conception of the soul that goes to Heaven, or to the Buddhist very-subtle-mind that leaves the body at death and passes into the bardo state.

Like his disciple, the fundamentalist Christian gym teacher, Mrs. Farmer, who is prone to oversimplified rhapsodizing about "righteousness" and who appears in a shirt that reads "God Is Awesome," Cunningham often talks about love, self-love, and confidence rooted in ego. In an early scene, Cunningham plays a video of a young boy, or "Fear Survivor," whom he claims to have helped during a motivational speech at Donnie's school. He goes on to explain his vaguely Christian, cultlike self-help group that orders all actions into binaries based around "fear" and "love" on a "Lifeline" and invites students to classify day-to-day situations that they encounter, and to modify their behaviors accordingly so that they are no longer "Fear Prisoners." According to Kelly, the "Lifeline" is based on a real experience from his childhood in which he incurred the wrath of a gym teacher for pointing out its absurdity. Donnie ultimately stands up to Cunningham and points out his hypocrisy, as Cunningham counsels a fat girl whose stepsister told the group that she was worried about her because she ate too much. Cunningham's response is that "we eat because we are afraid to face our ego reflection. How beautiful we are." Cunningham's emphasis on beauty, and on facing the ego in the mirror, for the sake of acceptance and validation, reflects a perversion of the Buddhist drive toward ego obliteration.

Donnie confronts Cunningham at the assembly because Frank the Rabbit tells him to, and he is later guided by Frank the Rabbit as he burns down Cunningham's house. While the police are putting out the fire, they find child pornography. Thus a bad guy is punished,

and Donnie's actions parallel his earlier mindless but similar actions as a juvenile delinquent and pyromaniac in his waking life, offscreen pre-jet-engine-crash world without causality.

Cunningham and his devotees speak of "passing through the mirror" disdainfully and encourage Donnie's mother to go home and pray that Donnie does not succumb. However, when Donnie looks in the mirror, he sees Frank the Rabbit, and if he pounds on his reflection, then the movie screen becomes the mirror and ripples—indicative, initially, of the fractured reality of his schizophrenia or of the tangential universe. In symbolically equating the screen with the mirror, Kelly encourages the spectator to engage actively in the debate and to face down his or her own Frank the Rabbits. Much of our interest in Donnie's character stems from this accessibility and from our empathetic connection to him: Donnie is a realistically drawn high school student who happens to be prone to hallucinations. For the Western viewer, he is familiar, as well, within the martyred mystic tradition. Very early in the film, Donnie stops taking his medicine, and as the film progresses, we learn from the psychiatrist, as his parents are learning, that he is a paranoid schizophrenic and he is not just having a behavior problem. Despite this, Kelly reveals in the director's commentary, "There's no illness. He was someone chosen to complete a task" (Rickman 379). In this, Kelly is referring literally to Donnie saving the universe as a martyr, but he is also slyly implying a Buddhist-based causal relationship that has been lacking in the film's exposition of Donnie's offscreen backstory, and in the events of his life pre–jet engine crash. We can read the pills and the mental illness, generally, as a plot device designed to allow Donnie to hallucinate, which in turn gives Kelly the space to articulate, or to try to articulate, the film's philosophical commentary on life, death, and the illusive nature of reality. The structural importance of his "illness" is reinforced in the director's cut, when the psychiatrist reveals near the film's end that his pills were a placebo. Ultimately, *Donnie Darko* requires both the hallucinations and the time travel to pave the way for Kelly's more nuanced, Buddhist theological heavy-lifting.

In the second half of the film, Frank the Rabbit appears more frequently and counts down the days until the world ends. Donnie becomes increasingly obsessed with time travel, as he desperately attempts to figure out what he is going through. Time travel, as well as the experiences that he remembers from his past, are ego

attachments as well. Donnie is not aware of what is happening, and, at least throughout most of the film, he does not want to travel back in time to fix anything tangible. He is drawn to it intuitively, instead, to explain both the bardo state (which he is also not aware of) and because he has convinced himself that if God allows time travel, then God must exist. This is the point in which his sympathetic science teacher points out a paradox in his argument and then stops the conversation because he does not want to lose his job (we can infer here that the teacher could lose his job for telling Donnie that God exists, or for encouraging him to think in that direction).

Donnie attempts to reconcile Hawking-inspired theories of wormholes, fourth dimensions, and time travel with Christian doctrine about free will and determinism, all while his hallucinations and his paranoia about the end of the world coming on Halloween grow more intense. In a scene with his overly clinical and sometimes seemingly mean-spirited psychiatrist, Donnie confesses that he has "given up worrying about it"—the "it," we later learn, is the existence of God. He states: "I've stopped debating it. The search for God is absurd if everyone dies alone. I don't want to be alone." The scene cuts to suburban moms drinking wine and discussing the finer points of Cunningham's theories, complete with testimonials like "I've been a prisoner of my own fear for thirty-nine years," which provides ironic contrast. Then the psychiatrist attempts to comfort Donnie by telling him that he is an agnostic, not an atheist. Of course, for a troubled teenager who has just fallen in love for the first time, this distinction is academic, and it brings him little peace, because both are overly theoretical and fixated on laws, rules, and definitions that ultimately work against the experientially based clarity that he seeks.

Donnie's attachment to his sensations and his schizophrenia paradoxically leads to clarity and to a world in which cause and effect makes sense. His visions reflect that the illusory self is already partially fragmented and are indicative of Donnie's movement toward clarity. Donnie's anger, sexual desire, and increasingly troubling hallucinations, and the contrasting ecstatic peace and understanding that he finds with Gretchen at last, are two sides of the same coin. Gretchen, in fact, can be read as a sexualized demon that rises up out of Donnie's mind at the moment of death. This type of attachment is represented, as well, by his fixation on sex during the scenes at the

psychiatrist's in which he is hypnotized, fantasizes about Christina Applegate from the eighties sitcom *Married . . . with Children* (1987), and nearly begins to masturbate.

Near the film's climax, at a Halloween costume keg party while Donnie's parents are away, "Love Will Tear Us Apart," by Joy Division, conflates love, death, loneliness, and sexual awakening, and heightens the film's ominous, fatalistic atmosphere. As Donnie and Gretchen emerge from a bedroom after presumably having sex for the first time, the film's tone shifts visually and Echo and the Bunnymen's "The Killing Moon" plays in the background. Donnie fills the frame momentarily with his arms outstretched and Christlike; the music is simultaneously ominous and euphoric, and the viewer feels torn—as if the scene is both the beginning and the end of something. Indeed the song and such parties were likely the soundtrack to, and the setting for, many a high school kid's deflowering in that era. Again, the spectator's empathetic engagement in the film is enhanced by *Donnie Darko*'s atypical capacity to push us out of its narrative and momentarily into our own memories.

In the scene that follows, while Donnie, Gretchen, and a couple of friends are harassed by a psychopathic bully while sneaking into the neighborhood hermit "Grandma Death's" house, Donnie encounters Frank the Rabbit in the flesh, and his hallucinations are revealed to be premonitions. Frank the Rabbit is actually his sister's boyfriend, who dresses up for the party in a rabbit costume complete with a ghoulish mask. When Donnie shoots Frank the Rabbit, after he accidentally runs over and kills Gretchen, the symbolic, hallucinatory plot and the primary plot are inverted, and Donnie has faced up to both his fears and his attachments to earthly reality. Essentially the fourth dimension, and the explicitly Christian allegory that the film adheres to, are devices that allow it to operate more subtly as it explores these Buddhist concepts. Donnie's attempts to describe what is happening to him through Christian theology ultimately fall short. That Frank the Rabbit kills Gretchen, and is shot by Donnie in retaliation, makes no sense other than as straightforward revenge in the film's primary reality. It might be a literal, if misdirected, allusion to Linji's eighth-century *kōan*, "If you meet the Buddha, kill him." Although mangled, it is nonetheless significant, because Donnie's clarity comes about only after the death of Gretchen and Frank,

which frees him from the film's primary/illusive/dream reality and allows him to "time travel" and accept his fate—that he will die, literally, or that he is already dead and in a bardo state, symbolically.

After the tragedy at "Grandma Death's," it is nearly morning, and Donnie returns home with Gretchen's body, steals the family Taurus, and drives back to the panoramic spot where the film opened. There is a close-up shot of an eye, random computer data, and a wave on a beach that Kelly has used as a refrain to indicate literal and figurative awakening throughout the film. Then Donnie looks at Gretchen peacefully before time rewinds, fireworks go off, and key scenes in the film speed up and repeat as it cycles back around to its own beginning. Donnie composes a letter to "Grandma Death" and reads it in voice-over: "I hope that when the world comes to an end I can breathe a sigh of relief because there will be so much to look forward to." The world coming to an end is the world of the film and his corresponding bardo state, which he now understands. As the close-up of the eye and the data reappears, and then morphs into a shot of a picture of an eye on Donnie's bedroom wall, he gets into bed and laughs ecstatically and knowingly as he accepts that he is dead, finally.

Like the reclusive former nun, Roberta Sparrow, nicknamed "Grandma Death" by the kids in the film, Donnie was forced into theoretical physics, and the viewer into corresponding science fiction plot elements, in an attempt to avoid what Sparrow whispers to him: "every living thing on earth dies alone." As Donnie quests down a logical dead end, the film's truths are revealed, or at least explored, symbolically. While the film reflects bardo, albeit bardo camouflaged by a science fiction subplot, and a cyclical structure in which the world ending in twenty-eight days is representative of Donnie's time in the *chosnyid* or *sipa bardo*, it is also significant that Kelly shot the film in twenty-eight days. In this, *Donnie Darko* is something of a magic mirror, Rorschach test, or exploratory text for Buddhist ideas in which Donnie's attachment—to his earthly reality, to ambiguity, and to his subsequent confusion—is symbolically shared by the viewer, whose own plot-based confusion parallels Donnie's eschatological confusion. However, unlike Donnie, the viewer is knocked out of the film's narrative and confronted with a philosophical ambiguity that Buddhism best elucidates.

In light of the spiritual questing and doubting, Kelly constantly foregrounds that to explain the film through time travel, or, more specifically, through questions about "whether God allows time travel, or whether time travel proves the existence of God," and with Donnie's attempts to ask his science teacher, is to sell it short. A more appropriate line of inquiry centers on whether time travel, or its metaphorical equivalent, memory, or attachment to memory, sensation, and experiences, leads to peace in life or in death. Kelly addresses these questions tangibly, even as he sorts through philosophical ambiguity, and challenges the viewer to engage in the same sort of questions that Donnie grapples with onscreen. Although these theological questions are set in motion by the film's science fiction and time travel plot devices, neither of these philosophical systems ultimately provides Donnie, or the viewer, with any comfort or relief. The film makes more sense in Buddhist terms because bardo represents a reprieve from Donnie's illness, despite the hallucinations, in that he has entered into a state of causality where his choices have clear-cut karmic results. For the spectator, who has just witnessed Donnie grow from troubled and despairing into an almost "normal" teenager only to be martyred, the film's attempted retreat into a "wrinkle in time" is tedious. More importantly for Donnie, the question of whether his epiphany, and his return to clarity and a causal world, was in a bardo state or in his waking life—itself a bardo state—is unimportant, because he achieves clarity regardless. To read the film as bardo, as well as a coming of age, high school story of the type that we are already intuitively familiar with in the West, and to consider Donnie as between incarnations, and still, somehow, achieving a chance at the normalcy that had alluded him for his entire waking life, is to allow for the sort of ambiguity that Kelly desires. None of the philosophical paradigms, be they relativity or Christianity, put forth in the film adequately explain Donnie's situation to Donnie, or to the viewer.

Notes

1. Kelly is one of Hollywood's youngest, and most philosophically ambitious, writers and directors. He wrote his first film, *Donnie Darko*, when he was twenty-five years old and shot it on a budget

of $4.5 million in twenty-eight days. The film opened just after the September 11th attacks on the World Trade Center, and, as a consequence, perhaps, of its advertising featuring an image of a jet engine crashing through a building, it did not initially fair well at the box office. But it became a cult classic, and when the director's cut was released in 2004, it enjoyed a second theatrical run.

2. Kelly also freely mixes Buddhism and Christian allegory in his second film, *Southland Tales* (2006). It stars the paradoxically seemingly unknown, yet exceedingly familiar, Justin Timberlake as Pilot Abilene, a soldier just back from Iraq, who quotes from the book of Revelation as he stands guard over the Venice Beach coastline and who abuses a drug called "fluid karma," which enables him to see angels and talk to God. The details are vague, but we can gather that Abilene was part of an experiment in which the soldiers were injected with fluid karma to help them fight better and to communicate telepathically on the battlefield. The experiment gone wrong evokes the backstory of *Jacob's Ladder*, in which Jacob's platoon was given the "ladder" drug, not to talk to god, or to each other, but to make them descend the figurative ladder toward their innate animal instincts so as to fight better.

3. Kelly's choice of setting transitions from the carefully reconstructed 1988 in *Donnie Darko* to the easily recognizable, though slightly off-kilter, apocalyptic near-future of 2008 in *Southland Tales* that is now the past. According to Manohla Dargis of the *New York Times*, *Southland Tales'* world "satirically imagines a wartime landscape unsettlingly close to a modern pessimist's vision of the day after next." In fact, a good part of the film's power derives from its uncomfortable proximity to the present—be it 2006 or 2013. In contrast to *Donnie Darko*, *Southland Tales* is explicitly political. But this was not Kelly's original intention, and most of the timely and disturbing elements of the film were added in the wake of the World Trade Center attacks. Kelly finished the film's screenplay just prior to September 11th, 2001. Originally it was just a satirical look at Hollywood celebrity and consumer culture. According to Kelly: "It was just about blackmail and a movie star and a porn star and two cops, and the

Hindenburg over downtown Los Angeles, but that never had any context" (Peranson).

For the sake of context, he spent over four years adding plot elements ripped from the headlines, like the war in Iraq, our lack of fossil fuels, and the Patriot Act, which the film morphs into a malicious and Orwellian shadow-government organization called U.S.I. Dent. Like a more realistic take on Ray Bradbury's science fiction classic "A Sound of Thunder," in which dinosaur-hunting time travelers accidently kill a butterfly in the past and return from the future to find that the present has changed into a fascist state with a slightly different alphabet. Furthermore, like Mike Judge's *Idiocracy* (2006), *Southland Tales'* near-future reflects our culture's collective fetishes, fears and neuroses amplified.

4. Similarly, in *Southland Tales*, Kelly shot the opening Fourth of July celebration-turned-start-of–World War III at his aunt's house in Abilene, Texas, and used his family and friends for extras. The faithfully recreated 1976 of *The Box* (2009) draws heavily on Kelly's biography as well. His husband and wife protagonists are, in fact, based on his parents. His mother was a teacher, and his father worked as an engineer at Langley Air Force Base (where they filmed some of the scenes). *The Box* was inspired by Richard Matheson's short story "Button, Button," and by the story's previous adaptation in an episode of the 1980s incarnation of *The Twilight Zone*. Kelly again mixes science fiction, big ontological questions, and issues of free will and determinism. The film's premise is similar to Shirley Jackson's short story "The Lottery" and centers on a mysterious box containing a button that, when pushed, will inflict death on a stranger. Essentially, *The Box* is an oversimplification of karma and a discourse on free will and determinism.

Although Kelly is quick to point out, "I'm not schizophrenic, I don't see rabbits [and] I don't travel through time," when questioned about the autobiographical elements of *Donnie Darko*, he is surely searching for something illusive in his past, and in all of our collective pasts, and this impulse is reflected not as much in his films' plots as in their specificity of detail that's indicative of his drive to reconstruct the past and revisit it literally as much

as symbolically (Murray). Despite the science fiction trapping, the proper nouns, and the heavy-handed use of references to contemporary pop culture, there is, ultimately, a Romantic sense of simultaneous possibility and longing in Kelly's work. Collectively, it seems as if he is after a sense of Wordsworth's "clouds of glory" from *Ode: Intimations of Immortality* and "spots of time" from *The Prelude*.

5. Perhaps the most haunting scene in *Southland Tales* is the Sparkle Motion–like dance sequence set in a funhouse arcade on the boardwalk in Venice Beach. Kelly explained in an interview that "it's about forgiveness, and a friend who accidently disfigures another one when in Iraq," but there is much more happening on a symbolical level (Peranson). As Timberlake's Abilene dances around in a bloody shirt and lip-synchs The Killers' song "All These Things I've Done," he is surrounded by a chorus line of otherworldly, flaxen-haired, candy-stripe nurses. Like the Sparkle Motion scenes in *Donnie Darko* and the eerie wedding slow dance in *The Box*, this scene is indicative of Kelly's use of song and dance at moments in his films when straightforward narrative is not enough to convey meaning.

As the nurses parade around Abilene cabaret-style and dance suggestively on top of the skee ball machines, he sings cryptic, salvation-centered lines like "I wanna shine on in the hearts of men / I wanna meaning from the back of my broken hand," and "I need direction to perfection." Both the chorus that follows— "I've got soul, but I'm not a soldier"—and the refrain—"you know you gotta help me out"—are reminiscent of Augustine's *Confessions*, as is the song's title, which is repeated, earnestly, at song's end. Abilene is searching for forgiveness or grace, and this makes sense, given his tendency toward Revelation and his experiences in Iraq. However, he is searching for meaning as well, and it is significant that he desires this meaning to come through conflict "from the back of [his] broken hand." As he seeks truth out of chaos that is internal, as much as literally manifest in the United States pre-apocalypse, like Donnie, he finds little peace in the philosophical schemas that the narrative offers him overtly. In addition to its Christian lyrics, "All These Things I've Done" represents an overly simplified and petty conception of karma.

Again, Kelly is grappling with Buddhist ideas while foregrounding archetypes culled from the Christian tradition.

Abilene wants to be saved and forgiven after he has taken fluid karma. In a sense, he is calling, explicitly, for the karmic tally, and for a causal reality, but he is doing so from within a drug-induced dream vision. At this point, it seems like Kelly is mixing theologies at will. The funhouse arcade complete with videogames and scantily clad, if vacant, women, and the Budweiser that Abilene drinks, intentionally spills, and pours over his head as he crushes the can, are reductively indicative of a stereotypical young American soldier's conception of heaven.

If would-be Muslim terrorists misread the Koran and thought that they would be blessed with a thousand virgins in Heaven, then Abilene's funhouse, which offers him a symbolic glimpse of the afterlife, is like an American soldier's twisted riff on the same theme. Kelly has called the "Killers" scene the "heart and soul" of the entire movie. In light of this, and his emphasis on forgiveness, we can infer that Abilene, like Donnie, is stuck in a figurative bardo in search of causality, but with only a literally minded, fundamentalist take on Revelation for solace (Peranson).

6. The theater scene alludes to the "Vertigo" scene in Terry Gilliam's *Twelve Monkeys* (1995), which also treats themes of schizophrenia and a secular apocalypse. In alluding to Gilliam alluding to Hitchcock, Kelly encourages further continuity breaking, extratextual remembering on the part of the viewer.

7. As if to compensate for these sorts of reviews, Kelly added twenty minutes of footage to the director's cut of *Donnie Darko*. After *Southland Tales* was booed at Cannes, he cut the film, trimmed some minor characters, and added special effects and CGI animation for the sake of clarity and to secure domestic distribution (Dargis).

8. Or *Southland Tales*' battlefield drug, fluid karma, another Buddhist red herring. In *Southland Tales*, Kelly is once again obsessed with eschatological questions and pokes fun at pop theology. The porn star Krista Now, for instance, whose stage name comes from her readiness to live/have sex in the moment, is reminiscent of Eckhart Tolle's self-help book *The Power of Now* (1997).

However, fluid karma, and the manner in which the film treats life, death, causality, and karmic accounting are more deeply developed than they initially seem.

9. In his self-righteous and haphazard mix of religions that essentially gets the theology wrong, Cunningham's character seems to parody Neale Donald Walsch's *Conversations with God* (*CwG*) series. However, the first *CwG* book was not published until 1995, and in light of the care with which Kelly reconstructed 1988 in *Donnie Darko*, this anachronism is unlikely. Kelly has mentioned in interviews that the "lifeline" exercise was based on his real-life experience. So it could be that Walsch tapped into the same pop theology self-help vein that Kelly's real-world gym teacher did in the eighties. Or that Cunningham is a composite character.

NINE

"Beautiful Necessities"

American Beauty and the Idea of Freedom

DAVID L. SMITH

A merican Beauty (1999) seems to tell a familiar story: man quits
dead-end job in disgust, loosens up, and finds new life through
adolescent fantasy; career-obsessed woman comes to a bad end; boy
and girl, drawn together by hatred of their respective families, make
plans to take off for the city. Moreover, like films from *The Gradu-
ate* (1967) to *Pleasantville* (1998),[1] *American Beauty* sets its drama
of emancipation in suburbia, rehearsing the message that life tends
to go stale within the confines of a picket fence, consumerist, career-
driven version of the American dream. Dismissive reviewers accord-
ingly noted the formulaic nature of *American Beauty*'s materials.
Its characters and storyline are drawn in broad, even "cartoonish"
strokes (Alleva, "No 'Leave It to Beaver'" 19). A mix of sensational
elements is thrown in to up the commercial ante (masturbation!
recreational drugs! borderline pedophilia!), but nothing here is par-
ticularly surprising. On the whole, this tale of liberation through
nonconformity is by now so well worn, so co-opted, so devoid of any
real critical edge, that it is natural to wonder why anyone would be
interested.[2]

Appearances can be deceptive, however. *American Beauty* is actu-
ally far more than a variation on a contemporary cliché. Its genius,
in fact, lies in the way it challenges the most basic assumptions of the
genre to which it seems to belong. Formally, *American Beauty*, like

other standard American tales of the pursuit of happiness, is a quest narrative. As such, its premise is that the meaning of life inheres in its story. A meaningful life, on this model, is a goal-directed activity, a project unfolding in time that reaches fulfillment, if at all, in its end. A life well lived will accordingly have a satisfying narrative arc, preferably shaped by heroic acts of will, leading from the place we stand to an "elsewhere" for which we yearn. This equation of meaning with story quietly dominates our thoughts about life and the self down to the deepest levels of the culture and appears prominently in the religions most of us adopt. We are bound for glory, heading home, or simply aiming to build a better world. Our joy and suffering along the way make sense in terms of the larger narrative frame. Take away the story and we can't help but wonder what it's all for.

There is, however, an alternative view of the sources of meaning in life that will be more familiar to students of Buddhism than to observers of American culture (although, as we shall see, it has national as well as global antecedents). According to this view, the meaning of life is not something to be attained through a quest, for the simple reason that the wholeness we seek—or whatever it is that we conceptualize as "meaning"—was never lost. It cannot be attained by an act of will. It cannot be attained at all, for its very nature is what Soto Zen calls *mushotoku*, nonattainment. Desire simply drives it away by giving credence to the illusion that life's meaning could ever be anywhere other than where we stand. The religions that speak of this sort of meaningfulness—several schools of Buddhism among them—accordingly give short shrift to the dramas of life in time. Life is *samsara*, a deterministic karmic wheel that conditions our will as thoroughly as our circumstances. To follow one's will—to pursue any quest—is thus simply to dig oneself deeper into one's fate. Nevertheless, a kind of liberation is possible in the midst of fate and inseparable from it: call it "enlightenment"; call it "seeing things as they are." On this account, liberation consists not in doing what one wills but in dealing mindfully with the life one has.

The author of *American Beauty*, Alan Ball, claims no formal acquaintance with Buddhism (Greenwald 43). Nevertheless, his Academy Award–winning script develops a home-grown version of Buddhism's alternative understanding of meaning. What *American Beauty* gives us, fundamentally, is a skeptical analysis of the very possibility of finding meaning through a quest. The world of *American*

Beauty is a closed, culturally deterministic system. Its characters are perfect creatures of their social locations. They may hope for something "more," but their very conception of this "more" derives from the culture that confines and defines their desires. Their stories are correspondingly bleak and self-defeating, the very definition of what it is to be trapped. And yet *American Beauty* is not a bleak or pessimistic film. Possibilities of meaning and freedom emerge from its deterministic world that have little to do with its characters' conscious intentions. The film, we might say, is a meditation on the disconnect between the narrative quests of its characters and the meaning that, in a few cases, happens to them.

Appreciative reviews of *American Beauty* seemed to sense that something as uncanny as this lay behind the film's extraordinary resonance but were at a loss as to how to identify it. Good acting certainly contributed to the film's mystique; inspired cinematography likewise. These might at least account for the film's extraordinary critical and popular success.[3] But many viewers and reviewers also pointed to "something else." Kenneth Turan in the *Los Angeles Times*, for example, wrote of something "undefinable" about *American Beauty* that makes its satire seem "more familiar than it is." In the same spirit of puzzled wonder, the terms "mystical" and "spiritual" frequently cropped up in connection with the rapt aesthetic of beauty that inspires some of the film's characters (Denby, "Transcending the Suburbs"). One reviewer characterized this sense of wonder as "Heideggerian," another as "vaguely Buddhist" (Alleva, "No 'Leave It to Beaver'" 19; Arthur 52). Alan Ball himself in an interview has associated this aesthetic sensibility with a "Buddhist notion of the miraculous within the mundane." But he seems more comfortable presenting this theme in looser, more universal terms. At the heart of life, says Ball, is a secret: "if there's any theme to this movie, it's that nothing is what it appears to be on the surface. That there is a life behind things and it's much more interesting and real than the veneer of reality that we all sort of tacitly agree to accept" (Shannon). If the film fascinates, then, perhaps it is because its author's sense of a hidden yet immediately available wonder is something his audience, on some level, already understands.

Vague as such suggestions may be, I take them seriously. Accordingly, I will explicate the "mystical" or more broadly spiritual aura of *American Beauty* as clearly as possible, drawing on analogues from

Buddhism and the works of Ralph Waldo Emerson to come to terms with the film's distinctive spirituality. Specifically, I show how *American Beauty* builds two distinct critical or interpretive frames around its story. One of these frameworks is social-psychological, the other more explicitly spiritual or religious. Together, these provide the vantage points from which the film explores the ironic disjunctions between quest and attainment, freedom and fate.

To establish the first of these frameworks, the film carefully and deliberately puts its characters' social and psychological motives in critical perspective. Specifically, it shows how the characters' quests for freedom are, in every case, symptoms of their starting points, expressions of the complexes from which they are trying to escape. The formal organization of the film, including its "cartoonish" simplification of character, is designed to make this point. The story focuses on two families, the Fittses and the Burnhams, who are next-door neighbors and who inhabit two distinctive complexes of cultural values and personality types—two architectural and sociological boxes. The Fitts family represents what we might as well call "the military-industrial complex." The head of the family is a retired air force colonel, identified in the script consistently as "the Colonel" rather than by name. The code of life he imposes on his family is a caricature of military discipline, an ethic of relentless command and control. His dedication to drawing and enforcing conventional boundaries is exemplified by his homophobia and his violent response to rule-breaking.

Next door, the Burnham household represents another typically contemporary style: more or less what Robert Bellah once labeled "expressive individualism" (Bellah et al. 33), but which I will call "the consumerist-entertainment complex." Lester, the father, works for a trade magazine called *Media Monthly*. Carolyn, the mother, is a kind of manic Martha Stewart—or as Jay Carr put it, "a Stepford wife on acid"—who struggles to succeed as a real estate agent, schools herself with self-improvement tapes, and dotes on material symbols of her achievement (Italian silk upholstery, a Mercedes SUV). The guiding light of the Burnham household, then, is desire—the drive for success, the drive for pleasure, and the drive toward a more perfect arrangement of appearances. ("See the way the handle on those pruning shears matches her gardening clogs?" says Lester in reference to Carolyn. "That's not an accident" [Ball 2].) If the Fittses illustrate the

deadening effects of the repression of desire, the Burnhams represent the pitfalls of its pursuit.

The paths to emancipation taken by members of these two families reflect the complexes that nurtured them. Ricky Fitts, the inscrutably rebellious son of Colonel Fitts, uses and sells marijuana, but, significantly, the variety he prefers was "genetically engineered by the U.S. Government" (Ball 46). That is to say, the culture of control, now taking charge of the blueprints of life itself, gives Ricky the means by which he seeks to transcend his family and the culture it represents. Another way in which Ricky finds a kind of freedom is through the view-monitor of his video camera. Ricky casts himself as a professional observer, a fearless student of other peoples' lives with no compunctions about peeping through their windows. He transforms ordinary experience by distancing it on film, asserting a kind of control over life through the neat rows of tapes that line his bedroom. But here again, the influence of the military-industrial complex is clear. Who is more adept at surveillance than the military? And who engineered the sophisticated equipment by which Ricky engineers his detachment? Ricky is thus caught in a bind that is familiar to anyone who has reflected on the paradoxes of contemporary popular culture, where anti-technological lifestyles are celebrated with electric instruments and anticapitalist rock bands are promoted by vast corporations like Sony BMG. The wildly mixed messages compel one to wonder how far emancipation by such means can go.

The rebellious members of the Burnham family are in a similar bind. They seek to mitigate or change their circumstances through drives, values, and impulses acquired from the cultural complexes from which they long to escape. As products of the consumerist-entertainment complex, they seek satisfaction in raw desire—the yearning for self-completion through acquisition, through novel experiences, and through the manipulation of appearances. Thus, young Jane builds for the future by saving her babysitting money for a "boob job" (Ball 72). Carolyn, whose kitsch romanticism extends to her choice of "Bali Hai" as dinner music, yearns her way into an affair with Buddy Kane, "the Real Estate King," who represents everything she longs to become. (His "personal philosophy" provides the perfect mantra for her preoccupation with appearances: "in order to be successful, one must project an image of success, at all times" [Ball 51].) Finally, Lester, in the film's main plot line, quits

his job in order to recover his life, renewing himself by falling back on his instincts.[4] His instincts turn out to be disturbingly regressive, however. He develops a crush on a teenage girl; devotes himself to working out because he wants to "look good naked" (Ball 44); and buys a 1970 Firebird, the car he "always wanted" (Ball 68). (It's red, of course—the color of desire—like the Burnhams' front door, Carolyn's roses, and Lester's own rose-petal fantasies.) Lester's pursuit of the girl, Angela, becomes the center of attention in the film for a number of reasons, not the least of which is pure prurience. Nevertheless, we can see how it fits the themes under discussion here. As in *Lolita*, the hyper-romanticism of a tabooed attraction serves as a symbol of the culture that nurtures it—a culture of yearning, for which real life is always elsewhere. Lester Burnham is no Humbert Humbert, but his middle-class desires are a match in both intensity and inappropriateness for those of Nabokov's cultured émigré. (And see how Angela's last name, Hayes, recalls Nabokov's Dolores Haze? That's not an accident.)

This analysis of the characters' motives points to a conclusion that has become rather routine in academic culture studies: in short, no exit. Culture is a totalistic system that affords no leverage point from which a genuine project of emancipation could get itself off the ground. Every apparent way out is already subsumed, already co-opted. The system may offer mitigations and palliatives—ways to keep hope alive—but no real alternatives. Ricky gets his drugs; Jane, Lester, and Carolyn get their romantic visions; but these are too deeply implicated in the system for us to even imagine an "elsewhere" to which they might lead. The conclusion of the story makes the futility and fatality of their choices clear. Lester is dead. Carolyn has lost her lover, her family, and probably her sanity. Jane's plans for escape are about to be thwarted and the Fittses—father, son, or both—will soon be picked up by the police for Lester's murder. (Lester's blood is on the Colonel's shirt; Ricky is on film offering to make the hit.)[5] In the end, then, history fails as a realm of freedom or source of meaning for any of these characters. It is rather a system of strict cause and effect, a karmic wheel, in which doing what one wants is equivalent to bondage under the iron law of one's conditioning.

What hope is there, then, for freedom? The remarkable thing about *American Beauty* is that it does not take that question as rhetorical. Instead of settling for one of the stock contemporary

responses to meaninglessness (playful nihilism, apocalyptic nihilism, existentialist posturing, or blind faith), it simply and honestly treats the question as one that's worth raising. If meaning is not to be found through emancipatory projects, then where is it to be found? If freedom does not consist in doing what one wants, then what is it?

To address these questions, the film constructs another critical frame around its story, loosely built of the moments in which various characters find their lives lit up by beauty. As noted earlier, the world of the film is not devoid of meaning. The kind of meaning its characters stumble across, however, is oblique or even irrelevant to their stories—to self-understandings that remain bound and blinkered by their circumstances. Beauty has little to do with what anyone intends or thinks they are doing. And yet, when it emerges it makes a difference, somehow transforming or opening up the realm of necessity from within.

This transformative difference is something that Ralph Waldo Emerson also discovered meditating on similar themes in his essay "Fate," according to which the fatal necessities of life, without our knowing how or why, can sometimes appear as "Beautiful Necessity" (*Essays* 967). Emerson is usually thought of today as a writer who promised easy access to worlds elsewhere—a "Transcendentalist" in a rather simplistic sense. In fact, his literary project was very nearly the opposite of this. He wrote to explore the spiritual possibilities of life in a world without supernatural recourse—a world like that of contemporary naturalism or classical Buddhism, in relation to which the very nature of transcendence and freedom need to be rethought.[6] Like Ball, that is, Emerson starts from a clear understanding that the world of which we are a part—the world that defines and delimits our possibilities—is a closed system, a single web of nature with no outside. This world accordingly offers no hope for freedom in the sense of escape or autonomous leverage over our circumstances, because its components, ourselves included, are inextricably interrelated. Nothing is what it is apart from the network of conditions that defines it:

> Observe how far the roots of every creature run, or find, if you can, a point where there is no thread of connection. Our life is consentaneous and far-related. This knot of nature is so well tied, that nobody was ever cunning enough to find

the two ends. Nature is intricate, overlapped, interweaved, and endless. (*Essays* 961)

It follows that Emerson, again like Ball, dispenses with the model of spiritual life as a quest for fulfillment "elsewhere," for the simple reason that there is nowhere else for our wholeness to be. "Other world?" Emerson reported himself exclaiming to the arch-supernat-uralist Sampson Reed, "There is no other world; here or nowhere is the whole fact . . ." (*Journals* 8: 183).

Nevertheless, according to Emerson, a kind of freedom and ful-fillment is possible within the conditions of fate—a freedom that is closely akin to the sentiment of beauty. From his own experience, he could point to moments when a sense of seamless immersion in the world produced a "perfect exhilaration"—moments when "all mean egoism vanishes. I become a transparent eye-ball; I am nothing; I see all; the currents of the Universal Being circulate through me; I am part or particle of God" (*Essays* 10). What turns the trick—what transforms the "bare common" into a realm of "immortal beauty"— is something that Emerson calls "thought," by which he particularly means the sort of thought that arises when "the inward eye opens to the Unity in things . . ." (*Essays* 955). In this more ecumenical age, he might well have called such a mode of thinking "mindfulness," since an important aspect of the Buddhist concept of mindfulness is awareness of the inextricable interrelatedness and absolute contin-gency of things—their dependent co-arising (*pratītya-samutpāda*). In any case, if such thought makes us free, it does so by way of an acknowledgment of fate—the recognition that we are immersed in a law-governed system that operates above our will. Thus, "the last lesson of life . . . ," Emerson writes elsewhere, is that "man is made of the same atoms as the world is. . . . When his mind is illuminated, when his heart is kind, he throws himself joyfully into the sublime order, and does, with knowledge, what the stones do by structure" (*Essays* 1075–76). The illuminated mind is free, then, not because it is any more autonomous than a sentient thrown stone, but because it finds its wholeness already given in the wholeness of the world.

Thus, "Fate" ends with a peculiar sort of call to freedom: "Let us build altars to the Beautiful Necessity, which secures that all is made of one piece." Precisely because we are of "one piece" with the universe, Emerson asserts, we participate in its strength and

intelligence. In this, we lose the delusion of one sort of freedom: the kind that holds that "one fantastical will could prevail over the law of things . . . as if a child's hand could pull down the sun" (*Essays* 967). We trade it, however, for the proper "necessitated freedom" of God himself, which consists in being "not a relation or a part, but the whole" (*Essays* 299). We find ourselves not *in* a world, over against the circumstances of life, but *as* a world, perfectly poised in the space of relations.

Similarly in the world of *American Beauty*, freedom appears only in the midst of iron conditions. The trap in which we find ourselves is transformed, if at all, through the insight that the trap is what we *are*, and through the sense of beauty or wholeness that accompanies the realization. Alan Ball's discovery of beauty in the midst of necessity thus reproduces a distinctly Emersonian approach to questions of meaning and freedom in the modern world.

I call this aspect of the film "spiritual" for a number of reasons. First and most obviously, it is because beauty enters the film in moments the characters themselves find intense, extraordinary, and revelatory, and which they sometimes characterize in explicitly religious terms. Ricky Fitts is the source of the two clearest cases of religious interpretation. With reference to a video he once took of a homeless woman frozen to death on the sidewalk—a touchstone for him of the world's beauty and sadness—he says, "When you see something like that, it's like God is looking right at you, just for a second. And if you're careful, you can look right back" (Ball 57). Second, there is Ricky's film of a plastic bag whirled by the wind, the film's central icon of beauty. About this Ricky says: "That's the day I realized that there was this entire life behind things, and this incredibly benevolent force that wanted me to know there was no reason to be afraid. Ever" (Ball 60). Less explicitly religious, but bearing a strong family resemblance to mystical literature through its theme of self-overcoming, is Lester's final comment in voice-over:

> Sometimes I feel like I'm seeing it all at once, and it's too much, my heart fills up like a balloon that's about to burst . . . and then I remember to relax, and stop trying to hold on to it, and then it flows through me like rain and I can't feel anything but gratitude for every single moment of my stupid little life . . . (Ball 100)

Comments like these put the viewer in mind of fairly familiar notions of transcendence, suggesting alternative horizons of meaning that place the film's cynical take on history in a wider perspective.

A similar point is made through the literal framing of the film between Lester's voice-overs. We know from the start that our narrator is a dead man. He soars with the camera above the neighborhood whose formal layout shaped his life. He floats free of time. His story is over; he knows what the dead know. And so his presence at the edges of the film hints at a dimension beyond the story, even while it is being told.[7] That dimension, however, has nothing to do with a literal promise of life after death, let alone with the stock Hollywood motif of the intervening angel. Rather, what Lester's perspective brings to the film is the suggestion of a larger structure of selfhood—a life "both in and out of the game," as Walt Whitman put it in "Song of Myself" (Whitman 191), or perhaps, as T. S. Eliot suggested in his rose-haunted *Four Quartets*, in and out of time. We are cued that the stories about to unfold are not going to tell us everything there is to know—that time itself, paradoxically enough, is not the whole story. Thus, like Ricky's God-language, the voice-overs introduce a promise of alternative sources of meaning.

Two episodes in the film stand out as fulfillments of that promise, moments in which the power of beauty becomes palpable to the audience as well as to the characters. First, there is Ricky's video of the dancing plastic bag, the film's most haunting visual image. Beauty, as epitomized in this scene, is an intrinsic value that is everywhere but seems to come out of nowhere. It emerges here from a situation that is utterly deterministic—a scrap of plastic caught in a vortex of crosswinds—and utterly ordinary, encountered "in an empty parking lot on a cold gray day . . ." (Ball 10), a stage direction that echoes Emerson's similarly fortuitous moment of vision on "a bare common, in snow puddles, at twilight, under a clouded sky" (*Essays* 10). Ricky's other encounters with beauty are similarly quotidian and similarly fatal: in a dead bird, in an old woman frozen on the sidewalk, and in the sadness of the girl next door. Whatever its occasion, though, beauty is intrinsically meaningful—a satisfaction unmatched by anything else represented in the film. It brings the characters who "get it" (Lester, Ricky, possibly Jane) a sense of meaning that is absolute and unquestionable—complete in a way that even threatens to cancel out the rest of life. As Ricky says, "sometimes there's so much

beauty in the world I feel like I can't take it . . . and my heart is going to cave in" (Ball 60). A close neighbor to death, beauty is at once eschatologically and ontologically ultimate; it interrupts or puts an end to the stories we struggle to sustain and speaks from beyond them. As Ball himself has glossed the point, "I think you have to have a deep and fundamental acceptance of mortality to really be able to see what's beautiful in life, because beauty and truth are inextricably connected" (Shannon). Beauty, like death, is what is ultimately the case. It is thus appropriate that beauty is what evokes the film's only God-language. In those moments when Ricky feels that God is looking at him, beauty is what he sees when he looks back (Ball 57).

Insofar as beauty stands apart from the characters' intentional quests—as a gratuitous interruption of the life of desire rather than a moment within it—it is strictly useless. It is simply a way of seeing the world clearly, apart from what we would make of it. Nevertheless, this kind of clarity can also have consequences for how life is lived. So in the film, a second focal moment in which meaning becomes palpable is a moral event: Lester's last-minute renunciation of his pursuit of Angela. Like the epiphanies of beauty, this moral epiphany is a simple matter of seeing clearly. Lester's desire for Angela had been driven by illusions and wishes, represented for us in the film's lurid fantasy sequences. Granted: his illusion about Angela is not too different from the illusion that Angela held about herself and tried, rather awkwardly, to project to others. This web of projection and deception dissolves, however, when, just as the flirtation is about to be consummated, Angela lets Lester see who she really is—admitting to her inexperience, changing her story. Lester, in turn, responds with poise, generosity, and tenderness. He does the right thing. It is not a triumph of principle but a triumph of natural compassion and clear, unclouded perception. Lester in the end thus finds and exercises freedom—not the freedom to do what he wants but the freedom to deal mindfully with what is real. And thus he discovers the beauty in his necessities. He has not found a way out of his circumstances, but he has found a way to own them that makes possible his final affectionate review of the moments of joy that punctuated his "stupid little life" (Ball 100).

In effect, Lester has learned the lesson of the tag-line used on the film's publicity posters: ". . . look closer." The way this phrase is presented in the ads, layered over a close-up of Angela's naked belly,

plays rather shamelessly on the prurience of the plot. Its second level of meaning, however, is a fair summary of the film's deepest theme: "Examine the motives that are drawing you to these images. Pay attention!" *American Beauty* is a film about prurience—about all that we find so desirable and entertaining in this world—that aims at disenchanting our attractions. It is a film about desire in which desire is ultimately dissolved in clarity. And always, seeing is the key. Eyes and vision are recurring motifs throughout the film: notably, in Ricky's reference to the eye of God; in the unblinking, fearless intensity of Ricky's gaze, which so impresses Jane; and in the final look in Lester's eye at the moment of his death, which so impresses Ricky.

What sort of freedom is possible, then, in a fateful and fatal world, where our every impulse to change is determined by what we would leave behind? What sort of liberation from the trap of culture is possible if the trap is what we *are*? What *American Beauty* suggests, I believe, is first of all that freedom, although it is not likely to be achieved by intentional effort, may nevertheless occur to us as an experienced quality, like the beauty that emerges from the dance of the wind-driven bag. It is not found beyond fate; we do not become who we are by becoming other than we are. Rather, it comes as an affirmative moment within fate, as in Emerson's tribute to "Beautiful Necessity," Nietzsche's "Yes" to eternal return, or Lester Burnham's joyful postmortem embrace of "every single moment of my stupid little life." Freedom is the discovery of beauty in our necessities, even as the trap is sprung and the gun is put to our head (in Lester's case, literally so).

Ball develops a similar take on the kind of freedom available within constraining circumstances in the project to which he turned soon after *American Beauty*, the acclaimed HBO series *Six Feet Under* (2001–2005). *Six Feet Under* revolves around a family in the mortuary business, the Fishers, who live in the funeral "home" named "Fisher and Sons." Each episode begins with a death, a fatality that cannot be escaped but whose effects must be borne, and to the Fishers fall the work-a-day, hands-on, commercial consequences. Part of the charm of the show, then, is the way it integrates mortality, in the starkly concrete form of dead bodies, into the bathos and pathos of American daily life. Handling death is the business the Fishers were born to. Nevertheless, it quickly becomes obvious that they are no wiser about it than the average person. They do not teach us how to

face death so much as illustrate the various dances by which the big secret—the elephant of mortality, here brought quite literally into the home—is endlessly approached and avoided.

More significantly, *Six Feet Under* turns the problem of facing death into a metaphor for the more immediate and perhaps more basic problem of facing oneself. Each of the regular characters is caught up in a protracted quest to become themselves. Each begins from a set of intractable confining circumstances, social and psychological. Each, in turn, is sufficiently self-aware to recognize their problem and to be endlessly yearning for change. For example, Ruth, the mother, is clearly aware that she sacrificed herself to an early marriage, and now, newly widowed, she struggles to find the self she feels she never quite became. Her older son, Nate, is a restless, uncommitted idealist with a terminal illness. David, the younger son, is shackled by miscellaneous fears; Keith, his lover, by anger. Brenda, raised by psychoanalysts, is interminably self-analytical. And so on. For each, real life seems to depend on something that eludes them: the right relationship, the right self-help philosophy, the right career. Each pursues this imagined fulfillment through countless transformations, dupes of what one minor character calls "that American thing": the endless quest for someone or something better (Sayeau 97). But every desired aim, in turn, proves unsatisfactory. And so the wheel of cyclic existence grinds on.

Six Feet Under is thus preoccupied with the way the desire for change—the deep aspiration to become who we are—at once fulfills and betrays us. It betrays us by fostering the illusion that we can ever truly escape from the conditions of existence. One of the show's strongest themes, in fact, is the virtual inevitability of entrapment. From the motif of coffins and boxes in the opening credits; to the feelings of characters in relation to their bad marriages, bad relationships, and all-around bad choices; to the overarching theme of inescapable death, the show relentlessly returns us to an awareness of limits. As the newly deceased Nathaniel Fisher puts it to his feckless son, Nate: "This is what you've been running away from your whole life, buddy boy. And you thought you'd escape. Well, guess what? Nobody escapes" (Heller 74).

Nevertheless, as in *American Beauty*, the sense of entrapment created by all this fate and mortality is not a dead end. By running repeatedly up against their limits, the characters are indeed

becoming who they are, albeit not in the way they had hoped. They find themselves as beings defined precisely by their conditions. And within those conditions, apart from all striving, they sometimes stumble across the sheer wonder of being alive (as Nate seems to do, intermittently, on the brink of his own death). The realization may not come with the kind of commanding joy that counterbalanced fate for certain characters in *American Beauty*. The light in the Fishers' neighborhood is more changeable and fleeting. Still, there is a kind of freedom, a liberating happiness discovered by some of the characters in *Six Feet Under* that consists in learning to deal mindfully with their necessities.

What is "attained" in such freedom is certainly paradoxical, because it brings nothing that one did not previously have. The self that is discovered or recovered is, after all, something from which one was never really separated. This is why, as noted earlier, the spiritual "discoveries" of Alan Ball's characters in both *American Beauty* and *Six Feet Under* are best understood on the model of what Soto Zen calls *mushotoku* or "nonattainment." According to this view, enlightenment, as an unconditioned reality, is outside all trains of cause and effect: not attained, not lost; neither an addition to life nor a subtraction from it. By its own seamless nature, it cannot come as the result of a quest or project in time; it cannot "come" at all, for it is not possible to be apart from it. Thus, as the Buddha reportedly says in the Diamond Sutra, "When I attained Absolute Perfect Enlightenment, I attained absolutely nothing. That is why it is called Absolute Perfect Enlightenment" (S. Mitchell 35).[8] Religious life may seem like a quest, a journey to the other shore, and may actually be structured as one. However, the actual relation, if any, between effort and attainment is not constrained by this narrative logic. The way keeps to its own ways, or as a Ch'an poem puts it: "Sitting quietly, doing nothing, / Spring comes and the grass grows by itself" (Blyth 31).

This is not to say that the characters' quests are completely irrelevant to the meaning they find. To focus once again on *American Beauty*, Ricky's pursuit of beauty on videotape is in some sense a means to his discovery of beauty in odd places (as is, perhaps, his use of marijuana). Likewise, Lester's growth in moral insight is a clear though unintended consequence of his restlessness. Because he quits his job, he loosens up; because he loosens up, he pays attention; and

because he pays attention, he recovers his world. The quest cannot be rejected out of hand, we might say, because questing and attainment, seeking and acceptance, are also dependently co-arising. The yearning that bedevils us should be given its due. Nevertheless, my point in this chapter has been that the genius of *American Beauty* is the way it places its relatively conventional narrative quests in the context of a deeper skepticism and a wider promise. Time, in the world of the film, is a fool's game, but not all of the characters are fools. Some of them manage to draw on sources that precede, exceed, and evade their own habits of self-reflection. They find themselves "both in and out of the game" and would not be themselves apart from this doubleness. In the end, it is an awareness of the necessary interplay between these perspectives—between the inescapable logic of the cultural game and the equally commanding moments in which we find ourselves apart from it; between the fatality of our traps and the possibility of freedom that persists within them—that constitutes the mysterious achievement of *American Beauty*.[9]

Notes

1. My survey of other films and television shows with which *American Beauty* was compared by early reviewers turned up the following, among others: *Sunset Boulevard* (1950) for the dead narrator voice-overs; *Lolita* (1962); *Sex, Lies & Videotape* (1989); *Happiness* (1998); *The Apartment* (1960); *Network* (1976); *Blue Velvet* (1986); *After Hours* (1985); *It's a Wonderful Life* (1946), for the "angel" motif; *Married . . . with Children* (1987–1997); *Welcome to the Dollhouse* (1995); and *The Ice Storm* (1997).

2. Respected critics who wrote dismissive reviews included Stuart Klawans, J. Hoberman, and Stanley Kauffmann. Janet Maslin was generally appreciative but, like many, saw the film as little more than a celebration of nonconformity.

3. Within a year of its release, the film had grossed over 130 million dollars, starting from a 15 million dollar production budget (see http://www.boxofficemojo.com/movies/?id=americanbeauty.htm). It won the Academy Award for Best Picture of 1999.

4. Kevin Spacey develops this view of Lester, the character he plays, in his interview with Jay Stone.

5. An early version of the script is available on the Internet, which begins with Ricky in prison. See http://scifiscripts.name2host. com/msol/A_B.html.

6. For a more extensive discussion of Emerson's views on the self and attainment, see David L. Smith.

7. Reviewers frequently compared this device to the famous use of a dead narrator in *Sunset Boulevard*. The comparison is close, but it only serves to highlight the differences between the films. In *Sunset Boulevard*, the voice-over is a tool of irony, allowing the narrator to crack jokes at his own expense and come to terms with the inevitability of his downfall. But something far more positive and spacious is achieved in *American Beauty* through the same device.

8. For further examples of the logic of nonattainment, which is closely related to the broader philosophical approach of nondualism, see David Loy, *Non-Duality*.

9. An earlier and shorter version of this chapter appeared in *The Journal of Religion and Film* 6, no. 2 (October 2002): 17 pars. http://www.unomaha.edu/jrf/am.beauty.htm, accessed 28 May 2013.

Afterword

On Being Luminous

GARY GACH

Cinema and Buddhism saturate everyday culture. This book is the first gathering of paths at their intersection. I'm thus honored, indeed, to offer an afterword. In a few pages, let's linger at that intersection, the larger panorama through which these texts each navigate.

For point of departure, I need look no further than the simple, practically hieratic architecture of this volume: a) movies about Buddhism, b) Buddhist approaches to nominally non-Buddhist movies. Such structure might be seen as aptly emergent out of Buddhism itself, namely, the view of reality as an infinite interpenetration of two gateways (aka The Two Doors): the ultimate and the relative; the timeless and the phenomenal. The Dharma pertains to all things, and every thing leads to the Dharma. This format affords a great opportunity, and paradigm, to appreciate vital inroads Buddhism is making within our culture and can provide solid grounding for future research yet to come.

I spotlight two essential, "big-picture" themes in this gathering—critical studies and cinema (movies in general)—braiding them with Buddhism; each as mutually informing, polysemous, and, ultimately, provisional frames of reference. We might begin from the emergence of Buddhism in the West. Then we can recognize Buddhism as a critical activity—as particularly evidenced in the second half of this book—and note a few critical strategies appropriate for

apprehending and applying Buddhism in cultural studies, particularly cinematic (i.e., pragmatism, phenomenology, cognitive studies, and performativity). Next, we consider a few ways in which cinema can reveal elements critical to Buddhism; for finer grain, we focus on particular Buddhist schools. To wrap up, we sketch some fertile transformation currently taking place within both cinema and Buddhism.

American Buddhism: An Idea Whose Practice Has Come

Actually, there's no reified, pregiven, off-the-shelf "Buddhism" for the West to import. It doesn't spread, like butter, from some off-the-shelf jar. Rather, it depends on how each person perceives, understands, and puts its timeless teachings (Dharma) into practice in their lives.

Historically, wherever the boat of Buddhism has docked, its teachings have mingled with native culture: shamanism, in Korea; Tao, in China; Bon, in Tibet; Shinto, in Japan, among others. Fortunately, Buddhism is basically simple and doesn't demand conversion (despite violent tendencies within our culture identified elsewhere herein as American Militant Buddhism). It needs only verification in one's own life. One needn't be "Buddhist" to enjoy its fruits. In the West, while it is indeed becoming a viable creed unto itself, it can also be communicated as interfaith, and is key in the growing trend of people making the sacred real for themselves (even atheists).[1]

As Buddhism's being adapted and adopted within the latter undefined contemplative practice movement, it's often without reference to Buddhism, per se. As mindfulness, for example, it's being taken up by the military as well as the workplace; it's entering K–12 curricula; and it's transforming healthcare, reframing fitness (physical only) as wellness (mind and body). Thus, it's not surprising to also see Buddhism as influencing movie topics, as well as becoming a probative and skillful critical tool for cinema studies, in general, particularly for religion and cinema.

Toward Buddhist Criticism

Criticism, from the Greek *kroinos*, simply means to choose. An edited collection, such as this, is such a critical activity, for example.

That's reflected in the discernment of mind and depth of heart of its authors; and, behind the scenes, are the editors' choices—what's been selected (and rejected), and how they've assembled the materials, informing them. This parallels, too, the countless choices implicit in cinema, as a compilation of short segments ("takes"). A classical analogy in which we can locate the inherently critical nature of cinema within a nonmaterialist context (e.g., psychology, philosophy, spirituality, religion) is Socrates's parable of the cave, as retold by Plato.

Here, we consider the uncritical, unexamined life (not worth living) as a cave. Here, its dwellers witness a continual shadow show, projected before them, as if its reality. Liberation here means not only turning around, discovering the fabricated, illusory nature of their experience, but also turning away and out into the sunlight (the Good, Truth, or, if you will, the Dharma). Substitute movie and projector for shadow puppets and flame, and the analogy is complete.

Lingering with our analogy, it can yield another paradigm: a traditional movie projector can be seen as but a variation of the camera. This dual function of the classical cinematic apparatus is akin to our brain—perceiving and performing. Our brain receives and processes sensory data, then responds with affect and behavior, based on its projection of the world. (An even more detailed schemata might also compare the lab processing celluloid film, and the brain imprinting psychological attachments.) One way out of a vicious cycle (illusion reinforcing itself) is with the wedge of critical awareness. Alongside his near-contemporary Socrates, Buddha offers just such a critique.

When Shakyamuni awakens, he realizes the seeds of awakening (*budh*) are inherent within all beings. His invitation is to perform this critical activity for ourselves. As philosophy, this is consonant with the American school of pragmatism. Indeed, there's a practical, can-do, Yankee empiricism to the Buddha's oft-quoted words to members of the Kalama tribe, advising no one to follow any of his teachings without first testing them out in one's own life. (*Ehipassiko;* see for yourself.)

This resonates too with another school of philosophy: phenomenology. Basic Buddhist tactics can be seen in its emphases on one's lived life (*Lebenswelt*); suspending unquestioned tradition and custom (*epoché*); seeing things in and of themselves (*"Zu den Sachen selbst"*).[2] As we step back from our habit energies, we observe

ourselves stepping back, as philosopher Thomas Luckmann puts it, "attending to experiences precisely as they present themselves." The path of phenomenology, still relatively neglected in cinematic studies, can liberate us from the common overreliance on deductive tactics—such as apprehending behavior of characters in a movie as displaying certain tendencies to then be captioned with pregiven concepts.

Indeed, through phenomenology we can steer clear of overdependence on deduction or induction, allowing a nondualist approach, consonant with Buddhism. Indeed, the performative engagement of the direct perception and intuition of the practitioner of phenomenology is a deeply contemplative practice. When philosopher Maurice Natanson states the rigorous science of phenomenology permits awareness of what-is-given to reflect on its own procedures, we can rightly hear the echo of mindfulness using the mind to apprehend mind, or the Zen strategy of turning the light back onto itself.

A relatively recent field of research with great potential for cinema studies, and Buddhism, is cognitive studies—itself an interdisciplinary Swiss army knife of skill sets from various disciplines (artificial intelligence, complexity theory, evolutionary biology, neuroscience, etc).[3] Consider the discovery of our brain's "mirror neurons" (aka "monkey neurons"), which don't differentiate between our eating a banana and our watching someone else eating a banana. Based on such findings, psychologist Daniel Goleman has extended his popularization of "emotional intelligence" to now encompass "social intelligence," referring to how one brain is dependent on other brains. (He's also noted how a movie plays its viewers, as if they were "neural puppets.")

Please consider, too, UCLA neurologist Daniel Siegel's research on the prefrontal lobe of the brain, thanks to which we can say to ourselves, "This is only a movie." (Movies don't stimulate this brain region; we do.) Such critical distancing can spell the difference between emotion (reactivity) and feeling (response). This prefrontal region regulates not only the body but also emotional balance and response flexibility, as well as attunement, awareness, and self-knowing. It's active during mindfulness, as well as intuition and morality. From this, we might appreciate mindfulness (and moviegoing) as enabling us to see ourselves as both object and subject.

The centrality of practice (and thus ritual) in Buddhism harmonizes, too, with performance studies, a discipline whose influence is in the background throughout my short survey. Consider, for example, how much of the Buddha's teachings could be viewed as instructions, to be performed. ("Notice your in-breath; notice your out-breath." "Refrain from harm, do good, keep a clear mind / an open heart." "Be a lamp unto yourself.") In this, Buddha's teachings might be seen as a species of performance art.

In Buddhism, there's an intimate marriage of the boundless and the formal, hence ritual. Many schools "perform" Buddhism through chanting and mental recitation, for example. Formal expressions vary with culture. Japan, expresses the Dharma through gardening (such as rock gardening, *karesansui*), haiku, calligraphy, flower arranging (*ikebana*), and ceramics, all of coming together in the tea ceremony (*chado*). Other examples are *aikido*, archery, and swordsmanship. In Tibet, we find the Mani festival, the masked ritual dance-drama called *chams*, and the visualization practice of *chöd*. As cultural performance of the Dharma, might we not now include cinema?

Performativity is useful, too, for opening studies out beyond literary text as a model, as was the case for cinema studies when I attended UCLA, in the 1960s. Cinema, we were told, originates in two camps: fiction/fantasy (such as with Georges Méliès) and non-fiction/documentary (e.g., *les frères* Lumière). This persists today, in both the academy and the marketplace. Yet would cinematic depiction of Siddhartha's enlightenment be fiction (a psychological speculation) or documentary (based on what evidence?). To convey the transformation, Bernardo Bertolucci's *Little Buddha* (1994) and David Grubin's *The Buddha* (2010) utilize animation, a fictional device with magical undertones.

A UCLA film student at that time, Jim Morrison (also founder of the rock group The Doors) posited a third category for cinema: the magical, such as magical lantern slide shows.[3] He looked to cinema's still-living roots in amulets and tarot cards, comics and tattoos. Asian Buddhist culture is rich with such examples—woodblock illustrations of sutras and folk tales (such as the Jātakas), the Zen ox-herding cycle, portable Buddhist shrines, and Vajrayana *tangka* (icons). In the performativity implied by these tools of the sacred, ontology is not pregiven but arises through participatory enactment.

The importance of devotional, sacral ritual is thus applicable for Buddhist adherents and cinematic audience (and students) alike.

Seeing Dharma through Cinema

In his introduction to this volume, John Whalen-Bridge shows us karma at play in *Groundhog Day*. Performatively, we might see this by viewing any fictional movie beginning in the middle, then continuing again from the beginning. All that happens in the second half can be seen as resulting from the characters' actions (and thoughts and words) in the first half. We can also see ethics at play in their decisions and conduct. Two more central Buddhist topics that cinema can illuminate quite well are immediacy and emptiness.

Author-screenwriter Alain Robbe-Grillet once posited, "The image is always in the present tense." A keen example of this is Yasu-jiro Ozu's *Tokyo Story*. Each frame and every sequence is given equal weight, without ever any extra emphasis. Each moment is unique, and one never quite knows what might happen next. (This immediacy of re-*present*ation can add extra punch to elliptical narratives, such as *Memento* and *Groundhog Day*, *The Saragossa Manuscript* and *Last Year at Marienbad*.) This illustrates the Buddha's teaching that, even if we're reviewing the past, or rehearsing the future, the only moment ever available for us is the present.

Dwelling in the present moment, we find awareness opens, within and without. In intelligent alertness, we might sense a nonmaterial dimension, we call spiritual: we might sense gratitude for the present of life, or a presence, as a state of grace. Buddhism restrains any attempt to conceptualize or reify such experience, preferring to refer to nonself, emptiness (śūnyatā). Not hollow nor nihilistic, Buddhist emptiness is really inconceivably fertile: the nature reality as empty *of*—empty of any separate, permanent selfhood.

We ordinarily don't perceive selfless blank essence directly, but it can manifest via consecutiveness, illusion, combination, relativity, spaciousness. These qualities are fundamental to the original basis of "moving pictures" in the assemblage of consecutive photos on flexible film stock, projected so as to give the illusion of continuity ("flicker fusion"). In a fourth-dimensional media, one image creates

meaning for the next, within a spaciousness no longer fixed by Aristotle's unity of time and place.

Our blind spot keeps us from seeing what's truly happening (the shadow-play, the illusion of persistence of vision). So we construct meaning from and for what we see. This can lead to anxiety or suffering when our reality construction is incorrect. (The stranger driving in front of us didn't intentionally "cut us off," they just happened to make a left turn.) And deep recognition of this provisional, interconnected, and tricky nature of reality can also engender compassion, for ourselves and others.

Indeed, cinema evokes empathy in its very nature of storytelling. The camera's various points of view invite us to go beyond limitations of personal self and trade places with characters portrayed. Without compassion, we might always be aware we're sitting in front of a screen. And this is part of the fun: sitting there in our jeans and sweater, and at the same time being superstars, thirty-three-feet tall, and sliding back and forth between the two realms, and ideally feeling them as one. (This is similar to the unification of subject and object occurring in meditation.)

When empathy intensively encounters suffering, it can transform into compassion. In compassionate viewing, we hope it all turns out ok, sometimes even for the heavies as well as the heroes. Art can takes us into the human heart of the demon as well as the victim; Dickens's Ebenezer Scrooge, for example. Recognition of this can engender a great humility. A Pure Land tenet is relevant here: we are more tainted than we might ordinarily think—and all the more deserving of the compassion.

Wisdom and compassion are bedrock in all schools of Buddhism; we can now refine our sense of them through emphases of different schools.

Different Flavors for One Taste—(The Taste of Freedom)

A variety of schools are present within American Buddhism. Each can offer further analogies for Buddhism in cinema. Consider, for example, the Insight Meditation (Vipassana) teaching of *noting* the myriad aspects of everyday experience: not thinking so much as

quickly acknowledging, knowingly. Cognitive studies have under-scored noting's efficacy in countering and neutralizing the reactive pull of difficult emotions. ("Name it, to tame it.") Such training in discernment has a cinematic analogy in our participation in a direc-tor's vision.

Attending a theatrical play, we choose when to look and when to listen, and on which character to focus. In a film, the director makes the selection for us, aided by cinematographer and editor; we recreate for ourselves his or her sense of the scene. Typically, filmgoers don't notice this process, preferring uncritical immersion. For instance, we don't commonly note how it's often the reaction shot that trig-gers audience response (e.g., the sight of a woman screaming, not the bug-eyed monster; or seeing the woman weeping at hearing sad news, not the reading of the news itself). Where a goal of Vipassana is to notice what we notice in life (rather than being pulled along by the nose, by our habitual, uncritical reactions), a critical cinema cor-relative is to appreciatively notice what a filmmaker notices (rather than passively consume). Thus we see both Buddhism and cinema offering the benefits of critical distance, refined awareness, and per-sonally evaluated response.

In the simple, spontaneous, intuitive school of Buddhism known as Zen, our lives can be compared to a movie, while śūnyatā can be compared to the blank movie screen—without which there'd be no mind moments to savor.[4] Just as a battery needs to be charged to con-tinue to function, so too do we need to periodically stop and face the blank essence of life, just as it is in the present moment, without overlaying any story line. To be fully alive, we need both: our lived life and its grounding in life itself. Zen nondualism understands the wisdom of balance, the Middle Way, in not dwelling too much on either story or blank screen. This could be likened to the Zen aes-thetic of Noh theater where intense emotion is balanced with a state of grace.

Being engrossed in a movie and exchanging our self with oth-ers is also reminiscent of the compassionate Tibetan practice *tonglen* (literally, receiving and sending)—and reveals the basic insubstan-tiality of self. We might hear an actor tell of "getting in touch with himself," but many confess enjoyment at the opportunity of not being someone else—and also how acting teaches them their lack of any core identity. Drama shows us that, given the circumstances, we

each could change who we thought we were in a second. As they say, there but for fortune go you or I. This wisdom engenders compassion, toward ourselves and others.

Long Live Impermanence!

Though positioned as a final entry, I'd like to relinquish any sense of closure. Indeed, the significances of this collection remain open. Instead, I wish to direct a bit of attention to current affairs that might serve as landmarks along the path of religion and film.

A few generations ago, it would have been hard to posit the concept and practice of the mutual commonality of different schools and lineages of Buddhism. Now, it's more common to appreciate a variety of traditions within Buddhism. Plus, what happens in the West has influence elsewhere. Case in point: in 2009, four women are fully ordained as nuns into a Thai Buddhist order, in Australasia—the first such ordination in Thai Buddhist tradition—and the echoes reach all shores and ears in the Dharma world.

Simultaneously, moviemaking and moviegoing are in upheaval. Anyone can make a movie today (think: YouTube). And you can find and view all the movies mentioned in this book in a matter of weeks now, rather than years. Yet this democratization creates a long tail. There are so many movies made each year that finding them becomes ever harder. One result is the emergence of movie festivals.

Case in point: the International Buddhist Film Festival (IBFF), alluded to in the introduction to this volume. As of this writing, it's celebrating its tenth anniversary season, having presented twelve festivals in ten cities on three continents, exhibiting nearly 350 films from twenty-two nations. For example, in Mexico City, 2008, it screened twenty-five films from over a dozen nations (over fifteen of which were premieres in Mexico) during an eleven-day run. Moreover, it provided a lightning rod for various local Buddhist groups to join each other and the greater community. Notable were an unprecedented encounter between a group of indigenous Mexican shamans and six Buddhist monks, plus the festival opening ceremony, in the city's famed central plaza, the Zócalo, where upwards of forty thousand people greeted Tibetan monks, flanked by Jumbotrons, as they chanted for peace with cymbals and long horns, broadcast live

on TV. (From the southern continent, this, too, is part of American Buddhism.)

Ever-evolving, IBFF's nonprofit umbrella, Buddhist Film Foundation, has been fiscal sponsor for the production of two dozen films, initiated a Buddhist Film Archive at UC Berkeley, operates the Festival Media distribution service (twenty titles licensed and over one hundred thousand DVDs sold), and is launching Buddhist Film Channel, a global, multilingual, video-on-demand platform with over one hundred films available for streaming and downloading.[5]

The Road Ahead

Buddhism in American culture is a practice whose time has come. And cinema is an excellent application of it for students and scholars; that is, those of us who wish to understand what we see and hear, feel and think.

As we've seen, what we can learn from cinema can be applicable to Buddhism, and vice versa. For a final example, consider how any movie is identical to itself, each time it's played or screened. It's the event that matters: there will be as many versions of any one, single movie as viewers, or viewings. Similarly, through whatever school or cultural manifestation, the Buddha teaches but one thing, the nature of the arising of suffering, which is to say, liberation from suffering—a single truth, with as many meanings as beings. May this groundbreaking book inspire an ample range of skillful, nourishing response.

Notes

1. A sizable, national survey, by Robert Wuthnow and Wendy Cadge, completed in 2003, revealed one in eight Americans acknowledged Buddhist teachings or practices as an important influence on his or her religion or spirituality. Another seminal study was conducted from 2001 to 2003, analyzing the unnamed "contemplative practices movement" in America, indicating this phenomenon as growing from periphery to mainstream of American society.

2. Modern phenomenology's founder, Edmund Husserl, was coincidentally contemporary with the early development of cinema. He also read and wrote on teachings of the Buddha. Fred Hanna calls attention to the assertion of Husserl's assistant, Eugen Fink, that the phases of Husserl's method are identical to phases of Buddhism.

3. Cognitive studies are indebted to contemplative practices, particularly Eastern. The relatively recent presence of practitioners adept at meditation permitted entry of the subjective as evidence for scientific study. Our caveat is that cognitive studies not be limited to the brain, given the power of the heart, the endocrine system, immunology, and so on.

4. In *Notes on Vision*, Morrison writes: "Cinema derives not from painting, literature, sculpture, theater, but from ancient popular wizardry . . ."

5. When Buddhist practice in America reached sufficient visibility, a mass-market glossy English-language magazine was proposed (now known as *Tricycle*). In initial discussions, a Buddhist film festival was also under consideration. Gaetano Maida, one of the founders of *Tricycle* at that time, went on to establish and maintain the International Buddhist Film Festival. *Tricycle* now hosts a Buddhist film festival online, in conjunction with Buddha Fest.

BIBLIOGRAPHY

"About the Production: *The Cup*." Fine Line Features, 1999. http://www.finelinefeatures.com/thecup, accessed 9 September 2004.

Abramson, Marc. "Mountains, Monks and Mandalas: *Kundun* and *Seven Years in Tibet*." *Cineaste* 23, no. 3 (1998): 8–12.

Aide-mémoire from U.S. State Department to the British Embassy, 13 July 1942, FO371/35756, British Foreign Office Records, The National Archives of the United Kingdom (UKNA).

Akass, Kim, and Janet McCabe. *Reading "Six Feet Under": TV to Die For*. New York: I. B. Tauris, 2005. Print.

Alleva, Richard. "No 'Leave It to Beaver.'" *Commonweal* 126, no. 19 (5 November 1999): 19–20. Print.

———. "A Risk Worth Taking: Scorsese's *Kundun*." *Commonweal* 125, no. 4 (27 February 1998): 21–22. Print.

Ames, Eric. "Herzog, Landscape, and Documentary." *Cinema Journal* 48, no. 2 (Winter 2009): 49–69. Print.

Anderson, Laurie. "Stories from the Nerve Bible." In *Culture on the Brink: Ideologies of Technology*, ed. Gretchen Bender. Seattle: Bay Press, 1994. 221–230. Print.

Andrew, Dudley. "The Neglected Tradition of Phenomenology in Film Theory." In *Movies and Methods*, Vol. 2, ed. Bill Nichols. Berkeley: University of California Press, 1985. 625–631. Print.

Arthur, Paul. "American Beauty." *Cineaste* 25, no. 2 (2000): 51–52. Print.

"Awards for Phörpa." Internet Movie Database, 1999. http://us.imdb.com/title/tt0201840/awards, accessed 5 September 2004.

Bahm, Archie J. "Buddhist Aesthetics." *Journal of Aesthetics and Art Criticism* 16, no. 2 (1957): 249–52. Print.

Ball, Alan. *American Beauty: The Shooting Script.* New York: Newmarket Press, 1999. Print.

Barthes, Roland. *Mythologies.* Trans. Annette Lavers. New York: Hill and Wang, 1972. Print.

Batchelor, Stephen. *Buddhism without Beliefs.* New York: Riverhead Books, 1997. Print.

———. "The Phenomenological Approach." *Alone with Others: An Existential Approach to Buddhism.* New York: Grove, 1983.

Bellah, Robert, Richard Madsen, William M. Sullivan, Ann Swidler, and Steven M. Tipton. *Habits of the Heart: Individualism and Commitment in American Life.* New York: Perennial Library, 1986. Print.

Bender, Courtney, and Wendy Cadge. "Constructing Buddhism(s): Interreligious Dialogue and Religious Hybridity." *Sociology of Religion* 67, no. 3 (2006): 229–47. Print.

Benjamin, Walter. "The Storyteller." *Illuminations: Essays and Reflections*, ed. and trans. Hannah Arendt. New York: Schocken Books, 1968. 83–110. Print.

Benton, Thomas Hart. "The Congressional Globe." In *A More Perfect Union: Documents in U.S. History*, ed. Paul F. Boller Jr. and Ronald Story. Boston: Houghton Mifflin Company, 1988. Print.

Bernbaum, Edwin. *The Way to Shambhala.* Garden City, NY: Anchor Books, 1980. Print.

Bhabha, Homi K. *The Location of Culture.* London and New York: Routledge, 1994. Print.

Bial, Henry. *The Performance Studies Reader.* Oxford: Taylor & Francis, 2007. Print.

Bishop, Peter. "A Landscape for Dying: The Bardo Thodol and Western Fantasy." In *Constructing Tibetan Culture: Contemporary Perspectives*, ed. Frank J. Korom. Quebec: World Heritage Press, 1997. 47–72. Print.

———. *The Myth of Shangri-La: Tibet, Travel Writing, and the Western Creation of Sacred Landscape.* Berkeley: University of California Press, 1989. Print.

Blyth, R. H. *Haiku. Volume One: Eastern Culture.* Tokyo: The Hokuseido Press, 1981. Print.

Bortolin, Matthew. *The Dharma of Star Wars*. Boston: Wisdom, 2005. Print.

Brannigan, Michael. "There Is No Spoon: A Buddhist Mirror." *The Matrix and Philosophy: Welcome to the Desert of the Real*. Chicago: Open Court, 2005. 101–10. Print.

Brooks, Peter. "Freud's Masterplot." *Yale French Studies* 55, no. 56 (1977): 280–300. Print.

Brown, Jason W. "Microgenesis and Buddhism: The Concept of Momentariness." *Philosophy East and West* 49, no. 3 (July 1999): 261–77. http://www.jstor.org/stable/1399895, accessed 12 June 2012.

Bucknell, Robert S., and Martin Stuart-Fox. *The Twilight Language: Explorations in Buddhist Meditation and Symbolism*. London: Curzon Press, 1993. Print.

Burtt, E. A., ed. *The Teachings of the Compassionate Buddha*. New York: Mentor, 1982. Print.

Bush, George W. "2005 Inaugural Address." The White House. 20 January 2005. http://www.whitehouse.gov/news/releases/2005/01/20050120-1.html, accessed 22 March 2005.

———. "2005 State of the Union Address." The White House. 2 February 2005. http://www.whitehouse.gov/news/releases/2005/02/20050202-11.html, accessed 22 March 2005

Campbell, Joseph. *The Power of Myth*. New York: Doubleday, 1988. Print.

Camus, Albert. *The Myth of Sisyphus*. New York: Vintage, 1955. Print.

Carr, Jay. Review of *American Beauty*. *Boston Globe*. 17 September 1999. Arts & Film. C4. Print.

Chandler, E. *The Unveiling of Lhasa*. London: Edward Arnold, 1905. Print.

Chang, Garma C. C. *The Buddhist Teaching of Totality*. University Park: Pennsylvania State University Press, 1989. Print.

Cho, Francisca. "Imagining Nothing and Imagining Otherness in Buddhist Film." In *Imag(in)ing Otherness: Filmic Visions of Living Together*, ed. B. S. Plate and D. Jasper. Atlanta: Scholars Press, 1999. 169–96. Print.

Christie, Ian, and David Thompson, eds. *Scorsese on Scorsese*. London: Faber and Faber, 2003. Print.

Churner, Leah. "An Interview with Richard Kelly, Director of *Donnie Darko*." Hybridmagazine.com. 1 October 2010. http://www.

hybridmagazine.com/films/0804/richard-kelly-interview.shtml, accessed 7 March 2014.

Clarke, J. J. *Oriental Enlightenment: The Encounter between Asian and Western Thought*. London: Routledge, 1997. Print.

Clifford, James. "Of Other Peoples: Beyond the Salvage Paradigm." In *Discussions in Contemporary Culture*, ed. Hal Foster. Seattle: Bay Press, 1987. 121–50. Print.

Coleman, Graham, and Thupten Jinpa, eds. *The Tibetan Book of the Dead*. New York: Penguin, 2005. Print.

Conze, Edward, trans. *Buddhist Scriptures*. London: Penguin Group, 1959. Print.

Cook, Francis. "The Meaning of Vairocana in Hua Yen Buddhism." *Philosophy East and West* 22 (October 1972): 403–15. Print.

Corliss, Richard. "Popular Metaphysics." *Time*. 19 April 1999. 76.

Daccache, Jenny George, and Brandon Valeriano. *Hollywood's Representations of the Sino-Tibetan Conflict: Politics, Culture, Globalization*. New York: Palgrave Macmillan, 2012. Print.

Dalai Lama. *Ethics for the New Millennium*. New York: Riverhead Books, 1999. Print.

———. *Freedom in Exile*. London: Hodder & Stoughton, 1990. Print.

———. *My Land and My People*. Ed. David Howarth. London: Weidenfeld and Nicolson, 1962. Print.

Dalai Lama, with Jean-Claude Carrière. *Violence and Compassion: Dialogues on Life Today*. New York: Doubleday, 1996. Print.

Dargis, Manohla. "Apocalypse Soon: A Mushroom Cloud Doesn't Stall 2008 Electioneering." (*Southland Tales*). *New York Times*. 14 November 2007. http://www.nytimes.com/2007/11/14/movies/14sout.html?_r=0, accessed 1 October 2010.

Darwin, Charles. *The Works of Charles Darwin*, 16 Vols., ed. Paul Barrett and R. B. Freeman. London: William Pickering, 1988. Print.

de la Rocha, Zack. *Rage Against the Machine*. Epic, 1992.

Decherney, Peter. *Hollywood and the Culture Elite: How the Movies Became American*. New York: Columbia University Press, 2005. Print.

Denby, David. "Lost in Translation." *The New Yorker* (22 September 2003). Print.

———. "Transcending the Suburbs." *The New Yorker* 75, no. 27 (20 September 1999): 133–35. Print.

Do, Thien. "The Quest for Enlightenment and Cultural Identity: Buddhism in Contemporary Vietnam." In *Buddhism and Politics in Twentieth-Century Asia*, ed. Ian Harris. New York and London: Continuum, 1999. 256–84. Print.

Dorsky, Nathaniel. *Devotional Cinema*. Berkeley: Tuumba, 2005. Print.

Doyle, Sir Arthur Conan. *The Annotated Sherlock Holmes*, Vol. 2, ed. and intro. William S. Baring-Gould. New York: Clarkson N. Potter, 1967. Print.

"Dreams of Tibet." *Frontline*. Narr. Orville Schell. PBS, Arlington, 1997. Television.

Dresser, Norine. "On Sticking Out Your Tongue." *Los Angeles Times*. 8 November 1997. http://articles.latimes.com/1997/nov/08/local/me-51420, accessed 5 July 2013.

Duerr, Maia. "A Powerful Silence: The Role of Meditation and Other Contemplative Practices in American Life and Work." The Center for Contemplative Mind in Society (2004). http://goo.gl/Ola3J.

Ebert, Roger. "*Donnie Darko*." *Chicago Sun-Times*. 26 October 2001. http://rogerebert.suntimes.com/apps/pbcs.dll/article?AID=/20011026/REVIEWS/110260302, accessed 1 October 2010.

———. "*Lost in Translation*." *Chicago Sun-Times*, 12 September 2003. http://www.rogerebert.com/reviews/lost-in-translation-2003.

Edelstein, David. "Bill Murray Opens Up in *Lost in Translation*." *Slate*, 11 September 2003. http://www.slate.com/articles/arts/movies/2003/09/prisoner_of_japan.html.

Edwards, Jonathan. "Sinners in the Hands of an Angry God." *The Norton Anthology of American Literature*, 5th ed., ed. Julia Reidhead. New York: W.W. Norton, 1998. 474–85. Print.

Elison, William. "From the Himalayas to Hollywood: The Legacy of *Lost Horizon*." *Tricycle: The Buddhist Review* 7, no. 2 (1997): 62–64. Print.

Emerson, Ralph Waldo. *Essays and Lectures*. New York: The Library of America, 1983. Print.

———. *The Journals and Miscellaneous Notebooks of Ralph Waldo Emerson*. Ed. William Gilman et al. Cambridge: Harvard University Press, 1960–1982. Print.

Epstein, Mark. *Thoughts without a Thinker*. New York: Basic Books, 1995. Print.

Fleming, Peter. *Bayonets to Tibet: The First Full Account of the British Invasion of Tibet in 1904.* London: Rupert Hart-Davis, 1961. Print.

Foulkes, Julia L. "Film Review." *American Historical Review* 99, no. 4 (1994): 1272–73. Print.

Fuchs, Cindy. "Movie Shorts: *Kundun*." *Philadelphia City Paper.* 16 January 1998. 65. Print.

Gach, Gary. "Mind Mirror: Buddha at the Movies." *Complete Idiot's Guide to Buddhism,* 3rd edition. Indianapolis: Alpha Books, 2009. Print.

———. "On Not Giving It a Name." *Urthona: Buddhism and the Arts* 23 (Dharma of the Moving Image) (2006).

Garfield, Jay L. "Dependent Arising and the Emptiness of Emptiness: Why Did Nagarjuna Start with Causation?" *Philosophy East and West* 44 (April 1994): 219–50.

Garner, Dwight. "*Seven Years in Tibet*." Salon.com. 11 October 1997. http://www.salon.com/1997/10/10/tibet_3/, accessed 1 November 2012.

George, David E. R. *Buddhism as/in Performance: Analysis of Meditation and Theatrical Practice.* No. 11 in Emerging Perceptions in Buddhist Studies. New Delhi: Printworld, 1999. Print.

Goleman, Daniel. *Social Intelligence: The New Science of Human Relationships.* New York: Random House, 2006. Print.

Goldberg, Ellen. "The Re-Orientation of Buddhism in North America." *Method and Theory in the Study of Religion* 11, no. 4 (1999): 340 56. Print.

Goldstein, Melvyn C. "The United States, Tibet, and the Cold War." *Journal of Cold War Studies* 8, no. 3 (Summer 2006): 145–64. Print.

Goodstein, Laurie. "Dalai Lama Says Terror May Need a Violent Reply." *New York Times.* 18 September 2003. http://www.nytimes.com/2003/09/18/us/dalai-lama-says-terror-may-need-a-violent-reply.html, accessed 7 March 2014.

Greenberg, J., T. Pyszczynski, S. Solomon, A. Rosenblatt, M. Veeder, S. Kirkland, and D. Lyon. "Evidence for Terror Management Theory II: The Effects of Mortality Salience on Reactions to Those Who Threaten or Bolster the Cultural Worldview." *Journal of Personality and Social Psychology* 58, no. 2 (1990): 308–18. Print.

Greenwald, Jeff. "Big Mind, Small Screen: *Six Feet Under*'s Alan Ball." *Tricycle: The Buddhist Review* 13, no. 4 (2004): http://www.tricycle.com/profile/big-mind-small-screen-six-feet-unders-alanball, accessed 4 July 2013.

Gupta, Rita. "Twelve-Membered Dependent Origination: An Attempted Reappraisal." *Journal of Indian Philosophy* 5 (1977): 163–86. Print.

Hagen, Steve. *Buddhism Is Not What You Think*. New York: Harper-Collins, 2003. Print.

Hale, Dorothy. "Post-Colonialism and the Novel." In *The Novel: An Anthology of Criticism and Theory, 1900–2000*, ed. Dorothy J. Hale. London: Blackwell Publishing, 2006. 653–73. Print.

Hanna, F. J. "Husserl on the Teachings of the Buddha." *The Humanistic Psychologist* 23, no. 3 (1996): 365–72. Print.

Hanson, Rick, and Richard Mendius. *Buddha's Brain*. Oakland, CA: New Harbinger, 2009. Print.

Harrer, Heinrich. *Seven Years in Tibet*. New York: E. P. Dutton, 1954. [Edition cited in chapter 3.] Print.

Harrer, Heinrich. *Seven Years in Tibet*. Trans. Richard Graves. London: Rupert Hart-Davis, 1953. [Edition cited in chapter 4.] Print.

Harvey, Peter. *An Introduction to Buddhist Ethics*. Cambridge: Cambridge University Press, 2000. Print.

Hedin, Sven. *A Conquest of Tibet*. New York: E. P. Dutton, 1934. Print.

Heidegger, Martin. *Being and Time*. New York: Harper Collins, 1962. Print.

Heller, Dana. "Buried Lives: Gothic Democracy in 'Six Feet Under.'" In Akass and McCabe, 71–84. Print.

Heraclitus. "Fragments." In *Philosophic Classics*, ed. Walter Kaufmann. Englewood Cliffs: Prentice Hall, 1961. Print.

Hergé. *Tintin in Tibet*. London: Methuen, 1962. Print.

Higginson, William J. *The Haiku Handbook*. Tokyo: Kodansha International: 1985.

Hilton, James. *Lost Horizon*. New York: William Morrow, 1933. [Edition cited in chapter 3.] Print.

Hilton, James. *Lost Horizon*. London: Macmillan, 1933. [Edition cited in chapter 4.] Print.

His Holiness the Dalai Lama. *Ethics for the New Millennium*. New York: Riverhead Books, 1999. Print.

Hoberman, J. "After Sunset: Coppola's Camera Karaokes through Tokyo and Finds Bill Murray Singing Roxy Music." *The Village Voice*. 10–16 September 2003. Print.

———. "Boomer Bust." *The Village Voice*. 15 September 1999. http://www.villagevoice.com/film/9937,hoberman,8285,20.html, accessed 28 May 2013.

Holden, Stephen. "*Kundun*." Review. *New York Times*. 24 December 1997. n.p. http://www.nytimes.com/1997/12/24/movies/film-review-the-dalai-lama-toddler-to-grown-man-in-exile.html, accessed 5 July 2013.

Horsman, Reginald. *Race and Manifest Destiny*. Cambridge: Harvard University Press, 1981. Print.

Hozic, Aida. *Hollyworld: Space, Power and Fantasy in the American Economy*. Ithaca: Cornell University Press, 2001. Print.

Hunt, Leon. *Kung Fu Cult Masters*. London: Wallflower Press, 2003. Print.

"In Conversation with Michael Eisner." *Charlie Rose*. PBS. 24 September 1998. Television.

Inada, Kenneth K. "A Theory of Oriental Aesthetics: A Prolegomenon." *Philosophy East and West* 47, no. 2 (April 1997): 117–31. http://www.jstor.org/stable/1399872, accessed 13 June 2013.

———. "The Buddhist Aesthetic Nature: A Challenge to Rationalism and Empiricism." *Asian Philosophy* 4 (February 1994): 139–50. Print.

———."The Challenge of a Buddho-Taoist Metaphysics of Experience." *Journal of Chinese Philosophy* 21 (January 1994): 24–47. Print.

———. "The Metaphysics of Buddhist Experience and the White-headian Encounter." *Philosophy East and West* 25 (April 1975): 465–87. Print.

———. "Problematics of the Buddhist Nature of the Self." *Philosophy East and West* 29, (April 1979): 141–58. Print.

———. "The Range of Buddhist Ontology." *Philosophy East and West* 38 (March 1988): 261–80. Print.

———. "Some Basic Misconceptions of Buddhism." *International Philosophical Quarterly* 8 (March 1969): 101–19. Print.

———. "A Theory of Oriental Aesthetics: A Prolegomenon." *Philosophy East and West* 47, no. 2 (April 1997): 117–31. http://www.jstor.org/stable/1399872, accessed 13 June 2013.

————."Time and Temporality: A Buddhist Approach." *Philosophy East and West* 24, no. 2, (April 1974): 171–79. http://www.jstor. org/stable/1398020, accessed 12 June 2013.

————. "Whitehead's 'Actual Entity' and the Buddha's Anatman." *Philosophy East and West* 1 (January 1970): 303–15. Print.

Inada, Kenneth K., and Nolen Jacobsen, eds. *Buddhism and American Thinkers*. Albany: State University of New York Press, 1984. Print.

Internet Movie Database (IMDb). Imdb.com. N.d. www.imdb.com.

Irwin, William, ed. *The Matrix and Philosophy: Welcome to the Desert of the Real*. Chicago: Carus Publishing, 2002.

Jefferson, Thomas. "Letter to W. S. Smith." Monticello.org. http://www.monticello.org/reports/quotes/liberty.html, accessed 22 March 2005.

Johannsen, Robert W. "The Meaning of Manifest Destiny." In *Manifest Destiny and Empire*, ed. Sam Haynes and Christopher Morris. College Station: Texas A&M University, 1997. 7–20. Print.

Jones, Ken. *The Social Face of Buddhism*. Boston: Wisdom Publications, 1989. Print.

Kasulis, T. P. "Truth and Zen." *Philosophy East and West* 30 (October 1980): 453–64. Print.

————. "The Two Strands of Nothingness in Zen Buddhism." *International Philosophical Quarterly* 19 (March 1979): 61–72. Print.

————. *Zen Action, Zen Person*. Honolulu: University of Hawaii Press, 1981. Print.

————. "The Zen Philosopher: A Review Article on Dōgen Scholarship in English." *Philosophy East and West* 28 (July 1978): 353–73. Print.

Kauffmann, Stanley. "In Search of an Author." *The New Republic* 221, no. 15 (11 October 1999): 36–38. Print.

Killmeier, Matthew A., and Gloria Kwok. "A People's History of Empire, or the Imperial Recuperation of Vietnam? Countermyths and Myths in *Heaven and Earth*." *Journal of Communication Inquiry* 29, no. 3 (2005): 256–78. Print.

Kim, Hee-Jin. *Dōgen Kigen: Mystical Realist*. Tucson: University of Arizona Press, 1975.

Klawans, Stuart. "The Boys of Summer." *The Nation* 269, no. 11 (11 October 1999): 34–36. Print.

Korom, Frank J., ed. *Constructing Tibetan Culture: Contemporary*

Perspectives. St. Jean, St. Hyacinthe, Quebec: World Heritage Press, 1997. Print.

———. "Old Age Tibet in New Age America." Korom, 73–97. Print.

Landon, Percival. *Lhasa.* 2 Vols. London: Hurst & Blackett, 1905. Print.

Landor, A. Henry. *Savage: Tibet and Nepal.* London: A. & C. Black, 1905. Print.

Lankavatara Sutra. Buddhist Information. http://www.buddhistinformation.com/lankavatara_sutra.htm, accessed 21 February 2005.

Le Bris, Michael. *Romantics and Romanticism.* Geneva: Skira, 1981. Print.

Lee Feigon. *Demystifying Tibet: Unlocking the Secrets of the Land of the Snows.* Chicago: Ivan R. Dee, 1996. Print.

LeFevre, Michael. "Dialogue: Combining the Spiritual and the Political." Interview with Tenzin Thethong published in *The Costa Rican Times.* 8 June 2013. http://www.costaricantimes.com/dialogue-combining-the-spiritual-and-political/16650, accessed 6 July 2013.

Levine, Robert. "The Resurrection of 'Donnie Darko.'" *New York Times.* 18 July 2004. http://www.nytimes.com/2004/07/18/movies/film-the-resurrection-of-donnie-darko.html?pagewanted=all&src=pm, accessed 1 October 2010.

Loeterman, Ben, dir. *Dreams of Tibet.* PBS. 28 October 1997. http://www.pbs.org/wgbh/pages/frontline/shows/Tibet/etc/script.html, accessed 27 June 2005. Filmmakers Library, 2001. Transcript.

Lopez, Donald S. "New Age Orientalism: The Case of Tibet." *Tibetan Review* (1994): 16–20. Print.

———. *Prisoners of Shangri-La: Tibetan Buddhism and the West.* Chicago: University of Chicago Press, 1998. Print.

Loy, David R. *Money, Sex, War, Karma: Notes for a Buddhist Revolution.* Boston: Wisdom Publications, 2008. Print.

———. *Non-Duality: A Study in Comparative Philosophy.* New Haven: Yale University Press, 1988; Amherst, NY: Humanity Books, 1998. Print.

Luckmann, Thomas. Ed. *Phenomenology and Sociology.* New York: Penguin Books, 1978, pp. 7–8.

Maslin, Janet. "Dad's Dead, and He's Still a Funny Guy." *New York Times.* 15 September 1999, Section E, p. 1. Print.

———. "*Heaven and Earth*: A Woman's View of Vietnam Horrors." *New York Times*. 24 December 1993. http://www.nytimes.com/1993/12/24/movies/review-film-heaven-and-earth-a-woman-s-view-of-vietnam-horrors.html, accessed 5 July 2013.

Masuzawa, Tomoko. "From Empire to Utopia: The Effacement of Colonial Markings in Lost Horizon." *positions: east asia cultures critique* 7, no. 2 (1999): 541–72. Print.

Mathison, Melissa. "Projecting Tibet." Interview with the Dalai Lama. *Tricycle: The Buddhist Review* 7, no. 2 (1997): 65–74. Print.

Matthiessen, Peter. *The Snow Leopard*. New York: Viking Press, 1978. Print.

McMahon, Jennifer L. "Icons of Stone and Steel: Death, Cinema, and the Future of Emotion." In *Death in Classic and Contemporary Cinema: Fade to Black*, ed. Jeff Greenberg and Daniel Sullivan. New York: Palgrave, 2013. Print. 73–90.

Merleau-Ponty, Maurice. "Film and the New Psychology." *Sense and Nonsense*. Evanston: Northwestern University Press, 1964. Print. 48–59.

Mitchell, Elvis. "An American in Japan, Making a Connection." *New York Times*. 12 September 2003. http://www.nytimes.com/2003/09/12/movies/film-review-an-american-in-japan-making-a-connection.html?pagewanted=all&src=pm, accessed 5 July 2013.

———. "Sure, He Has a 6-Foot Rabbit. Does That Mean He's Crazy?" *New York Times*. 26 October 2001. http://www.nytimes.com/2001/10/26/movies/film-review-sure-he-has-a-6-foot-rabbit-does-that-mean-he-s-crazy.html, accessed 7 March 2014.

Mitchell, Stephen, ed. *The Enlightened Mind*. New York: HarperPerennial, 1991. Print.

Mitchell, W. J. T., ed. *Landscape and Power*. Chicago and London: University of Chicago Press, 1994. Print.

Mohanty, Chandra Talpade. "Under Western Eyes: Feminist Scholarship and Colonial Discourses." In *Colonial Discourse and Post-Colonial Theory: A Reader*, ed. Patrick Williams and Laura Chrisman. New York: Columbia University Press, 1994. 196–220. Print.

Morrison, Jim. *The Lords and the New Creatures*. New York: Simon & Schuster, 1970. Print.

———. "Notes on Vision" in *The Lords and New Creatures*. New York: Simon & Schuster, 1987.

Mullen, Eve L. "Orientalist Commercializations: Tibetan Buddhism in American Popular Film." *Journal of Religion and Film* 2, no. 2 (1998): n.p. Print.

Murray, Rebecca. "Q&A with Writer/Director Richard Kelly." About. com. 19 October 2003. http://movies.about.com/cs/donnie darko/a/donniedarkork.htm, accessed 1 October 2010.

Nesselson, Lisa. "Director Secretly Filmed in Tibet." *World Tibet Network News.* 10 June 1999. http://www.tibet.ca/en/wtnar-chive/1999/6/10_1.html, accessed 27 June 2005.

Nhat Hanh, Thich. *Creating True Peace.* New York: Free Press, 2003. Print.

Nguyen, Hanh, and R. C. Lutz. "A Bridge between Two Worlds: Crossing America in Monkey Bridge." In *The Emergence of Buddhist American Literature,* ed. John Whalen-Bridge and Gary Storhoff. Albany: State University of New York Press, 2009. 189–206. Print.

O'Sullivan, John. "The Great Nation of Futurity." *The United States Democratic Review* 6, no. 23. http://cdl.library.cornell.edu/cgi-bin/moa/moa-cgi?notisid=AGD1642-0006&byte=217466124, accessed 7 March 2014.

Papamichael, Stella. "Lost in Translation." BBC, 7 January 2004.

Peranson, Mark. "Richard Kelly's Revelations: Defending *Southland Tales.*" Cinema-scope.com. Issue 27. 1 October 2010. Web.

Plato. "Allegory of the Cave." in *The Republic of Plato,* 2nd edition, trans. Allen Bloom New York: Basic Books, 1991. 193–220.

Pope, Alan. "'Is There a Difference?' Iconic Images of Suffering in Buddhism and Christianity." *Janus Head* 10, no. 1 (2007): 247–60. Print.

Pyszczynski, T., J. Greenberg, and S. Solomon. "Why Do We Need What We Need? A Terror Management Theory Perspective on the Roots of Human Social Motivation." *Psychological Inquiry* 8, no. 1 (1997): 1–20. Print.

Pyysiäinen, I. "Buddhism, Religion, and the Concept of 'God.'" *Numen: International Review for the History of Religion* 50, no. 2 (2003): 147–71. Print.

Rabgyal, Nawang. "Letter to the Editor of the *New York Times* from the Dalai Lama's Representative." Canada Tibet Committee. 24 March 2005. http://www.tibet.ca/en/wtnarchive/2003/9/23_1. html, accessed 7 March 2014.

Raud, Rein. "The Existential Moment: Rereading Dōgen's Theory of Time." *Philosophy East and West* 62, no. 2 (April 2012): 153–73. Print.

Rickman, Gregg. "The Last Temptation of Donnie Darko." In *The Science Fiction Film Reader*, 1st ed., ed. Gregg Rickman. New York: Limelight, 2004. 369–81. Print.

Roosevelt, Theodore. Letter from President Roosevelt to the Dalai Lama, 3 July 1942. In U.S. State Department, *Foreign Relations of the United States*, 1942, Volume 7: 113. Print.

Rosenblatt, A., J. Greenberg, S. Solomon, T. Pyszczynski, and D. Lyon. "Evidence for Terror Management Theory I: The Effects of Mortality Salience on Reactions to Those Who Violate or Uphold Cultural Values." *Journal of Personality and Social Psychology* 57, no. 4 (1989): 681–90. Print.

Roxy Music, "More Than This." Avalon, EG Records, 1982, CD.

Ruskin, John. *Modern Painters*, Vols. 2–4. London: J. M. Dent, 1906. Print.

Said, Edward. "Consolidated Vision." Excerpt from *Culture and Imperialism*. Hale, 691–715. Print.

———. *Culture and Imperialism*. New York: Alfred A. Knopf, 1993. Print.

———. *Orientalism*. New York: Vintage Books, 1979. Print.

San Filippo, M. "Lost in Translation," *Cineaste* 29.1 (2004): 26–28.

Sayeau, Ashley. "Americanitis: Self-Help and the American Dream in *Six Feet Under*." Akass and McCabe, 94–108. Print.

Schechner, Richard. *Performance Studies: An Introduction*. New York: Routledge, 2006. Print.

Schell, Orville. "Between the Image and the Reality." Interview with Becky Johnston. *Tricycle: The Buddhist Review* 7, no. 2 (1997): 75–81. Print.

———. *Virtual Tibet: Searching for Shangri-La from the Himalayas to Hollywood*. New York: An Owl Book, 2000. Print.

Schwartzbaum, L. "The Best of 2003." *Entertainment Weekly*, 19 September 2003. Print.

Scofield, Aislin. "Tibet: Projections and Perceptions." *East-West Film Journal* 7, no. 1 (1993): 106–36. Print.

Scott, A. O. "The Dead Have Messages for the Land of the Living." *New York Times*. 15 October 2010. http://movies.nytimes.com/2010/10/15/movies/15hereafter.html?pagewanted=all.

Shannon, Jeff. Interview with Alan Ball for Amazon.com (1999). 28 May 2013. http://www.spiritualteachers.org/alan_ball.htm.

Siegel, Dan. *The Mindful Brain: Reflection and Attunement in the Cultivation of Well-Being*. New York: WW Norton & Co., 2007. Print.

———. *Mindsight: The New Science of Personal Transformation*. New York: Random House, 2010. Print.

Sivaraksa, Sulak. *Conflict, Culture, Change: Engaged Buddhism in a Globalizing World*. Boston: Wisdom Publications, 2005. Print.

Slotkin, Richard. *Regeneration through Violence: The Mythology of the American Frontier, 1600–1860*. Norman: University of Oklahoma Press, 2000. Print.

Sluyeter, Dean. *Cinema Nirvana: Enlightenment Lessons from the Movies*. New York: Three Rivers, 2005. Print.

Smith, David L. "'The Sphinx Must Solve Her Own Riddle': Emerson, Secrecy, and the Self-Reflexive Method." *Journal of the American Academy of Religion* 71, no. 4 (2003): 835–61. Print.

Smith, Gavin. "Martin Scorsese Interviewed" January/February 1998. http://www.filmcomment.com/article/martin-scorsese-interviewed, accessed 7 March 2014.

Sogyal Rinpoche. *The Tibetan Book of Living and Dying*. New York: HarperCollins, 1993. Print.

Soucy, Alexander. "Language, Orthodoxy, and Performances of Authority in Vietnamese Buddhism." *Journal of the American Academy of Religion* 77, no. 2 (2009): 348–71. Print.

Stephens, Rebecca L. "Distorted Reflections: Oliver Stone's *Heaven and Earth* and Le Ly Hayslip's *When Heaven and Earth Changed Places*." *Centennial Review* 41, no. 3 (1997): 661–69. Print.

Stone, Jay. "Spacey on Reawakening." *Ottawa Citizen*.15 September 1999. B8. Print.

Suzuki, Daisetz T. *Introduction to Zen Buddhism*. New York: Grove Weidenfeld, 1964. Print.

———. *Zen and Japanese Culture*. Princeton: Princeton University Press, 1959. Print.

Tatz, Mark. *The Skill in Means (Upayakausalya Sutra)*. New Delhi: Motilal Banarsidass, 2001. Print.

Taylor, Philip. "Modernity and Re-Enchantment in Post-Revolutionary Vietnam." In *Modernity and Re-Enchantment: Religion in*

Post-Revolutionary Vietnam, ed. Philip Taylor. Singapore: ISEAS Publishing, 2007. 1–56. Print.

Thanissaro Bhikkhu. "The Roots of Buddhist Romanticism." Buddhist Information of North America Library and Electric Sangha, 2002. http://www.buddhistinformation.com/roots_of_buddhist_romanticism.htm, 19 September 2005.

"The Boy on the Throne." *Oprah*. CBS. Harpo Productions, Chicago. 17 March 1998. Television.

——— *Interbeing: Fourteen Guidelines for Engaged Buddhism*. Berkeley: Parallax Press, 1987. Print.

———. *Living Buddha, Living Christ*. New York: Riverhead Trade, 2007. Print.

Thoreau, Henry David. *Walden*. Boston: Beacon Press. 2004. Print.

Thurman, Robert. *Inner Revolution: Life, Liberty, and the Pursuit of Real Happiness*. New York: Riverhead Books, 1998.

Travers, Peter. "Lost in Translation." *Rolling Stone*. 8 September 2003. http://www.rollingstone.com/movies/reviews/lost-in-translation-20030908, accessed 5 July 2013.

Travis-Robyns, Suzan Ruth. "What Is Winning Anyway? Redefining Veteran: A Vietnamese American Woman's Experiences in War and Peace." *Frontiers* 8, no. 1 (1997): 145–67. Print.

Turan, Kenneth. "The Rose's Thorns." *Los Angeles Times*. 15 September 1999, Part F, 1. Print.

Turner, S. *An Account of an Embassy to the Court of the Teshoo Lama in Tibet*. New Delhi: Manjusri, 1971. Print.

van Gennep, Arnold. *The Rites of Passage*. Chicago: University of Chicago Press, 1960. Print.

Varela, Francisco J., Evan Thompson, and Eleanor Rosch. *The Embodied Mind: Cognitive Science and Human Experience*. Massachusetts: MIT Press, 1999. Print.

Verniere, James. "Coppola's Jaded 'Lost' Character Fills the Bill." *Boston Herald*. 12 September 2003. Print.

Victoria, Brian. *Zen at War*. New York: Weatherhill, 1997. Print.

———. *Zen War Stories*. New York: Routledge, 2003. Print

Wachowski, Andy, and Larry Wachowski. "Introduction to *The Ultimate Matrix Collection*." In *The Ultimate Matrix Collection*, dir. Andy Wachowski and Larry Wachowski. Warner Home Video, 2004.

Wachs, Jeffrey. "His Cup Runneth Over: An Interview with Director Khyentse Norbu," n.d. Reel.com. http://www.reel.com/reel.asp?mode=features/interviews/norbu, accessed 21 June 2005.

Wallis, Glen, comp. and trans. *Basic Teachings of the Buddha*. New York: Modern Library, 2007. Print.

Walters, James. *Alternative Worlds in Hollywood Cinema: Resonance between Realms*. Bristol: Intellect, 2008. 110–15. Print.

Warner, Brad. *Sit Down and Shut Up: Punk Rock Commentaries on Buddha, God, Truth, Sex, Death, and Dōgen's Treasury of the Right Dharma Eye*. Novato: New World Library, 2007. Print.

Whalen-Bridge, John. "What Is a Buddhist Film?" *Contemporary Buddhism*, 15.1(2014), DOI:10.1080/14639947.2014.890358.

White, George. "Views in India, Chiefly among the Himalayan Mountains, 1825." In *Eternal Himalaya*, ed. H. Ahluwalia. New Delhi: Interprint, 1982. Print.

Whitman, Walt. *Complete Poetry and Collected Prose*. New York: The Library of America, 1982. Print.

Winthrop, John. "A Modell of Christian Charity." Collections of the Massachusetts Historical Society. Boston, 1838, 3rd series 7: 31–48. Hanover Historical Texts Projects. http://history.hanover.edu/texts/winthmod.html.

Wright, Dale S. "The Awakening of Character in the Buddhist Film Mandala." *Literature and Theology* 18, no. 3 (2004): 308–20. Print.

Wuthnow, R., and W. Cadge. "Buddhists and Buddhism in the United States: The Scope of Influence." *Journal for the Scientific Study of Religion* 43, no. 3 (2004): 363–80. Print.

Zacharek, Stephanie. "Lost in Translation." Salon.com. 12 September 2003. http://www.salon.com/ent/movies/review/2003/9/12/translation/index_np/html, accessed 5 July 2013.

———. "The Creepy Suspense inside 'The Box.'" Salon.com. 5 November 2009. http://www.salon.com/2009/11/06/the_box/, accessed 7 March 2014.

Zigmond, Dan. "Yoda Dharma." *Tricycle: The Buddhist Review* (Fall 2005): 100–02.

FILMOGRAPHY

2012. Dir. Roland Emmerich. Perf. John Cusack, Chiwetel Ejiofor, Amanda Peet. Columbia Pictures, 2009.

The Age of Innocence. Dir. Martin Scorsese. Perf. Daniel Day-Lewis, Michelle Pfeiffer, Winona Ryder. Columbia Pictures, 1992.

American Beauty. Dir. Sam Mendes. Perf. Kevin Spacey, Annette Bening, Mena Suvari. DreamWorks Studios, 1999.

Anger Management. Dir. Peter Segal. Perf. Adam Sandler, Jack Nicholson, Marisa Tomei. Columbia TriStar, 2004.

Annie Hall. Dir. Woody Allen. Perf. Woody Allen, Diane Keaton, Tony Roberts. United Artists, 1977.

The Box. Dir. Richard Kelly. Perf. Cameron Diaz, Frank Langella, James Marsden. Warner Brothers, 2009.

The Buddha. Dir. David Grubin. Perf. Richard Gere, HH the Dalai Lama, W. S. Merwin. PBS, 2010.

Bulletproof Monk. Dir. Paul Hunter. Perf. Chow Yun-Fat, Seann William Scott, Jaime King. Lakeshore Entertainment, 2003.

Casino. Dir. Martin Scorsese. Perf. Robert De Niro, Sharon Stone, Joe Pesci. Universal Pictures, 1995.

The Cup. Dir. Khyentse Norbu. Perf. Orgyen Tobgyal, Neten Chokling. Fine Line Features, 1999.

Donnie Darko. Dir. Richard Kelly. Perf. Jake Gyllenhaal, Jena Malone, Mary McDonnell. Pandora Cinema, 2001.

Dreams of Tibet. Dir. Ben Loeterman. Perfs. Martin Scorsese, Jon Avnet, Richard Gere, Henry Kissinger, Jamyang Norbu, Orville Schell, Steven Seagal, Tenzin Tethong, Adam Yauch. PBS. Transcript (October 28. 1997), http://www.pbs.org/wgbh/pages/frontline/shows/Tibet/etc/script.html (accessed June 27, 2005). Filmmakers Library, 2001.

The Empire Strikes Back. Dir. Irvin Kershner. Perf. Mark Hamill, Harrison Ford, Carrie Fisher, Frank Oz. 20th Century Fox, 1980.

Fight Club. Dir. David Fincher. Perf. Brad Pitt, Edward Norton, Helena Bonham-Carter. 20th Century Fox, 1999.

Gone with the Wind. Dir. Victor Fleming. Perf. Clark Gable, Vivien Leigh, Olivia de Havilland. MGM, 1939.

Groundhog Day. Dir. Harold Ramis. Perf. Bill Murray, Andie McDowell, Chris Elliott. Columbia Pictures, 1993. 25th Anniversary Edition Film.

Heaven and Earth. Dir. Oliver Stone. Perf. Hiep Thi Le, Tommy Lee Jones, Joan Chen. Warner Bros. Pictures, 1993.

It's A Wonderful Life. Dir. Frank Capra. Perf. James Stewart, Donna Reed, Lionel Barrymore. Liberty Films, 1946.

Kill Bill. Dir. Quentin Tarantino. Perf. Uma Thurman, David Carradine, Daryl Hannah. Miramax, 2003.

Kundun. Dir. Martin Scorsese. Perf. Tenzin Thuthob Tsarong, Tencho Gyalpo, Sonam Phuntsok. Touchstone, 1997.

Kung Fu. Creator: Ed Spielman. Perfs. David Carradine, Keye Luke, Radames Pera, Philip Ahn. Warner Bros., 1972–75. Television show.

The Last Samurai. Dir. Edward Zwick. Perf. Tom Cruise, Ken Watanabe, Billy Connolly. Warner Bros., 2003.

Leaving Las Vegas. Dir. Mike Figgis. Perf. Nicolas Cage, Elizabeth Shue, Julian Sands. United Artists, 1995.

Light of Asia (*Prem Sanyas*). Dir. Franz Osten and Himansu Rai. Perfs. Seeta Devi, Himansu Rai, Sarada Ukil. Great Eastern Film Corporation, 1925. Feature film.

Little Buddha. Dir. Bernardo Bertolucci. Perf. Keanu Reeves, Bridget Fonda, Chris Isaak, Ruocheng Ying, Sogyal Rinpoche, Ven. Geshe Tsultim Gyeltsen. Miramax Films, 1994.

Lost Horizon. Dir. Frank Capra. Perf. Ronald Colman, Jane Wyatt, Edward Everett Horton. Columbia Pictures, 1937.

Lost in Translation. Dir. Sofia Coppola. Perf. Bill Murray, Scarlett Johansson, Giovanni Ribisi. Focus Features, 2003.

The Lover [*L'Amant*]. Dir. Jean-Jacques Annaud. Perf. Tony Leung Ka Fai, Frédérique Meininger, Arnaud Giovaninetti. AMLF, 1992.

Mandala. Dir. Kwon-taek Im. Writers: Song-dong Kim (novel), Sang-hyon Lee. Perfs. Sung-kee Ahn, Mu-song Jeon, Jong-su Kim. Hwa Chun Trading Company, 1981. Feature film.

The Matrix. Dir. Andy Wachowski and Larry Wachowski. Perf. Keanu Reeves, Laurence Fishburne, Carrie-Anne Moss, Hugo Weaving. Warner Bros. Pictures, 1999.

The Name of the Rose. Dir. Jean-Jacques Annaud. Perf. Sean Connery, Christian Slater, Helmut Qualtinger. Constantin, 1986.

Raging Bull. Dir. Martin Scorsese. Perf. Robert De Niro, Cathy Moriarty, Joe Pesci. United Artists, 1980.

Seeking Heartwood. Dir. Adam Eurich. Perf. Bhikkhu Bodhi, Rev. Danny Fisher, Richard Gombrich. [in post-production]

Seven Years in Tibet. Dir. Jean-Jacques Annaud. Perf. Brad Pitt, David Thewlis, B. D. Wong. TriStar Pictures, 1997.

Six Feet Under. Creator Alan Ball. HBO, 2001–2005. Television.

Southland Tales. Dir. Richard Kelly. Perf. Sarah Michelle Gellar, Dwayne Johnson, Justin Timberlake. Universal, 2006.

Star Wars: Episode III—Revenge of the Sith. Dir. George Lucas. Perf. Ewan McGregor, Natalie Portman, Hayden Christensen. 20th Century Fox, 2005.

The Secret of Buddha, also known as *A Scream in the Night.* Dir. Fred C. Newmeyer. Writer, Norman Springer (story). Perf. Zarah Tazil, John Ince, Manuel López, Lon Chaney Jr. http://www.youtube.com/watch?v=rGt2MD0drc0, 1935.

The Silver Buddha. Dir. A. E. Coleby. Perf. H. Agar Lyons, Fred Paul, Joan Clarkson, Humberston Wright. Stoll Picture Productions, 1923.

The Soul of Buddha. Dir. J. Gordon Edwards. Writer Theda Bara. Perf. Theda Bara, Victor Kennard, Florence Martin. Fox Film Corporation, 1918.

Tokyo Story (Tōkyō monogatari). Dir. Yasujiro Ozu. Perf. Chishu Ryu, Chieko Higashiyama, Setsuko Hara. Sochiku, 1953.

Wall Street. Dir. Oliver Stone. Perf. Charlie Sheen, Michael Douglas, Tamara Tunie. 20th Century Fox, 1987.

CONTRIBUTORS

Richard C. Anderson is an independent scholar and former assistant professor of philosophy from the United States Military Academy, West Point, New York. His interests, articles, and publications have centered on aesthetics, ethics, and just war theory, including *Philosophy 9/11: Thinking about the War on Terrorism* (2005). He holds an MA in Philosophy from the University of Connecticut and a BA from Western New England College, Massachusetts. His current research focuses on peace studies and the application of nonviolent means to global conflict resolution.

Felicia Chan is Lecturer in Screen Studies at the University of Manchester. Her research explores the construction of national, cultural, and cosmopolitan imaginaries in cinema, as well as the influence of institutional and industrial practices on the production, distribution, and reception of film. She has published essays in several journals and edited volumes, including *Chinese Films in Focus I and II* (2009) and *Theorizing World Cinema* (2012). She is also coeditor of *Genre in Asian Film and Television: New Approaches* (2011).

B. Steve Csaki holds a doctorate in philosophy from the State University of New York at Buffalo. He specializes in comparative philosophy and is particularly interested in exploring the parallels that exist between Zen Buddhism and classical American pragmatism. He has published essays in volumes including *The Lord of the Rings and Philosophy* (2003) and the *Journal of the Association for Interdisciplinary Study of the Arts*. He recently coedited *The Philosophy of the Western* (2010) with Jennifer L. McMahon. From 1998 to 2006, he was Visiting Professor at Centre College in Danville, Kentucky, where he

taught courses in philosophy, humanities, and Japanese, and served as the coordinator for the Japanese program. Csaki has now relocated to Oklahoma where he is an independent scholar and rancher. He owns and operates Watershed Ranch with Jennifer McMahon.

Gary Gach is founder of Mindfulness Fellowship, San Francisco, author of *The Complete Idiot's Guide to Buddhism*, and editor of *What Book!? Buddha Poems from Beat to Hiphop*. His work has appeared in numerous periodicals and anthologies, including *American Cinematographer, Harvard Divinity Bulletin, Language for a New Century, Technicians of the Sacred, Veterans of War, Veterans of Peace*, and *Yoga Journal*. He was recently cast for a role in *Your Good Friend*.

Devin Harner is Associate Professor of English at John Jay College of Criminal Justice / The City University of New York where he teaches journalism, film, and contemporary literature. His recent publications include essays on musicality and structure in Ciaran Carson's *Last Night's Fun*; on Chuck Palahniuk's nonfiction; on the film *Adaptation*'s relationship to Susan Orlean's *The Orchid Thief*; and on virtual time travel through YouTube. He is currently at work on a book exploring Philip Levine and Gary Snyder's treatment of landscape, post–World War II history, and autobiography.

David A. Harper is Assistant Professor of English in the Department of English and Philosophy at the United States Military Academy, West Point, New York. He earned his doctoral degree from the University of Texas, Austin, and works primarily on John Milton and British literature of the seventeenth and eighteenth centuries. He has recently published articles in *Review of English Studies* and *The Papers of the Bibliographic Society of America* and has an article forthcoming in *Studies in Philology* on Shakespeare's sonnets. His current project traces the redemption of *Paradise Lost* from Milton's political and religious reputation.

Charles Johnson, a 1998 MacArthur fellow, is emeritus professor at the University of Washington. His fiction includes *Faith and the Good Thing* (1974), *Oxherding Tale* (1982), *Dreamer* (1998), and *Middle Passage*—for which he won the National Book Award (1990)—and

the short story collections *The Sorcerer's Apprentice* (1988), *Soul-catcher and Other Stories* (2001), and *Dr. King's Refrigerator and Other Bedtime Stories* (2005). His nonfiction books include *Turning the Wheel: Essays on Buddhism and Writing* (2003), *Being and Race: Black Writing Since 1970* (1988), *Taming the Ox: Buddhist Stories and Reflections on Politics, Race, Culture, and Spiritual Practice* (2014), two collections of comic art, and *Bending Time: The Adventures of Emery Jones, Boy Science Wonder*, a young adult book he co-authored with his daughter Elisheba Johnson and illustrated. In 2002 he received the Academy Award in Literature from the American Academy of Arts and Letters.

R. C. Lutz teaches English and works as a consultant for CII Partners in Bucharest, Romania, after graduating with a PhD in English and Film Studies from the University of California, Santa Barbara. Academic publications include articles on the Vietnamese American experience such as "The Wartime Diaries of Dang Thuy Tram: Extolling and Gendering the Heroine's Voice in Postwar Viet Nam and Beyond," in *Women and Language: The Gendering of Talk, Gossip, and Communication Practices across Media*, edited by Sarah Burcon and Melissa Ames (2011) (with Hanh N. Nguyen). Lutz works on Pacific Rim literature, history, and culture.

Jennifer L. McMahon is Professor of Philosophy and English at East Central University. McMahon holds a doctoral degree in Philosophy from the State University of New York at Buffalo. She has expertise in existentialism, aesthetics, and comparative philosophy. She has published articles in journals including *Asian Philosophy* and *The Journal of the Association for Interdisciplinary Study of the Arts*, as well as essays on philosophy and popular culture in volumes including *Seinfeld and Philosophy* (2000), *The Matrix and Philosophy* (2002), *The Lord of the Rings and Philosophy* (2003), *The Philosophy of Science Fiction Film* (2007), *House M.D. and Philosophy* (2008), and *Death in Classic and Contemporary Film: Fade to Black* (2013). She recently edited *The Philosophy of Tim Burton* (2014) and coedited *The Philosophy of the Western* (2010) with B. Steve Csaki. McMahon and Csaki own and operate Watershed Ranch in Oklahoma where they live with their two children.

Jiayan Mi is Associate Professor of Comparative Literature, Film, and Critical Theory in the departments of English and Modern Languages and Literatures at The College of New Jersey. He is the author of *Self-Fashioning and Reflexive Modernity in Modern Chinese Poetry, 1919–1949* (2004) and coeditor with Sheldon Lu of *Chinese Ecocinema in the Age of Environmental Challenge* (2010). He is currently completing a book project, tentatively titled *Heteroscapes: Topography and Contested Navigation in Modern Chinese Literature and Film.* He has published articles in both Chinese and English on comparative literature, visual and cinematic culture, globalization and cultural consumption, and East-West postcolonial and gender politics.

Eve Mullen joined the Religion faculty at Oxford College of Emory University in 2006. Mullen earned a BA in Religion at Washington and Lee University in 1990, an MTS from Harvard in 1992, and her PhD in Religion from Temple University in 1999. Her areas of expertise include Tibetan Buddhism in America and religion's role in identity construction. She is a Fulbright U.S. Scholar and a Fulbright Senior Specialist in American Studies and Religious Studies. Mullen is the author of *The American Occupation of Tibetan Buddhism: Tibetans and Their American Hosts in New York City.*

Hanh Ngoc Nguyen is a PhD candidate, writing her dissertation on Vietnamese national cinema in the English Department of the University of Florida, Gainesville. She also specializes in Asian American studies. She holds an MA in Film Studies from the University of California, Riverside, and a BA in English and Film Studies from the University of the Pacific at Stockton, California. She has published a series of articles on the Vietnamese and Vietnamese American experience, including "A Bridge between Two Worlds: Crossing to America in *Monkey Bridge*," in *The Emergence of Buddhist American Literature*, edited by John Whalen-Bridge and Gary Storhoff (2010) (with R. C. Lutz) and the forthcoming "'That Dissident Whore': The Struggle for Gender and Authorial Authenticity in Duong Thu Huong's Novels."

Danny Rubin, after many years of writing for professional theater companies as well as scripting industrial films and children's television, began writing screenplays. His screen credits include *Hear No*

Evil, *S.F.W.*, and *Groundhog Day*, for which he received the British Academy Award for Best Screenplay and the Critics' Circle Award for Screenwriter of the Year, as well as honors from the Writers Guild of America and the American Film Institute. Rubin has taught screenwriting in Chicago at the University of Illinois, Columbia College, and the National High School Institute; at the Sundance Institute in Utah; the PAL Screenwriting Lab in England; the Chautauqua Institution in New York; and in New Mexico at the College of Santa Fe. He is currently the Briggs-Copeland Lecturer on Screenwriting at Harvard University.

David L. Smith is Professor in the Department of Philosophy and Religion at Central Michigan University. His research explores the religious implications of Romanticism, the writings of Ralph Waldo Emerson in particular, and the Emersonian echoes that continue to inform American religion, literature, and film. David has published essays on Walter Mosley, Ralph Waldo Emerson, and the films of Charlie Kaufman.

Gary Storhoff was Associate Professor of English at the University of Connecticut, Stamford Campus. He has widely published in American, African American, and Ethnic American literature. He is the author of *Understanding Charles Johnson* (2004) and coeditor of *The Emergence of Buddhist American Literature* (2009) and *American Buddhism as a Way of Life* (2010). Gary passed away on November 7, 2011.

Karsten J. Struhl teaches political and cross-cultural philosophy at John Jay College of Criminal Justice (CUNY) and the New School. He has coedited *Philosophy Now* (1972, 1975, 1980), *Ethics in Perspective* (1975), and *The Philosophical Quest: A Cross-Cultural Reader* (1995, 2000). He writes about such topics as ideology, human nature, just war theory, global ethics, radical democracy, visions of communism, ecology, spiritual atheism, Marxism, and Buddhist philosophy. His articles have appeared in a variety of journals, books, and encyclopedias.

Jason C. Toncic is a poet and a freelance scholar. He teaches at Glen Rock High School in Ridgemont, New Jersey.

John Whalen-Bridge is Associate Professor of English at the National University of Singapore. He is author of *Political Fiction and the American Self* (1998). With Gary Storhoff he has edited the SUNY series Buddhism and American Culture, including *Emergence of Buddhist American Literature* (2009), *American Buddhism as a Way of Life* (2010), and *Writing as Enlightenment* (2010). He coedited *Embodied Knowledge: Traditional Asian Martial Arts in a Transnational World* with Douglas Farrer (2011) and he edited *Norman Mailer's Later Fictions* (2010) all by himself. His article "Multiple Modernities and the Tibetan Diaspora" appeared in *South Asian Diaspora*, and he is currently writing a study of "soft power" as a weapon of the weak, focusing on Tibetan self-immolation.

INDEX